Stitching Resistance
Women, Creativity, and Fiber Arts

Edited by Marjorie Agosín
Wellesley College, Massachusetts, USA

Solis Press

Dedicated to Rebecca Leavitt (1947–2013) whose vision and solidarity for women's voices continue to inspire all those that knew her.

ISBN: 978-1-907947-90-2

Published by Solis Press, PO Box 482, Tunbridge Wells TN2 9QT, Kent, England

Web: www.solispress.com | *Twitter:* @SolisPress

Contents

Introduction: To Weave a World

In the house at the end of the world, as my grand-parents, Jewish immigrants from central Europe and the Ukraine, used to call Chile, there were secret rooms that I loved to explore. One of them was a room where a beloved nanny and survivor of multiple earthquakes, Carmen Carrasco, used to keep a collection of brooms to sweep away the evil spirits or for good luck to return to the house. In another room she kept wool from the south of Chile, even further than the end of the world. This room, filled with diverse fragrances was the most magical place in the house. My memories of it are the most vivid of my childhood.

The memories of the wool that Carmen brought from her village have remained among my most recurrent as well. The wool was soft and it smelled of smoke as it was often kept in rooms filled with salamanders (the old fireplaces used in the homes of the south). It also smelled like, and evoked in me, the beginning of seasons according to the colors. Sometimes when the rains descended over our city, I would lend my two tiny arms to Carmen so she could *ovillar la lana* (wind the wool) making me feel so very useful and happy. I also loved going to her room at twilight, when the trees played with the shadows, to see how she made quilts out of patch-work to be sent to her relatives dispersed throughout our very long and narrow country.

Fibers, scraps of cloth, and wool were all important elements of life in the Chile where I grew up. The beautiful crafts produced with these textiles were emblematic of a time of innocence, a time when the work made with one's hands conveyed purity and beauty. These textiles continue to be powerful. They offer comfort and a sense of security to those who make them, as well as to those who wear them or decorate their homes with their vibrant colors. When I travel away from what I consider my spaces

of safety, I wear my grandmother's white crochet shawls and socks that she made. These handmade objects not only protect me but allow me to feel I'm always immersed in the memories they carry: memories of love, of beauty, and of refuge. Away from the domestic spaces of the home, cloth has taken on yet another meaning for me. As a young woman in exile in the USA, I dreamed about the room filled with wool and about the ways in which fabrics became my memory as well as my identity.

The power of fabrics can be amplified well beyond the individual experience. Often, the creation of these pieces begins within the home but they travel out into the world sharing their stories. Esther Krinitz, Netty Vanderpol, and Violeta Parra's creations (as appearing in the chapters of this book) for example, are exhibited in museums worldwide. It did not begin this way. The individual artists featured in the chapters and the movements that follow, present an interesting journey from stitching the internal to the external; a journey from the hearth to the collective voice of the world.

In 1976 I became involved with the Chilean *arpilleristas*, the women who created memorial patchworks to remember life before and during the Pinochet dictatorship. They created *arpilleras* to remember the disappeared, to honor their presence and their lives. Holding the *arpilleras* in my hands I would imagine how these mothers tenaciously re-created the life of their children through stitching. Despite the early obstacles I faced, this work became the most important in my academic career.

This book, *Stitching Resistance*, began to develop many years after my work on the Chilean *arpilleristas* was completed. I came to realize how important the work of weaving, stitching, and embroidering has been for women around the world, spanning across all disciplines and time. Thus, this collection of

essays began to take shape in my hands and in the hands of those who wrote them as I invited people from different disciplines including poets, philosophers, scholars, social workers, folklorists, and art historians to contribute. People of all trades and disciplines and from around the world have the enormous capacity to convey ideas about stitching. The reader will hopefully find inspiration, delight, and a tremendous sense of awe on reading these diverse essays all united by the commonality of fabric arts and by their power to transform and inspire.

This book is organized into four parts: Stitching as a Metaphor, In Women's Hands: The Art of Resistance, In Women's Hands: Communities of Hope, and Every Stitch a Memory.

Part I: Stitching as a Metaphor, explores how the weaving arts have from antiquity to the present been essential metaphors for mending. They help us compose and better understand our world in a non-verbal manner. The first chapter of this collection, "Fated Webs" by philosopher Anne Ashbaugh, is a beautiful meditation on ancient Greek philosophy with the central idea that beauty and the art of healing create alliances and dialogues with one another. Penelope becomes the central figure of this essay, not only as a weaver who unweaves until her husband returns to Ithaca, but also as an artist who meditates on this process of weaving as a form of writing and transforming the world around her.

This chapter is followed by Ester Andradi's "Stitch by Stitch," a meditation on the ways in which literature and stitching relate to one another. Andradi ponders the etymology of the word textile and its uses from ancient times to the present, also discussing why the invisibility of women as related to textiles has been so pervasive throughout history. She reflects on stitching as a form of resistance that reconstructs through the recording of memories, voicing a silent reality. Ashbaugh and Andradi's chapters can be read as dialogues on the ancient art of embroidering and stitching and women's place as they became the tellers of their own stories through the power of cloth.

Writers Lori Marie Carlson and Sheryl St. Germain explore how lace and knitting have informed their creative work. Lori Marie Carlson considers the intrinsic beauty of lace, its legendary origins, and the role it has played in her own narratives. She describes the "delicate," "resilient" nature of old lace, its strength and comments on the material's reflection of the individual artists' hands implying their strength and skill. Sheryl St. Germain writes, in a very poignant way, on how knitting has been both a meditation and a process of healing as she narrates the complex life history of her troubled son. She demonstrates how knitting has brought her a sense of understanding of life under duress.

The chapters "Spirit Socks," written by writer and knitter extraordinaire Lorraine Lener Ciancio and "Knot Magic" by poet and mystery writer Linda Rodriguez complement one another. In both of these chapters, knitting, weaving, and stitching are portrayed as other worldly, magical tasks. In Taos, New Mexico, Ciancio brings us back to the Martínez Hacienda with all its history and power. Ciancio conveys the beauty and warmth of a pair of socks and the profound experience of crafting them. She describes how knitting connects her to the past and brings her and others joy. Rodriguez writes of the importance of crafting in her life, expressing its comforting and even curative effects. Stitching connects her to her ancestors and represents a strong, and even magical, power. For Carlson, St. Germain, Ciancio, and Rodriguez, stitching contains emotion. Observing and creating fiber arts become a powerful experience. This first part, Stitching as a Metaphor, moves with ease from ancient to modern times. Whether personal or historical, the metaphors address how the delicateness, intricacies, and strength of stitching, knitting, and lace allow female artists to explore their own lives as well as those of their communities.

The second and third parts of the book, In Women's Hands, focuses on contemporary times, and more specifically on women and textiles. The chapters included in Part II, In Women's Hands:

The Art of Resistance, discuss cases in which female art has served a purpose larger then the individual artist. Rather then having an individual focus, female fiber art has often been crafted to explore social issues and inspire change for the benefit of their communities and the world.

This part begins with a theoretical article by Roger Dunn. He presents an historical journey on women's arts, primarily in the USA, and comments on their place in history. Like philosopher Anne Ashbaugh, Dunn also draws inspiration from the stories of women in Greek mythology illuminating the important impulses for creating art. Professor Dunn explores how the values of morality and femininity have defined women's fiber arts and how, throughout history, it has been incredibly difficult for women to enter the artistic world of Western tradition. Professor Dunn inspires us to think about the alternate ways in which women have achieved notoriety in the arts of quilting and patchwork, constructing fewer egocentric narratives and instead creating collective narratives made out of often fragmented stories of women's lives.

Professors Marilyn Kimmelman and Rebecca Leavitt explore the practical manifestations of women's arts and crafts in the USA in their chapter "American Women Crafting Cloth: From Bees to Blogs." This essay also carries a dialogue with Professor Dunn's piece as they both explore the inner and outer spaces of women's art. Kimmelman and Leavitt explore many early nineteenth-century cases in which women in North America and other parts of the world have worked together to create quilts and linen for the betterment of their families and how these have evolved to become more subversive and political forms of art. Kimmelman and Leavitt discuss a variety of these cases such as Judy Chicago's *The Dinner Party* and the quilts that aided slaves in the USA as they sought freedom. As we read the articles by Dunn and Kimmelman and Leavitt, we come to understand how all forms of stitching have had a vibrant evolution in women's art. They have not been forced to invisibility as mentioned by Dunn but have instead become powerful forms of expression.

Roberta Bacic explores the art of the *arpilleras* in Chile and how women began making them under the most adverse conditions. The pieces exemplify the artists' courage and through apparently innocent images create narratives that witness the dark history of Chile under the Pinochet dictatorship. They also tell the stories of young people whose lives were truncated as they were taken abruptly from their homes and disappeared. The *arpilleras* were often made of leftover scraps of cloth given by solidarity groups or by women who had disappeared people's clothing, making history almost physical and keeping it and memory alive. In Gaby Franger's chapter "Survival–Empowerment–Courage," we also learn how the *arpillera* workshops in Perú serve as a way to memorialize through arts and crafts workshops. Creating *arpilleras* has become a community effort that sustains and unites women as they depict injustices of the past and present.

Many practitioners of *arpilleras* as well as quilts and other fiber arts creations ask themselves about the legacy of their work. Will they continue to be made by the hands of the young generation or perhaps other forms of visual narratives will take shape? The work of curator Roberta Bacic answers this essential question. This tireless activist has during the last decade produced countless exhibits in many parts of the world including Argentina, Germany, Japan and New Zealand. Bacic believes that *arpilleras* continue in numerous forms and are united by a sense of universality as well as diversity.

Bacic has inspired many women around the world and in conflict areas, such as women in Barcelona where women retell the history of the Spanish Civil War, to tell their stories in cloth, many of these for the first time. Also, Bacic has created exhibits where the Irish quilts are in constant dialogue with the contested histories as they refer and retell the conflict in Northern Ireland.

The legacy of the *arpilleras* lives on in the many manifestations that have emerged from the original

patchworks made by the women of Chile, *arpilleras* that continue to create a dialogue with resistance around the globe.

A similar story can be found in the chapter "Seeing Voices: Srebrenica's Filaments of Memory" by Inela Selimović in which she discusses the Srebrenica Memorial Quilts project. The collective nature of quilt-making has become a way to memorialize the 1995 mass murder in Srebrenica, Bosnia. The project is gradually mending ethnic divides because the women who work on the quilts are ethnically diverse. The project addresses the healing process and is dedicated to protecting peace and documenting both cruelty and kindness. By recording both tragedy and hope, the women aim to prevent future brutality of a similar nature and provide evidence that art can be a tenacious thread towards the persistence of memory. All of these essays prove that the fiber arts can empower, remember and have a significant effect both on the individual and communal, even global scale.

The chapter by Professor O'Connor bridges many traditions as well as cultural representations of the history of the quilt in Ireland. In her essay, we can understand the evolution of this tradition from its simplicity as an essential element of the household to cover, to protect, and at the same time as an object that has a deep meaning aesthetically, and also as an equalizer in terms of its social component, since all different social classes practice this art form. At the same time, Professor O'Connor also addresses the political uses of the quilting tradition in Ireland used by both Protestant and Catholic women during the times of the Troubles as a way to heal and to create understanding and dialogue between the two communities.

It is also interesting that the Irish quilts made during the Troubles resonate with the work of the *arpilleristas* as a way to heal, and to create scraps of remembrance during the military dictatorship. It is also important to not to forget how the history of the Irish quilts stitches fundamental moments of individual lives and, at the same time,

encompasses a collective memory where issues of human rights, restoration, and collective justice are addressed through the quilt. This chapter once again allows us to understand how the quilt evolves throughout history and how it is used to express moments of political resistance as well as the rearticulation of history and memory; all done and constructed by the work of women from both sides.

As Kimmelman and Leavitt mention, threads have served as women's pens and the expression of history and witnessing of lives, often submerged to invisibility, have emerged victoriously through cloth narratives. In Part III, In Women's Hands: Communities of Hope, we gather Renée Scott, Michal Held, and Emma Sepúlveda Pulvirenti's chapters. These pieces address the fiber artwork of female communities that have empowered women, giving them an opportunity to write and dictate their own stories and futures.

In the chapter "In Women's Hands: Manos del Uruguay and Stories of Empowerment," Professor Renée Scott discusses community efforts in Uruguay to empower through the fiber arts. She writes of an extraordinary cooperative, Manos del Uruguay. This cooperative was created exclusively to empower women of very low economic status and it truly has been an example of altruism and nobility. Poorer women are taught how to craft with wool while the women who founded the organization provide a space for the creation of their beautiful wool items and transportation to Montevideo for them to be sold. The women who work in Manos del Uruguay develop a way to sustain themselves, become independent and are greatly empowered.

For poet and folklorist Michal Held, the arts of sewing and knitting are a part of her daily life and the focus of much of her research. In "Text-Tiles: Reflections of Women's Textiled World in the Judeo-Spanish (Ladino) Poetic Tradition," she speaks of the ancient poetic tradition of the Sephardims and how the images of knitting and embroidery have been carried, through word of mouth, in their

ancient songs as though they themselves have embroidered life into history.

Emma Sepúlveda Pulvirenti's chapter also explores the significance of stitching with reference to poetry and music. She writes of the *bordadoras* (embroiderers) of Isla Negra in Chile, of their history and how their artwork has inspired poets such as Pablo Neruda and folklorist musicians such as María Angélica Ramírez and Violeta Parra. The stitched creations of the *bordadoras* are innately connected to Isla Negra as they depict scenes of nature. *Bordadoras* have had a significant impact on the lives of Isla Negra inhabitants. They bring color and beauty to homes and the community, improving the quality of life. *Bordadora* projects have united the women who craft them, created community and new economic prospects and opportunities. Stitching has strengthened the four communities described in this part. It has played a critical role, recording and persisting memory and hailing new and exciting opportunities for each.

Part IV, Every Stitch a Memory, consists of the work of six individual artists. We explore how memories and the past have been stitched into textiles and how stitching and writing are intertwined. The first two authors, Bernice Steinhardt and Dunreith Kelly Lowenstein write of female artists who grew up in Europe during the Holocaust. Years later, after the passing of time and history allowed them to process their pain, they were able to recreate some of their experiences through cloth. Steinhardt narrates her mother Esther Krinitz's history with great poignancy, beginning with her early childhood as she observed Esther sewing and as she went on to create magnificent tapestries of her life. With dedication and a great sense of aesthetic beauty, Esther recreated life under the Nazi occupation and conveyed how the sense of innocence and peace that had characterized her life before the war collapsed. It took years for Esther to process the trauma of exile, eviction from her home and death but, like the *arpilleristas*, she manifested her grief through beauty and with precise stitches composed her story.

In the essay "Every Stitch a Memory," Lowenstein writes about the artist Netty Schwarz Vanderpol. Like Esther Krinitz, Netty used needlepoint to depict her wartime experiences, trying to somehow capture the brutality of the Holocaust. These two European artists depict their wartime experiences distinctly, yet their pieces are united by the detailed labor of love and remembrance in every stitch. Like their sisters in Chile, Perú, and Bosnia who created anonymous art, they felt compelled to document the cruelties of history. The expression of trauma and its recovery is manifested in all these artists' work, both individually and collectively, through cloth. Their fiber art documentations create the impression that memory itself is a patchwork that one can dismember, create, and revisit.

In the chapter entitled "Violeta Parra's *Arpilleras*: Vernacular Culture as a Pathway to Aesthetic Self-determination," Professor Gina Canepa writes about Violeta Parra, one of the most extraordinary and prolific artists of Chile and Latin America. I believe that Parra's inspiration to make beautiful and colorful wall hangings came from her experience as a folklorist and her commitment to bring the works of a people's art to the public. There are very few studies that deal with Violeta's visual art and her *arpilleras*, but I am certain, and as Canepa points out, that the Chilean *arpilleras* were inspired and influenced by Parra's work. The use of burlap, for example, as a backing cloth, the use of colorful wool and the themes that Violeta Parra depicted, all point to this. Her works are in most cases denunciatory of the profound gap between the rich and the poor and also speak of the invisible minorities of Chile, such as women, children, and the indigenous population, who were seldom put into accounts. In this way, Parra acknowledges and records parts of history that have been neglected.

In Professor Heather Russell's work, "Quilted Discourse: Writing and Resistance in African Atlantic Narratives," we come to understand important parallels between quilting and writing, and, in particular, a quilting aesthetic that is an intrinsic part of female

African art as well as the works of African American women writers. Russell uses the concept of the quilt to discuss and illuminate the exploration of the quilt form in literary narratives. She evokes the art of quilt-making in the work of African American women writers and uses the concept of the quilt and the braid to construct theories about how women's narratives can also be read as quilts, woven into each other. The aesthetics that continue in the works of contemporary women writers, especially African Americans, have a sense of energy, a "spark," as Russell indicated, from the slave traditions. We observe that many cultural traditions flourish in the visual as well as in the narrative and how these two parallel worlds have served to create a tradition of resistance from the time of slavery to the present.

Professor Ana Luszczynska follows some of the concepts expressed in Russell's chapter and examines the literary text, *In the Time of the Butterflies* by Julia Alvarez. Her analysis is a very close textual reading that addresses how the element of sewing accompanies the narratives of the three Mirabal sisters. The central characters move back and forth from the domestic realm of their childhood to the revolutionary stand they take fighting the Trujillo dictatorship in Central America. As Luszczynska clearly points out, throughout the book we observe how sewing has the quality of transformation from the world of domesticity to political empowerment.

Marcela Orellana Muermann also explores how literature emulates the concept of weaving. In her chapter, "Of Letters and Baskets: Wicker and Poetry," Orellana returns to her native Chile and creates a dialogue between three poets from the south of Chile: Efraín Barquero, Faumeliza Manquepillán, and Graciela Huinao. In this dialogue we find a profound reflection on the concept of textiles and poetry through the uses of metaphors based on the ancient concepts of weaving and writing.

Part IV, Every Stitch a Memory, encapsulates many ideas that have appeared in these pages and there is a conversation with each of the pieces as if we as readers are engaged in the art of quilting narratives in cloth. This part addresses how literature, lace-making, and quilting traditions hold a parallel with literary voices and ancient traditions. Text and textiles are inseparably linked, each nurturing and inspiring the other, telling stories and keeping history and memories alive.

All the essays in this anthology effectively reflect this connection as they convey fascinating, literary, personal, community, and world-level analyses of the fiber arts. In the first part we bear witness to the incredible power stitching has even as a metaphor. Reflecting on history, myths and personal experiences, the writers demonstrate that acts of stitching, knitting, and quilting have the ability to mend and cure, even soothing a mother's broken heart and providing comfort for the sick. Stitching becomes a powerful, even magical art.

Fiber arts have proven to be especially empowering for women. The chapters in the second part explore this through analysis of myths, history, political movements, and movements for social change. Stitching can sustain communities, keeping them alive and thriving as demonstrated in the Manos del Uruguay organization and in the Navajo and Sephardim communities. These essays reflect a common thread in women's stitching: that the impulse behind female art is often external rather than individual. It is created for betterment of the world and to bring about peace whether on a family, country, or global scale.

As Inela Selimović writes, the women in Bosnia quilt stories and bear witness to history, no matter how cruel, in order to bring about a more peaceful future. This recording of history is a crucial aspect of stitching. Fiber arts provide a way to document and remember history and keep memories alive. Women working in textiles have demonstrated a desire to record history from the most intimate experiences to those that move beyond the personal realm to the historical. And an experience that begins with the artist creating on her own can grow into the reflection of a much larger history.

This collection is extraordinary in many ways. The scholars and artists who have contributed to the anthology provide perspectives from diverse disciplines, all of them carry a dialogue and resonate with each other. I invite the readers to enter into the spaces that each of these chapters convey, from the marvels of ancient Greece, with its myths of weaving and unweaving, to the groups around the world who have used stitching to inspire positive change and peace. We will observe how the individual artist moves from the private narratives of self to the public discourse of art as a tool to empower and transform the lives of women and their communities.

There is much to comment on in each of these chapters, all especially written for this book. I am certain that every reader will find meaning as he or she encounters these essays, whether in the visionary pages of Roger Dunn who rethinks the history of female artistic expression and the incorporation of craft into their art, or in Ester Andradi's essay in which, with painstaking detail, she analyzes the meaning of textiles within women's art and literary imagination.

In each of these chapters about individual artists or social movements, I have found the intense need to live in beauty and create meaningful works of art. The need to create forms of beauty allows the artist to transcend horror, improve society, and envision a brighter future.

The threads, the scraps of cloth, the wool, the lace, and the stitching are all manifestations of beauty, resistance, courage and the possibility to embroider the world with grace and light.

Marjorie Agosín, Editor
Wellesley College, Massachusetts, USA

Acknowledgments

This book began many years ago as a dialogue between friends who are scholars and activists and deeply interested in women's artistic expression as a way of empowerment and resistance. I am thankful to each of the contributors who so generously accepted my invitation to participate in this project and wrote specially for it.

My conversations with each one of the participants was instrumental in the writing of the introduction. I am especially grateful to my ongoing conversations with Roberta Bacic and Anne Ashbaugh.

I also want to thank my student Gabriella Wayne for her editorial and technical skills while she prepared the manuscript and also a very deep heartfelt thanks to Lesley Gray and Robert Gray from Solis Press who from the very beginning embraced this project and have made it possible to happen. They are both extraordinary editors as well as a pleasure to work with.

Rebecca Leavitt, a dear friend and contributor, passed away before this book was published. This collection is dedicated to her memory as well as her passion for women's work. I owe much of this book to our long conversations in the coast of Maine. She was an avid listener and an inquisitive mind. She left us far too soon but her writings and her spirit continue to nourish us.

I also want to dedicate this book to Anne Ashbaugh for her infinite wisdom and her infinite vision.

Contributors

Esther Andradi

Esther Andradi is a novelist, journalist and the author of two novels who divides her time between Buenos Aires and Berlin.

Anne Ashbaugh

Anne Ashbaugh is a professor in the Department of Philosophy of Towson and Rutgers universities. Professor Ashbaugh has published works in ancient Greek philosophy, philosophy of literature, and Latin American thought. Her doctorate was from Duquesne University in Pittsburgh in 1974. Postdoctoral work was carried out at Princeton University and the universities of Padua, Salamanca, and Cambridge.

Roberta Bacic

Roberta Bacic, originally from Chile, has lived in Northern Ireland for many years where she has become a leading curator in showcasing textile arts of significant social relevance (more information is available from www.cain.ulst.ac.uk/quilts). In the past seven years she has curated more than fifty exhibits around the world, focusing specially on *arpilleras* that depict conflict and state violence. She was a lecturer at the Universidad de Valdivia in Chile from 1973 to 1981 and from 1992 to 1996 was a researcher at the National Corporation of Reparation and Reconciliation, the follow-up body of the Chilean Truth Commission.

Gina Canepa

Gina Canepa is professor of Latin American literature at Providence College. She specializes in Chilean writers and has written a book on Violeta Parra's work as a poet and visual artist.

Lori Marie Carlson

Lori Marie Carlson is an essayist and novelist who divides her time between New York City and Durham, North Carolina. She is a professor at the English Department at Duke University.

Lorraine Lener Ciancio

Lorraine Lener Ciancio lives in Taos, New Mexico and is a writer, knitter, photographer, and editor of the annual SOMOS anthology, *Chokecherries*, currently in its twentieth year. She occasionally teaches workshops in knitting and writing memoir and blogs at The Knitorialist (http://knitorialist.blogspot.com/).

Roger Dunn

Roger Dunn is professor emeritus of art history, Bridgewater State University (BSU), Bridgewater, Massachusetts. He received his doctorate in art history from Northwestern University, Evanston, Illinois. Previous positions include curator of the Brockton Art Museum, and gallery director in Boston. At BSU, Professor Dunn designed and co-taught a course, "Women in the Visual Arts," which was offered nearly annually from 1988 to 2002. He has organized numerous exhibitions and have several published exhibition catalogs and articles, including several on women artists or patrons.

Gaby Franger

Professor Dr. Gaby Franger is vice dean at the Faculty of Social Work and Health and head of the degree program "International Social Work and Development" at Coburg University of Applied Sciences and Arts in Germany. She is co-founder of "Women in One World" center for international and intercultural research on women's daily lives in Nuremberg and of the Museum of Women's Culture(s) Regional–International in Fuerth.

Michal Held

Dr Michal Held teaches at the Hebrew University of Jerusalem, Israel. Her work focuses on Judeo-

Spanish (Ladino) literature and culture, emphasizing questions of ethnicity, identity, gender, and the Holocaust of the Sephardic Jews; and on contemporary Hebrew literature. Dr. Held's book *Ven Te Kontare* (*Let Me Tell You a Story*) is a multidisciplinary interpretation of the personal narratives of Judeo-Spanish speaking women storytellers from the linguistic, literary, and folkloristic perspective, relating to sociological, anthropological, psychological, and cultural contexts. She has published many essays on the above-mentioned subjects, as well as on folkloristic perspectives of Jerusalem, and on the web-based life of ethnic groups that are no longer active in the offline world, which she defined as "digital home-lands." Michal Held's poetry uniquely fuses Hebrew with Judeo-Spanish. Her recent book of poetry is *Merachefet al Pnei HaMayim* (*Over the Face of the Waters*).

Marilyn Kimmelman
Marilyn Kimmelman has been vice president for academic affairs for a college in Pennsylvania, dean of instruction and then director of academic affairs for a medical school in New Jersey. Dr. Kimmelman has published on empathy in medical students, personality archetypes, and psychological issues in organizational change. She began her career as a newspaper reporter, a columnist, and an advertising copywriter. She works as an editorial and educational consultant.

Rebecca Leavitt
Rebecca Leavitt is a professor and founding member of the Department of Social Work at Bridgewater State University (BSU) in Bridgewater, Massachusetts. Dr. Leavitt has also coordinated the Women and Gender Studies Program in which she teaches a course on psychosocial development of women using poetry and literature to help empower her students. She teaches an interdisciplinary course on "Perspectives of the Holocaust" and has interest in international social welfare conducting study tours to South Africa and Israel. Professor Rebecca Leavitt is professor emeritus at BSU and has written essays exploring women creativity and education.

L. Dunreith Kelly Lowenstein
Dunreith Kelly Lowenstein is an educational consultant and freelance writer who is particularly interested in stories of resilience and creative expression in the face of adversity. A longtime educator, she most recently was a member of the senior leadership staff of international nonprofit organization Facing History and Ourselves. Dunreith holds a master's degree from Smith College and a bachelor's degree from Williams College.

Ana Luszczynska
Ana Luszczynska is a professor of Latino studies at Florida International University and the author of *The Ethics of Community: Nancy, Derrida, Morrison, and Menendez*, a multidisciplinary study exploring US Latino and African American literature.

E.M. O'Connor
E.M. O'Connor is a writer, editor, and translator. Her translation of the novel *I Lived on Butterfly Hill* by Marjorie Agosín was published in March 2014 by Simon & Schuster, and her translation of *Fish* by Peruvian poet Mariela Dreyfus is forthcoming by Nirala Publications. Her writing has been featured in *Literal*, *Mandorla*, *The Recorder*, *Monitor on Psychology*, and *Revista: Harvard Review of Latin America*, among others. E.M. O'Connor currently teaches literature and Spanish at Lesley University in Cambridge, Massachusetts. She is writing her first novel.

Marcela Orellana Muermann
Marcela Orellana is a professor of literature and folklore at the Universidad de Santiago in Chile. She is the author of several articles on popular folklore and the book *Lira Popular. Pueblo Poesía y Ciudad en Chile*.

Linda Rodriguez
Linda Rodriguez's novels, *Every Broken Trust* and *Every Last Secret*, and books of poetry, *Skin Hunger* and *Heart's Migration*, received many awards, including Malice Domestic Best First Novel, Midwest Voices & Visions Award, International Latino Book Award finalist, Thorpe Menn Award for Literary Excellence, Elvira Cordero Cisneros Award, Eric Hoffer National Book Award finalist, Ragdale and Macondo fellowships.

Heather D. Russell
Heather Russell is professor of African American literature at Florida International University and the author of the book *Legba's Crossing: Narratology in the African Atlantic*. She has also authored numerous articles on Caribbean music.

Renée S. Scott
Originally from Uruguay, Renée S. Scott is a professor of Latin American literature and culture at the University of North Florida. She is the author of many articles on gender and ethnicity. Her most recent book is *What is Eating Latin American Women Writers? Food, Weight, and Eating Disorders*.

Inela Selimović
Inela Selimović is a visiting lecturer at Wellesley College, Massachusetts. She specializes in twentieth and twenty-first century Latin American literature and film. In addition to her academic pursuits, Dr. Selimović has also conducted numerous human rights-focused projects at home and abroad. In 2010, she worked at the United Nations Security Council in New York City as well as the United Nations High Commissioner for Refugees in Sarajevo, Bosnia and Herzegovina. She spent several days with Srebrenica-displaced families in Ilijaš in June and July of 2010.

Emma Sepúlveda Pulvirenti
Emma Sepúlveda is a professor of Spanish literature and director of the Latino center at the University of Nevada. She is the author of several publications among them *Setenta Días de Noche* about the struggles of the Chilean miners trapped in a mine in 2010 and their rescue.

Sheryl St. Germain
Sheryl St. Germain a native of New Orleans directs the creative writing program at Chatham University. She is a poet and writes non-fiction essays. *Let it Be a Dark Roux* and *Between Song and Story* are among her most recent books.

Bernice Steinhardt
Bernice Steinhardt is the president of Art and Remembrance, a nonprofit arts and educational organization she and her sister founded as a testament to the legacy of their mother, Esther Nisenthal Krinitz, a Holocaust survivor who depicted her experiences as a young girl in Poland in a series of beautiful and deeply moving fabric panels. Recognizing the power of their mother's art to change hearts and minds, they created Art and Remembrance to share her work and those of others like her who depicted their experiences as victims of war, oppression, and injustice. Since its founding in 2003, the organization has created a traveling exhibit of Esther Krinitz's art; published an award-winning book, *Memories of Survival*; and produced an award-winning film about Esther Krinitz, *Through the Eye of the Needle*. Until her retirement from federal service in July 2011, Bernice was a senior executive for more than two decades at the US Government Accountability Office (GAO), the investigative and analytic arm of the US Congress.

PART I STITCHING AS A METAPHOR

Fated Webs

ANNE ASHBAUGH

Introduction

… when you come home to your mother, does she let you do whatever it takes to make you happy, like playing with her wool or her loom when she is weaving? She doesn't stop you from touching the blade or the comb or any of her other wool working tools, does she?"

"Stop me?" he laughed. "She would beat me if I laid a finger on them" (*Lysis* 208d–e).

THE GREEK MYTHOS of weaving unfolds within the fabric of life and inserts itself into poetic practices and philosophical discourse. From Hesiod's *Theogony* to Plato's dialogues, weaving and the tools of weaving gave concrete representations to human frailty and its epistemological prowess. There is something mysterious and alluring about a craft primarily practiced by women within the confines of the home, which in turn, becomes a metaphor for cunning (both human and divine), thinking, inquiry, and sundry mental pursuits essential to the survival of cities and souls. Athena, goddess of wisdom, born clad in armor directly from the head of Zeus, presides over weaving. Athena, in fact, taught this art and her patronage further strengthens the relationship between weaving and thinking. Under her tutelage, weaving is female/male, the cultural roles of both genders intertwined through Athena's twofold attributes as weaver and warrior. As such, the practice of weaving and its symbolic power surmount the dichotomy between inner/outer, female/male, and hearth/marketplace to expose the structures of thinking and the cultivation of cunning. In so far as weaving produces clothes that retain vital

heat, serve as a protective skin to brazenly face the elements, support political action, allow commerce, and shroud bodies for burial, this craft entwines another pair of opposites: life and death. The woven cloths accompany humans like a fate.

The cloth, particularly a burial shroud, invariably adorns the body it protects. In this respect, we could add that weaving involves also an integration of life and art and that it manifests and responds to an appetite for beauty. It is not enough to tightly intertwine threads. The creation of cloth must insert beauty into the satisfaction of a mundane need for shelter beyond the hearth. That is, weaving takes place within the home but it reaches outside the walls of home and domesticity to support the public life of citizens and the exploration of new geographic horizons, but the movement beyond the hearth requires the mediation of beauty. Mythologically, we could say that the path from Hestia to Hermes requires Aphrodite. Why must beauty be an integral part of weaving and how the beauty of a woven cloth adds a therapeutic dimension to the craft are issues that shape the inquiry this chapter proposes to complete as it examines two tapestries provoked by violence, Philomela's and Helen's cloths, and one shroud damaged to prevent violence: Penelope's many-times-woven shroud destined for Laertes. In the process, I hope to show the personal and deeply mythological link between these women and contemporary Latin American weavers of *arpilleras*. This aspect of the study confronts the fact that neither hearth nor agora guarantees a safe space for women. First and foremost, then as now, women also weave to break a silence imposed by the enormity

of some violence suffered, and to express an uncontainable need to seek redress. Invariably, the woven cloths express female cunning in the face of violence. A woman's sexual integrity suffers violation, or a threat of violation, and she ingeniously weaves, introducing her experience into the threads of the cloths she fashions to sustain and enhance daily life. Somehow, she realizes that what inserts itself into human experience necessarily belongs within the threads she daily weaves: as lives shape a social fabric, threads shape the cloths that sustain vital processes and the health of the body. The resulting tapestries either record the suffered violence or, as we find in the case of Penelope, the act of weaving itself becomes a ruse to thwart potential abuse. The woven cloth speaks a history denied, communicating simultaneously the silent condition of woman and her realization of an inner power to destine: to release the primitive strength of the Moirai.

Thinking Symbolically

> It is probable that "that which is not" has got woven in with "that which is" in a kind of plaiting of this sort. It's very strange too (*Sophist* 240c).

Greek myths are not fables. Nor are they moral tales. They do not seek redress in the ordinary sense of the word. They seek "to equal" (*ad-aequus*) a situation, to void an inconsistency or simply to restore balance (*adaequare*). The myths stand as symbolic expressions that enable us to understand and/or experience human life from different angles: they expose the surfeit of meaning that attaches to human action and transforms it into a horizon, a place for seeing what was hidden. In the weaving contest between Athena and Arachne, for example, we can observe with Athena how the monstrosity of Arachne's compulsion to weave turned her work into expressions of wild accusations against the gods (Ovid, Met. VI. 106–52). When Athena observed Arachne, the goddess appreciated the beauty and grace of the motions through which the weaver fashioned cloth.

Athena, nonetheless, saw also the carelessness with which, in her compulsion to weave, Arachne treated sacred matters. In particular, the goddess perceived the literal mindedness resulting from Arachne's expedience. For example, weaving the conception of Perseus, Arachne perceived and displayed only Zeus' sexual plundering of Danaë, imprisoned in a tower by Acrisius, her father. Arachne failed to see and expose the significance of Zeus' complete caress of the maiden made possible by Zeus' taking the shape of a golden shower. She missed the symbolic power of Perseus' conception as an event that resulted from divine penetration of every pore of a woman's skin. Arachne remained blind to the possibility that Zeus *cum* shower of gold covering Danaë enacted the conception of heroic male gentleness: Perseus' uncanny tenderness towards women and his ability to handle kindly even a Gorgon's head.[1]

Throughout the contest, Arachne's weaving was dedicated to literally and mindlessly reproduce stories of apparent divine debauchery. Arachne just wanted to weave and win by demonstrating that

1 Discussing the relationship between Perseus and Medusa in his memo on "Lightness," Calvino (1993) perfectly captures Perseus' sensitivity towards women. Perseus has just freed Andromeda and killed a sea-monster. Calvino notes that, desiring to wash his hands after the bloody ordeal, Perseus cannot continue to hold the gorgon's head: "And here Ovid has some lines (Met. IV.740–52) that seem to me extraordinary in showing how much delicacy of spirit a man must have to be Perseus, killer of monsters: 'So that the rough sand should not harm the snake-haired head (*anguiferumque caput dura ne laedat harena*), he makes the ground soft with a bed of leaves, and on top of that he strews little branches of plants born under water, and on this he places Medusa's head, face down'." Calvino calls Perseus' action described by Ovid, "a gesture of refreshing courtesy toward a being so monstrous and terrifying yet at the same time somehow fragile and perishable." The paralyzing power of the gorgon's head transformed the plants into corals to adorn the nymphs Perseus so well understands.

FIGURE 1.1 *Weaver* (1999) by Kael Ashbaugh.

Examining the threads of Philomela's story, Helen's tapestry, and Penelope's ruse, we hope to avoid the pitfalls of Arachne's literal mindedness. Instead, we will release the symbols from the bonds of literality and explore perspectives not ordinarily given by perception alone. Thus, faced with the story of a god who becomes a shower of gold to possess a human maiden, we will not merely see just a randomly voracious god. We will ask: why a shower of gold? What perspectives do such shapes open to sexual experience? Why this shape with Danaë but that of a bull for Europa? Was it simple expedience and Zeus' rush to enter the prison that motivated the shape? Is the story perhaps not about Zeus but about Perseus, who was thus begotten?

Textile Beauty

> The person who has been guided in matters of love, who has beheld beautiful things in the right order and correctly, … all of a sudden will catch sight of something wonderfully beautiful in its nature … (*Symposium* 210e).

The three weavers whose myths interest this chapter experienced and handled erotic desire gone awry: (1) Tereus' failure to govern his lust culminates in Philomela's rape and maiming; (2) Paris' passion (and perhaps Helen's, too) leads to adultery and broken promises, and (3) the suitors' hunger for power and possessions (Penelope herself included among the possessions) tests Penelope's fidelity and harbors the suitors own destruction. If we follow Plato's path, we would say that all three acts of violence derailed love from its natural course: "catching sight of something wonderfully beautiful" (*Symposium* 210e). That is precisely what the weaving rectifies. Where love had become hunger, weaving inserts "the sight of something wonderfully beautiful" in the path of Eros. This insertion redirects the course of vital love. Weaving has this power because from the outset, this craft had already attached a measure of beauty even to the satisfaction of the

her skill and will power remained superior to that, which in her experience, any god had exhibited. To Athena, mindlessness must appear monstrous and the empty cunning that settled in the hands of Arachne, a cunning that failed to touch Arachne's mind and soul, called the goddess to restore balance. Arachne does not deploy symbolic thinking to interpret divine gestures. She just weaves. Hence, Athena transforms Arachne into a spider. This is not a punishment. It is a statement. The myth says that to weave, as did Arachne is no different from living the live of a spider. Actually, a spider more genuinely lives the life in question: since a spider gives shape to that which it secretes from within. Arachne, on the other hand, wove stories about the gods that were not hers and which by appropriating them literally, she managed to deflate. Transforming her into a spider, Athena enriched Arachne's life.

mundane need to protect the body from extreme temperatures. Through weaving, Philomela, Helen, and Penelope intertwine the violence that they experienced into a beautiful design. In a sense, their weaving is a way of transforming their experience by allowing the violent event to manifest beauty. The phrase "giving birth in beauty" (*tokos en kalo*, *Symposium* 206b7–8, e5), so difficult to decode in Plato's *Symposium*, may find some clarity in these myths mediated through weaving. Consider the following progression from birth to death: (1) Zeus gives birth to Athena from the beautiful order of his mind; (2) weaving, Athena gives birth in the beauty of the patterns and colors of her designs, and in the patterns and actions of those whose life responds to the directions of her wisdom: Odysseus, Penelope, Telemachus, to name a few; (3) Philomela practices Athena's craft to re-insert into the world an act removed from public life when Tereus cut Philomela's tongue, (4) Helen weaves into a tapestry the war narrated in the *Iliad*, a poem singing the wrath of Achilles that deflects and transforms the rupture caused by adultery through the sheer contrast between Achilles' profound pain and Menelaus' sangfroid; and (5) Penelope adorns death and destruction. The latter is perhaps the most triumphant of all the adornments because during the three years that Penelope unwove Laertes' shroud, sleepless Penelope persuaded death to act as sleep: absent by daylight, and present only at night and for Penelope's eyes only, assuming the shape of her unweaving.

Among woven threads, beauty situates itself in a way analogous to lived experiences: it is as if the threads of life and the threads of cloths became irremediably mixed. Thus, the rape of Philomela disappears from Tereus' life until Philomela, deprived of her tongue, weaves the violent attack. That "voice of the shuttle," as Aristotle describes Philomela's craft in *Poetics* (1454b) weaves rape and mutilation into textile beauty. Once the rape finds expression among the textile threads, Tereus realizes that he himself has torn the fabric of his family. Seeing Philomela's cloth, Prokne understands. Prokne feeds

to Tereus the body of their son. After Tereus eats his son, the ultimate destruction of his rape becomes evident to him. That is, Prokne takes her sister's tapestry and translates it into a craft that Tereus can understand: cooking. It was Tereus' sexual hunger and his casual devouring of family ties that Prokne reenacted in the cooking of their son's body. The two fabrics: the textile and the vital texture become entangled to equal or restore balance.

As I mentioned earlier, in tapestries, clothes, and the like horror manifests in the midst of beauty. My suggestion is that the beauty lends stability to the vital ruptures that violence produces. Thus, Philomela's tapestry is not giving a moral or a normative account. The tapestry heals an imbalance, which Prokne enacts into the web of her life with Tereus. In painting, we see an example of such transformations in Picasso's *Guernica* (Museo Nacional Centro de Arte Reina Sofia, Madrid). The gray-black and white painting captures a moment of utter destruction on April 26, 1937 when German and Italian planes bombed the Basque town of Guernica.[2] The bodies of horses, men, women, bulls, and buildings crushed each other in an explosion of pain. Yet, the painting fascinates for its beauty, too. The artistic event affirms the horror and heals it by the sheer presence of beauty. The bombing of Guernica remains a horrible act, but Picasso's painting has allowed the experience to enter our imagination and our memory aesthetically restoring the vital thread snapped by war. The painting cannot defy Atropos. It can, however, provide a space of light where Klotho spins her threads again and Lachesis apportions balance. The daughters of night

2 Jörg Diehl, in a report written seventy years later and published in *Spiegel International* (April 26, 2007) notes that the commander of the Condor Legion, Wolfram von Richthofen, wrote the following in his journal, "Guernica, city with 5,000 residents, has been literally razed to the ground. Bomb craters can be seen in the streets. Simply wonderful."

(*Theogony* 215–19) apportion a space pulsating with life to anything born in beauty.

In weaving, we get closer to this healing aspect of beautiful representations because whenever we remember it, tell it, or write it, life itself appears to be something woven into a tapestry composed of other lives and events. Mythologically, we could say, that present at birth Klotho spins the thread of a life, Lachesis measures its length, and at the end, Atropos cuts it off, but off what? Does Atropos sever us from a larger tapestry of all lives or from the spindle on which the thread was spun? Whether we respond favoring the social reading of the metaphor or the solipsistic one, we still inhabit the metaphor of weaving and a fated web.

Primarily a domestic craft, weaving accrued ritual power. In the case of the Arrehphoroi, for example, we find that the imparting of the craft took place in the Acropolis. Young girls lived there preparing for married life through rituals and by perfecting their ability to spin and weave. The young girls wove a *peplos* for the statue of Athena. The *peplos* was used in a ritual at the end of the great Panathenaia. Presumably, the story of Philomela and Prokne, too, was incorporated into the rituals of this festival and statues of the two sisters stood in the Acropolis (Marble group 1358).[3]

Penelope's Ruse

… let me finish my weaving before I marry, or else my thread would have been spun in vain (*Odyssey* 2.97–8).

Like Klotho and Lachesis, Penelope spins and measures the thread. As a woman she weaves. Then, like Atropos, she cuts the threads or reduces her woven cloth to snapped threads. Her ruse necessitates that she be able to unweave: like Atropos. Penelope appears to have the strength of Atropos not only for snapping threads but also for sustaining her marriage to Odysseus. Thus, Penelope is "atropic" – she cannot be turned from her purpose. Furthermore, she weaves a death shroud for the father of a man she has pronounced to be dead but hopes is alive. In so doing, Penelope anticipates the death of Laertes to sustain the possibility of Odysseus' return. The myth of Penelope, therefore, expresses a connection to the third daughter of night that renders Penelope's work mysterious, bordering on the sacred.

Unweaving requires sufficient strength to snap threads and disentangle the organization of the woven texture and the poet leaves no doubt about Penelope's ability to unweave. Penelope is not only prudent, thoughtful, and faithful, she also has thick hands (*Odyssey* 21.6–7).[4] Literary critics have covered this description with translations that refeminize Penelope and several scholars have sought emendations to suggest alternate readings and avoid admitting Penelope's robustness. The adjective *pachus*, a term that Homer uses frequently to describe a man's hand, doesn't sit well with traditional images of womanhood. Yet, we find in the *Iliad*, that twice Athena's hands, too, are thus characterized (*Iliad* 21.403, 424). That is, both Athena, divine weaver, and Penelope human weaver and unweaver, have thick hands. I take it that it is weaving itself that so develops the hand muscle producing the appearance of thickness proper to a strong hand. After all, weaving is Penelope's main activity until book 23 of the *Odyssey* when her erotic desire reawakens. Worth noting is the fact that other women weave, but only Penelope has a hand like Athena's own. For example, Kalypso (5.62) and Kirke weave (10.222–5). Thus, weaving is not simply a domestic activity in the ordinary sense of the term "domesticity." It is Penelope, however, who is bound to her

[3] For a detailed analysis of how the statues enact our myth in the Acropolis, see Barringer (2005). In his study of the statues, Becatti (1951) identifies the statues in south 20 as Procne and Philomela: the first reads the account while the second holds a shuttle (38–40).

[4] A friend, AC, noted the difficulty of unweaving and K. Ashbaugh noted the thickness of Penelope's hands.

histos or loom.[5] Kalypso and Kirke, on the other hand, intertwined weaving with erotic fulfillment.

In summary, Penelope's power to unweave derives from her power to weave. That is, weaving gives her the thick, strong, hand that facilitates her ability to unweave. Yet, unweaving, she not only exercises her cunning in rhythm with her hands, she contrives a δόλος, a stratagem through which she can sustain the order of her household under the indirect governance of Odysseus' father, whose regal shroud Penelope dutifully weaves and equally dutifully destroys.

Penelope creates a space for her unweaving by weaving arguments through which effectively she persuades the suitors about her need to practice her craft with diligence. When Antinoos first discloses the ruse, he exposes also the complex texture of the arguments Penelope used. First, Penelope appealed to the suitors' greed for her property and money by claiming that it would be a waste of yarn not to finish the shroud (*Odyssey* 2.97–8). It would also be a waste of the spinning labor or in symbolic terms, a crime against Klotho, or one's own destiny. Secondly, Penelope appealed to the suitor's appetite for good reputation pointing out that some women among the Achaians would reproach her if she let a man of such wealth as Laertes' be buried without a shroud (*Odyssey* 2.99–103). If word reached the Achaians that it was the suitors who prevented Penelope from finishing a hero's shroud, the shame would fall upon the suitors. Penelope knows her audience and knows exactly how to persuade them by arguing from a perspective consistent with the suitors' values and their desires. Thus, the ruse is twofold. It consists of unweaving Laertes' shroud in

[5] The word ἱστός presents a nice parallel between Penelope and Odysseus: the term means both "loom" and "mast" or "anything set upright" for that matter. Just as Odysseus tied himself to the mast of his ship to prevent succumbing to the Sirens, Penelope tied herself to the loom in her household to prevent succumbing to the suitors. On this topic, see Ahl and Roisman (2007).

secrecy and weaving persuasive arguments in public. In both cases the ruse gives birth in beauty: in the shroud and in the argument. The latter allows us to gaze at the beauty of customs and rules (*Symposium*, 210c–d). In these two respects also, Penelope is *Athenian* or better, Athena-like.

Unweaving Penelope's Ruse

… Athena has lavished upon her skill unsurpassed in the crafting of beautiful things and a noble mind and astuteness … (*Odyssey* 2.116–17)

Three times the story of the ruse enters the text of the *Odyssey*. The ruse, in fact, is woven into the texture of the poem and each time it appears, its facticity is born in poetic beauty. Thus, thrice-born nobly, the ruse ceases to be a transgression or an ignoble lie and becomes an artistic contrivance. In the beauty of the poem, deceit becomes craft (two of the meanings of the term δόλος). Just as Arachne's transformation into a spider overcame the ugliness of her unthinking boasts and the crassness of her interpretation of myths, this thrice-told inception of Penelope's ruse into the fabric of the *Odyssey* neutralizes any ugliness that could attach to the deceit. While the ruse situates weaving at the core of Penelope's attempt to rule her household, the *dolos* also shows how weaving and deception delineate an interesting metaphorical space. Thus, Prometheus in Aeschylus' *Prometheus Bound* (line 610) tells Io: "I will tell you plainly all that you like to know, [610] not weaving riddles, but in simple language, since it is right to speak openly to friends." The verb Aeschylus uses is "*emplekôn*" which translates as "weaving." In *Libation Bearers* (line 220) Aeschylus uses the verb "*plekô*" when Electra tells Orestes: "But surely, stranger, you are weaving some snare about me?" In addition, we find that according to Aristotle, (*Nicomachean Ethics* B7, chapter 5) Aphrodite is called a "weaver of whiles in Cyprus born." Finally, and unfortunately too extensive to consider in this

short chapter, is Plato's analysis of weaving in the *Statesman* and the *Sophist*. In the first, the art is defined as "intertwining of different kinds of threads" but the *Statesman* is said to weave into one fabric the virtues of courage and moderation so that they may be inserted into the practice of the city. Ruling and weaving become irremediably mixed because what is woven may be incorporated into the fabric of life, in this case the life of the city. In the *Sophist* (259e), the stranger suggests that language itself requires weaving to communicate, since a statement consists in the weaving of different linguistic elements (verbs and nouns) into a whole. And that section, too, has a Penelopean ring noticeable when the stranger from Elea remarks that, "the most complete disappearance of all discourse is to undo each thing from everything. For discourse has come to be for us on account of the weaving together of kinds" (*Sophist* 259e).

What is it exactly that the poem intertwines into its fabric through the thrice told ruse? Consider the insertions of the ruse into the text (*Odyssey* 2.93–110; 19.160–90; 24.140–68). The first appearance of the ruse passes through the lips of Antinoos, a suitor enraged at having been duped and who in turn, seeks to dupe Telemachus into believing that Penelope's action will reflect badly on Telemachus and has already wasted his substance by prolonging the time that the suitors remain in the household waiting. Antinoos fails though his argument appeals to the same values that Penelope had evoked. What remains interesting, however, is that Antinoos voiced his shameful predicament, and thus inserts the ruse into the fabric of the poem, in an attempt to steal the ruse and deceive by revealing Penelope's deception. Even the revelation of Penelope's outstanding cunning becomes for Antinoos a tool for persuading Telemachus and deceive. The first layer of the ruse-tapestry, therefore, is one of threaded deceits.

Penelope is the architect of the second insertion of the ruse into the poem when she confesses her deed to a stranger who turns out to be her husband (*Odyssey* 19.137–55). That is, when Penelope acknowledges her ruse, the poem inserts her confession in the midst of the threads of Odysseus' own ruse. Couched within Odysseus' web, Penelope admits: "They keep hastening marriage, and I keep spinning deceptions" (*Odyssey* 19.137). Her truth and the corroboration of the fact that at least as far as Penelope's deception was concerned, Antinoos spoke accurately, fits within Odysseus' own ruse. The second layer of the ruse tapestry intertwines the first layer of deceit as a confession of the truth into another deceitful ploy.

The third insertion of Penelope's ruse calls out from the after life through the ghostly voice of a dead suitor who interlaces the ruse in the discussions of the war woven by Helen and remembered in the underworld by Agamemnon (*Odyssey* 24.131–49). Penelope's guile belongs now to a larger context that extends from life to death and later. The third layer of the ruse-texture gives to understand that Penelope's deceit belongs among the deeds of Achilles, Patroklos, Ajax, and even Agamemnon himself. Deceit is now strategy, clearly deserving of praise. The ghost of Amphimedon calls the ruse "another deception that she in her spirit invented" (*Odyssey* 24.138). Notice that the first insertion of the ruse took place early in the poem and aimed to persuade Telemachus to take the suitor's side. Then, Penelope weaves the tale into the concluding verses of the poem and finally, the poem takes the threads of Penelope's deceit into the underground to tie the beginning of the poem to its conclusion. Were the poem a tapestry, Penelope's guile would adorn a top right corner, the bottom left corner and the bottom right.

The three accounts of Penelope's ruse are virtually identical. Amphimedon, however, adds an important alteration describing the finished, washed shroud: "it shone like the sun or the moon" (*Odyssey* 24.148). I take this reference to the shining cloth to be crucial for understanding the therapeutic power of beauty discussed earlier. Recall that Homer likens two other places to the splendor of the sun and the

moon: the house of Menelaus (*Odyssey* 4.45) and the house of Alcinous (7.84). What about those houses resembles the sun and the moon? Perhaps in their wealth both Menelaus and Alcinous owned many shiny objects of gold, etc. I think, however, that the reference is to the tranquility and order of the households and the beauty within. Beauty of such light that it allowed Menelaus to tell the story of Helen's infidelity without destroying the marital bond and let Alcinous tell the story of Aphrodite's adultery without bringing upon himself the wrath of the gods. That is, there is an inner harmony and aesthetic splendor that sustains peace sufficiently to allow those stories to unfold without harm. This suggests that beauty is a place of light where we can repair torn flesh and ripped tapestry. That is, I take it, the power Beauty has to restore and support balance in the face of horrendous deeds.

Helen's Tapestry

But anyone with any understanding would remember that the eyes may be confused in two ways and from two causes, namely, when they've come from the light into the darkness and when they've come from the darkness into the light (*Republic* 518a).

Helen wove an oral tapestry. The few lines that situate her in the *Iliad* portray her recording images of battles raging outside her window. The image gives intense inwardness to the poem. Helen becomes the poem's self-awareness. The poem is all we can say about her tapestry, and her tapestry captures the poem. The beauty of Helen's tapestry heals the carnage outside immediately it happens. Achilles's pain and even Helen's betrayal of Menelaus acquire a new aspect. Helen's tapestry, in that respect, resembles Picasso's *Guernica*. It captures destruction and bloodshed in a beautiful medium where beauty can heal pain even as it conveys the experience and sets it down to be remembered.

The woven details all appear in the poem itself. We should envision Helen weaving Achilles'
shield, Penthesilea's blood, and bodies falling in the field of battle. Whereas for our other tapestries we have only the story line to guide us as we envision the woven images, in the case of Helen's tapestry we have multiple details to direct our imagination. We know more about Helen's tapestry than about her. In fact most accounts about Helen tend to be contradictory and confusing. Presumably, she is the daughter of Zeus yet Tyndareus engendered her. Helen, furthermore, is innocent of adultery yet she is the lover of Paris before and during the war. She is the restored wife of Menelaus yet wife of Achilles in another plane. The beauty of her face and form is legendary but left to our imagination. The beauty of her tapestry is in every line of the Iliad, including the line that describes Helen weaving. Thus situated, Helen's tapestry overcomes even the possibility of any harm that could result from its construction.

Helen can transform violence with her hands and with her face. Helen is luminous (*Iliad* 1.200) and light seems to emanate from her arms. She is "white-arm'd" (*Iliad* 1.157) and the sensuousness that presumably brought Paris to capture her (or to accept her as a gift from a grateful Aphrodite) becomes sheer light in the *Iliad*. Helen shone before Priam and the old men with him blamed the gods for the war, not her. "When they bright Helen saw"[6] they first reasoned that "for beauty such as this" anything can be endured since "in every look she seems,

6 *Iliad* (3.200). About this passage, Quintilian writes (lib. 8, c.4): "How astonishing must that beauty have been which elicited such warm admiration, not from Paris her lover, not from a young man, or one of the vulgar, but from old and very wise men, seated by the side of Priam! The king himself, too, after all the losses of a ten years' war, and especially the deaths of so many of his sons; when the danger of utter destruction of himself and people was impending; the king to whom that face, the cause of so many miseries, ought to have been hateful and abominable; even he kindly calls her his daughter, invites her to take a seat by himself, makes excuses for her, and denies that she is to blame for any of his misfortunes."

in very deed, one of the goddesses!" (*Iliad* 3.204–5). Only innocence and forgetfulness emanated from the vision of Helen. Helen's body represents the sensuality that beauty retains and which it can translate into a light space of healing as we hear her tapestry recited, and the characters within the poem see her light. Notice, however, that the beauty of Helen's face led Priam to deny any guilt, to cease to feel the burden of his pain in the oblivion of pleasure. Not so the tapestry. There is no forgetfulness in the tapestry. Helen's weaving begins like the Iliad with the wrath of Achilles and his thirst for balance in a universe lopsided with the destruction of his loved one.

Athena's art by no means wipes monstrous acts from history. It demonstrates. Demonstrated in beauty, violence and horror may be contemplated and remembered without repeating the harm. What cannot be tolerated is often forgotten and cannot be prevented. What is reinserted in beauty permeates memory and may be prevented. In beauty, Atropos snaps the fated web of violence.

Bibliography

Ahl, F. and Roisman, H.M. (2007) Rival homecomings, pages 109–26 and 114 in Bloom, H. ed. *Homer's The Odyssey*. New York: Chelsea House.

Barringer, Judith M. (2005) Alkamenes' Prokne and Itys in context, pages 165–73, in Barringer, J.M. and Hurwitt, J.M., eds. *Periklean Athens and its Legacy: Problems and perspectives*. Austin, TX: University of Texas Press, 2005.

Becatti, Giovanni (1951) *Problemi Fidiaci*. Milan: Electa.

Calvino, Italo (1993) *Six Memos for the Next Millennium*. New York: Vintage.

Stitch By Stitch: About Needlework, Embroidery, and Writing

ESTHER ANDRADI

I

In the beginning was needlework.

II

It was women who weaved nets for collective hunting, inventing one of the most useful tools for life in the Neolithic period and generating what some scientists don't hesitate to denominate as the revolution of fiber (Adovasio *et al.*, 2007). These original weavers shared equally with the hunters the task of providing food for the children and the group, and above all, they facilitated language and invented agriculture. In other words, they gave life to a more complex society where women, the aged, and children constructed the social fabric.

The choice of the word "constructed" here is not gratuitous. The Sanskrit root *teks-* signifies both needlework and construction, and later would translate as *text* in Latin.

According to the *IndoEuropean Etymological Dictionary of the Spanish Language* (Roberts and Pastor, 1996–7):

Teks-: To weave, to fabricate
Sanskrit: builder
Persian: builder
High German: to labor
Hititis: to assemble

Latin: to weave, circumstance, text, context, texture. Pretext: to place something stitched or woven in front of something.

Is writing then derived from needlework as the relationship with the origin of the words might suggest? Do needle and the thread precede the chisel with which women honored the gods, carving the poetic word upon stone in Babylon more than 4,000 years ago?

III

In his dairy *The Temptation of Failure*, the Peruvian writer Julio Ramón Ribeyro notes on October 16, 1973:

Writing is like weaving, it is necessary to know at what point the work will be created: once the stitch is selected, the work creates itself. I don't know if in Latin or in any other language the same verb is used for the act of writing and weaving. But, apart from the stitch, it is necessary to recognize beforehand the pattern: to know if one is going to knit a sock or knit a bathrobe. All of this is much more complex than one might think. And as I have neither the stitch nor the pattern, the pages, my many immaculate pages, accumulate fragments like this, which are juxtaposed in order to form something inorganic, discontinuous, the negation of what I want to do, in other words, the testimony of the non work, of the lack of productivity and insignificance (Ribeyro, 1992–5).

IV

Writing is like weaving, I insist. Only one needs to know with which stitch one wants to write, and once one knows, one writes all at once. And here we are, regressing to a time in which almost everything is unknown, that nebulous time before history, when the *macho* male draped in skins would emerge from the cavern in search of food, while the offspring, the women and the elders remained in the cave like hungry young pigeons. That's what they told us for so many years and in the name of science, which is purportedly neutral, we believed it. Until recently. It is what occurs to me as I am moved while reading about the discovery of weavings dating back 27,000 years; Laura Asturias, a Guatemalan, describes it in her article "Evidence of Textiles in the Ice Age" (Asturias, n.d.). An eminent group of investigators coordinated by Olga Soffer "discovered" that needlework was already an important part of daily life of the cavern dwellers 15,000 years earlier than was originally believed. This is a revolutionary discovery which is important in and of itself, as it changes the image of the *macho* male covered in skins for another wearing a sweater knitted by his beloved, and that of the scientific gaze, for it no longer focuses on major events, rather sees in the smaller, less significant, the existence of something that had always been the case, but had not been acknowledged. Suddenly, the invisible work of women, children and the elderly acquires an immense value and illuminates the cave from another perspective.

V

To say that the domestic is perishable is a patently obvious truth. By virtue of being perishable, however, it threatens to become eternal. Or almost. The secret to defeat oblivion resides in tenacity. Or necessity. Or both. The erudite Soffer points out that this is a discovery about the role that women, young girls and young boys play in the Paleolithic period. How was it that Soffer (2000) came to the realization?

> I had noticed some interestingly unusual parallels; I had photographed them, but I really didn't pay much attention as I had other questions to answer, so I set aside those slides. Two or three years later, Jim Adavacio, one of my colleagues and a prominent specialist in prehistoric textiles, visited me. I took out the photographs and asked him if he had any idea as to their significance. He looked at me. "These are impressive textiles," he replied.

Soffer admitted that for her and her colleagues, it was an enormous surprise to learn that textiles have existed for so much longer than originally understood, since the belief circulated that those technologies had been practiced well after humans began to plant their own food and to live in settlements during the Neolithic period. "We are talking about a difference of approximately 15,000 years," the archeologist pointed out.

How is it possible that something so important has slipped by inadvertently? "We haven't exerted ourselves enough to study the perishable," insists Soffer. For her, what is most important about these perishable articles (in other words, those created with natural materials, like wood, plants, etc.) is that they tend to be associated with the work of women, boys, girls, and the elders. "Thus, by not discovering them and acknowledging them, one tended to think solely in terms of men clothed in skins from the Ice Age period." In other words, no one ever asked what the women did.

> We have totally ignored the reality of the ethnographer because he tells us that the majority of what people use is not preserved, it's not everlasting. Thus we should make a concerted effort to search for this, and upon making this effort, we discover that it is there and it reveals to us a new perspective which we had never seen before. The significance of these discoveries for the understanding of ancient civilizations is that it opens windows for us onto landscapes and the invisible majority unrecognized by those who studied the Paleolithic era.

What is the invisible majority? "Women, girls and boys, the elderly," Soffer responds.

> The use of nets in hunting. Communal hunting with nets is converted into a possibility that is something more common on our own continent, with its aboriginal people, as well in other places. And hunting with nets is frequently communal, which means that everyone is involved in the search for food. In other words, it wasn't solely the task of valiant hunters that brought the food home. We are now beginning to appreciate what the other people did, instead of simply admiring the great hunters.

VI

Analía Bernardo (1997), an Argentine scholar, writes:

> Around the third century BC the priestesses of Inanna and other goddesses began to write on mud tablets, with wedge-shaped characters, and Sumerian hymns. Under the sponsorship of Nisaba, the goddess of agriculture, inventor of writing, the priestesses also used wedge-shaped writing to administer both politically and economically the temples where – along with sacred rites – different activities were carried out: commercial and artistic, professions, workshops, storage of cereals, and the elaboration of bread, oils, incense and weavings.

"I am that one which is obtained after desire," the Sumerian poets sang invoking the Goddess:

> And you who seek me should know
> That your search and your desire will not be fulfilled
> If you don't know the Mystery:
> If you search for it, you won't find it within you
> Nor will you find it outside of you.
> Because I have resided within you from the beginning
> And I am That One, which is obtained after desire.

VII

In previous years, Gilbert Durand (1982) had already suggested what Olga Soffer confirmed decades later. "The instruments and products of weaving and sewing are universally symbolic of development," Durand writes. "In Japanese or Mexican mythology as well as in Upanishad or Scandinavian folklore, one can find this ambiguous individual, who at once weaves and is in charge of threads. Przyluski states that the derived name is Moira." Durand cites the name as Atropos del Radical Altro, closely related with Atar, the Asian name for the great goddess. The spindle and the spinning wheel with which the spinners spun destiny became an attribute of the revered goddesses, especially the goddesses of the lunar theogonies. It would be those Selenic goddesses who must have invented the profession of the weaver and are famous in the art of textiles.

The weaving of nets in the Neolithic period. Or the weaving in Precolombian communities. The Quipus in the Andean cultures. The Quipu, that system of knots which served as a means of computation and which, according to the Peruvian anthropologist, María Rodorosky, also must have been a form of writing. After all, the verb *contar* is used indiscriminately in mathematics and in literature.

VIII

What lobotomy of memory erased the neurons of the human species to facilitate the disappearance of the makers of the nets of history? History and myth are repeated. The very same complexity disturbed Theseus, slayer of the Minotaur. Without the threads of Ariadne, the mythological hero would have been incapable of orienting himself in the labyrinth, yet later on, once the objective was achieved, he decides to abandon the wise woman on a deserted island. Is it that history in some place mimics the myth? Or is it that science is exempt of the vice of an idle interpretation?

IX

In the work, *Die Efingdung der Poesie*, the Austrian author and essay writer, Raoul Schrott (2009), has

dedicated himself to the translation, introduction, and diffusion of the earliest poetry that humanity has known, dating back some 4,000 years. It is known that the first poet was a woman, Endehuanna, the mother poet of humanity and of Sumerian literature. In the introduction Schrott suggests that, in the beginning, both poetry and music were in the hands of women. The ritual rounds and the sacred rites of paying homage to the goddesses with singing, telling and rhyming were not then the tasks of men, and, in *The Greek Myths*, Graves (1993) is convinced that poetry arose as a form of homage to the goddesses. That is to say, with a great deal of certainty, the task of the priestesses or feminine initiatives. And thus it was perpetuated, the poetic myth in cryptic language, as poetry was the form developed in order to evade censorship and death by a triumphant patriarchy. It is what the Lacanian writer, Luz Freire, brilliant like no other, related in her conferences in Lima, Perú, in the mid-1980s. "Poetry," Luz declared, "was born as a form of resistance by women to the new patriarchal order. Thus its codes, its hermeticism, its metalanguage."

Later on, many years afterwards, what we know came to pass. At some moment in history, stitching and manual labor were substituted by writing, which becomes a terrain almost impossible to transit for women. Weaving and stitching become the means of harnessing the creative energy of women and are converted into the only refuge of expression. What is produced then is the split and the hierarchization of the work considered "feminine" and writing, the latter ascending to a superior and exclusive sphere. As a result, in the nineteenth century and at the beginning of the twentieth century, when women reappropriated the space of writing, they fled from the needle and thread as if these were diabolic. And rightly so, because for centuries, one action interred the other, and now it was necessary to be careful to not fall under the halo of the embroidery-frame. Speaking of which, during this time I read that Emilia Pardo Bazán (1851–1921) detested thread, thimble and needle, that she abhorred

needlepoint and darning, and preferred to throw herself into a blank page and a pen to illustrate those *Los Pazos de Ulloa* (Pardo de Bazán, 1986), before wandering among armholes and tucks, because as she declared in her self-portrait: "I am a soul of a masculine heart beat." That men don't embroider or weave, one could say today to the extraordinary Emilia, is as disputable as limiting weaving and embroidery to "properly" feminine tasks. Because what matters, finally, in art and in creation nowadays is not the subtraction, but rather the addition of possibilities.

X

During the 1990s an image circulated in my head. It was an image embroidered in cross-stitch. Seen from the distance, it was a feminine figure, but as the gaze drew closer, different figures of women appeared. And since it came in cross-stitch, I decided to tell it as if I were embroidering. Even though I am not skilled in the technique of embroidery or weaving, I was able to find advice from my mother. That's how my novel, *Tanta Vida* (Andradi, 1998), was born, which by chance coincided with my own pregnancy. The gestation of the novel included a diary of writing where I narrated the phases and the difficulties experienced in weaving a similar story. I attempted to narrate an itinerary about bodies, our bodies, those plowed bodies, embroidered, crisscrossed by fortune – and misfortune – in the adventure of procreation. I intuited that the narration had to be written like embroidery – or weaving – combining writing with the "works" typical of the genre. I tried to express the relationship of writing with weaving and embroidering in the gaze of those who preceded us, with the way of being in the world and apprehending that our ancestors united us, and that, by means of that very voice which "gives birth," its name so often is ignored. But it is "written" in the words of the language that marks our infancy, and that gratuitously is not "maternal."

XI

The title of my diary is *Margomar*. The word *margomar*, according to the dictionary of María Moliner (1986), is an ancient form of naming embroidery, the origin of which is unknown. *Margomar*: embroider the land, write the sea.

XII

Margomar, July 15, 1992, Berlin:

For several days I tossed around the idea of cross-stitch embroidery to fill in the blanks always with different colors, resulting in a certain form, from a rose, to birds, to a city in geometric designs. It can be any and everything. Cross-stitch is flexible.

I speak by phone with my mother and I ask her the name of that technique. She can't recall the name. I went to the doctor's last Thursday and I am distracted by some images that hang from the walls of the waiting room. They seem very ancient, they reproduce rural, country vignettes. I look at them from afar, and I don't realize the weight of the background, the weave that structures the shades of colors. Upon drawing closer, everything becomes clear: Like in the simulation of images on the computer, or as with cinema, only then in the nearness does one glimpse the interwoven texture that the image forms.

From afar, the presence of the spaces in the canvas is invisible.

XIII

Margomar, July 22, 1992, Berlin:

I search for "cross-stitch" in the dictionary. And it states: *cruceta*, embroidery to fill making a picture. And then I go to the word "embroider": the origin of the word is unknown, in the past the word "*brosler*" was used. To work, *margomar*. The word "*labrar*" is the form of embroidering the cloth with threads. And then I become fascinated by the different words that express the different forms of embroidery: *filetón*, *gurbión*, *orzoyo*, *bricho*, *almendrilla*, *abasto*, *filitré*, and several more pages.

XIV

Margomar, July 25, 1992, Berlin:

I think that one could write any work signifying women if one were to rescue language from embroidery as structure. For example, the stretcher frame. Or perhaps the plaited rope: strands of thick silk, formed by small threads that were previously intertwined. A twisted ensemble of strands of anything.

And why not the embroidery canvas? With the incursion into the world of microchips and quantitative physics, the reconsideration of the details of feminine "work" can take on a totally distinct dimension. Not only is it another form of thinking, it is also a different way of exercising the brain. And the loom, is it not a binary system, illustrious predecessor of the system that moves the heart of each hard drive?

XV

Margomar, July 29, 1992, Berlin

When mother sees an embroidery or a weaving that she has never seen before, she wants to see if she can take it with her, in other words, if she is capable of capturing and configuring the "model" in her head. The model is not for building, rather for "taking" and "applying". It is not the destruction of nature; is it the adaptation to it?

Or the re-elaboration of something from which it, nature, offers?

In October 1992 I am pregnant, with embroidery and with Raquel, who was born in June 1993.

XVI

Margomar, July 17, 1994, Buenos Aires

The logic of cross-stitch, is it the logic of memory? If so, the distinct spaces of stitches in reality configure the weaving of this book. The only thing that I know is that there is an original history and from there the world parades past in 64 days. But since cross-stitch is not a straight line, neither is it the most rapid journey between two points. Because the vision of a hexagram takes me back six years, towards a life that I didn't live, towards others; it is the journey of blood, always filled with unanticipated nooks and crannies.

Many years later, I found the illuminating testimony of Alieda Verhoeven, a Dutch feminist who chose to live in Argentina, ecologist, champion of human rights and of women. Alieda writes, quoted by Silnik (2005):

> I very much like to embroider in cross-stitch and it happens to me that while this is taking shape, for example, the tree, with each stitch, I think about the trunk of the lineage of so and so, then the sky, the water, and none of these can be missing ... And I remember the inundations, and everything has ... and one continues embroidering and evoking memory, but also the future, projecting ahead. Generally it takes me 45 minutes to an hour, and it is almost as though it were a prayer ... it's very beautiful.

XVII

Is there a moment in which writing or the impossibility of realizing it leads to madness? When has it been said that the madwoman of the house is literature? In German the word *spinnen* is also applied in everyday speech to the synonyms of fantasizing, hallucinating, losing all common sense. It shouldn't seem too perplexing to suppose that such an acceptance could have its grounding when the impossibility of speaking was accentuated precisely among women. And while they wove, since they could not or should not write, they fantasized. Fantasizing can be a form of resistance, just as becoming crazy is a form of saying no. And since one can't always be in opposition, the great-grandmothers fantasized

while they were weaving. Might this be the birth of myth? Myth is sound, a construction within a community. But those who ruminated about it in the ears of their children in order to ease their fear in the face of the inevitable darkness of a night without electricity were women. If it is not true and well founded ... (*Si non e vero e ben trovatto ...*).

XVIII

Cassandra de Christa Wolf asks:

> I take the test of pain. The same as would a doctor, who pinches a muscle to see if one is dead, I pinch my memory. Who might find once again, and when, language? Might it be one whose pain shatters the brain in half? And until then, until him, only the groans and the orders and the screams and the "yes-sirs" of those who obey (de Christa Wolf, 1987).

IX

From the catacombs and caverns, enclosed in towers, huts or palaces, the adventure of women was not circumscribed to discover continents, cross rivers and mountains, name things, invent and discover worlds. In the light of neuroscience, today we know. The adventure of women, that enclosed sex, was expanded inwards, weaving novel neuronal webs for the species, writing a history of resistance from the world of domesticity, in the ancient world of Grecian women, feeding amnesiac philosophers and scientists, living in Diotima of Mantinea, deprived of history and yet very self-assured.

In nineteenth-century Spain, Mariana Pineda went to the scaffold to embroider the flag of liberty. The poet, Federico García Lorca, immortalized her in the eponymous work:

> Oh! What a sad day in Granada
> Which made the stones cry
> Upon seeing Marianita die
> Upon the scaffold for not speaking out

Marianita, seated in her room,
Never stopped contemplating:
If only Pedrosa were to see me embroidering
The flag of liberty!

With *Mariana Pineda*, needle and thread recuperate once again their sense of origin. They are constituted in the language of memory. The indescribable. That which has no name. They conquer anew the stolen space in order to reconstruct the social fabric of their societies and their punished bodies. From there, the bad example expands. Thread and needle symbolize patience, which, as one knows, comes from peace. Stitch by stitch they resist in the round where memory is made. The needle penetrates the fabric and leaves a trace of color. And little by little a memory is drawn. In the form of a cross, many crosses. The women of Chile resist and denounce a ferocious dictatorship with their *arpilleras*. The Mothers of the Plaza de Mayo write with a needle and thread on their white handkerchiefs in their unfaltering search for their detained sons and daughters – disappeared by the civilian–military dictatorship in Argentina. The survivors of the violent genocide in Guatemala embroider their histories of rape and massacres. And now in Mexico, men and women touched by so many deaths decide to embroider the construction of a memorial that encompasses the entire country.

XX

The author and essay writer, Francesca Gargallo, writes in her, yet unpublished, essay "Embroideries of peace and memory: a process of visualization" about the resistance of embroidery in the cities of Mexico:

Each embroidery returns dignity of humanity to the deceased bodies that have been reified, humiliated, scoffed at by a propagandistic, excessive violence, that attempts to discipline through horror and strikes mercilessly at the mothers, the fathers, the friends, the transients, whichever citizen, male or female, impeding their reaction, leaving them with their mouths wide open in the face of the inconceivable. With blood red thread, with green worsted yarn the color of hope, with black strands of mourning and white thread, embroidery is a humble act of solidarity that defies the total impunity of war that isn't, rather the sum of confrontations between a repressive state and the immense criminal network with strong attachments to the corporate web of legal business.

To embroider is to give voice to a reality that the system pretends is known and is silenced. It is a means of avoiding the lack of memory. Seated on the floor, on stools, in their own chairs, stitch after stitch, threading their reflections, the men and women who embroider for peace have rescued the memory of the victims of war without possible refuge, trenches, or exile.

In many myths and traditions, to sew, to undo the sewing and sew anew the world is the task of time, lord of the will of gods and goddesses. When the needle enters and exits reality, it accommodates that which people cannot tolerate, whether unjust or painful. From there symbolically embroidery implies a threaded needle, a will of iron and the absolute conviction that things should not continue to be the same.

XXI

From *Margomar*, 1996, Buenos Aires:

At the end of October 1996, the novel is completed. Two names have been considered: "Exemplary Women" and "The Book of Blood," ultimately converted into a garland of this history. And *Tanta Vida*, gestation of the bolero "*Sabor a mi*", which had been the thread from the beginning, is imposed as the title.

Ever since then, *Tanta Vida* lives on its own, even though I continue to refer to it to speak of other projects.

Acknowledgment

For Asteria and her sisters. All of them weavers. Translated by Jacqueline Nanfito.

Bibliography

Adovasio, James M., Soffer, Olga and Page, Jack (2007) *The Invisible Sex*. New York: Smithsonian Press/Collins.

Andradi, Esther (1998) *Tanta Vida*. Buenos Aires: Simurg.

Andradi, Esther (1999) Some fragments of *Margomar* were published in *Confluencia. Revista Hispánica de Cultura y Literatura*, Spring 1999, Volume 14, Number 2, Greeley, Colorado.

Asturias, Laura (n.d.) "Evidence of Textiles in the Ice Age". Translation and publication in the virtual journal *La Tertulia*.

Bernardo, Analía (1997) *Eurínome, la Diosa Creadora*. Colección Mitología Femenina, digital edition by the author, Buenos Aires.

de Christa Wolf, Cassandra (1987) *Casandra*. Translated from German by Miguel Sáenz. Barcelona: Círculo de Lectores.

Durand, Gilbert (1982) *Las estructuras simbólicas del imaginario*. Madrid: Editorial Taurus.

Graves, Robert (1993) *The Greek Myths*. London: Penguin.

Moliner, María (1986) *Diccionario de Uso del Español*. Madrid: Gredos.

Pardo de Bazán, Emilia (1986) *Pazos de Ulloa*, 3rd edition. Barcelona: Editorial Brughera.

Ribeyro, Julio Ramón (1992–5) *La tentación del fracaso*. Jaime Campodónico, ed., Lima.

Roberts, Edward A. and Pastor, Barbara (1996–7). *Diccionario Etimológico Indoeuropeo de la Lengua Española*. Madrid: Alianza Editorial.

Schrott, Raoul (2009) *Die Erfindung der Poesie. Gedichte aus den ersten viertausend Jahren*. Frankfurt: Eichborn Verlag.

Silnik, M.A. (2005) Extract from *Alieda Verhoeven. Varaciones en Las Cinco Voces para una Historia Viva*. Mendoza, Argentina.

Soffer, Olga (2000) Fragments of an interview that took place on June 16, 2000, by Eleanor Hall on the program *PM*, transmitted by the ABC (Australian Broadcasting Corporation).

Little on Lace

LORI MARIE CARLSON

My love of lace is directly related to my affection for snow. When I was a child, growing up in the hinterlands of Chautauqua County in New York State, the winters were all about icy white for miles upon miles. Snowflakes, their intricacy and daintiness, fascinated me. I would take a magnifying glass, hold it up to my bedroom window, which was lit with tiny crystal jewels, a kind of snowflake veil, and stare for hours at their exquisite perfection. All sorts of questions came to mind. I wondered how divinity could make such art. I mused on their purpose. I pondered whether or not a human being could execute something comparable.

In my adolescence, I became enamored of *haute couture*. I spent hours studying the most up-to-date European fashion. I loved the elegance and simplicity of Italian design, the unassuming lines of Nordic wear. *Vogue* magazine was always on my bedstand, along with histories of England and France. It was during this time that I saw a white Chantilly evening gown (Valentino?) in *W*. This dress, like a daydream, linked the image of snow to the magic of artisanry. It would presage my fancy for lace wedding attire. I remember that one of my favorite past-times, when I was a college student studying in Spain, was to look at the bridal-shop windows near Puerta del Sol in Madrid. The dresses were elaborate and fine, with much lace trimming. Now, there seems to be a revival of lace, at least in high fashion. Witness Kate Middleton's wedding gown. And although lace today continues to be made by hand, if rarely; it has none of the pictorial depth and dazzlement of the old grand dames whose stunning tableaus of castles, dragons, saints, kings and queens, gardens and battlefields can mesmerize.

In my twenties, I started wondering about the history of lace.

I discovered that old lace or *lacis* made in the Middle Ages was a convent handicraft, and that while not much was written down about its origin, there were documented associations with ancient Israel and Mary. It is believed by some historians and theologians that a form of lace was being crafted in the time of Christ. Catholic narrative has Mary being the spinner of perfection. Some surmise that lacemaking was taught to Spanish nuns by Arab matrons. Whatever its genesis in Europe, we do know that the first lace pattern book was published in Italy in the sixteenth century and that lacemakers in Venice were exceedingly accomplished practitioners of needlepoint lace. In fact, one of the best-known stitches was termed *"punto in aria."* Dutch lace, a handicraft still going strong, was among the most sublime, and crafted by nuns as well as by women at home. Housewives and spinsters, young girls and maidens throughout Europe made lace by candlelight and oil lamp in their abodes. It is no wonder that many lacemakers went blind.

Old lace, dating from the sixteenth and seventeenth centuries, while extraordinarily delicate, is resilient. Its ethereal weft – as light as baby's breath – belies a rather alchemic construct. The meandering of threads, their interstitial complexity, ensures long life. And strength. Old lace has stood the test of time. Magnificent examples are extant in museums, palaces, churches, and monasteries today. It was one

such piece, a lace circumcision cloth, at the Musée du Costume et de la Dentelle in Brussels, that fired my imagination and led to the creation of my third novel, *A Stitch in Air* (Carlson, 2013). What was it about that particular creation, among many glorious examples, that arrested me so? I think it was this: it spoke to me of birth, of innocence, of purity, of beginnings and of pain that leads to awareness. And as I stared at the nearly microscopic wisps and amusements, chain stitch and split stitch, which painted a picture of nature, with its petals and sparrows, love knots and arabesques I think I saw the hand of its maker.

Bibliography

Carlson, Lori Marie (2013) *A Stitch in Air: A novel.* Lubbock, TX: Texas Tech University Press.

It's Come Undone: Crocheting and Catastrophe

SHERYL ST. GERMAIN

… the human hand … has its own form of intelligence and memory. Elizabeth Zimmerman.

SOME OF MY EARLIEST memories involve watching my mother crochet in our small living room on nights when my father was away working his second job or out somewhere carousing. She couldn't afford wool yarn, so she used synthetic, but oh the bright and colorful afghans she made for all of her five children! Although I don't remember her ever smiling while she crocheted, she seemed more serene than at other times, centered, surrounded by balls of yarn, an afghan slowly taking shape in her lap. Sometimes she worked with granny squares, stacking up hundreds of multi-colored quadrangles next to her on the sofa, then, months later, stitching them together in a lively design, making a whole of pieces in ways I'm sure she wished she could do with the broken bits of her life with my father.

Even as a child I perceived the swirl of chaos around my father, who often came home late from work, smelling funny and slurring his speech. I sensed my mother's crocheting was a way of creating a bit of calm in the frequent storms my father choreographed, storms that included strange women calling our house late at night, strange women's jewelry found in his car, increasing DUIs, car accidents, and hospitalizations until, finally, just short of his sixtieth birthday, his liver in an advanced state of cirrhosis, he slipped into a vegetative state and died a few months later. In those years I kept a journal and wrote poems in secret, which became my way of reflecting on my father's life, since my mother rarely talked about it unless forced. Instead of talking, instead of writing, she crocheted.

My mother has shared with me that crocheting all those years was, for her, a form of meditation. Instead of doing almost nothing, as in traditional meditation, with one's hands, hers were always moving, always in contact with the yarn she was looping and yarning over and pulling through in a rhythm I now understand, as a crocheter myself, underlies any thoughts scuttling about in your brain. Whatever else you might be thinking about while crocheting, you usually have to be counting – *one single crochet front loop only; one back loop only, skip one stitch; three single crochets in the next stitch, repeat until you have 150 stitches.* Counting underlies all your thoughts in crochet, giving them a substance and song they might otherwise not have had.

If you're mourning some loss, as my mother often would have been – not only did she lose her husband over the years to other women and drink, but both her younger sister, and her troubled son, my brother, died young of drug overdoses – the yarn slowly but surely binds you to that loss. Maybe your stitches take on the shape of your grief, swelling as your eyes do, maybe you tighten them when angry or hold the tension a bit more loosely when you're sad. Maybe you're thinking of someone you love who's not lost but still alive, your focus to create something beautiful for him, to stitch your affection into the yarn.

While I grew to trust words to stitch the wounds in my heart, my mother preferred crocheting. The comfort of the ball of yarn next to you, the satisfac-

ing with color, the colors must echo and complement each other the same way words do in a poem or lyric essay.

I first turned to writing poems as a way to find vessels to contain the chaos of the family into which I was born; poems offered a way to present a gift to the world that often came from those early days' tragedy. Crocheting has become a force almost equal to poetry as an expressive art for me, since both are creative acts that can be at once calming and transformative, both empowering in times of crises.

The truth is, of course, that women have often used some kind of fiber art – weaving, knitting or crocheting – as a tool for getting through difficult times. The earliest literary example we have might be Penelope, Odysseus' wife, who promises she will remarry once she finishes weaving a burial shroud for Laertes. During the day she works on the shroud, but unravels it at night, hoping Odysseus will return before she is forced to marry one of her property-hungry suitors. This story also points out that it's not the product of the weaving that's important, rather the process itself.

Several recent books link crochet's older sister, knitting, to psychological and spiritual recovery. Ann Hood's memoir, *Comfort: A journey through grief,* and her novel, *The Knitting Circle,* to pick two of my own favorites, are both inspired by her own experience learning to knit to help recover from the unexpected death of her young daughter (Hood, 2008, 2009). Likewise, crochet blogger Kathryn Vercillo's site, Crochet Concupiscence, is full of stories of many who crocheted their way through grief; she herself has written of how she crocheted her way out of depression.

My own drug of choice is crochet, not knitting, although most yarn stores, pattern magazines and books privilege knitting. Crocheting is in my blood because that's the art my mother taught me, and it's what her mother taught her. I learned to hold a crochet hook around the same age I learned to wield a pen, and it feels as natural to hold a crochet hook as it does a pen.

tion of it growing smaller as your project takes on shape and dimension; the wonder of the colors as they reveal themselves in a stitch, especially when you have a skein of multi-colored or self-striping yarn; the rhythm of the changes of colors and of the stitching itself; the sensuous sliding of the hook into the opening of the stitch; the pulling and looping and yarning over; the comforting feel of the completed stitch; these are some of the reasons I imagine she came to love crochet.

I make my living now as a poet and teacher of writing, although I also crochet, and I can't help but see connections between writing and crocheting. When crocheting a long row of single crochets, the rhythm of it feels to me like a kind of poetic meter, an extended trochaic foot, one that slides around, has a bit of a southern accent maybe, with slightly too many syllables – enter, yarn over, pull, enter yarn over pull – . It feels as if you're weaving a poem. A row of crocheting is not unlike a line of poetry where foot and meter are important, the turning chain like the rhymed syllable of the last word of an iambic pentameter line. If you're work-

Knitting and crocheting are sometimes confused, as they both involve yarn and may lead to similar projects: hats, scarves, gloves, sweaters, afghans, blankets. I often crochet in public – it's a great way to sit through bad poetry readings if you are not at liberty to leave – and am constantly responding to questions of "What are you knitting?" with *I'm crocheting*. Both arts involve manipulating loops of yarn, although knitters use two knitting needles, while crocheters employ a single tool, the crochet hook. Crocheters enjoy dozens of kinds of stitches; knitters have only two. Crocheting uses more yarn than knitting, and has more architecture. Running your hands along a crocheted item you'll feel the bumps of the stitch, which are in higher relief than those of knitting.

I now crochet as much, if not more, than my mother, and I'm grateful for her early lessons. I'm lucky to be able to afford the kinds of yarns my mother could not. I like to use kettle-dyed, natural yarn (as opposed to synthetics) for my crochet projects as I prefer the slightly coarser look and variegations in color; I like handspun yarns such as those from Malabrigo, a woman's collective in Uruguay, that vary in lovely ways both in the shades of the color of the yarn and in the diameter of the yarn itself so that it might be thick at one part and thin in another. As the yarn runs through my fingers I think of the animals or plants from which it came, and I feel more connected with the earth. I also like supporting the women in rural areas of South America, many of whom would live in poverty without the ability to make and sell this yarn.

Unfortunately, a love of crocheting is not the only thing I share with my mother. Like her, I also gave birth to a son who would grow into a troubled teenager, and whose journey, like my brother's, deeper and deeper into drugs and alcohol would dominate my waking hours for many years and haunt me in midlife even more than I was already haunted by the deaths of my brother and father.

Ten years ago my son, who was then nineteen and had been growing increasingly hostile to every-one who loved him during his teen years, took a turn for the worse, exhibiting a kind of emotional cruelty I can hardly bear, still, after all these years, to re-enter. He seemed to be spiraling into blackness; he'd dropped out of high school, refused to find work, and had been picked up on several occasions for public drunkenness and shoplifting. Hanging out with a crowd deep into hard drugs, one of his friends who regularly shot up heroin was so proud of it that he had taped needles onto his guitar. My son was jobless and living in my basement, although he had talked a doctor into giving him a prescription for Adderall so that he could get up in the mornings and look for a job, which he never did. I would sometimes find him and a girlfriend asleep in the basement in the mornings, emptied wine bottles on the floor, they unable to rise. I doled out the Adderall, one a day, until he visited his father, from whom I was divorced, in Texas, for a couple of weeks. He took the prescription bottle with him, and when I asked for it back on his return he claimed to have lost it.

One night, when I was out of town and he was home alone, the garage caught fire and burned to the ground. The house itself was scorched on one side and could have also gone up with my son asleep inside, the fire-chief told me later, if someone who witnessed the blaze had not called the fire department. The fire-chief also said my son had been so "inebriated" when he interviewed him about the fire he could hardly understand what he was saying. Years later my son would confess that he and friends had had a party in the garage that night; they had all gotten drunk and high; he had fought with one of the friends, who had later set the garage on fire in retaliation.

When I returned home from my trip, in addition to the charred space where the garage used to be, I found bottles of beer stashed everywhere in the house, in record cabinets, clothes drawers, under beds. I found evidence online through chat boxes he'd left open on my computer, that he'd been stealing copious amounts of cough syrup, wine, and beer.

He was advising friends on how to shoplift as well as how to mix drugs to achieve various kinds of highs. When I confronted him one afternoon about what I'd found, he called me a stupid fucking bitch, and locked himself in his room. Later that night I found a message he'd left for me on the desktop of my computer in about 32-point bold: I HATE YOU. I HOPE YOU DIE.

Not long after this confrontation he wound up in jail overnight because of a drunken fight that left him with two black eyes and, later, an altercation with a policeman while he was still drunk. That night, while he was in jail, one of his former girlfriends confessed to me how worried she was about him, his drinking, the drugs (specifically Adderall) she said he was doling out to friends, selling, and abusing it himself. She confirmed my suspicions that he had not lost the prescription bottle of Adderall.

The next morning the police informed me he still had so much alcohol in him that they could not even bring him in front of the judge for sentencing. They suggested one option to protect him might be to have him committed for drug and alcohol abuse. I suspected he would never forgive me for this act, but I also couldn't see that I had many other options.

While he was still sobering up in jail I submitted the paperwork to have him committed. I had to write on the commitment papers that I felt he was a danger to both himself and others. It was by far the most agonizing writing I have ever done, the most horrific paper I have ever felt it necessary to sign.

During his commitment I began to crochet an afghan for him. I had crocheted on and off since I was a child, but this was the first time I'd taken it up almost out of desperation. I felt helpless; everything seemed so chaotic. I could hardly get a sentence out during visits to the hospital where he was being confined before he'd curse and tell me to go away. From the dark and angry place where he lived, he couldn't hear or receive my words or love. As a mother this rejection was painful; as someone who had spent her life making poems and essays,

stitching words, if you will, to speak, the failure of my own words made me feel wretched. I couldn't console even myself with words; the feeling of what was happening seemed so raw, I couldn't bear, then, to try to capture it in words. Even now, reliving those events to write this chapter, is excruciatingly painful.

If I felt my words had no power then, or if I could find no way to bring them to power during those black times, if I couldn't seem to pick up a pen, I could still pick up a crochet hook. I could count rows, stitches. I could bear to think of what my son's life had become while I crocheted, the murmuring of my counting in the background.

And so I began crocheting for him, as my mother had for all of her children so many years earlier. I made the afghan of colors I thought he would like in a pattern I thought he might like. The project kept me sane for the month he was in the hospital, and gave me something both aesthetic and sensible to do with my hands, my grief, my wordlessness. I couldn't solve his problems, but I could unscramble the design dilemmas of an afghan; I could hook him a gift that could stitch a mother's love into the silent weight and heft of yarn.

I chose worsted weight wool, the right weight for something you want to give warmth: a thick, but not chunky yarn. I don't remember the precise pattern or color scheme, but I do remember blacks, purples, and yellows: in my mind, yellow for hope, black for grief, purple, one of his favorite colors. A repeating series of puff stitches that shaped large ovals that looked something like eyes. Even now, so very many years later, I remember how satisfying it was to sit on my sofa in the evenings when it was very cold outside to work on this afghan. The snow falling, fire blazing in the fireplace, the afghan growing under my fingers, slowly, day by day. Sometimes I thought of my mother and all those nights she had crocheted while my father was drinking himself to death. I hoped some intervention would save my son from that fall, but I was beginning to feel all but powerless to help.

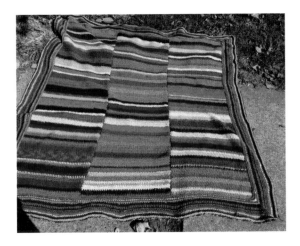

Once the pattern was ingrained in my fingers I didn't have to think about it so much; it felt at times as if I were in a trance, my fingers making the same movements over and over again: *Yarn over*, insert hook into the stitch; *yarn over*, pull through; *yarn over*, pull through again; *yarn over*, pull all loops off the hook; half double-crochet formed for the background. Three rows of that. Then the puff stitches: five yarn-overs and pull-throughs that made a stitch that puffed out just as the name suggests. I crocheted through the nights and thought about my son. Yellow. *Yarn over, one.* Maybe he'll never speak to me again. *Insert hook into stitch.* It's not about you, Sheryl, it's about him. Maybe the forced twelve-step program will help. *Yarn over, two.* At least he isn't with the guy who tapes needles to his guitar. *Pull through.* How long will he be angry, will the meds help? *Yarn over three.* Are they treating him well? *Pull through.* What else could I have done? *All loops off hook.* Repeat for black, purple. And on and on, over and over, hundreds of rows, thousands of stitches.

When he was released from the hospital, he was required to continue in a twelve-step program for another nine months and to have a stable place to live. He stayed with me for a while in Iowa where we'd been living, then moved to Texas to be with his father, who bought him a beer for his twentieth birthday, and so it started all over again, the drinking, the drugs, the anger. He stopped taking the medications that had been prescribed to him while he'd been in the hospital, where, in addition to drug and alcohol abuse, he'd been diagnosed with bipolar disorder.

After a few months he returned to Iowa, but not to stay with me. He avoided talking with me as much as possible, moving in with a new girlfriend I didn't trust or like and some other friends I also didn't trust or like. They lived in a falling-apart house with broken windows. I don't know how he managed money for the cigarettes he'd started smoking. He rarely visited, though he occasionally tolerated a short visit from me. I taught my classes during the day, numb, saw a therapist weekly, also numb, and worked on the afghan at nights, which was the only time I felt alive. Each time I picked up the hook and pulled the afghan on my lap I felt balanced, focused, a clear project in front of me. Sometimes this was the only time in the entire day I felt centered. If I lost attention and forgot to count I could rip a few rows out and start over. If I put my mind to it, though, if I focused only on the pattern, I could make a perfect row, which was something, given the ragged world into which I had fallen.

If I allowed feelings of hopelessness to take over while stitching (and I sometimes did), there were always the intensely beautiful colors of the afghan emerging in a pattern to remind me I was actually accomplishing something. Yellow, a field of goldenrod, purple the color of ripe eggplant, black, the darkness I was keeping at bay by stitching it into the afghan. The colors, the pattern, the design reminded me, over and over, with each stitch, that beauty might come out of grief.

When you feel hopeless, as if you can do nothing right, it's useful to have a reminder that you can engage in an activity that will grow into something of value. The long rows needed to make afghans allow you to sink into a soothing rhythm. There's nothing unexpected, no horrible blow-up, no yelling or screaming or fighting, just the hook moving

in and out, in and out, reliable, steady, familiar as your breath. The thing taking shape, almost imperceptibly, under your fingers, an object whose colors and design you chose. Crocheting does not offer the oblivion of drink, which I sometimes also engaged in those days; it requires rather the opposite: engagement. Although I could not bring myself to write poems around this time, I kept up a journal, and crocheting allowed me quiet time to reflect. I may not have written much, but I meditated deeply, partly thanks to the act of sitting down every evening to work with my hands.

By the end of six weeks I had completed so much of the afghan that it covered the lower half of my body as I worked on it. The afghan began to keep me warm in ways I hoped it would eventually warm he who would not be spoken to.

At one point while I was still working on the afghan, my son, drunk and high, paid a surprise visit to his old girlfriend, the one who had shared with me her fears about his trajectory. She wouldn't let him into her apartment, so he kicked the door in. She called the police, but he got away before they arrived. A warrant was issued for his arrest. I learned from one of his friends that he was hiding from the police with the guy who had needles taped to his guitar. It was Christmas time. I had a bag of groceries and kitchen supplies under the tree for him.

One evening not too soon after the door incident, as I was sitting on the sofa crocheting, I saw, though the living room window, his current girlfriend's junker car pull up in front of the house. He and the girlfriend were sitting in the car smoking and talking. I only had a few minutes. I called a friend. Please, I said, call the police, tell them he is outside of my house. I don't have time. Tell them to come get him.

I hung up, and in a minute my son came in. It was awkward. He didn't want to sit down. He just wanted to pick some clothes up, he said. We talked for five minutes, the Christmas tree lights twinkling, the fireplace blazing, the unfinished afghan on the sofa, the afghan he didn't even know was for him.

At some point the doorbell rang and two policemen asked for my son. I pointed to him. He didn't resist. They put him in handcuffs and took him away.

I finish the afghan while my son is in jail. I drive out to see him a few times, but after awhile I stop, because he usually winds up telling me to fuck off.

Although I love designing crocheted items and I love the actual act of crocheting, I do not enjoy the finishing-off part. That is the part where you have to weave in all the ends so that they don't come undone. If you have been working with yarns of different colors you may have lots of ends that need to be woven in. It is not exciting. It's not creative. There is no comforting rhythm because you are constantly starting and stopping at often-irregular intervals. You have to use a tapestry needle to weave the ends in, threading it with the yarn ends you've left hanging where you changed or ran out of yarn. You weave in and out of the stitches, first one way and then the opposite way, and when you've woven enough so that it seems it would be impossible for the stitch to come to come undone, you snip the yarn and pull the stitch over it so that you can't see the work you've just done securing the stitch. It is tedious work, but it's something you need to do if you want your work to last and not come apart the first time you wash it.

Perhaps another reason I don't like weaving in the ends is because it means the project is almost finished; I've become intimate with this work, it's come alive under my hands and I've put a lot of myself into it. Now it will be done, finished, like a novel whose characters have drawn you in close for a time. To finish is to abandon them.

I gave my son the afghan when he was released from prison. He moved back in with the girlfriend I didn't like in the broken down house with the broken windows I also didn't like, and I don't know if they used the afghan or not, but sometime later when I helped him move out of that place I found it stuffed in a black plastic bag. He said it had come partly undone and they hadn't known what to do with it.

I took the afghan home with me; it smelled like cigarette smoke and sour wine, but I repaired where it had unraveled and went back to re-check everywhere I had changed yarn to make certain it wouldn't unravel again. I washed it, checked it again, then folded it neatly and put it in my linen closet. I would give it back to him when he was settled in another place.

Today, ten years after my son's initial release from prison, he still struggles with some of the same issues that got him into trouble when he was younger. He has returned to jail on several occasions for relatively minor issues, and admits to having a drinking problem, but he has a stable job that he likes and is relatively independent. We talk frequently and he asks and accepts advice. He tells me, sometimes, that he loves me. Although his moods vary widely, and he struggles, as I do, with depression, most of the time he no longer feels like a danger to himself or others.

I honestly do not know if the acts of having him committed and jailed helped. What I do know is that the time in the hospital and jail stopped for two short periods what seemed like a staggering fall that could have led to his death and perhaps those of others. What I do know is that crocheting the afghan was a good decision for me. I was able to keep balanced and even *spirited* in the sense of filling myself with something that felt spiritual in a dark, dark time, through crochet. Idle hands may not necessarily be the devil's tools as the saying goes, but idle hands certainly are the tools of listlessness, depression, and spiritual torpor. When I think of the afghan I made my son so many years ago, I feel a satisfaction I can hardly express that something both practical and beautiful came from sorrow and a sense of helplessness.

This year, I crocheted an alpaca hat and wool scarf for him for Christmas. The hat is made of soft brown baby alpaca, comfortable and slouchy, the yarn lustrous and silky. The yarn is so soft it feels like it will melt in my hands, and is exactly the color of his hair, a bright, hopeful brown. Alpaca

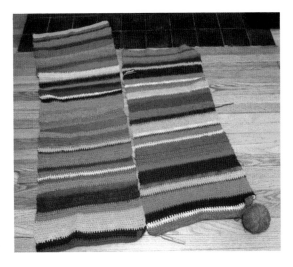

is as soft as cashmere but stronger than wool. I made the hat of simple single crochets with intricate increases.

When I visited him over the Christmas holidays in Texas, where he now lives, he wore the hat the whole time after I gave it to him, and even slept with it on. He drank a lot while we were there and I could see he was depressed; at one point when we were alone together, tears fell from his eyes as I was driving him to his father's house. "I don't know what will become of me, Mom," he said, pulling the hat down around his ears.

I made the scarf in a gray yarn crocheted in a ribbed pattern with a thin row – quietly shocking – of multicolored yarn, with hues of turquoise, deep blues, reds, and pinks. The idea for the scarf was inspired by Navajo weavers, many of whom include a "spirit line" in their blankets, a small strand of contrasting color that flows from the original design element to the outer edges. The line is there so that the weaver's creative spirit does not get trapped in the blanket, unable to make anything else. It is, if you will, a way out. As much love and hope as I might put into a scarf or hat or afghan, I don't want my own spirit trapped there. I want to be able to pick up a hook as I pick up a pen, over and over again,

to write with yarn as I write with words, to not get lost, but to get out and start again somewhere else, yarning over and entering another stitch. It's not unlike the kind of writing I'm doing right now, a writing that causes one to have to descend or revisit some dark place, but to be able to come out of that place.

I also want to be able to *let go*, something my own work with twelve-step programs has taught, and so the spirit line for me is also a physical symbol that at the same time I'm making something for my son I'm also letting go of him. I'm not a super power, not a higher power, I'm only a mother whose role in his life will continue to recede as he ages.

The hat and scarf, like the afghan I made for him years ago, are kinds of prayers, ways of touching one who still, sometimes, will not let me touch him, one who, sometimes, is suspicious of words. The hat and scarf will warm him in ways I wish I could with my hands. Maybe, now, he can sense my crochet gifts to him as spirit-warmers as well as body-warmers.

Poet Pablo Neruda says that writing should be like bread, and I have always loved the idea that our words might feed one who could otherwise go hungry, that writing could be that necessary and elemental. But bread, once eaten, is gone, whereas an afghan, blanket, or crocheted garment can be used over and over. So of late I have been hoping that my writing can be as useful as a blanket made with my own hands. That this essay of woven words, in the hands of a reader, might delight, comfort, and warm. That it be there, to return to, again and again, providing a safe space for reflection.

I don't want to think what might happen if my son doesn't stop drinking, I don't want to think how little I can influence his life. This hat, this scarf, each stitch a word in a prayer: *Keep-him-warm, keep-him-safe, keep-him.* I crochet words, wish, blessing, and spell into the scarf, I make the hat a magic thing, like the cap of Hades, one that may make him invisible to the terrors of night. I hope my stitches will hook something words cannot. I crochet apology, regret; I crochet hope, I crochet sorrow, desire, rhythm, beauty. I weave in the ends, trust it won't come undone, and gift it, this talisman, this charm, this scar, beautiful, of catastrophe.

Bibliography

Hood, Ann (2008) *The Knitting Circle: A novel.* New York: W.W. Norton.

Hood, Ann (2009) *Comfort: A journey through grief.* New York: W.W. Norton.

Vercillo, Kathryn (2013) Crochet Concupiscence. Available at www.crochetconcupiscence.com/ (accessed October 2013).

Spirit Socks

LORRAINE LENER CIANCIO

IN 1992 MY HUSBAND and I moved from the east coast where we'd always lived, to Taos, New Mexico. This was a bold move meant to change our lives – and it did. We have been here ever since. Some friends and family members we left behind have learned to love it as much as we do and visit often – a few have even moved here themselves. During the early years in Taos I took up the art of knitting again. Beautiful yarns were available and, among other garments, I learned how to knit socks. They were alternately functional and magical and I have turned out hundreds of pairs as the ancient knitters did, but under different circumstances.

Taos has an interesting, complicated history, yet three cultures have endured in the region for centuries. Students of history, scientists, archaeologists, geologists, many others have helped to unravel the story of this ancient land. I thank Marc Simmons (1991) for his book *Coronado's Land*, David J. Weber (1996) for *On The Edge of Empire*, and Fray Angelico Chavez (1981) for *But Time and Change*.

In 1972, the Hacienda de los Martínez became a Taos Historic Museum and was saved from disintegration and disrepair. With a reputation as a serial sock knitter I was approached, a few years later, by the education director of the Hacienda, whose wife

FIGURE 5.1 The Taos mountains.

owned several pairs, to demonstrate sock knitting during the annual weekend Old Taos Trade Fair. I was surprised. I didn't know much about the history of the Hacienda and certainly never thought about hand-knitted socks in relation to it. What I learned was the Hacienda was more than just a home for the Martínez family. It served as a workshop, factory, trading post, general store, gristmill, ranch, and farm.

What I remember about those mid-September trade fair weekends was the scent of cedar and piñon wood smoke outside the open door in the walled courtyard of the Hacienda. The intense sun and crisp warmth served as a backdrop to music, mariachis, and the historian who showed up twice a day to enact part of Padre Martínez's story in the center courtyard of what was once his home. Traditional foods were cooked over wood fires. Enthralled kids watched Spanish marionettes and dancers. An area outside the walls of the Hacienda was reserved for traders, real mountain men, and a handful of the enthusiastic people, sometimes scholars, who followed trade fairs throughout the summer, camping out and reenacting other eras through their clothes and temporary lifestyle. A few local craft vendors sold jewelry made from trade beads, turquoise and silver, or bags fashioned from Pendleton blankets and fringed buckskin.

This annual event is a modern version of trading practices that go back to pre-history. The mountain men (yes, that's what they are called), spread their wares out on blankets on the ground in neat arrangements of knives, tools, fur, and leather goods. They wear western hats and faded denim jackets, generally have beards, and look as weathered as their hats and boots. This is what they choose to do, travel around the western half of the country from trade fair to trade fair, keeping hundreds of years old traditions alive.

Its location in the northern region of the Southwest meant that Taos, New Mexico has played an important economic role since ancient times. The Taos valley runs north and south, bordered by the deep gorge of the Rio Grande to the west and moun-

tains to the south, east, and north. It became a trading center that connected the people of the southern Rocky Mountains, the Rio Grande and western pueblos and the Plains. Until the 1780s, it had long been the scene of lively trade fairs. After that time and well into the 1800s, trade continued with the Indians and along the Camino Real, the king's highway, that ran north from Mexico City. Hispanic settlers lived at the edge of the camino and traveled that trade route with goods made in northern New Mexico. One of the most valuable trade items was woolen socks.

The weather is nearly perfect in autumn in Taos. Cloudless cobalt-blue skies, aspens on mountaintops glowing orange and salmon, cottonwood trees alongside streams and *acequias* (irrigation ditches) wave yellow-leaf branches through gentle winds. Somehow, the sense of history of the Pueblo people who have lived on this land for more than a thousand years, as well as Hispanics whose families have been here for hundreds of years and Anglos who settled here a century ago, seems sharper in late September when seasons are provisionally balanced between summer's drift into fall and the coming bitter winter. It's a perfect time to think about wool. And the Hacienda is the place to begin.

For many years starting in the late 1700s, the Martínez Hacienda acted as a factory for hand-knitted socks. They were considered almost as valuable as the mythical gold the Spaniards had come to New Mexico seeking. So valuable that in 1826, Antonio Severino Martínez, father of Padre Antonio José Martínez, listed forty-four pairs of socks in his will.

When the Spanish arrived they brought with them tools and new knowledge and disastrous change. A Spanish soldier wrote in his diary at the time that they had one goal, "to serve God and the king, and to get rich." By 1540 the Spanish dominated the Pueblo tribes in what is now New Mexico.

The Spanish brought weapons, horses, pigs, and Churro sheep descended from an ancient Iberian

FIGURE 5.2 Churro wool.

breed. They also brought the skill of knitting to the Pueblo people, eventually replacing the looping techniques of finger weaving. It is believed by some historians that the first knitted stockings were footless leggings. Marc Simmons (1991) wrote that he chanced on a colonial chronicle of a German Jesuit priest who described "stockings from New Mexico that have no feet." Soon after that discovery, the author, visiting a market at one of the Indian pueblos on the Rio Grande "suddenly spied a pair of new-made, black wool stockings without any feet." He concluded, "Indians, who still use their own knitted variety, pull the ends under their heels so that the upper half of the foot is covered and the toes are left bare … a number of elderly Pueblos and Navajos continue to wear these traditional stockings."

Little knowledge of knitting in ancient northern New Mexico is known and Simmons, whose book on daily life in Colonial New Mexico is eminently readable and engaging, probably wasn't much interested in the subject and didn't care to research it any further. I don't blame him, it is more appealing to anthropologists and fiber fanatics like me.

I remember the story I was told of an elderly Taos Pueblo man named Joseph. On his friend's birthday, Joseph gave him a pair of socks. This was a gift reserved for only the most important people in the Pueblo man's life and he was honoring his friend in this way.

"When I was a child," Joseph said, "my feet were always cold and I had to walk everywhere. When I got a pair of hand-knitted socks, I cherished them and wore them until there was nothing left. I was never sure if I would ever have another pair again. I still value the miracle of socks."

As the native elder said to his friend that day, socks are a miracle. They have been around in some form for more than a thousand years. Remnants of socks have even been found on the feet of Egyptian mummies. And what can be more basic to mortal comfort than a pair of wool socks on a chilly morning?

In the late 1990s I read about an elder on the Soowahlie Reserve in British Columbia who was taken from her home at age eight and placed in a boarding school. She was required to speak only in English and allowed to spend one month a year at home with her family. She and the other girls at the school were expected to produce two pairs of socks per day. They also turned out leggings and vests for the boys who did the outdoor work on the school farm. It wasn't until the 1950s that the mandatory boarding school system in British Columbia ended.

In New Mexico by the mid-seventeenth century, the Pueblo Indians were knitting hundreds of pairs of wool socks for distribution among the colonists. The socks were collected as a form of taxation by the Spanish governor of Santa Fe. Hundreds of pairs of knitted stockings were used as trade items with Chihuahua, Mexico in exchange for manufactured goods such as iron, cotton, silk, and ceramics.

In preparation for my demonstration, I visited the so-called weaving room at the Hacienda where a replicated sock was on display in a glass case. Nothing remains of the socks that were knitted at the time and anthropologists and ethnographers had determined that the thick gray wool socks, crudely knitted from undyed, natural gray and white wool were the type produced at the Hacienda when it functioned in part as a small factory in which

numerous household servants or slaves worked at hand carding fleece, spinning yarn, and knitting socks. They estimated that the entire process took thirty hours from carding to completed socks. I've never kept track of how long it takes to knit a pair of socks using already spun commercial yarns, but in all likelihood it comes close to fifteen or twenty hours. I've never had the urge to log my sock knitting hours so I don't know for sure.

In addition to prepping the wool and knitting the socks, women and girls did the cooking and the most menial jobs. They also wove blankets, *sabanilla*, a wool form of broadcloth or sheeting, rugs or *jergas*, and wearing-blankets called *serapes*.

The sock on display in the weaving room was dark gray with white ribbed cuffs, heels and toes, and made of thick, coarse wool. No doubt it would be warm. I decided to reproduce several pairs with soft wool to exhibit and sell during the fair. I soon

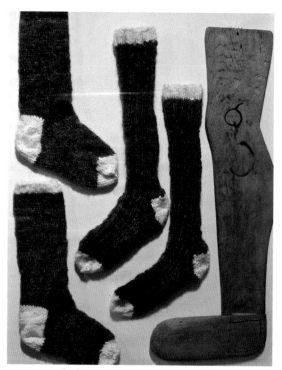

FIGURE 5.3 Socks.

discovered that I couldn't tolerate working with only gray and white wool for long. On my table beside the regulation almost authentic-looking socks, were pairs in orange and white, gray and red, brown and green, and several pairs made with multi-colored yarns.

I can't help but think that the women and girls who knitted countless pairs of socks would have been less troubled if colors were available to them as they are to me. Color can alter moods and even heal. It would have been a tedious task to work only with undyed natural wool. Like having a vast garden with only one kind of flower in it. Or reading the same poem over and over in a book with no other poems, day after day, year after year, in servitude.

Indian slavery in Spanish America began in 1493 with the first colonies. As Spain's frontier moved north from Mexico the Spanish brought with them the *encomienda* system in which the *encomiendero* (protector) was given control of an area and compelled to civilize and Christianize the natives. He was also permitted to exploit their labor.

Northern New Mexico history is a bloody one with a long cycle of raids, abductions, and retaliations. Before Indian slavery was made illegal by presidential proclamation in 1865, raids were carried out by Spanish colonists on native villages along the Rio Grande and by Natives on Hispanics. The majority of captives were women and children whom wealthy Spanish ranchers accumulated like material goods. When slavery was finally declared illegal, native domestic servants had become culturally Hispanic and stayed on because they knew no other life and had no place to go. It was not unusual for these women to marry and become members of the family with full inheritance rights. On the other hand, Indian men were difficult to restrain and were apt to escape or murder their captors. As a result they were often killed rather than taken. In turn, Indians raided Hispanic settlements, kidnapped women and children and adopted them into their own families to offset the depletion of their numbers. Hispanic and Anglo women and

FIGURE 5.4 *Vigas* and ghosts.

children became acculturated into the tribal groups that held them. At some point, among one tribe, a new clan was established that recognized descent from captives.

At the Hacienda that first weekend, I knitted all day and set out my work as an offering to the spirits of departed knitters who worked because they had no choice. I felt their presence embedded in the thick walls made of straw and earth, and in the ceiling topped by massive *vigas* or beams, crossed with ancient aspen or cottonwood *latillas* and covered with two to four feet of dried mud. Still strong and standing, the ancient construction technique used to build the Hacienda was first introduced to the Spanish by the Moors sometime in the first millennium. The Pueblo Indians used a similar technique nearly 500 years before the Spanish arrived on the scene.

As I knitted, bits of straw and earth dust occasionally floated down from the ceiling onto my hands holding four thin wooden needles and yarn. A nudge to remember? Bits of falling straw seemed to carry spirit messages. I tried to acknowledge them. (This sort of thinking easily occurs in the enchanted land of northern New Mexico and I probably wouldn't have felt it if I were knitting in a Manhattan museum.)

After two full days in that mud-walled room I went home tired and filled with new appreciation for the privilege of being able to go into a local yarn shop and pick out from a vast array of choices, exactly the color and texture of sock yarn that fit my mood at that moment; to look forward, at home, to preparing a cup of tea and leisurely casting on stitches for a new sock project, not out of necessity or because I was forced to, but purely

for my own joy and the comfort and pleasure of others.

The great Pablo Neruda once wrote about a pair of sea-blue hand-knitted socks "shot through by one golden thread" that a sheepherder friend had knitted for him. In the last stanza of "Ode to my Socks" he says,

> beauty is twice
> beauty
> and what is good is doubly
> good
> when it is a matter of two
> socks
> made of wool
> in winter.

I spent two days in that room each year for the next four or five years, surrounded with the ghosts of knitters past. I felt their presence. Friendly, empathic, their spirits were embedded in the thick adobe walls and mud floors sealed with ox blood and ash. They watched silently.

There is a feeling of solidity and steadfastness within the walls of the Hacienda in spite of the low narrow wooden door kept open during the fair, the visitors and clear light of autumn days spilling in and out of the room along with the ordinary smells of burritos and fried bread. The muted click of knitting needles wielding an age-old technique that turns wool string into socks adds to the sense of timelessness.

Today, inexpensive machine-made socks are readily available to anyone on the planet, while hand-knitted socks bring a good price as more and more fiber artists are taking up the craft and spinning and dying their own wool. Southwestern textiles are sought after and considered "clothes of the spirits" linking together the earth and sky. I like that and I will continue to honor those ancestors who weren't mine, but who I claim as mine every time I begin knitting another pair of socks.

Bibliography

Chavez, Fray Angelico (1981) *But Time and Chance: The story of Padre Martinez of Taos, 1793–1867.* Santa Fe, NM: Sunstone Press.

Simmons, Marc (1991) *Coronado's Land: Essays on daily life in Colonial New Mexico.* Albuquerque, NM: University of New Mexico Press.

Weber, David J. (1996) *On the Edge of Empire: The Taos Hacienda of Los Martínez.* Santa Fe, NM: Museum of New Mexico Press.

Knot Magic

LINDA RODRIGUEZ

Draw out the thread
from the cloud of purple wool
teased almost to vapor.
Make the insubstantial and weak
strong enough to carry the burden
of cloth, rope,
mending and making thread –
all through the magic
of concentration and twist.
Spin the spindle.
Let it twist the fibers into miracle
as it drops, whirling.
Then test the yarn
as you wind it on,
thinking all the while
of the one this spell is for,
spinning once again,
ancient process,
skill, art, magic.

Later, you'll skein it
on the niddy-noddy,
wash and whack it to bloom,
and hang it weighted
down to set the twist.
No wonder goddesses
carry distaffs and wield
spindles as scepters of power.
This earliest magic
is a mystery to us in this age.

Both my grandmothers were accomplished needlewomen.

My Scottish grandmother, the minister's wife, sewed perfect quilts, dresses, and curtains. She even dyed old nylons and made realistic-looking silk-flower corsages for all her granddaughters at Easter. She never saw a pattern in a magazine that she couldn't make. She taught me how to sew doll clothes and quilts by hand and rapped my knuckles sharply if I was lazy or clumsy and took big, sloppy stitches.

In her youth, my Cherokee grandmother had been a weaver of baskets of stunning beauty still used every day in her home. At the time I knew her, she knitted and crocheted. She showed me how to create a fabric out of one long continuous piece of yarn with only two sticks or one hook. She also taught me that stitches of any kind – knit, crochet, or sewing – were related to ancient knot magic, as was all weaving of cloth or baskets with its interlacing of fibers. She didn't spin, although her mother and grandmother had, and she believed it was the most powerful magic of all. She had traveled to New Mexico and seen Navajo weavers carding, dyeing, spinning, and weaving wool. She told me that they were still in touch with that old magic.

So I started out ahead of most of my age-mates, thanks to these two very different women who also taught me how to cook, grow vegetables and can them, kill, clean, and fry chickens, bake bread, and other skills that have been important in my life. I knew how to make my own clothes and, later, those of my children.

E li si, my Cherokee grandmother, was not a pattern follower like my other grandmother. She taught me to envision within my own mind what I wanted to make and to design and create it as I worked. In my twenties as a broke young wife and mother, I would use the craftsmanship and skills taught by one grandmother and the vision and creative confi-

dence taught by the other to make the fashionable black velvet sofa and loveseat my young husband desired that I didn't want us to go into debt to have.

Always in the back of my mind remained *E li si*'s words that spinning was the oldest and most powerful magic. I already knitted and sewed items for my loved ones in which I poured intention and desire into each stitch – for health and healing, for protection, for comfort in grief and pain, for success, for luck, for all the good I wanted to give those I loved. I had begun using color to reinforce these intentions and different stitches to create symbols to underscore my wishes and desires for my family and friends.

One day, I walked into a yarn shop to buy more knitting yarn and found a display of spinning wheels and spindles with a woman giving a demonstration of the ancient art of spinning. I walked out with a hand spindle and half a pound of cherry and indigo hand-dyed merino wool, and I set out to teach myself to spin. I learned that merino, buttery-soft and beautiful as it is, is not the ideal fiber for learning to spin. My progress moved much faster when I found Romney, a longer, sturdier wool.

Spindle, knitting needles, tapestry loom play a role in keeping me in touch with my ancestors and the traditions of knot magic and making tangible wishes for the ones we love. I have a knitting

FIGURE 6.1 Yarns.

machine but never use it. My big floor loom with its harnesses has turned into a cat gymnasium. Although I own an electronic sewing machine, when I sew, I choose the handwork of appliqué, embroidery, and crazy quilting.

I am drawn to the most labor-intensive, hands-on experience because much of the creativity moves through my hands in direct line to the hands of those ancestors before me who spun, hand knit, hand sewed, and wove with the simplest looms. This act of making is a kind of reverence – for the fiber and the animals and plants from which it came, for the chain of daughters and granddaughters who have learned and passed on the skills down through the centuries, for the relationships with family and friends and the community formed of caring for them.

Whether the yarn spins fine enough for a knitted lace shawl, smooth and strong enough for embroidery or appliqué, or fat and fluffy enough to pack down and cover the strong warp threads in a tapestry bag, rug, or wall hanging, my mental, physical, and spiritual energy is invested in its making and its use to create something beautiful, serviceable, and powerful in its own quiet way.

In 2006, one of my dearest friends faced aggressive breast cancer. The prognosis was alarming. Desperately concerned, I worked round the clock to spin and knit a multicolored shawl full of healing and strengthening intentions. She wore the shawl through surgery, radiation, chemotherapy, and recovery. She beat the cancer and has since passed the shawl on to fifteen women friends and friends of friends faced with diagnoses of cancer. All survive and thrive to this day. Each wore the shawl throughout her ordeal. Many doctors have allowed them to wear the shawl during surgery, knowing the role of comfort and belief in defeating cancer.

I have since met several when they have come to my readings to meet me and thank me, but originally, I knew none of these women, save Deborah, my beloved friend for whom I originally made that

FIGURE 6.2 Deborah's shawl.

shawl with so much intense desire and desperate, focused wishing for her survival and good health.

I have a photograph of myself as a toddler, sitting outside under a flowering quince in a tiny chair, cocker spaniel beside me. My feet stick out, plump legs too short to touch the ground. Stocky child, broad face, dark eyes staring intently – Indian, like my father. Pudgy right arm extended, finger pointing at something out of the photo. My husband calls this picture "Let my people go!"

I must have been trying to work some such magic because, by then, I had already learned from *E li si* that pointing a finger carried power, just as words did, and neither must be used carelessly. That was bad, *u yo i*, and dangerous, *ga ni ye gv*.

We were staying with my grandmother. When my parents went out, she sat with me, knitting or sewing, told me teaching stories. If I begged, she brought out her blue shawl, wide as wings, long with silky fringes, and danced. She used to dance with other women at pow-wows and stomp dances. No longer. She just shook her head. "Let the young ones show off. Someday you'll have a shawl to dance with."

Tall, beautiful bird, swooping blue wings through the air and whirling them around her while she

stamped her feet in the pattern that I tried to imitate. Finally, she furled wings and stood still for a second before opening them wide again to wrap me in the soft, smooth shawl with *E li si*, smelling of sage, tansy, lemon balm, and lavender. That smell was only hers.

Once, I got into Mother's array of cosmetics, drew lines and thundermarks on my face, told Grandmother I was a real Indian. She laughed and told me I had no choice as she scrubbed my face with a washcloth.

"My blood runs in you," she said. "In the old days, before the Trail of Tears, girls could be warriors, too. I see that blood runs in you."

When Mother returned – her make-up messed up, nail polish spilled – she spanked me, screamed at Grandmother and at Daddy. Only twenty-one and pregnant with her fourth, she blamed everything bad in her life on my father's Indian blood, but I knew that couldn't be true.

E li si didn't get drunk and beat anyone up, the way Daddy sometimes did. She didn't gamble the grocery and rent money away. And Grandmother was way more Cherokee than Daddy was. Of course, Cherokee was not something Daddy was proud to be.

Now, I sit, knitting, sewing, weaving, and tell my Jewish husband the teaching stories I used to tell to my Cherokee-Chicano children. He listens to me tell of Uktena, the dragon with a snake's body, deer legs, antlers, and a crystal in his forehead that gave power to see past and future and work magic. He listens to stories of the Little People, of Stoneskin, super-human cannibal-wizard, and Selu, First Woman, our divine mother who gave us the gift of corn, even though she was being murdered for it.

My husband says, "As long as one person still tells the stories, nothing is truly lost. A culture is its stories, as a family is."

In this world that despised my grandmother, I have only bits and pieces of the language. *Tsa la gi*, she gave me, leftovers from her own mother. But my home is full of shawls, warm, thick, wool shawls and graceful fine lace alpaca shawls I've knit with yarn I spun myself, woven cashmere shawls, and shawls sewn from cotton and silk. I swirl around myself long, graceful stoles and rainbow-colored triangle shawls with dangling fringes.

Home permanently now, due to illness, from work at the women's center I once ran, I wake and wrap myself in a purple shawl and sit at the computer sending a press release for an immigration rally or organize an environmental summit with a blue, gray, and white shawl covering my shoulders. *E li si* was right about another thing. All my life I have been fighting battles. What a strange and silly picture to this world – warrior in shawls.

Ga ni ye gv! Let my people go!

PART II IN WOMEN'S HANDS: THE ART OF RESISTANCE

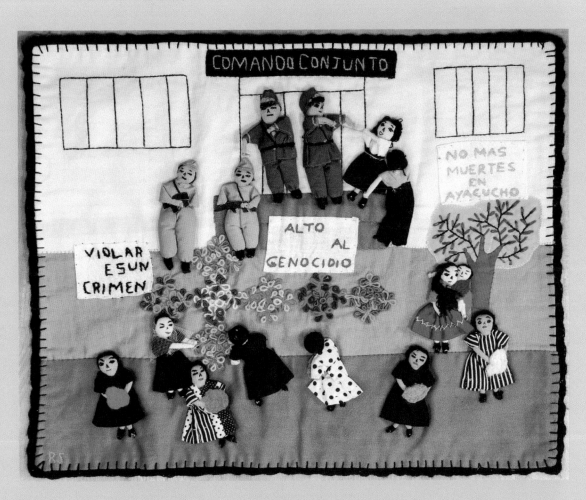

The Changing Status and Recognition of Fiber Work Within the Realm of the Visual Arts

ROGER DUNN

Creations in Fiber as a Worthy Art Form

ONE OF THE EARLIEST stories of a great fiber artist comes to us from ancient Greece, and was recounted in the *Metamorphoses* in the year 8 CE by the Roman writer, Ovid. It tells of the boastful mortal woman Arachne, a spinner and weaver zealously proud of her tremendous talent, which was so impressive that even nymphs of land and sea would come to watch her at work. Among the various attributes of the great goddess Athena (referred to as "Pallas" in Ovid's account) were those of wisdom and skill in handicrafts. Appearing to Arachne in the guise of an old woman, Athena warned the mortal weaver about respecting the divine source of her great abilities. Instead, Arachne arrogantly dismissed any other source of her skills but that of her own accomplishments. Hence the goddess revealed her true form and challenged Arachne to a weaving contest. Arachne wove an incredibly beautiful tapestry dealing with the carnal misdeeds of the gods while Athena wove one portraying her heroic contest with Poseidon to become patron deity of Athens. When the contest was over, the goddess, enraged with Arachne's lack of respect for the gods in both the subject matter of her weaving and the rejection of the source of her talent, destroyed Arachne's tapestry. Arachne hanged herself, but Athena kept her alive and transformed her pendant body into a spider, a creature doomed along with her progeny to forever spin and weave webs.

The story makes clear that the main sin of Arachne was not so much her arrogant pride and lack of respect for the gods, though grievous enough, but her failure to recognize that her creative skills were divinely inspired, a gift from the goddess herself. As though universally understood, the story also assumes the exalted rank of the art of working in fiber – an endeavor worthy even of one of the most powerful of deities. Similarly, the divine working of fiber is told in the story of other Greek goddesses known as the Three Fates, who determine the course of each of our lives by spinning it out in a thread that is eventually cut, establishing the time of death. Fiber, thus, is an allegory of the very course of one's life. Indeed, prior to manufactured textiles and ready-made clothing, working in fiber was a preoccupation critical to the survival and prosperity of the individual, family, and community. Functional and creative fiber work was an activity found with rare exception in every family setting. Though practiced by some men, working in fiber was regarded throughout history and throughout the world as the domain and special accomplishment of women. In the native societies of North America (with the exception of the Pueblo people), weaving and needlework, and often basketry and pottery, were the sole domain of women, though exceptions might be made for men who identified themselves as women, and chose to live their lives as such.

Athena's role as a divine fiber artist herself established her as the patroness and inspiration for those mortals who were essentially her disciples in the fiber arts. It was a central theme in her worship. Each year, a select assembly of young women of Athens would spin and dye the fiber, then weave and embroider a woolen garment, or *peplos*, for their goddess to be presented during the celebration of her birth at her greatest temple, the Parthenon on the Acropolis. The presentation of the sacred *peplos* as the culmination of the Panathenaic procession was recorded in the sculpted frieze that originally wrapped around the exterior walls of the temple (the frieze is now in the British Museum in London). The presentation of the beautiful new *peplos* to the temple's priest and priestesses appeared directly over the entrance to the Parthenon, further signifying its crucial role in the ceremony. The sacred *peplos* was to serve as a new garment for an ancient statue of the goddess that was housed in the adjacent shrine of the Erechtheion, a sacred image thought to have been a gift to her people by the goddess herself. Thus, the Athenian maidens honored their goddess with the gift of a beautiful work of fiber art, the most worthy offering while simultaneously acknowledging the divine source of their skills. Important as well is the fact that the product was the result of community effort, and this means of bringing women together has been often a meaningful tradition through the ages and across the globe. Similarly, offerings of cloth are part of Buddhist and Hindu presentations to the images within the temples or home shrines, adorning the sculpted icons.

Such stories from ancient times, along with later records and evidence, make clear the highly regarded role of creative endeavors in fiber for women, both divine and mortal. Fiber arts among women have been international throughout history, and work in fiber was practiced by all social classes. The famous eleventh-century Bayeux Tapestry, a 230-foot silk embroidery on linen illustrating Duke William of Normandy's conquest of England, has been attributed in French lore to the work of his Queen Mathilda and other ladies of her court (featured in the Musée de la Tapisserie Bayeux, Normandy, France). It was created for the Cathedral of Bayeux, where it was hung annually for nearly seven centuries into the eighteenth century. Like the *peplos*, this is another example of the importance of fiber arts in a religious context, along with altar cloths, vestments and other church fabrics. While the attribution to Queen Mathilda has been contested, it is well within probability since documentation before and after confirms that royal and aristocratic women practiced fiber arts, as did women and girls of all levels of society. Moreover, silk was an expensive fiber imported from the East and not available to, or worthy for use by, lower classes. A twelfth-century hand scroll on silk from China portrays elegant ladies of the Tang Dynasty court (eighth to ninth century) in different stages of preparing silk fabric, from spinning the thread to polishing the woven cloth with hot irons (Museum of Fine Arts, Boston). The beauty of the women is associated with the elegance of their work. The refinement of silk is expressive of their own feminine quality and merit. Again, the activities shown demonstrate a communal effort. In China, the working of silk fabric was poetically associated with the longing for a male loved one who was far away, with connotations of feminine steadfastness and virtue.

This symbolism rings true in Western tradition as well, consistent with how work in fiber arts became associated with feminine morality and constancy. It is to counter the idea of how idle hands and leisure time may lead to misconduct, especially lost virtue or infidelity. Work in fiber further demonstrates a devotion to family and even stability within the community. In Homer's *Odyssey*, Queen Penelope of Ithaca maintains her marital fidelity and, moreover continuity in government, for the twenty years of her husband's absence by continuous work on a woven tapestry. To resist her many suitors, she promises to choose one of them once the work is done, but unravels each day's work the following

night. In the scene of Dutch artist Judith Leyster's painting of 1631, *The Proposition*, a man touches the shoulder of a seated young woman, while offering her coins illuminated by a nearby oil lamp. Evidently uneasy, she focuses on her needlework (Royal Picture Gallery, Mauritshaus, Netherlands). Unlike contemporaneous Dutch brothel scenes, this woman's clothing is tightly buttoned to the neck; the scene is quiet, even intense rather than raucous. In another of many examples of this symbolism of fiber arts, in the years 1793–4 the American artist Gilbert Stuart painted the commissioned portrait of Mrs. Richard Yates, the wife of a very successful New York businessman involved in the international import/export business (National Gallery of Art, Washington, DC). It is surely as she wanted to be rendered; elegantly dressed in white satin and silk gauze, she is shown drawing a needle and thread through a piece of gauze fabric as she stares out at the viewer. Within all the material comforts of her privileged life, needlework is a worthy and virtuous pastime, indicative of a serious and industrious mind. Hence, much of the character of Mrs. Yates is conveyed by the activity of her hands, and it is quite natural for the viewer to respond with a feeling of familiarity and respect for the subject. This is just a single example of many portraits that portray a woman involved in needlework.

As early as the story of Eden, the clothing of oneself and one's family is associated with the necessities of warmth, protection, and social interaction. Critical needs also resulted in bed coverings, wall hangings, and rugs to insulate against the cold, and baskets and pouches to carry and store goods. Fiber works served as well the basic human instincts of creative expression and enhancing one's environment. Given the prevalence and profound significance of the fiber arts in human history, important questions must be raised as to why the greatest achievements in this art form have received so little recognition in the commemorations and histories of the visual arts, and what has occurred since to rectify this omission. In a summary which already may be too obvious to the reader there are several factors for this neglect:

- The patriarchal structure of most societies and the subordinate role of women and hence their achievements.
- A categorization of the arts in the Western world that gives top rank to those areas of visual creativity practiced by men, especially those of advanced education.
- This categorization that denigrated works that had a primarily functional purpose.
- The fact that the criteria, assessment and writings on the arts have been dominated by white males of European or American lineage.

These are the factors that needed to be overcome before acknowledging recognition of women's achievements in any arena of the visual arts, especially in fiber arts. What needed to be dealt with first was the lack of recognition for women's achievements in the art forms that were accepted as those of greatest importance, and secondly a challenging of the criteria as to what constituted noteworthy achievements in art in terms of medium and purpose. This new assessment began with the feminist movement of the 1970s and has been on-going.

Beginnings of the Recognition of Women's Contributions to Art and History

In 1971, art historian Linda Nochlin published the now famous essay in *The Art Bulletin*, "Why Have There Been No Great Women Artists?" (Nochlin, 1988). As she would write later, at that time "there was no such thing as a feminist art history: like all other forms of historical discourse, it had to be constructed." In her essay she challenged the "white Western male viewpoint, unconsciously accepted as *the* viewpoint of the art historian." Her essay was the beginning of a questioning of who establishes

the criteria for success in art, how the road to success is controlled, and how recognition is given to achievement – or withheld throughout history, if not within one's own time. Ultimately, it would lead to a reassessment of the very fundamental notion of what constitutes "art" in the realm of visual and material culture, and who deserves the title "artist." This would be seismic in art history and criticism, we might say equivalent to a seven on the Richter scale, though much of the shifting of the earth happened as a series of considerable after-shocks.

Soon after her essay, Nochlin would collaborate with Ann Sutherland Harris on the exhibition "Women Painters: 1550–1950," which opened at the Los Angeles County Museum in December 1976 and was subsequently shown in Austin, Pittsburgh, and Brooklyn. Borrowing works from international collections, it traced the history of the achievements of women painters in the Western world. Its focus on painting, long regarded as one of the "fine arts" was important for showcasing the impressive art of women in an art form and medium that was still regarded as one of the highest levels of visual creativity, ranked as such since the arguments in its favor by no less than Leonardo da Vinci in the late fifteenth and early sixteenth centuries. The focus on Europe and America was within the parameters of those high standards as well, by which most art was still being judged, at least in terms of art history and criticism. So the feminist movement in art history began by a breaking down of the walls from the inside of that strong, long-constructed bastion, first by showing that over history many women had been able to meet and exceed the accepted standards, and had done so within the then-preferred geographic and art historical traditions. At this time, it was the painting as done by European and American women. Later feminists – and others – challenged the very categories and criteria of art.

The exhibition organizers went on to produce a book of the same title that was published in 1979 (Harris and Nochlin, 1979). That year was a critical one, for it also featured at least three other ma-

jor events in the feminist art movement. Two were publications: Germaine Greer's *The Obstacle Race*, subtitled "The fortunes of women painters and their work;" and film-maker Mirra Banks' *Anonymous Was a Woman*, dealing with women's achievements in textile arts (Greer, 1979; Banks, 1979). Banks' book was subtitled "A celebration in words and images of traditional American art – and the women who made it." The third event was in the form of a massive work of art, one that was on the beginning of a ten-year worldwide tour. It was the conception and achievement of artist Judy Chicago's *Dinner Party*, a complex sculpture and craft installation (Chicago, 1996). These three historical studies and the art installation greatly advanced the growing exploration and new recognition of the contributions of women throughout history and the challenging of the criteria and means of assessment that had limited their artistic development or recognition of their notable achievements.

Both the text by Harris and Nochlin, and Germaine Greer's *The Obstacle Race* are surveys within the context of traditional art historical studies of the time and, as such, directed the reader to many little known or entirely unrecognized artists. The catalog by Harris and Nochlin gives brief biographies of a number of painters, often presented for the first time. Both books make the point that women's training and practice within the field of painting or sculpture often were only possible through collaboration with male relatives, whether father, brother, or husband. Most often their work was subordinated to that of their male relative or close associate. For example, the famously talented Marietta Robusti was a much favored assistant within the workshop of her father, Jacopo Robusti, better known as the major sixteenth-century Italian Renaissance artist Tintoretto (the "little dyer of fabric"). Out of his studio came enormous canvases that were beyond the achievements of a single hand. In fact, the marriage that Tintoretto arranged for his daughter was contingent on her ability to continue working in his studio. He even refused the requests of Phillip II of Spain

and Maximilian of Austria to allow her to work in their courts. The seventeenth-century Dutch artist, Judith Leyster is said to have stopped painting at the age of twenty-six when she married her painter husband Jan Molenaer. Yet the paintings that came out of his studio after their marriage look familiarly like her earlier work. Perhaps his male signature and business contacts served to bring the highest income into the household. Of greater offence, as with other women artists, Leyster's earlier work was over time often attributed to, and sold as, that of a much more famous and highly marketable male artist. In her case it was fellow Haarlem artist, Frans Hals. Unscrupulous dealers throughout time have reassigned women's work to notable male artists for maximum profit. The sculptor Camille Claude, through an introduction by her brother, became accepted as a student in the studio of French sculptor Auguste Rodin. She became his chief assistant (and mistress) during the mid to late 1880s when his studio was most productive and successful. Later, she left claiming he was stealing her ideas, and the work ascribed to him of that time does indeed show similarity to Claudel's independent works. She became so obsessed with, and disturbed by, the failed artistic and emotional relationship, and recognition for her contributions to his oeuvre, that her mother and sister consigned her to a mental hospital where Claudel spent the rest of her life. In the celebrated forms of art, therefore, women were subject to male connections, training, and collaborative efforts. The same was not the case in fiber arts, passed on from woman to woman, where training was provided outside of formal academies or other institutions, and where the results were much more dependent on feminine criteria and affirmation.

Training for women aspiring to be artists in the fine arts was restricted both in the medieval guild systems and the academies that followed. Admissions sometimes were based on very limited quotas, if admission was allowed at all. At one time the premiere Académie Royale in France (later the Académie des Beaux-Arts), which was the model for art academies in many places, restricted its members in painting to just two women while admitting many dozens of men. The training in art academies and other art schools usually followed social mores in limiting the extent by which women could work from the nude figure, even though achievements in drawing, painting, or sculpting the nude were regarded as the most important skills of an artist. Opportunities for women to enter the field of architecture were even more restricted. The best credential of the day for a nineteenth-century architect was training at the École des Beaux-Arts in Paris, yet women were not accepted. The Californian Julia Morgan challenged this bias through repeated applications and communications with the reviewing committee until she succeeded in 1899 in becoming the first woman student of any nationality. Returning to California, she established a successful architectural firm that had a number of employees, including several women. Though she had many clients, her most notable was the publisher William Randolph Hearst, for whom she designed the complex of buildings, grounds, and pools of San Simeon. Literacy for women often restricted artistic achievement and recognition. In many Asian cultures, such as China and Japan, the very limits of literacy available to women restricted participation in the artistic realm where calligraphy and associated skills of painting and poetry were regarded as the highest forms of art, though the rare exceptions are works by empresses, princesses, and other court ladies … or, notably, the geishas of Japan.

What comes forward in Greer's work and subsequent writings by other authors is that the artistic career and production of the woman artist was often less egocentric than that of her male counterpart. She might subsume her contribution into that of her male partner or associate when economically or socially efficacious. Responding to traditional expectations of women – or the hard reality – the female artist concerned herself more times than not with what would work best in bringing economic and social success to family or community.

A more recent example is evident in Lee Krasner's subordinating her own studio work and career to the promotion and accommodation of that of her husband Jackson Pollock until after his death. It was only then that she allowed her own career to take off. The famous Native American potter Maria Martinez freely taught her trademark style of black-on-black pottery, first to her husband Julian and then to anyone within the San Ildefonso Pueblo in New Mexico where she lived. She even permitted other potters to put her name on their works because the greater income given her name would benefit the community at large, and indeed her style of pottery greatly boosted the economy of her pueblo as a whole. Often the woman artist, not identifying herself as such, felt she was simply creating something that was useful to herself, her family or community and which needed no exaltation beyond the appreciation expressed by her intimate circle for a purposeful object achieved with accomplished technical skill. Originality in design and technique, and personal expression, would add to this.

Breaking Down the Artistic Hierarchies

By focusing on painting, the works of Harris and Nochlin and Germaine Greer shed light on the gender bias of an art form dominated by men. In so doing, they did address an art form considered "fine art" as opposed to those visual arts that women had more commonly practiced, such as fiber arts (weaving, quilting, embroidery, clothing design, etc.) or ceramics. Such useful arts had become known as the "minor arts," "decorative arts," or simply "crafts," with the implication that they were lesser to the "*fine* arts" of painting, sculpture, and architecture. Works in fiber are very rarely included in the philosophy of aesthetics as well as in art history and criticism. These useful arts had been traditionally practiced by women, and so by their very catego-

ry and functionality were treated as less worthy of importance and historical documentation or intellectual analysis. That seemed all the more so since they were often unsigned, anonymous – the result of their lesser status or celebrity. Training in these crafts typically came from older female family members, and rarely had the cultural pedigree of guild training, a school or academy. When there were programs for the crafts, they were in separate vocational or technical schools from those teaching the "fine arts." It would not be until the founding of the Bauhaus in Germany in the 1920s that fine arts would be merged with the so-called "minor arts" with a revolutionary curriculum that is still followed by art programs today. Faculty and students of the Bauhaus were women as well as men, and fiber arts were included as a legitimate form of artistic expression. Still, somewhat like the caste system in India, the conscious or subconscious hierarchy of art forms remained in place in art schools, museums, criticism, and histories even long after it has been officially repudiated.

The cultural mind-set that these traditions and artistic hierarchies established was wide-ranging, long-lasting, and deep in artistic biases. Mirra Banks' *Anonymous Was a Woman* (Banks, 1996) helped to break the tyranny of artistic hierarchies by giving worthy attention to the creativity of women in visual mediums and forms that were rarely accorded any substantial recognition in the annals of art history or in the marketplace of art: samplers, quilts, needle points, and watercolors. Her focus is Americans of the eighteenth and nineteenth centuries. Illustrations of many different works in fiber are juxtaposed with quotations from women's journals, letters, articles, poems, and other writings. In introductory essays, along with a compilation of words and images, the lives of women in this period were revealed in their own words and visual accomplishments. Banks begins with a telling quote: "Young ladies should be taught that usefulness is happiness, and that all other things are but incidental." (Lydian Maria Child, *The American Frugal Housewife*, 1832.) Many of the

quotations in Banks' book relate work in fiber to the other obligations of women, expressing the notion that women might be either more or less devoted to – and successful in – those other household obligations as signified by their commitment to working in fiber.

Many of the works illustrated in *Anonymous Was a Woman* are identified as to maker; only a few are anonymous, despite the book's title. But anonymity has to do with recognition for one's worth and an interest in their life story, whether the name of an artist is known or not. Working in fiber was a skill that women were expected to master from a very early age. Needlepoint samplers survive from girls as young as five. Perhaps this very commonality in various forms of fiber production among almost all members of the "weaker sex" rendered the fiber arts more ordinary or commonplace, less worthy of celebration on a community, national, or international scale. The greater expectation was that the creation would keep the memory of the maker in the minds of her family, as noted in this quotation Banks' gives by a woman identified simply as Aunt Jane in Kentucky:

> I've been a hard worker all my life, but most all my work has been the kind that perishes with the usin', as the Bible says. That's the discouraging thing about a woman's work … But when one of my grandchildren or great-grandchildren sees one o' these quilts, they'll think about Aunt Jane, and, wherever I am then, I'll know I ain't forgotten (Banks, 1996, page 121).

The quotation reflects limited expectations for one's achievements, but a desire for remembrance by one's descendants. (I am reminded at this point of my own experience as a child I grew up watching my paternal grandmother who lived with us continually adding to a quilt that was a genealogy of the family after her generation. In carefully done stitched panels and script were recorded children, grandchildren and great-grandchildren. Not long after her death, the quilt went to an uncle and aunt, but was tragically stolen along with other items when their house was broken into.)

It is the creative outlet that women traditionally have had in fiber arts and other crafts that is fundamental in the celebration of women's achievements in Judy Chicago's *The Dinner Party* which, as previously mentioned, also saw its debut in 1979. The work consists of a table in triangular configuration containing thirty-nine place settings, thirteen on each side, with each place setting dedicated to a particular woman in history or legend. The white floor below has 2,300 hand-cast triangular porcelain tiles inscribed with 999 names of other notable women from history or religion. The triangle is an ancient symbol of women and of the goddess, also the female pubic triangle, repeated in those numbers divisible by three. The number thirteen is the number of men at the Last Supper, but also a number associated with a witches' coven; a contrast between deeply-rooted traditions of male holiness and female evil. The theme of a "dinner party" refers to the domestic role of women in preparing and serving meals, notably here to a large gathering. Each place setting is designed according to the cultural style and time period of the woman celebrated. Each plate has a design invoking the vulva but, as noted by the artist, also symbolizing a butterfly for metamorphosis and liberation. As with the fiber arts, china-plate painting was one of those areas of artistic activity long practiced by women, and Judy Chicago herself had studied the techniques. Under each plate is a pieced and embroidered place mat hanging over the edge of the table with the name of the woman commemorated.

In the period when *The Dinner Party* was created and produced, 1974–9, Judy Chicago engaged the collaboration of many female and male artisans. This collaboration itself was intended to recall how women's creative achievements, such as quilts, tapestries, or ceramics, were often achieved through coordinated efforts of more than one person. In its first showing at San Francisco's Museum of Modern Art, the work attracted 100,000 visitors in a three-

month span. The work now resides in the Brooklyn Museum of Art after languishing for many years in a warehouse after its first tour. The fact that it is such a large work and a controversial one for the time because of the grand feminist message and vulva imagery, especially derided by members of the US Congress since its exhibition sites received funding from the National Endowment of the Arts, meant that few institutions could or dared make a place for it. Its importance in the recognition of women in all areas of endeavor cannot be overstated, as is its exultation of the areas of creativity traditional to women throughout history.

History has demonstrated again and again that recognition is often about gender and medium. Looking at Amish quilts made by women in Pennsylvania in the nineteenth and early twentieth centuries, one sees simple compositions focused intently on color relationships, in which nuances of hue, saturation, and intensity and their interactions predate comparable work in painting or printmaking from later masters of the celebrated styles of Op Art or Minimalism, such as Josef Albers or Victor Vasarely. For many years in the museums and marketplaces of art, the quilts have been deprived of the recognition and financial rewards accorded the nonfiber works by the much later male artists tackling the exact same issues of composition and color in the "fine arts" of painting and printmaking. Similarly, it has only been in recent years that attention has been given to the brilliant abstractions found in the quilts of the African American women of Gee's Bend, in the rural district of Alabama. Notable are the accomplishments of the brilliant artist Annie Mae Young, whose work is comparable if not surpassing so much of the abstraction in oil on canvas in recent decades. Even so, training in the new "art academies" of the art colleges and universities remains an important credential or transit for one's career. The result is to accord the same unequal recognition to virtually any art outside of Eurocentric standards, traditions, and avant-garde movements. But, as mentioned earlier, there has been a seismic shift, much of it occurring because of the groundwork laid by the pioneer works already discussed.

In 1981, just two years after the seminal works of Nochlin, Harris, Greer, and Chicago, the National Museum of Women in the Arts (NMWA) was incorporated. Taking over an elegant old Masonic temple in the heart of Washington, DC, it opened to the public in 1987. As stated on its website, it is "the only museum solely dedicated to celebrating women's achievements in the visual, performing, and literary arts." Its mission has been "to reform traditional histories of art." It was the answer to Linda Nochlin's seminal article of 1971, "Why Have There Been No Great Women Artists?" It is dedicated to discovering and making known women artists who have been overlooked or unacknowledged, and assuring the place of women in contemporary art. Despite the positive mission of the new institution, in a way this recalls previous world's fairs or expositions, such as that in Chicago in 1893 or in San Francisco in 1904, in which there was a women's building that celebrated the achievements of that sex, while the more numerous other buildings celebrated mostly male accomplishments. While it is good to have a "women's building," and NMWA is an important contribution to achieving recognition for women artists, the real mission must be to showcase the achievements in the visual arts by both sexes in the same venues, rather than encourage segregation. Still, it is worth noting that the arts that have received the major focus in NMWA are those traditionally associated with men: painting and sculpture. With more limited attention are the art forms traditional to the creative endeavors of women.

A more radical challenge to the gender and racial inequity in the art world was taken up by a group that called themselves the Guerrilla Girls (Guerrilla Girls, 1995). The group was started in 1985 in protest against an exhibition at the Museum of Modern Art titled "An International Survey of Recent Painting and Sculpture." Of 169 contemporary artists represented, purported to represent the best of

current talent, only seventeen were women. Since then, their on-going actions include posters and billboards with statements such as "Do women have to be naked to get into the Metropolitan Museum? Less than 5% of the artists in the Modern Art Section are women, but 85% of the nudes are female"; "When racism and sexism is out-of-style, how much will your art collection be worth?"; or "You're seeing less than half the picture without the vision of women artists and artists of color." The public appearances of their members involved wearing gorilla masks. In this guise they would crash exhibition openings at museums and commercial galleries to protest the dominance of white male art, or they would give public talks. Keeping their identities unknown, though including women artists, they took on the names of women artists in history such as Frida Kahlo, Artemisia Gentileschi, or Käthe Kollwitz. Other equally radical forms of feminist demonstrations in the arts have continued. At the same time, other performance artists, as they came to be known, addressed women's issues through improvisational monologues and actions done within the setting of art gallery or museum.

Identity and Empowerment Through the Fiber Arts

Once the scholarly exploration had begun as to what women have achieved in visual creativity, the inevitable result was the questioning of what constitutes "art" in the first place, and who makes those decisions. Are the "fine" arts finer than what had been known as the "minor or decorative" arts because of years of formal training, hours of labor, lesser functionality, and mediums used? All art is functional in some way, especially the so-called fine art of architecture. Training in some manner occurs in all art forms, and many hours of labor can result in a sculpture or a weaving, an etching or a needlepoint. Once these categories were explored, and the study of the achievements of women in all areas

of visual creativity expanded, the hierarchies fell apart. It should be noted that this exploration coincided with a growing recognition of the arts produced in various cultures beyond those in Europe and North America. Many more books and articles, and many more artists have expanded the dialogue.

Notable artists, such as Audrey Flack, felt that it was critical to grapple with the issues of feminine identity within the traditional media of first painting and then sculpture. Associated with the style of photorealism, Flack's paintings of the mid to late 1970s and early 1980s involved still-lifes that included imagery of chance, mortality, but most of all the jewels and cosmetics of the feminine role and ideal of beauty. They fall into the tradition of still-life painting called "Vanitas" and "Memento Mori," themes dealing with the luxuries and transience of beauty and life itself. As a Jewish woman, she incorporates into these sumptuously rich arrays of objects a Margaret Bourke-White photo of Holocaust victims, an early photo of herself, or that of the American ideal, Marilyn Monroe – an ideal that a young Jewish woman could attain most often through a subjugation of her natural appearance and identity. An earlier painted series depicts images of Spanish Baroque sculptures of Mary, *Macarena of Miracles* and *Lady Madonna* to name a couple within this theme, which explored the subject of the primal goddess, usually shown with the miraculous tears that were often attributed to such images. They brought into question the male-oriented religions that supplanted the goddess, and Flack's works evoke the tragedy of the loss of this compassionate mother deity by her tears. The image of Mary was poignantly Flack's self-portrait as well, another irony. A decade later this led to her series of sculptures of goddesses. These images are proud, commanding and sometimes nakedly heroic. At that time she said, "My intention now is completely clear in my mind: I want to create a healing energy." In fact one of the works in the series is titled *Islandia: Goddess of the Healing Waters* (1987, Samuel P. Harn Museum of Art, University of Florida, Gainesville).

It is in marked contrast that, at the same period of time, other female artists like Judy Chicago embraced the traditional arts of fiber practiced by women to define themselves, woman's experience, or broader global issues. By so doing they focused attention on their work as serious art, not merely to be dismissed as "craft." Judy Chicago herself followed *The Dinner Party* with sets of quilts that dealt with the experience of giving birth and, conversely, the Holocaust. The history of quilts is one of the great stories of the fiber arts. Among the many purposes and meanings they were given, were those of the "Underground Railroad" prior and during the US Civil War. For example, a quilt with black piecing, hanging outside a home, signaled a place of refuge.

Faith Ringgold, born and raised in New York's Harlem, was a practicing painter in the early part of her career, having studied in a traditional art program at City College. Later, inspired by her mother who was a dressmaker, she developed a series of works that combined quilt-making with acrylic painting, eventually dubbed "story quilts." Her mother collaborated with her on the first of these, the year before her death, which depicted portraits of thirty residents of Harlem. A subsequent story quilt, *Who's Afraid of Aunt Jemima?* directly challenged stereotypes of African American women and were among similar works by Ringgold and others that neutralized the negativity of the stereotypes by embracing them and exploring their histories. Active in the civil rights movement, in 1968 Ringgold led a group of other black artists protesting that no African American artists were included in the Whitney Museum's special exhibition of American painting and sculpture of the 1930s. In the 1990s she produced a delightful series of quilts filled with ironic meanings, titled *Dancing at the Louvre,* based on a trip she made to Paris in 1961 with her mother and two daughters (Cameron *et al.,* 1995). The family is juxtaposed before paintings by white artists, or Matisse is seen working from a black model as, in fact, he did. *The Sunflower Quilting Bee at Arles* depicts eight women from history, who were active in the struggles for black and feminist equality, working on a quilt of sunflowers, in a field of sunflowers, with Vincent van Gogh standing behind (1991, private collection).

Ringgold is a good example of how women have reclaimed the fiber arts as the historic domain of women to define their modern identities, assert their rights, and tell their stories in the very creative medium once relegated to women as a lesser art. Having gone through the traditional artistic training that led to a career in painting, she abandoned that to embrace the medium of her gender, and to restore its role as an expressive and valued art medium, just as she has dealt with the stereotypes of black women in her works. In reclaiming the role of fiber in the creativity of women, she could empower her identity and race in the themes explored on fabric.

As with Ringgold, for many women artists the traditional feminist medium of fiber arts has become a way to address on-going traumas of social and gender inequity, and to deal with other issues dear to their hearts. Canadian artist Sandra Meech has produced quilts concerned with climate change and the loss of native forests. Massachusetts artist Clara Wainwright has created personal and "community quilts." The latter explore the issues of groups on society's fringe: troubled youths, the wives of Gloucester (Massachusetts) fishermen, Tibetan refugees. She refers to these works as "stitching together their stories." Other Wainwright quilts have responded to such events as the Virginia Tech shootings or the Iraqi war. In other words, the reclamation of fiber arts has become a specifically feminist voice to address issues dear to the hearts of most women. One recent example (2005) would be how an internet networked group of women produced knitted forms of wombs to be left on the steps of the US Supreme Court to support *Roe* v. *Wade,* and protest attempts to overturn it, a project titled "Wombs on Washington."

The recognition and revival of the many forms of fiber arts then have continued in the art of women

as a means of survival, expression, communication, and the defining of one's gender and its roles, and to make important expressive and literal statements about the concerns and values of women. While the styles may vary in culture and geography, the purposes are so much the same – or extraordinarily special.

Acknowledgment

The material included in my essay is a result of co-teaching a course titled "Women in the Visual Arts" each year from 1988 to 2007 at Bridgewater State University in Bridgewater, Massachusetts. The teaching and background research was in collaboration with Professor Mercedes Nuñez, who was the major inspiration and influence for my interest in this topic and the related issues. While it is difficult to back track on all our teaching resources that contributed to my essay, those of greatest importance for this essay are listed.

Bibliography

Banks, Mirra (1979) *Anonymous Was a Woman: A celebration in words and images of traditional American art – and the women who made it.* New York: St. Martin's Press.

Blanchard, Lara (2007) "The Emperor's New Clothes: Desire and Politics in Huizong's Court Ladies Preparing New Woven Silk." Available at www.academia.edu/1677767 (accessed October 2013).

Boardman, John (1985) *The Parthenon and Its Sculptures.* Austin, TX: University of Texas Press.

Broude, Norma and Garrard, Mary, eds (1982) *Feminism and Art History: Questioning the litany.* New York: Westview Press.

Broude, Norma and Garrad, Mary, eds (1992) *The Expanding Discourse: Feminism and art history.* New York: Westview Press.

Cameron, Dan, Powell, Richard, Wallace, Michelle *et al.* (1995) *Dancing at the Louvre: Faith Ringgold's French collection and other story quilts.* Berkeley, CA and Los Angeles, CA: University of California Press.

Chadwick, Whitney (2012) *Women, Art, and Society,* fifth edition. New York: Thames & Hudson.

Chicago, Judy (1996) *The Dinner Party.* New York: Penguin Books.

Gouma-Peterson, Thalia (1992) *Breaking the Rules: Audrey Flack, a retrospective 1950–1990.* New York: Harry N. Abrams.

Greer, Germaine (1979) *The Obstacle Race: The fortunes of women painters and their work.* New York: Farrar Straus Giroux.

Guerrilla Girls (1995) *Confessions of the Guerrilla Girls.* New York: Harper Collins.

Harris, Ann Sutherland and Nochlin, Linda (1979) *Women Artists: 1550–1950.* New York: Alfred A. Knopf.

National Gallery of Art website, *Catherine Brass Yates (Mrs. Richard Yates),* www.nga.gov/content/ngaweb/Collection/art-object-page.563.html (accessed October 2013).

Nochlin, Linda (1988) *Women, Art, and Power and Other Essays.* New York: Harper & Row. (This compilation includes her famous essay of 1971, "Why Have There Been No Great Women Artists?")

Ovid (2005) (orig. 8 CE), *The Metamorphoses,* translated by Frank Justus Miller. New York: Barnes & Noble.

Paris, Reine-Marie (1988) *Camille Claudel.* Washington, DC: The National Museum of Women in the Arts.

Peterson, Susan (1997) *Pottery by American Indian Women: The legacy of generations.* New York: Abbeville Press.

Pentney, Beth Ann (2008), Feminism, activism, and knitting: Are the fiber arts a viable mode for feminist political action? *thirdspace: a journal of feminist theory & culture,* Volume 8, Issue 1 (Summer). Available at www.thirdspace.ca/journal/article/viewArticle/pentney/210 (accessed October 2013).

Ringgold, Faith. The artist's website available at www.faithringgold.com (accessed October 2013).

Shea, Andrea (2012) "Visionaries: Creative Power Couple Bill and Clara Wainwright." Available at www.wbur.org/2012/04/17/bill-clara-wainwright (includes YouTube interview with Clara Wainwright) (accessed October 2013).

Sterling, Susan Fisher. "Our History," website for the National Museum of Women in the Arts available at www.nmwa.org/about/our-history (accessed October 2013).

Wiltge, Sigrid Wortmann (1993) *Women's Work: Textile art from the Bauhaus.* San Francisco, CA: Chronicle Books.

American Women Crafting Cloth: From Bees to Blogs

MARILYN KIMMELMAN AND REBECCA LEAVITT

Hundreds of years of women's diligent efforts in the creation of crafts, lifting and climbing for better conditions for craft work and increased value for their crafts, have given birth to thriving communities of crafters who value and embrace the making of the art. The twenty-first century in the USA has seen a resurgence of domestic arts sent through a culture of mobility carrying a message of social and political activism, environmentalism, and sustainability.

Throughout time, women have sent messages using threads as their pens. Messages sent from hands that sew, knit, weave, or spin, sent from minds to hands to cloth in the past are now sent from hand to cloth to keys, continuing to build community and stretching the reach of the messages to global villages. The spinning bees and guilds of old are the netrings and knitting blogs of today. The sometimes subversive messages women hid in scarves and quilts are still being sent but they are encrypted in wires and meshes, websites, blogs, and webrings of the new millennium.

> They told the story of her life just as surely as if her needle had been threaded with ink and her beautiful evenly spaced stitch had become words (Hedges, 1991, page 184).

The use of craft as subversive can be found throughout history. To call someone crafty is to identify them as clever and cunning (Bratich, 2006). Rutgers professor Jack Bratich (2006) notes that the character Madame DeFarge in the book *A Tale of Two Cities*, secretly encoded the names of those to be executed into her knitting. A blog post describes the legendary Betsy Ross as "a pioneering woman who knew how to use a pair of scissors" (Women's Empowerment Street Team, 2007). Legend tells us of a secret meeting among Betsy Ross, George Washington and friends, in May of 1776, that led to Ross, a widow and single mother of seven daughters struggling to run her own upholstery business, being chosen to sew the flag heralding the birth of a new nation for the rebels. She changed Washington's original design from a six-pointed star to five point, since the five point could be cut with a single scissors snip (Independence Hall Association, 2013).

Until the early to mid nineteenth century, most women in the USA were kept within the contexts of their homes, contributing to their families by sewing clothing for their children and linens for tables, quilting for warmth, and embroidering for decoration. Within this patriarchal society, women found ways to spin their tales, use their talents, and uplift their spirits. Before they were allowed to read, write, or vote, they could pick up their needles, their threads, and their fabrics. Their hands became vehicles of expression honoring family events, preserving memories, and, ultimately, displaying protests. Ironically, these well-developed and creative domestic skills eventually helped to open doors for women to enter the outside world.

Significant forces contributed to women stepping into new domains. In 1826, during the Industrial Revolution, in Lowell, Massachusetts, thousands of women were recruited to work for the mills opened by the textile corporations, enabling many rural women to improve their families' and their own financial statuses. According to Ferrero *et al*.

(1987), the women would work for two to four years contributing funds to help further the education of their brothers while providing some savings and a sense of independence for themselves. Working conditions deteriorated and French Canadian and Irish women immigrants began replacing some of the local women. Working long hours and living in close quarters gave rise to a sense of community and bonding among the women. In 1834, they organized the first strike to protest wage cuts and a series of protests against the oppressive conditions in the mills was both an empowerment opportunity to move beyond the home and a challenge to confront the ruling paternalistic power structure.

Women became a strong force as a community through the groups they formed to share in art, whether through quilting bees, through art classes within the settlement houses, an approach to social reform in the late 1800s where the middle class and urban poor shared knowledge, culture, healthcare and education (Hull House in Chicago; Henry Street in New York), or through the women of the Saturday Evening Girls Pottery Club, in communities designed to introduce immigrant women to art, literature, and culture.

The women shared stories and concerns enabling some to use their artistic skills to support the abolitionists, others to form the Women's Christian Temperance Union and to later achieve suffrage. Along the way, their quilts spoke volumes, weaving patterns of the North Star to follow for the escape routes of the Underground Railroad, offering messages of protest against the abuse of husbands under the influence of alcohol and advocating women's rights to vote. Examples include the Crusade Quilt which contained over 3,000 women's signatures, used to celebrate the passage of the state prohibition amendments (Ferrero *et al.*, 1987). In 1848, when Cady Stanton stood before the Seneca Falls Convention advocating women's suffrage, the Arts and Crafts movement, encouraging workers to take pride in their craft skills and use simple forms, had already begun to provide

women with fundraising and business skills to wage greater independence and the potential to change their lives (Zipf, 2007).

Prior to and during the Civil War, quilts were sewn to support the abolitionist movement and sold at fairs to raise money for the cause. Many African American quilts displayed the quilt-making traditions of African ancestors. In the South, slave women would sometimes become quilt makers and dress makers for their owners, developing very artistic and complex patterns. Their quilts were either kept as property of the Southern families they worked for, used as warmth in their slave quarters, or passed on to other generations.

Some believe women hung message quilts on their clotheslines as signals to slaves seeking the Underground Railroad, although historians differ and dispute the accounts (Dobard and Tobin, 1999). Slaves sometimes hid coffins, crosses, and religious symbols in their quilts or designs they sewed for masters to honor their African past. According to Elsley (1996, page 1) "the quilt is not just a bed cover, but it can be a political manifesto: It speaks its maker's desires and beliefs, hopes and fears through its images, colors, patterns and pieces." Amish women, traditionally discouraged to express themselves, found quilt making an avenue for social exchange as well as a way to raise funds.

Hawaiian flag quilt traditions date to the mid-1800s but took on a new significance with the annexation of the Hawaiian Islands to the USA in the late nineteenth century. The Royal Hawaiian flag quilt was used to promote Hawaii as a sovereign nation, symbol of Hawaii's own nationalism, rebuking the foreign political domination by the USA that occurred in the 1890s (Ferrero *et al.*, 1987). When Americans overthrew the Hawaiian monarchy in 1893, Queen Liliuokalani and her companions made a crazy quilt during imprisonment with the center square having the words "I'm imprisoned at Iolani Palace ... we began the quilt here." The words began a political statement on the events that led to the queen's imprisonment, and documents her ten

months as a prisoner. Richly colored and brocaded silks and ribbons incorporated into the quilt were from the queen's wardrobe. The quilt outlines the course of Hawaii's history, names supporters, and includes commemorative and patriotic badges. The quilt began as a needlework piece and evolved into a fervent political statement (Ryan, 2013). "Each cloth is a bit of archival information … by creating these memory cloths, and taking control of their lives in a communal setting, with shared concerns, social consciousness develops, connecting female to female through fiber arts" (Becker, 2007).

Across cultures and throughout time, women have woven cloth to tell stories and document history. There are many examples of women who have contributed to the creation of cloth that demonstrate a social and political vision, only a few of which are mentioned here. When Judy Chicago set the table for *The Dinner Party*, she also set the stage for raising the value of women's history through art, finding pride in long-diminished domestic and anonymous crafts such as ceramics, china painting, needlework, embroidery, sewing, and moved women to boldy make art of the central core or vaginal imagery. Controversy surrounding Chicago's treatment of workers on the project has echoed through the years; however, her contribution to valuing craft as art resonates louder.

Chicago's work on the *Holocaust Project* followed (1985–93) as she collaborated with her husband, photographer Donald Woodman, to create a 3,000-square foot exhibit fusing photography with drawing and painting placed on panels of photolinen, sometimes using silk-screening (Chicago, 1993). Again, Chicago's intent was to have art display and capture the visual images of this horrific event to keep it present and alive in the eyes of others so that it will be more fully understood and prevented from happening again. Her interest in women's history, feminism, the evil roots of patriarchy, and a desire to better understand her own family's background as Jews led Chicago to devote several years to this project.

American quilting has been a storied source of expression for women for decades. In the 1960s, as a result of the 1965 Voting Rights Act, a priest, Reverend Francis X. Walter, was driving in a rural area of Alabama to document any harassment of blacks by whites. He noticed three beautiful, bold and unique quilts hanging on a clothesline on the site of an isolated cotton plantation owned by Joseph Gee. Most of the quilters there were descendants of slaves. After much networking, community building, and financial support, he helped the women establish the Freedom Quilting Bee, a collective of women quilters, one of only a handful. The women sold their work to stores and they have been shown in museums throughout the country, providing the women with financial empowerment and reviving interest in patchwork quilts that had extended back in culture over 140 years (Callahan, 1987). Not far from this area, the Gullah, a culture of black Americans from South Carolina and Georgia, have preserved their African cultural heritage sewing pieces of strips like African country cloth in their quilts, carved walking sticks, and finely crafted basketry.

Artist and author, feminist and activist, Faith Ringgold, creates quilts that tell stories with the details of painted figures framed by piecework fabric. Her rich innovative narrative quilt work celebrates female creativity and undervalued domestic arts, for instance, in her *Family of Women*, 1970s' portraits from her childhood that included costumes sewn by the artist's mother, a seamstress. Ringgold's work is filled with themes of race, gender, community living, and multiculturalism. Her highly imaginative and inventive images include *Quilting Bees*, *Cotton Fields*, and the *Underground Railroad* and others that speak to social consciousness.

The detailed work of quilter Terese Agnew takes a political stance in a process of "drawing with threads" (Agnew, 2012). Her *Portrait of a Textile Worker* was constructed of more than 30,000 clothing labels mailed to her from all over the world and then stitched together to form an image that provokes the exploitation and abuse of laborers who

make cloth globally in disenfranchised circumstances. Consuelo Jimenez Underwood's weavings express her own history as a migrant worker and express a history of the marginalized and downtrodden. Materials woven into her large textiles include rope, string, paper bags, safety pins, and feathers, expressing content on a canvas with her chosen materials.

The 54-ton AIDS Memorial Quilt (NAMES Project Foundation, 2011) is a continually growing monument to those who had died of AIDS and is the largest piece of folk art in the world. Its individual swatches (or blocks) are often stitched in a community or family atmosphere reminiscent of the earlier women's cooperatives of quilting bees where groups would come together supporting and inspiring each other to capture stories and memories. New York resident Drunell Levinson organized "September 11 Quilts" to help people mourn the losses connected with the event and to remember the individuals who died at the World Trade Center and the Pentagon, again building support through this communal project. "The meaning and value craft takes on as a form of resistance to industrialized life has endured for well over a century but its precise significance to different groups at different times is complex and multivariate" (Smith, 2010).

Women's contributions to the textile industry, mathematics, and science have often remained hidden in the telling of history. Ada Byron Lovelace, in the early 1800s, was an English mathematician and writer, who wove tapestries and was obsessed with weaving encrypted messages in scarves (Bratich and Brush, 2011). Lovelace worked with what some term the first general-purpose computer, Charles Babbage's analytical engine, to create the first algorithm, what is now known as a computer program, for a machine. Sadie Plant (1997) suggests that the binary code of 1/0 in computer programming came from knit/purl. Computer language has been connected to weaving, drawing on a lexicon of terms such as net, network, web, web weaver, and threads.

The decline of domesticity in the USA, in the years following the Civil War, grew with industrialization and the invention of "labor-saving devices" such as washing machines, sewing machines, and vacuums in middle-class homes (Kendall-Tackett, 2001). The work continued to take women's time but "starved their brains" (Matthews, 1989). In this era, women's handmade quilts were soon replaced with machine-made quilts with the advent of the sewing machine, although many women continued quilting to commemorate important family events, to provide warmth for family members, and, as time went on, to advocate for social and political reform through their stitched, personally inspired messages. No longer responsible for sewing, quilting, or stitchery, the outlet for creativity for women became denigrated and diminished. Women at home were portrayed as idle loafers. They became consumers of goods to run their homes. Many women in the early twentieth century found mass-produced goods were more easily accessible than what they would sew, knit, quilt, or stitch for themselves.

In the 1950s, as urban women became more isolated in their homes, they had fewer and fewer outlets where they could be part of a community. Many middle-class suburban white women were encased in their automobiles or spending their days chauffeuring the family. Historian Glenna Matthews (1989) attributes the early women's movement with adopting and proliferating the culture's contempt for domesticity.

Commercialization of hobby activities, instant foods, mass-produced clothing, and devices such as vacuum cleaners and sewing machines brought technology into the home. Television sent messages of what we should look like in terms of families and styles; leading the way with Donna Reed, *Father Knows Best*, and Lucille Ball. Women became more removed from each other, concentrating on having dinner on the table and, at best, joining the local mental health group to discuss their ideas with their neighbors. A simmering unhappiness with their roles and their diminished status as resident readers

of *Ladies Home Journal* set the stage for the opening blast of the women's movement to be fired up with the publication of Betty Friedan's *The Feminine Mystique* (Friedan, 1964). This phenomenon, along with the do-it-yourself books of the 1960s and 1970s flower children, helped establish a counterculture "from growing organic food to a geodesic dome" (Smith, 2010, page 209).

In pivotal events in the 1970s and 1980s, the women's peace camp protests at the Greenham Common Royal Air Force Base in England, protesting against the deployment of cruise missiles, a protest that lasted for 20 years, crafts were central to the activism efforts. The "knitted fence" of women's bodies was one demonstration of the perseverance and determination of the protestors.

Two generations later, a flurry of disenchanted young urbanites have embraced a politics of resistant self-sufficiency reintroducing traditional folkways from blacksmithing and welding, knitting, and hand-sewing to darkroom photography, advocating preindustrial practices and the use of trash can and recycled materials products via Facebook, zines (mini-publications), MySpace, websites, diary blogs and netrings devoted to knitting (Williams, 2011). Betsy Greer, credited with creating the term "craftivism" in 2003, stated that craftivism was "a way of looking at life where voicing opinions through creativity takes your voice stronger, your compassion deeper and your quest for justice more infinite" (Greer, 2013).

The cultural phenomenon of craftivism relates to "traditional handcraft often assisted by high-tech means of community building, skill-sharing and action directed toward political and social causes" (Buszek and Robertson, 2011). Its roots are traced to the political convictions of the Arts and Crafts movement and it is connected to the phenomena of third-wave feminism, environmental conciousness, antiwar politics, anti-capitalism, and anti-sweatshop organizing. According to Betsy Greer one of craftivism's strengths is its encouragement of the return to a use of skills that were once valued to clothe the family and maintain the domestic sphere. She states that crafts were bypassed by modernity and by the efforts of second-wave feminists during the 1970s (Greer, 2013). Along with the creation of a unique craft, the act of crafting creates and sustains a community of crafters and a concerted effort to engage in anti-capitalism, environmentalism, and feminism (Buszek and Robertson, 2011).

In what Minahan and Cox (2007) call the "stitch 'n bitch" movement, they credit the digital communications networks of today as helping to provide opportunities for women to meet virtually through the internet, and physically, in hotels and cafés, to socialize and share their crafts. Bratich and Brush (2011) quote Minahan and Cox as describing fabriculture as a new way of connecting using traditional crafts skills and yarns as the optical fiber and twisted-pair cable used for telecommunications (Minahan and Cox, 2007). Bratich and Brush (2011) note the number of websites and blogs devoted to fabriculture and conclude that domesticity is a thoroughly online affair. They describe these social "meshworks" and link them back to guilds or identity-based communities of old. Ostrovsky (2011) writes in *Herizons* that Etsy.com, the online crafting marketplace, has 10–13 million sales a month and that the site's craft sellers have an average age of thirty-five with fifty-eight percent of them having a college degree. The US Craft Yarn Council (2013) estimates there are approximately 38 million knitters and crocheters in the USA today, many of whom are between the ages of twenty-five and twenty-four.

Feminism's umbrella covers a multitude of philosophies and theories, as diverse as the women who have discussed and disagreed about its basis as a concept. There are those who now break its timeline into three distinctive waves. Lisa Jervis, cofounder and publisher of the magazine *Bitch: Feminist Response to Pop Culture*, speaking at the 2004 conference of the National Women's Studies Association, stated:

the discourse around waves is divisive and oppositional. Writers and theorists love oppositional categories … and much has been written about the disagreements … antagonisms between feminists of the second and third waves, while hardly anything is ever said about our similarities and differences … We all want the same thing; to borrow bell hooks' phrase, we want gender justice (Jervis, 2004).

For the purpose of understanding, the first wave is said to span history from the nineteenth century to the early twentieth century, with feminists such as Mary Wollstonecraft, Susan B. Anthony, Lucy Stone, Helen Pits, and many more. The Seneca Falls Convention and the passing of the nineteenth amendment to the US Constitution were markers for this wave. The second wave stretches from the early 1960s through the late 1980s, beginning with Betty Friedan's publication of *The Feminist Mystique*, the founding of the National Organization for Women, the Equal Pay Act in 1963, the 1972 Title IX of the Civil Rights Act, and the historical *Roe* v. *Wade* decision. Prominent players included Bella Abzug, Gloria Steinem, Angela Davis, Lorraine Bethel, and Andrea Dworkin. The third wave, sometimes termed the postmodern wave, spanning the early 1990s to the present, is led by Generation Xers born in the 1960s and 1970s.

When Jennifer Baumgardner and Amy Richards (2000) wrote their book they defined the ascendance of "girlie culture," a female self-empowerment that emerged in the 1990s with groups like the punk rock riotgrrls, the 2003 March for Women's Lives, and the publication of riotgrrl zines. They stated that a generational struggle over feminism marks a new era with the ending of the second wave and the growth of the third wave. Roots of the term "third wave" can actually be traced to a 1989 speech by National Oganization for Women president Patricia Ireland who stated, in response to federal and state restrictions on abortion, that a "third wave is coming," acknowledging the growing activism of young, college-age women. In 1992, Rebecca Walker and Sharon Liss formed the Third Wave Direct Action

Corporation to mobilize young people to become politically active. Committed to multigenerationalism, multiculturism, and multiclass efforts, these concepts are key to the third wave (Fudge, 2005).

Founding feminists of the third wave are, in some cases, literally daughters of second-wave feminists. Third-wave organizer and chronicler Rebecca Walker is the daughter of second-wave novelist Alice Walker; the authors Jennifer Baumgardner and Amy Richards were both raised by second waivers who were part of organized feminist groups (Walker, 2009). Rebecca Walker states that the third wave was influenced by the postmodernist movement and seeks to reclaim and redefine ideas, words, and media that transmitted ideas of womenhood, femininity, and gender, saying the spirit and intent of the third wave shone through in Eve Ensler's *The Vagina Monologues* (Ensler, 2008), the book and the play that explored "vagina-centered topics." The third wave professes to be more inclusive of women of color than the other two waves have been. Third wavers cite icons of powerful and influential women as Mary J. Blige, Queen Latifah, *Buffy the Vampire Slayer* (1997–2003) and *Girlfriends* (2000–8).

The profemininity of young women expressed in Debbie Stoller's *BUST Magazine* is where we can most identify the reclamation of cooking, crafting, and valuing of crafts as a link to female history. The hard-fought for accomplishments of the second wave, not the least of which include women's studies programs in colleges, feminist publication outlets like *Ms. Magazine*, visible women leaders in powerful political offices, were already existent when third wavers came to be. Heather Ross, author of the website Weekend Sewing says the current generation of women are the first generation for whom home economics classes were not required, as in need of "empowerment."

Bratich and Brush (2011) examine the resurgence in "fabriculture" and the popularization of do-it-yourself craft culture, stating that "while cyberculture and digital culture seem inherently

opposed to the archaic practices of weaving, spinning and crafting, we situate fabriculture within this field of new media study. Ultimately, we seek to conceptualize craft as power (the ability or capacity to act) as a way of understanding current political possibilities" (page 234). The authors define fabriculture or craft culture as "the whole range of practices usually defined as domestic arts: knitting, crocheting, scrapbooking, quilting, embroidery, sewing, doll-making," saying "we are referring to the recent popularization and resurgence of interest in these crafts, especially among young women" (page 234). This includes popular culture forms of crafting like Martha Stewart as well as craftivism. In the national bestseller, *Stitch'n Bitch: The Knitter's Handbook*, the title of which plays on a lexicon from knitting circles in the Second World War, Debbie Stoller (2003) placed knitting within the realm of feminism, encouraging a reverence for previously devalued feminine activities such as knitting, crafting, cooking, and keeping house, and evoking the term "girlie feminism." Stoller celebrates the domestic arts and boosting women's sense of community through empowerment and social justice. She states that to celebrate knitting is a feminist act itself because the denigration of knitting correlates with the denigration of this traditionally women-centered activity (Stoller, 2003). "A pervasive influence in the support of women's crafting, knitting has exploded in popularity in retail stores, on websites and in rooms in communities – there are over 800 public knitting groups in nearly 300 locations" (Craft Yarn Council, 2013). Objections to public displays of knitting in this era have been likened to the outcry against public breast-feeding years ago (Higgins, 2005). Beth Ann Pentney, writing in 2008, notes that there are those that argue that this celebration of the domestic arts is neither political nor feminist, "rather, the resurgence in the popularity of knitting is merely an extension of a trend that supports individualistic, apolitical consumerism (yarn prices)" and "certainly reflect a tendency to sell to upwardly mobile women with considerable disposable income" (Pentney, 2008). Heywood and Drake (2004) echo that "the experience of 'third world' women and men who work in textiles complicates the potential for reclamation and celebration of feminist knitting practices."

"I want to WEAR my hot pink sparkly Hello Kitty push-up bra, not burn it ... And now, I want to MAKE the damn thing first. Because I can" (www.blogher. com/modern-crafting-movement-and-feminism, June 8, 2010; accessed December 2013). Crafter Cat Mazza, and her website microRevolt, voices concerns over global sweatshop conditions for garment production and workers worldwide and her Stitch for Senate project involved knitting helmet liners for soldiers and sending them to every Washington, DC senator to protest against the war in Iraq. The Peace Ribbon Project honored victims of the Iraq war, by creating a cloth memorial panel to soldiers and Iraqi civilians, with 225 completed panels by 2007. This, and many other projects, were initiated by CODEPINK, a women's grassroots peace and justice movement. Other explicitly activist craft-connected organized efforts include Wombs on Washington, Cast Off Knitting Club, Knit4Choice, Anarchist Knitting Mob and Revolutionary Knitting Circle.

Guerrilla knitting groups, such as Knitta, based in Texas, have encased trees and lamp posts in hand-knit cloth. Artist Lacey Jane Roberts, known for her huge-scale knitted art installations (Lam, 2012), and for using a vintage 1974 plastic toy Barbie knitting machine, includes a pink-knitted barbed-wire fence with its purpose to "dismantle systems of power through soft medium associated with warm homey comfort" (Gschwander, 2008).

The Canadian author of several popular knitting books, Stephanie Pearl McPhee, oversees the blog Yarn Harlot. She documents, in photos, the communities of knitters and organizes the knitters to effect social change. Her group of knitters support the work of Doctors Without Borders, raising funds and advocating for social causes with the group she created called Knitters Without Borders. According to

Pearl McPhee (Wills, 2007), women today can knit because of the work of the feminists of the second wave who relinquished activities like sewing and knitting "in order to break down notions of what women were capable."

The Danish artist Marianne Jørgensen and London's Cast Off Knitting Club, along with a global group of volunteers, sewed together over 4,000 pink squares to cover a Second World War tank in 2006, in protest to Denmark's participation in the Iraqi war. Knit-ins, knit graffiti, and yarn bombing acts are markers of what Rozsika Parker (2010) says brought the craft out of the home and into the public space. Craftivism, says Jacqueline Wallace (2013), represents a merging of media as it is both "tactile and tactical." Yarn bombers are adding delicate knitted tokens to concrete environments. The Knitted Wonderland project in Austin, Texas in the plaza of the Blanton Museum, where tree trunks were wrapped in bright pink, blue, and green yarns to beautify the environment, in 2011, were photographed by organizer Magda Sayeg and others and uploaded to the internet to share the images instantly with networks of crafters and others.

The Wombs on Washington was an organization and a project that appeared in the online magazine *Kitty* in 2004 by a group of women in a members-only community termed Knit4Choice. Inspired by a knitted womb pattern created by crafter M.S. Carroll, the group planned to use the pattern to create knitted wombs and drop them on the Supreme Court building steps, in Washington, DC. The actual womb drop never coalesced but it inspired a powerful debate and the community building often characteristic of organized protest movements. Canadian artist and breast cancer survivor, Beryl Tsang's knitted breast prostheses, created in response to unappealing alternatives for mastectomy replacement forms, led to her creation of the website Tit-Bits, a welcoming and creative online space for women with breast cancer to share information and create a community. Tsang has made her pattern available for non-commercial use

through knitty.com and other knitting communities. Thus, she has, according to Beth Ann Pentney (2008, page 7), "shifted the emphasis from dependency on the medical system to women's self-healing, creativity and humor." There's also Jennifer Stafford's DomiKNITrix online site, self-described as living to whip her knitting into shape as the yarn sits up and begs to be wrapped around her littler needle (Stafford, 2011).

New social networks and communities emerge as women continue to weave their voices into art, creating connected cultures where craft practice and social statement resonate. Their creative spirits unfold in multiple colors, textures, and twists and turns. It remains for the world to view, encode and appreciate the multiple meanings unfolding in threads.

Bibliography

Agnew, Terese (2012) Drawing with threads. Available at www.pbs.org/craftinamerica/education_threads.php (accessed October 2013).

Baumgardner, Jennifer and Richards, Amy (2000) *Manifesta: Young women, feminism and the future.* New York: Farrar, Straus & Giroux.

Becker, C. (2007) Amazwi Abesifazne: Voices of women, pages 113–30, in Livingstone, Joan and Ploof, John, eds. *The Object of Labor: Art, cloth, and cultural production.* Chicago, IL: School of the Art Institute of Chicago Press.

Bratich, J. (2006) The other world wide web: Popular craft culture, tactile media, and the space of gender. *Critical Studies in Media Communication* Volume 29, Number 30.

Bratich, J. and Brush, H.M. (2011) Fabricating activism: Craft-work, popular culture, gender. *Utopian Studies* Volume 22, Number 2, pages 233–60.

Buszek, M.E. and Robertson, K. (2011) Introduction. *Utopian Studies* Volume 22, Number 2, pages 197–200.

Callahan, N. (1987) *The Freedom Quilting Bee.* Tuscaloosa, AL: University of Alabama Press.

Chicago, Judy (1993) *Holocaust Project: From darkness into light.* New York. Penguin Books.

Craft Yarn Council (2013) Knitting & crocheting are hot! Available at www.craftyarncouncil.com/know. html (accessed October 2013).

Dobard, R. and Tobin, J. (1999) *Hidden in Plain View: The secret story of quilts and the Underground Railroad*. New York: Doubleday.

Elsley, J. (1996) *Quilts as Text(iles): the semiotics of quilting*. New York: Peter Lang.

Ensler, Eve (2008) *The Vagina Monologues*. New York: Villard Books.

Ferrero, P., Hedges, E. and Silber, J. (1987) *Hearts and Hands*. San Francisco, CA: The Quilt Digest Press.

Friedan, Betty (1964) *The Feminine Mystique*. New York: Dell.

Fudge, R. (2005) Everything you wanted to know about feminism but were afraid to ask. *Bitch: Feminist Response to Pop Culture* Issue 31. Available at http://bitchmagazine.org/article/everything-about-feminism-you-wanted-to-know-but-were-afraid-to-ask (accessed October 2013).

Greer, Betsy (2008) Knitting for good!, in Stoller, D. ed., *Stitch'n Bitch: The Knitter's Handbook*. New York: Workman Publishing.

Greer, Betsy (2013) Craftivism. Available at http://craftivism.com/definition.html (accessed October 2013).

Gschwandtner, Sabrina (2008) Lacey Jane Roberts: Dismantling systems of power. *Interweave Knits* Winter.

Hedges, E. (1991) The needle and the pen: The literary rediscovery of women's textile work, in Howe, Florence, ed. *Tradition and the Talents of Women*. Urbana, IL: University of Illinois Press.

Heywood, Leslie and Drake, Jennifer (2004) "It's all about the Benjamins": economic determinant of third wave feminism in the United States, pages 13–23, in Gillis, Stacy, Howie, Gillian and Munford, Rebecca, eds. *Third Wave Feminism: A critical exploration*. Basingstoke: Palgrave Macmillan.

Higgins, C. (2005) Political protest turns to the radical art of knitting. *The Guardian* January 31. Available at www.theguardian.com/uk/2005/jan/31/arts.artsnews1 (accessed October 2013).

Independence Hall Association (1995) July 4. Retrieved from www.ushistory.org (accessed October 2013).

Jervis, Lisa (2004) The end of feminism's third Wave. *Ms. Magazine* Winter. Available at www.msmagazine.com/winter2004/thirdwave.asp (accessed October 2013).

Kendall-Tackett, Kathleen (2001) Hearth and home: The fascinating history of women's domestic work in America, Chapter 4, in *The Hidden Feelings of Motherhood: Coping with mothering stress, depression, and burnout*. Oakland, CA: New Harbinger.

Lam, M.L. (2012) Lacey Jane Roberts: Tearing down the master's house. *Fiberarts* Volume 37, Number 3, page 40.

Matthews. Glenna (1989) *"Just a Housewife": The rise and fall of domesticity in America*. New York: Oxford University Press.

Minahan, S. and Cox, J.W. (2007) Stitch'nBitch: Cyberfeminism, a third place and the new materiality. *Journal of Material Culture* Volume 12, Number 1, pages 5–21.

NAMES Project Foundation (2011) www.aidsquilt.org (accessed October 2013).

Ostrovsky, Deborah (2011) Confessions of a reluctant crafter. *Herizons: Women's News + Feminist Views*, winter 2012. Available at: http://www.herizons.ca/node/508 (accessed December 2013).

Parker, Rozsika (2010). *The Subversive Stitch: Embroidery and the making of the feminine*. New York: I.B. Tauris.

Pentney, Beth Ann (2008) Feminism, activism and knitting: Are the fiber arts a viable mode for feminist political action? *Thirdspace: A Journal of Feminist Theory and Culture* Volume 8, Number 1. Available at www.thirdspace.ca/journal/article/view/pentney/210 (accessed October 2013).

Plant, Sadie (1997) *Zeros and Ones*. New York: Doubleday.

Ryan, T. (2003) The queen's quilt. *Honolulu Star Bulletin*, March 10, 2003. Available at http://archives.starbulletin.com/2003/03/10/features/story1.html (accessed October 2013).

Smith, R. (2010) Antislick to postslick: DIY books and youth culture then and now. *Journal of American Culture* Volume 33, pages 207–16.

Stafford, Jennifer (2011) DomiKNITrix catches you up (September 4, 2011). Available at www.domiknitrix.com/knittingblog.cfm (accessed October 2013).

Stoller, Debbie (2003) *Stitch'n Bitch: The Knitter's Handbook*. New York: Workman Publishing.

Walker, Rebecca (2009) Third Wave: An accurate and succinct rendering. Available at www.rebeccawalker.com/blog/2009/09/04/third-wave-an-accurate-and-succinct-rendering (accessed October 2013).

Wallace, Jacqueline (2012) Yarn bombing, knit graffiti and underground brigades: A study of craftivism and mobility. *Journal of Mobile Media* Volume 7, Number 1. Available at http://wi.mobilities.ca/yarn-bombing-knit-graffiti-and-underground-brigades-a-study-of-craftivism-and-.mobility/ (accessed October 2013).

Williams, K.A. (2011) "Old time mem'ry": Contemporary urban craftivism and the politics of doing-it-yourself in postindustrial America. *Utopian Studies* Volume 22, Number 2, pages 303–20.

Willis, Kerry (2007) *The Close Knit Circle: American knitters today*. Westport, CT: Praeger.

Women's Empowerment Street Team (2007) Women's contributions: Betsy Ross. Available at http://we-etsy.blogspot.co.uk/2007/09/womens-contributions-betsy-ross.html (accessed October 2013).

Zipf, Catherine (2007) *Professional Pursuits: Women and the American arts and crafts movement*. Knoxville, TN: University of Tennessee Press.

The Art of Resistance, Memory, and Testimony in Political *Arpilleras*

ROBERTA BACIC

ARPILLERAS ARE THREE-DIMENSIONAL APPLIQUÉD textiles of Latin America that originated in Chile. The backing fabric of strong hessian, known as *arpillera* in Spanish, became the name for this particular type of tapestry. Empty potato or flour sacks have also been used for the backing, and this has given them their typical size – a quarter or a sixth of a sack. As Ariel Zeitlin Cooke has said: "This is an art of poverty" (Cooke and MacDowell, 2005, page 49). At a later stage, dolls and other little memorabilia started to be sewn on to these *cuadros* (pictures) and this gives them a special, personalized quality.

It is believed that *arpilleras* originated in Isla Negra, an area along the central part of the Chilean coastline. In 1966, Leonor Sobrino, a longstanding summer visitor to the area, encouraged local women to use embroidery to depict scenes of their everyday lives. In this we see the interplay of different cultures – the residents of Isla Negra and the visitors – leading to the creation of a new art form – *arpilleras*. Incidentally, another visitor/resident of Isla Negra who interacted with the community and as a result produced some of his great poetry, was Pablo Neruda, the Chilean poet who won the 1971 Nobel Prize for Literature. The group of women became *Las Bordadoras de Isla Negra* (the Embroiders of Isla Negra) and, mainly in the long winter months, they embroidered bucolic scenes of their everyday rural lives. In 1970 the group's *arpilleras* were shown for the first time in the National Museum of Arts in Chile.

Another source and influence was Violeta Parra, the Chilean folk singer, who told a journalist in 1958 while she was ill and not able to sing, "*arpilleras* are like songs that one paints" (Parra, 1985). In this context, Parra started to embroider, paint, and sculpt and in 1964 she exhibited twenty-two *arpilleras* at the Louvre in Paris together with twenty-six paintings and thirteen sculptures.

Three-dimensional in nature, the art of political *arpillera* making, which stems from the Pinochet era in Chile, brings us powerful, raw testimony of the events from this violent regime and latterly from other repressive governments in various places across the globe. From rural villages and urban workshops in Chile, these deceivingly simple textiles have traveled worldwide and carry with them a "trail of context" from their creation to their viewing. In their journey, they create bonds between the *arpillerista* artist and the audience, growing in magnitude of meaning, linking the viewer to the resistance in which the *arpilleras* were born. They represent what might be considered as a "folksiness" or lesser genre of art and yet they are exhibited, without apology, in museums art galleries, universities, and embassies. In every step of their journey, the *arpilleras* have demonstrated resistance: resistance against poverty by creating a grassroots export; resistance against repressive regimes by narrating the story of daily life under such regimes; resistance against the very idea of nonresistance by making sewing an act of subversion; and resistance against the expectations of the

art world by being exhibited as if they are works of classical art.

Historical Context

During the dictatorship of Augusto Pinochet from 1973 to 1990 the tradition of *arpilleras* developed to give voice to the repressed and disenfranchised of Chilean society. *Arpilleras* were used during this period to tell the stories of the "disappeared," the tortured, the poor and the imprisoned when these experiences could not be testified. In the words of novelist Isabel Allende:

> The *arpilleras* are storytellers, for it is through them that these women have recorded and preserved the memory of a period of Chilean history that many others have chosen to forget (Agosín, 2008, page 74).

In 1970, despite a US-led campaign against him, Salvador Allende was democratically elected as the first Marxist president in the Americas. Three years later, on the September 11, 1973, a US-backed coup by Pinochet ousted Allende's government and replaced it with a repressive dictatorship (Kornbluh, 2004). According to official statistics published in August 2011, there are 3,216 officially disappeared and executed people and 38,254 survivors of political imprisonment and torture (ICSO, 2013).

The *arpilleras* that were provoked into existence by the Pinochet regime were not the first, nor indeed the last textiles with a story, to be born out of violence. The Hmong people produced story clothes, Afghanis produce detailed rugs, and the Zulu created memory cloths all of which "do slightly different things, and bring different meaning to events and how we live with their memory afterwards" (James E. Young in Cooke and MacDowell, 2005, page 33). Young, when writing of the war tapestry makers, adds: "They [the tapestries] have a common maternity: most are done by women whose roles in these conflicts were remarkably similar – often caught in the crossfire of advancing and retreating armies, often innocent bystanders and victims, and only occasionally war combatants themselves" (Cooke and MacDowell, 2005, page 34). In Chile, the trend was no different. It was the mothers and the grandmothers, the partners and the lovers, the sisters and the daughters, who created the first *arpilleras* to "speak against the silence and the shadow" (Agosín, 2008, dedication) of the regime.

Individual and Universal

A striking element of *arpilleras* is the dichotomy of the individual and the universal. This binary relationship works on a number of levels across the pieces. There is the individual experience of the *arpillerista* and of the audience that then views her work; the individual experience of the person whose family member was detained, disappeared, killed and the universal experience of all of those men and women who lost and lose their loved ones; and the individuality of the Chilean, Peruvian, or Argentinean case of torture and poverty and the universal experience of these same issues.

For the individual Chilean *arpilleristas*, the making of *arpilleras* provided both an economic outlet and a medium through which they could bear witness to the atrocities of the regime and the hardships and joys of daily life during it. Agosín (2008, page 9) writes that, the *arpillera* "process of creation" came from "desperate economic necessity and a virtually hopeless quest for justice for the many women who had lost husbands, sons, and daughters at the hands of the regime." The *arpilleristas* did not work using bought rolls of cloth; their material was drawn from what they could lay their hands on. Necessity, so it is said, breeds invention, and the busy hands and minds of these women were no exception to this. The women delved into the resources known to them and created something fresh from what they already knew. Workshops of women, who had previously produced images of rural Chile, of hills and sunshine, and farm scenes, displayed the vigor for change and captured the new situation in their

later work. This was the context of the creation of the *arpillera*; the context of their eventual audience was rather different.

The majority of *arpilleras* found their way into the world via nongovernmental organizations and Church-run charities to be sold to raise essential funds for the communities that made them, as well as to raise awareness of the oppressive acts of the Pinochet regime. Many of those who bought the *arpilleras* were middle class, some with an interest in Latin America, others perhaps simply drawn to the craft's style, or eager to involve themselves in some kind of charitable effort. Even now, audiences far removed from the humble beginnings of the *arpilleras* find a natural bond to them. The *arpillera*, whatever its country of origin, has managed to traverse the gulf between their individual creation by the *arpillerista* and the universal experience of their many audiences and the response of present-day *arpillera* followers from other parts of the world.

There is also the individual experience of daily life under the regime as translated into the *arpilleras* and the way in which these same pieces then reflect the greater universal experience of the suffering at the time by many other Chileans. For many of the *arpilleristas* the stitching of their stories of resistance offered a medium through which they had an opportunity to channel their individual stories of suffering. A most poignant fact of the evolution of the *arpilleras* is that it was often the scraps of clothing from the disappeared which were sewn into the images – see Figure 9.1 for an example. Thus, the women used not only their material resources, but something deeper than that, they sewed their lives and their loss into the tapestries.

Figure 9.1 is an *arpillera* by an unknown *arpillerista*. It dates from the late 1970s and follows a classical pattern. The size corresponds to the equivalent of a fourth or sixth part of a flour sack. The Andes mountains define the country – Chile – which is crossed by mountains from north to south, so becoming an element of identity. The sun in the center makes the political statement that it shines

for all. Another almost standard element is the use of scraps of colored materials to give birth to the characters, buildings and other elements of the local environment of their neighborhood. "I can remember us using the trousers, shirts, pullovers, pyjamas and even socks of our disappeared to sew and stitch our *arpilleras*." Another element present in this *arpillera* is the use of simple blanket stitch and then around it crocheted red wool to resemble a frame, to let us know this is a picture, to hang in a room, to live with and not to be used as a practical domestic artifact.

The use of materials immediately connected to the disappeared brings us to the actual manufacturing process of the *arpilleras*. The art of the *arpillerista* is one of dedication, precision and time, and it is sometimes painful to produce. It was driven, not only by economic necessity, but also by a need to relate a story. The process of creation cannot be rushed. The *arpilleristas* may have been expert seamstresses, and their hands could fly across the materials like a brush across a canvas, but their thought processes, individually and collectively, were profound and sometimes it was a painful and lengthy process to find the way to portray and share them. Thus, in these communities of cloth, scissors, and needles, the women poured their stories into the cloths. The miniature figures, that protested or screamed or danced or begged, moved from their fingers to the cloth and took with them their stories and pain. James E. Young writes, "every movement of the hand that pushed the needle in and pulled it out" is reflected in each stitch, and each shows "memory as a physical activity, a material process whereby artists make sense of events inwardly and outwardly in the same act" (Cooke and MacDowell, 2005, page 34). This sense of process, the transfer of the story from person to cloth is beautifully described in the words of one *arpillerista* who explained how the textile "received her tears," with the *arpillera* soaking them up. Here, both figuratively and literally, the process of catharsis drew the *arpillerista*'s story and pain from her.

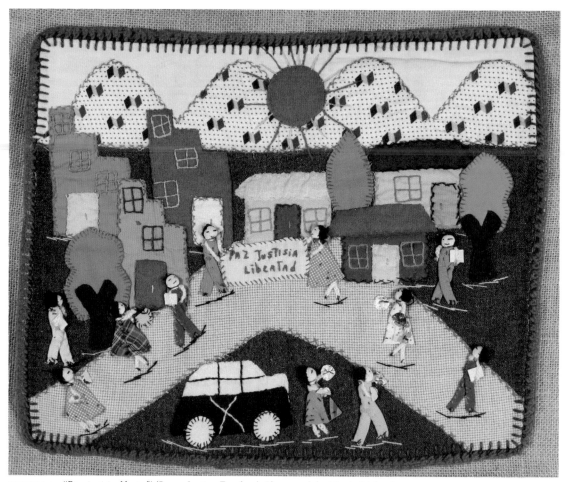

FIGURE 9.1 "*Paz, justicia, libertad*" (Peace, Justice, Freedom). Photograph by Martin Melaugh.

The duality of making the *arpillera* is apparent in how the *arpilleristas* did not only tell their individual stories. By stitching the narratives into pieces of hessian, the *arpillerista* threaded the stories to become everyone's story. The *arpilleras* link and relate to numerous contexts. The stitches transcribe stories of political unrest, personal and group trauma, suffering, and the working-class environment of those who produced them. From the clatter of the women's workshops of *La Vicaría de la Solidaridad* to the various corners of the globe where they have

been exhibited, *arpilleras* leave a trail through the different contexts to which they were attached, and each time bring something new with them. Paul Ricoeur, the late French hermeneutical philosopher, wrote of the way in which stories transgress the temporal, so that certain stories can be omnipresent across the generations. Imagine the example of a child who hears stories from her grandfather of the war he lived through, and by virtue of this they both share the experience; it is both past and present. Thus, these two people live across generations

bridged by memory and stories. Ricoeur describes this as being part of a "threefold realm" where we are oriented "toward the remembered past, the lived present, and the anticipated future of other people's behavior" (Ricoeur, 1990, pages 112–13).

The *arpilleras* themselves relate traumas that other mediums of communication may not have managed to convey. Thus portrayed in this striking manner, the doll-like figures inhabit a world where universal contexts of poverty, torture, and so on, can be imposed on them. Their simplicity also means that they open up the possibility for reappropriating them for new contexts. They allow anyone willing to take the time to pick up a needle and thread to relate their own stories through cloth and stitches – a reality visible in the continuation of the *arpillera* tradition into other Latin countries and more recently far beyond. Women who have or have not been sewing or using other textile traditions have equally adopted this resource that allows them to tell their own stories.

The *Arpilleras*: Stitching Narratives of Resistance

With little fanfare the *arpillera* tradition has carried its message of resistance from Chile to much further afield. Every step and every stitch of the *arpillera*'s journey can be described in terms of resistance. In the very first place, the groups of women who met to create them were resistant in many ways. Marjorie Agosín, speaking of her first meeting with a group of *arpilleristas*, describes them carrying bread bags full of scraps of cloth with determination in their faces, "as if their lives were carried in those bags whose purpose was to find out about the fate of their loved ones. They were there with their lives, memories, and families, all braided together and united through a scrap of cloth" (Agosín, 2008, page 77). The apparently innocuous then became an act of radical subversion. Vivienne Barry's striking short film about the *arpilleristas* (*Como Alitas de Chincol*)

shows how the *arpillera* workshops became genuine acts of resistance against the regime (Barry, 2004). It took about five years for the government to become aware of their subversive nature, simply because they used such a mundane daily activity to express their resistance. In addition, the *arpilleras* were acts of resistance in the way in which they broke with tradition. First, the *arpilleras* resisted the customary format of rural idyll by depicting images of political oppression and more urban reflections of daily life. Second, they allowed women to resist traditional roles making them economically more empowered – something that was especially relevant when many of the traditional breadwinners had disappeared or were imprisoned. Violeta Morales, the sister of the disappeared Newton Morales, said of her work:

> With the money from the *arpilleras* I pay the light and the water bills, and buy the notebooks and pencils the children need for school. Sometimes there is something for food, too. When we get a bigger order, on payday I buy a hot dog for each person in our family. It's such a lovely celebration (Agosín, 2008, page 43).

All of the motivating factors of the women's daily lives, of poverty, grief, resistance, joy were stitched in as acts of resistance and in turn they produced something that could spread that message of struggle across the world. This brings us to their next act of resistance. The *arpilleras* fought the confines of simply being pieces of traditional art sold to raise funds and awareness, additionally they have become ambassadors. The *arpilleras* bring a particular history of Chile, the darkness and the light of the time, and carry it across the world. They represent the living that created them, and the dead that they were made to memorialize. In their ambassadorial role *arpilleras* bring aspects of Chilean culture with these stories wrapped inside. And in this role they in turn inspire and bring out empathy and impulse to respond with their own narratives. The *arpilleras* then act as a reminder to us of what we have and startle us into seeing what others have lost. Through this, the

arpilleras compel us to do something, to in turn bear witness for the suffering of those in the tapestries.

At an early stage, the art form of the *arpillera* spread to women's groups in Perú, considered in depth in Chapter 12 of this book by Gaby Franger, and more recently to Spain, Brazil, the UK, Ireland, Germany, Zimbabwe, Colombia, Nicaragua, Ecuador, and Argentina. Across these varying contexts, in workshops primarily attended by women, the burning issues are remarkably similar. Triggered by the exhibi-

tion "The Politics of Chilean Arpilleras" that went to Barcelona during late 2008, a group of women from Badalona, in the outskirts of Barcelona, Spain, started to make *arpilleras* depicting their experiences during the Spanish Civil War (1936–9) as well as life in their community. Figure 9.2 shows Republicans fleeing into exile. Arpilleristas de Fundación Ateneu Sant Roc, as the women call themselves, have developed in content and technique and have participated in numerous exhibits in their neighbor-

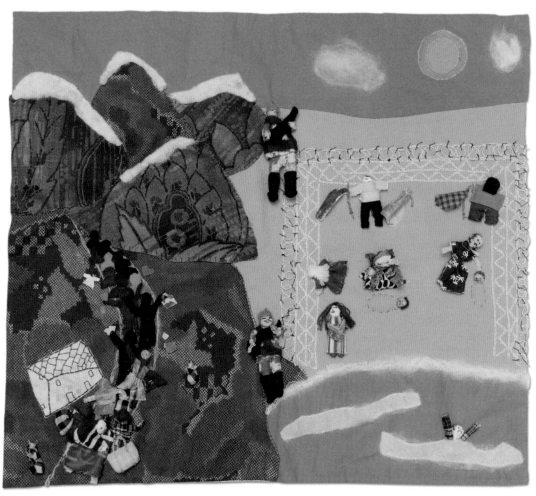

FIGURE 9.2 *"Exilio de los Republicanos catalanes cruzando los Pirineos"* (Exile of the Catalonian Republicans crossing the Pyrenees). Photograph by Roser Corbera.

hood and far beyond, reaching Argentina, Germany, USA, and New Zealand.

As women reflect, discuss, and caress the different textured fabrics, stories of political conflict, anti-war protests, repression, resistance, survival, denial, death, disappearances, displacement, national histories, environmental concerns, and transition to democracy are stitched. And so the *arpilleras* have continued to promote a message of resistance and have inspired other groups to stage their own acts of resistance.

How could the person who pauses in front of one of these vibrant tapestries in any *arpillera* exhibition respond? They might be considered as merely colorful craftwork exercises, examples of a tradition that began in Chile and which has now stretched and evolved across other Latin American countries and into Europe, Africa, and Asia. They may be read as symbols of camaraderie, created by groups of women working together and producing a product that they could then sell to help provide for themselves, their families, and communities. They may also be seen as manuals from campaigners whose message was otherwise stifled from being heard in any other way, traces of a context which no longer exists except in these tapestries and people's memories. The pieces are, indeed, one and all of these things and reflect as a whole an *arpillera* in themselves; a collision of styles, histories, experiences, and messages which provide us with an overarching message of the continuity of daily life yesterday and today, and its stories of loss, grief, anger, joy, frustration, and hope.

At first glance, these pieces are simply pretty textiles. However, if one looks closer at the apparently innocuous brightly colored three-dimensional dolls dancing across some of these works, you see that they are not simply puppets but protesting campaigners; the impoverished seeking food, shelter, and employment. Brightly colored houses at closer inspection reveal themselves to be overcrowded shanty towns, layers of daily life which are sewn on to these rags and strips of cloth, scraps of material

which themselves carry stories of former lives and histories, now reinvented as stories for us. Whatever strikes you first when glancing across these beautiful works of art, be sure to look again, and then again, and even again, for each piece carries layer upon layer of meaning, symbolism, and stories which can be related to our own daily existence, stories which we can live.

Acknowledgments

This chapter is based on a paper prepared for the opening of the exhibition "Transforming threads of resistance: political *arpilleras* and textiles by women from Chile and around the world," February 27 to March 9, 2012, commissioned by the Art of Conflict Transformation Event Series and hosted at the University of Massachusetts/Amherst, USA and the National Center for Technology and Dispute Resolution. The commissioning organization, directed by Professor Leah Wing, has welcomed the publication of this chapter.

Bibliography and further reading

Agosín, Marjorie (2008) *Tapestries of Hope, Threads of Love, The Arpillera Movement in Chile 1974–1994*, 2nd edn. Lanham, MD: Rowman & Littlefield Publishers.

Barry, Vivienne (2004) *Como Alitas de Chincol*. Available at www.youtube.com/watch?v=CNKeLhTyiWQ (accessed August 2013).

Conflict Archive on the Internet (2013) Located at the University of Ulster. Available at www.cain.ulst.ac.uk/quilts (accessed December 2013).

Cooke, Ariel Zeitlin and MacDowell, Marsha, eds. (2005) *Weavings of War: Fabrics of memory*. Michigan State University Museum.

Franger, Gaby (1988) *Arpilleras Cuadros que hablan Vida cotidiana y organización de mujeres*. Perú: Movimiento Manuela Ramos.

ICSO (2013) Instituto de Investigación en Ciencias Sociales. www.icso.cl/observatorio-derechos-humanos/ (accessed August 2013).

Jelin, Elizabeth (2003) *State Represssion and the Struggles for Memory*. London: Latin American Bureau. Originally published in 2002 in Spanish as *Los trabajos de la memoria*. Coyoacán: Siglo XXI Editores.

Kornbluh, Peter (2004) *The Pinochet File: A declassified dossier on atrocity and accountability*. New York: National Security Archive.

Parra, Isabel (1985) *El Libro Mayor de Violeta Parra*. Madrid: Ediciones Michay.

Randle, Michael, ed. (2002) *Challenge to Nonviolence*. Bradford: University of Bradford.

Ricoeur, Paul (1990) *Time and Narrative*, Volume 3 (Kathleen McLaughlin and David Pellauer, translators). Chicago, IL: University of Chicago Press.

Sepúlveda, Emma (1996) *We, Chile. Personal Testimonies of the Chilean Arpilleristas*. New London, CT: Azul Editions.

Young, James E. (1993) *The Texture of Memory: Holocaust Memorials and Meaning*. New Haven, CT: Yale University Press.

Young, James E. (2005) Living with the fabric arts of memory, pages 31–6, in Cooke, Ariel Zeitlin and MacDowell, Marsha, eds. *Weavings of War: Fabrics of memory*. Michigan State University Museum.

In addition to these referenced books, dozens of testimonies and interviews taken by the author between 1975 and 1995 were reviewed. Also, several journals and magazines were consulted, as well as *ad hoc* and relevant web pages. Newspapers from the Chilean dictatorship were consulted during 2010/11 in the Biblioteca Nacional de Santiago de Chile and phone as well as e-mail interviews took place.

Seeing Voices: Srebrenica's Filaments of Memory

INELA SELIMOVIĆ

Memory is a gust of absence
Words do not reveal
They silence
Language vanishes
In Srebrenica
This evening
When death
Returns to your house (Marjorie Agosín, "Srebrenica").

IN JULY 1995, WITH the mass killing of over 8,000 people in Srebrenica, the war in Bosnia and Herzegovina became a serious matter for most of the international community. Apart from signaling the reality of the Bosnian genocide, the same month had also marked nearly three and a half years of the nation's hemorrhaging across its ethnic groups, which led to approximately 100,000 dead and over one million internally displaced persons and refugees (Mousavizadeh, 1996). When Bosnia and Herzegovina declared its independence from the former Yugoslavia on March 1, 1992, it encountered strong opposition from largely ethnic Serbs who boycotted the referendum on Bosnia and Herzegovina's independence with armed resistance. The next three years unfolded into a bloody war between those who sought to keep multiethnic Bosnia holistically united in its territorial and cultural integrity, and those who sought to partition the newly emerged country along ethnic lines. Several months after the genocidal mass murder in Srebrenica, a peace agreement was reached in Dayton, Ohio (November 21, 1995) and finally signed in Paris (December 14, 1995). The Dayton Peace Accords put an end to the war, creating a loosely multiethnic and democratic government with two entities the Bosniak/Croat Federation of Bosnia and Herzegovina and the Bosnian Serb-led Republika Srpska. Srebrenica's grisly aftermath – over 8,000 non-Serbs killed, mostly men and boys – continues to haunt the town's inhabitants who stayed as well as those who remain displaced for different reasons (Leydesdorff, 2011). Among the displaced survivors from Srebrenica, a small group of women emerged whose ties to their native town are, quite literally, being threaded back together through the artisanal act of quilting.

The Srebrenica Memorial Quilts Project continues to weave those who once were into the collective memory of Bosnia and Herzegovina. Such an undertaking has not yet resulted in complete acceptance across the nation, but has certainly provided a powerful site that works against the potential oblivion of the genocide. The nomadic nature of traveling quilts allows the involved women weavers to strengthen their human rights-focused activism at home and abroad. Yet, remembering certain events meaningfully might be as taxing as keeping their atrocity-ridden fragments in oblivion. In this context, Paul Ricoeur is particularly useful in thinking about the exercise of memory and the latter's complex manifestations. Ricoeur remarks that memory, at its most basic level, signifies recalling in action. According to Ricoeur, "remembering is not only welcoming, receiving an image of the past, it is also searching for it, 'doing' something" (Ricoeur, 2004, page 56). For Ricoeur, an act of remembering is, cognitively and pragmatically speaking, an exercise of search, discovery, and engagement.

Most of the women artisans involved in the Memorial Quilts Project have emerged as the double-witnesses to the genocide in Srebrenica. On one hand, many of them narrowly escaped their deaths in Srebrenica during an orchestrated ethnic cleansing, which led to the demise of most of their male kin.[1] On the other hand, the act of weaving these panels has turned them into witnesses, once again, through their threading narration. With each quilt's panel, through several letters that only begin to do justice to one's personhood via his or her first and last names, we are subtly reminded of the appalling human rights violations that had astonished – yet perhaps not sufficiently – the international community in the last quarter of the twentieth century. The Srebrenica Quilt's filaments, which bear this memory – though through deliberate textual scarcity – strike powerfully with the victims' selfhood, threading together a patchwork of memory of the largely innocent town inhabitants. By focusing on the Srebrenica Quilt's basic design and nomadic characteristics, this chapter examines the women weavers' rudimentary yet complex and compelling human rights roles in their commemoration advocacy for dead victims of the mass atrocity of Srebrenica. In dissecting such roles, this chapter additionally engages in a brief cross-cultural comparison between the Srebrenica weavers' practice of memory and the most salient women activists' efforts against historical amnesia in the Southern Cone of Latin America.[2] While chronologically distant and socio-politically different, each women's memory group emerged from the political debris of socialist experiments, military coups and bloody movements before democratic formations in their societies took root.

I. The Post-conflict Women's Weaving of the Past: Imprinted Psyches

No one / bears witness for the / witness (Paul Celan, "Ash-glory").

Handmade quilts by women with human rights-focused narrative have permeated societies for centuries.[3] Most of such quilting efforts in the twentieth and twenty-first centuries, as this book's chapters demonstrate, focus on remembering those who suffered and perished under one or multiple forms of oppression: forced disappearances of political dissidents in Chile (*arpilleras*); genocide in Rwanda; genocide and war in Iraq; the infamous Rio Negro massacre in Guatemala; Maasai widows and girls from Kenya; or Nepali women sufferers from the

[1] Mann (2005) offers a thorough analysis of the Bosnian war through a socio-historical lens (see his chapters 12 and 13). Up to date, it is known that, at least, two women (Nasiha Nuhanović and Remzija Dudić) were among the largely male victims at Srebrenica during the initial genocidal surge.

[2] While the core nations of the Southern Cone include Argentina, Chile, and Uruguay, this chapter will mainly draw its comparative examples from the women survivors' human rights work in Argentina and Chile. The political realities and their aftermath the women activists faced in Argentina and Chile share several salient intersecting as well as bifurcating points with the Srebrenica women activists' efforts. Roniger and Sznajder's (2012) article is worthy of citing regard-ing the varied and common repressions among these three Southern Cone states in the 1970s onward. The authors make such a distinction early into their article as follows: "[t]he forms of extent of repression varied among them, with illegal abductions, torture, and disappearances figuring prominently in Argentina, political killings being salient in Chile, and long-term imprisonment of citizens being the rule in Uruguay" (page 703).

[3] One of the most salient quilt projects comes from Athens, Georgia by a former slave Harriet Powers (1837–1910). In fact, Powers' quilt *American* (1895–8) comes to mind immediately. Numerous quilts emerged during the Civil War as currently exhibited at the Museum of Fine Arts in Boston, Massachusetts.

condition of uterine prolapse to mention a few of the most notable examples. These projects have often led to public and virtual quilt exhibitions to draw additional global attention to their human-rights focused work and implications such as the 2013 exhibition entitled "Advocacy Quilts: A Voice for the Voiceless" at Kean University.

Weaving among women survivors from Srebrenica, as it occurs presently, was not an organized human rights activity during the war in Bosnia. Unlike the Chilean *arpilleras*, for instance, whose "clothes of resistance" or tapestries, sought to represent the quest for the disappeared dissidents during the Pinochet regime, the Srebrenica weavers' quilt work emerged globally after the war.[4] The first hand-woven wool quilts came about among a group of women from the nongovernmental organization Bosnian Family (BosFam) in 2007.[5] The BosFam was founded in 1994 by the British charity Oxfam – during the war in Bosnia – in Tuzla and coordinated by a former academic and inhabitant of Srebrenica, Munira Beba Hadžić, largely to help displaced women from across the country piece their lives together though quilting. The Srebrenica Quilt – woven by women survivors solely to pay homage to the fallen victims in Srebrenica – was finished at BosFam before the twelfth commemoration of the genocide in Srebrenica. Subsequently, this quilt became available to the public in the USA on July 8, 2007 in St. Louis. The choice of St. Louis was important for it is the US city with the largest concentration of the Bosnian diaspora abroad since the war's end. Yet speaking on behalf of fallen victims or survivors is

as delicate as it appears necessary among the Srebrenica weavers. The difficult aspect of speaking on behalf of the murdered might stem from finding an appropriate way to interlace together the loss, mourning, and remembrance. This is particularly true as the Srebrenica massacre – or any massacre for that matter – defies any language or image that could do justice for speaking on behalf of the tortured, disfigured, and ultimately piled up bodies in numerous mass graves.[6] Yet looking at the BosFam Memorial Quilts' statement of purpose, one senses the power of necessity to prevent the Bosnian genocide from falling into the oblivion: their quilts are "intended as a living memorial to all who were murdered in the July 1995 massacre – and a reminder that the massacre can never be forgotten."[7]

Such a statement merits additional attention as it serves as textual prelude for quilts that bear a sparse, but meaningful, memorial text on their panels: the victims' first and sometimes last names. Viewing their quilts as "a living memorial" gives their advocacy a humane and resolute dimension, whereby these women's work cannot be overlooked by their contemporaries or by future generations. The last segment of the mission is directed to the future generations of Bosnia in the Ricoeurian sense of the use of memory regarding traumas. Drawing on Tzvetan Todorov's essay entitled "Les Abus de la mémoire," Ricouer (2004) assumes rather a sensible approach to memory. When acting in a memorial mode toward a traumatic past, those who seek to remember must "extract from traumatic memories the exemplary value that can become pertinent only when memory has been turned into a project. If the trauma refers to the past, the exemplary value is directed toward the future" (page 86). At the risk of

4 Chile lived its military government from 1973 to 1990 under General Augusto Pinochet. Pinochet's dictatorship led to thousands of disappeared and imprisoned political dissidents during this period. The Chilean quilt advocacy has been tackled at length by Agosín (1996).

5 Most quilts are housed at the BosFam and/or Advocacy Project sites except for those that travel to different exhibition events at home and abroad.

6 See the Human Rights Watch publication (October 1995) entitled "Bosnia and Herzegovina: The Fall of Srebrenica and the Failure of UN Peacekeepers."

7 An online video clip entitled "Rebuilding After the Srebrenica Massacre in Bosnia" offers a rich display of the nongovernmental organization's mission.

stating the obvious, then, Ricoeur, above all, favors a meaningful display of the worthy lessons learned from the past. The BosFam's weavers appear in agreement with this philosophical take, even if unknowingly, in a three-pronged way. First, the women weavers pledge straightforwardly to weave life into their quilt panels as a permanent condemnation of the indiscriminate killings of their family members. Second, such efforts imply an overt confrontation of the perpetrators who had sought to extinguish their selfhood in Srebrenica permanently. Third, weaving at the BosFam site means recreating – even if faintly – their largely bi-ethnic communal coexistence of the past.

These women weavers' primary objective is unquestionably their altruistic responsibility to the Srebrenica victims (see Hadzic, 2012). Zooming in on the Srebrenica Quilt – which is collection of the subsequently discussed Advocacy Project (AP) – one is struck by the quilt's richness in color, bold, and diverse designs of each panel (Figure 10.1). Various in depth or lightness of color – green, purple, blue, and/or white – these panels (40 cm × 40 cm each) rest against a red background together with individual inscriptions of the fallen victims' names. The exact date of the Srebrenica massacre – July 11, 1995 – rests on the solid red upper side of the quilt. Each panel nonetheless exhibits a textual scarcity: merely the victims' first and last names. As most human rights-focused quilt projects, this quilt certainly appears rich in implications. If viewed as a communicative artifact, it subtly speaks in different voices. Each name claims one of the twenty stitched together panels such as "Ibro, Nasiha, Alem, Almir, Remzudin" to mention a few. These names, woven in with distinctive quilt handwriting, either rest below each design or remain nearly grafted toward the central image of the panel. As such, the quilt exudes a fragmented cohesiveness of voices, whereby each name remains unique in its personal implications, colors and the letter size stitched together in a visual display of their shared demise. The blueprints for their design might have stemmed from deeply

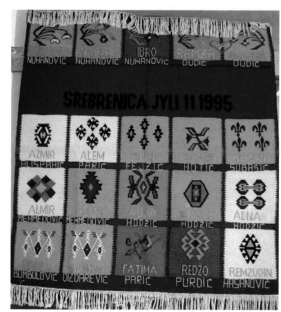

FIGURE 10.1 The Srebrenica Quilt. Courtesy of the Advocacy Project: A Voice for the Voiceless.

personal experiences of those who knew the victims, their weavers' perception of the killed, or perhaps a combination of both. Unlike certain human rights-based contemporary quilts (i.e. Chilean burlaps) that insinuate or directly depict fragments of violence or human suffering, the Srebrenica Quilt is mostly in flowers and images that bear a resemblance to gemstones.

The Srebrenica Quilt could be unquestionably considered a form of personal testimony. When thinking of personal testimonies and human rights, we must recall Kay Schaffer and Sidonie Smith's (2004) book. In this work, Schaffer and Smith map out the interaction between personal testimony and human rights under term "life narrative" (page 13). Such narratives are "strong, emotive stories often chronicling degradation, brutalization, exploitation, and physical violence; stories that testify to the denial of subjectivity and loss of group identities" (page 4). In retrospect, the case of Srebrenica – and its inhabitants' testimonials – certainly fit Schaf-

fer and Smith's perspective of narrating lives in the wake of human rights violations. A cursory look, though, at the first Srebrenica Quilt – if viewed as a cultural narrative – complicates these scholars' notion of the "life narrative" as being primarily composed of experiences of suffering: it lacks any explicit reference to violence and killings. Instead, the quilt's weavers opt for a simple memorial list of the victims' names. Yet reading across the quilt undoubtedly spells a narrative of the indiscriminately murdered victims' lives. And those familiar with the Srebrenica context cannot but sense how the quilt's design imposes a series of pauses between the inscribed names. This, in turn, allows for a silent moment between each panel, paying tribute to those who once were. Given its distinctive juxtaposition of the contrasting color palates, victims' names, and floral and geometric images, this advocacy narrative pulls the observer into the different personalities of each quilt panel. At a basic level, then, what might be called a "scarce narrative," leaves room for subtle messages about "the denial of subjectivity" and the aftermath of such a denial.

The BosFam-sponsored quilts have not been dormant human rights artifacts. The Srebrenica Quilt carved out its pacific yet assertive human rights role abroad in 2007 on its display at The Hague during the commencement of Radovan Karadžić's trial at the International Criminal Tribunal for the former Yugoslavia (ICTY) (Figure 10.2). Karadžić – the former Bosnian Serb leader – is on trial for his alleged role in the siege of Sarajevo and the killings in Srebrenica. Karadžić is known for his zealous military directives during the war in Bosnia against non-Serb population. One such a directive (issued on March 8, 1995) comes to mind immediately – which was subsequently part of the ICTY trials as Directive 7 – in the context of besieging several small towns in the eastern Bosnia during the war. In Directive 7, Karadžić commanded the following: "[c]omplete the physical separation of Srebrenica from Žepa as soon as possible, preventing even communication between individuals in the two

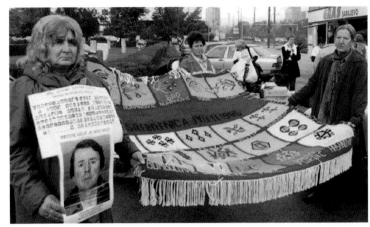

FIGURE 10.2 The Srebrenica Quilt (2007) at the International Criminal Tribunal for the former Yugoslavia (ICTY) at The Hague, Netherlands. Women weavers and human rights activists exhibit their quilt during Radovan Karadžić's opening trial remarks. Courtesy of the Advocacy Project: A Voice for the Voiceless.

enclaves. By planned and well-thought out combat operations, create an unbearable situation of total insecurity with no hope of further survival or life for the inhabitants of Srebrenica".[8] This discursive directive, soaked in lethal rhetoric, generated an equally deadly aftermath. "Words can kill" reminds us Nigel Eltringham (2004) in his reference to the Rwandan genocide, "or at least motivate a person to kill. It is through language that the primal impulses, the likes and dislikes, the hatreds and enmities, the stereotypes and degrading and dehumanizing characterizations of those who are not desirables or rivals for political and economic power or status, are transmitted ... words are the carriers of deeds" (page xii). The chief words that the Srebrenica weavers had center-staged in 2007 – with the Srebrenica Quilt – echoed in silence deadly aftermath of dehumanization. In this visit's context, the quilt was simultaneously a proof of their own struggling with the war-imposed dehumanization of

[8] See the following case no.: IT-04-80-I at: www.icty. org/x/cases/tolimir/ind/en/tol-ii050210e.htm (accessed October 2013).

their own selves and their eradicated family members as well as of mnemonic endurance against what Alexander Hinton (2002, page 29) termed "effectively disseminat[ed] messages of hate" for genocidal purposes.

Hinton (2002) focuses on the discursive constructions of hate as effective preludes for genocide. According to Hinton, genocides are "distinguished by a process of 'othering' in which the boundaries of an imagined community are reshaped in such a manner that a previously 'included' group … is ideologically recast (almost always in dehumanizing rhetoric) as … a threatening and dangerous other – whether racial, political, ethnic, religious, economic, and so on – that must be annihilated" (page 6). The Srebrenica Quilt – one out of fifteen quilts – stands firmly as a mnemonic relic against any potential social transcending of the annihilation consequences. Consequently, bringing the Srebrenica Quilt to the ICTY in 2007 could be viewed as a peaceful assurance that the victims' voices are not only heard, but also *seen*. It embodies both symbolic and tangible defiance to the "othering" processes from the past in a civil mode. If quilt advocacy projects indeed tell stories, than, juxtaposing the opening of Karadžić's trial with the Srebrenica Memorial Quilt allows each – and in most such cases opposing – sides to be heard before the international community regarding the context in question. BosFam's Hadžić has explained in numerous interviews that The Hague should be only one of these quilts' international destinations. In fact, the first quilt (the Weaver's Quilt) and additional memorial quilts have traveled through Europe and the USA regularly as reminders of the fatal and final interruption of these victims' life narrative.

Although the Srebrenica Memorial Quilts aim at remembering a specific group of the war victims in Bosnia, the women's weaving group at the Bos-Fam is not ethnically homogenous. According to its director, Beba Hadžić, the site draws women from all ethnic groups, especially recreating a small-scale and bi-ethnic setting typical of the pre-war town of Srebrenica for dialogue and initial stages of meaningful reconciliation. The "BosFam Srebrenica Memorial Quilt Project," explains Hadžić, "was never for one [ethnic] group of women … [it includes] women from different nationalities". Most post-conflict reconciliation processes are challenging, hardly ever one-dimensional and naturally demand long-term commitments among all involved parties. Erin Daly and Jeremy Sarkin (2007) underscore the importance of language in reconciliation processes: "The language of reconciliation is almost invariably about the past: working through the past (*auferbeitung*), let bygones be bygones, the need for closure, forgive and forget, settling accounts" (page 131). These scholars underscore the language and its complexities when past and present get conflated through memory. Their work exudes a cautionary message, though, for "we should not say that memory of the trauma impedes reconciliation, but that it challenges reconciliation" (page 131). One such a challenge rests with the ability to remember fairly. Tzvetan Todorov – opposing Paul Ricoeur's notion of "duty of memory" – has termed processes of fair or balanced remembrances as "the work of memory" (Todorov, 2003, page 175). In brief, Todorov philosophically calls attention to the importance of assuming an impartial position in relation to the work of memory. "Ritual commemoration," explains Todorov, "when it only confirms a negative image of the other in the past or a positive image of the self, is ineffective as a tool of public education" (page 175). Keeping this in mind, then, certain ritualistic activities among the Srebrenica weavers have demonstrated how such reconciliation challenges can be tackled with more symbolic effectiveness. Engaging in informal and interethnic practices of everyday life such as Bosniak and Serb women's coffee gatherings, weaving, knitting, or conversing, may have earned this nonhomogenous group a unique space in the work of memory. Hadžić refers to it as a practicum for reconciliation, or in her words "reconciliation in the field". If we recall Todorov's claim that "the past can make a contribution to the constitution of

collective and individual identities, and it can support the development of values, ideals, and principles" (Todorov, 2003, page 176), than, such exchanges of everyday life among the women weavers might as well be perceived as a reconciliatory dimension worthy of cultivation.

II. The Aesthetics of Remembrance: Weaving in Comparative Return Journeys

> Those who have a memory are able to live in the fragile present moment. Those who have none do not live anywhere (Patricio Guzmán, *Nostalgia for the Light*).

Atrocities – and subsequent personal testimonies – naturally cut deep across disciplines, inspiring action but also texts, images, music, or performances to keep memory of such atrocities alive. Yet Anne Cubilié cautions that personal testimonies often have notable deficiencies. According to Cubilié, the practice of testimony will "[n]ever be free of controversies over questions of historical veracity and ideological motivation" (Cubilié, 2005, page 8). Such controversies are particularly possible when atrocities are far from the international community's direct lens for immediate confirmation of or engagement with historical veracity. Technological advancements during the last quarter of the twentieth century onward have made international claims of ignorance of on-going atrocities nearly impossible and may have also challenged accepting false witnessing. The global community had access virtually to Rwanda or Bosnia in the 1990s just as it does not lack access to Libya and Syria currently. And certainly Srebrenica was not an exception since its fall into the perpetrators' hands took place simultaneously on the ground as well as on CNN television. While Sidonie Smith's affirmation that "human rights narratives complicate our registers of objectivity" (Smith, 2012, page 634) must be con-

sidered with respect, the case of Srebrenica might be less of a complication on the objectivity front regarding the fallen. In this case, therefore, the Srebrenica weavers and their quilts might have rather a different role, namely "educa[ting] us about the cultures of rescue and the limits of our management of injustice through the human rights regime" (Smith, 2012, page 634). Such "limits of injustice" still continue to manifest themselves among the women weavers from Srebrenica. Weaving of their quilts for many women also signifies waiting for proper burials of their missing family members. The process of finding the missing from Srebrenica is largely directed through the work of the International Commission of Missing Persons (ICMP) in Tuzla. The complexity rests with the fact that certain mass graves were removed after the genocide and their whereabouts remain unknown.[9] In accordance with the ICMP's DNA findings, this removal had slowed down the search and complicated the identification processes of victims due to the intermixing of the decomposed bodies on the second removal.

While different in context and socio-political nature, the Srebrenica weavers have lived through fairly similar personal uncertainties about their missing family members as did the Mothers of the Plaza de Mayo in Argentina during and after the Dirty War (1976–83), and as still do some women of the Atacama Desert in Chile.[10] Such a compara-

9 Secretary Madeleine K. Albright – in her then capacity as United States Permanent Representative to the United Nations in 1995 – issued a statement with photo images regarding the existence of mass graves around Srebrenica on August 10, 1995 during a meeting at the United Nations Security Council.

10 The period from 1976 to 1983 in Argentina is known as the *guerra sucia* or Dirty War led by military generals. It has been estimated that by 1983, close to 23,000 individuals had disappeared in Argentina as political dissidents. Apart from other relevant scholarly work on the Dirty War's trauma and recovery, Taylor (1994) and Robben (2005) embark on a rich interdisciplinary analysis of representation of and cohabiting with socio-political traumas in Argentina. Additional works for all three political contexts of this essay, among others, are Stover (2005), Chaney (1993), Robertson (1999), and Feitlowitz (1998).

tive take is particularly apt when thinking of William Faulkner's remark on survivors from profound traumas in *Requiem for a Nun*. The past, Faulkner reminds us, "is never dead; it isn't even past" (Faulkner, 1951, page 92). If Faulkner's words imply the multidimensionality of affliction survivors persistently carry forward, then the past's pulse is bound to reverberate into the present with an equal persistence. When we juxtapose the mothers (sisters, wives, daughters) of Srebrenica of today and those of Buenos Aires in the late 1970s, the BosFam's weaving center therefore might be what the Plaza de Mayo was initially for the Argentine mothers in terms of women's solidarity and organic human rights activism. Director Hadžić views such weaving gatherings as a kind of women's "self-help center" during which their ethnicity – whether Bosnian or Serb – does not emerge as an obstacle to women's mutually supportive behavior. It might, in fact, remind us of a basic form of altruism. Samuel and Pearl Oliner tackle altruism through a psychological lens. In their estimation, being altruistic essentially first entails practicing genuine inclusiveness. Individuals involved in an altruistic behavior are those whose "ego boundaries were sufficiently broadened so that other people were experienced as part of the self" (Oliner and Oliner, 1988, page 183). Although most Srebrenica weavers are almost exclusively the sole survivors from their Bosniak families, they engage with the women from other ethnicities in an altruistic mode at the weaving workshop. As the processes of locating their family members' missing bodies continues, such altruistic interactions could be viewed as a rudimentary restoration of their social and quotidian existence.

The strength of the women survivors' local support and human rights efforts unquestionably benefit through international solidarity. Another comparative juxtaposition of *las madres* and the Srebrenica weavers comes to mind immediately. *Las madres'* togetherness in human rights activism during and after the Dirty War in Argentina resulted in what Alicia Partnoy has termed the "discourse of solidarity" (Partnoy, 2010, page 10). Partnoy draws attention to the victims' and survivors' resistance to silence, which for *las madres* manifested itself through weaving of texts and their ultimate publications.[11] Partnoy's notion of "discourse of solidarity" has shed light on the need for the victims' and survivor' partaking in threading their history both individually and collectively. Yet as Jo Fisher (1989) confirms solidarity – especially international solidarity – was crucial for bolstering the mothers' altruistic but also sociopolitical positionality at home, which ultimately aimed at solidifying them as an effective human rights community. According to Fisher, "[i]nternational solidarity offered them both the resources they required to continue their struggle and a measure of protection for their own personal position" (Fisher, 1989, page 85).[12] With an altruistic attention from abroad, the mothers further strengthened their peaceful perseverance at home, as Marjorie Agosín writes: "when the sun devours like an irascible accomplice, and we see them

[11] In addition to Partnoy's article, Fisher's (1989) book is another treatise that exposes the mothers' diverse and differing efforts to strengthen their activism's togetherness.

[12] In an interview with María del Rosario, Fisher learns the following: "After the World Cup, when the journalists from all over the world went back with reporters about what was happening in Plaza de Mayo, people abroad began to take more notice of us. A Dutch reporter … wrote a big article on us in the newspapers and in 1978 our first support group was established by the women of SAAM, which in Dutch stands for Solidarity with the *Madres de Plaza de Mayo*. The wife of the ex-prime minister, writers, journalists and artists all joined and there was a singer who recorded a song about us to raise money. This was our first financial help. In France people began demonstrating outside the Argentine embassy in support of our struggle. After that solidarity groups were set up all over Europe and in Canada, organizing events, raising money. Financially, we have managed only because of foreign support" (Fisher, 1989, page 85).

together with their heads covered by kerchiefs they resemble hallucinatory doves that shine in the middle of a nebula and appear singing prayers of life" (Agosín, 1992, page 5). Having taken to the streets with their white handkerchiefs, sown in with the names of their disappeared children's names and birthdays, *las madres* assured that "the middle class parties finally developed enough backbone to follow up the earlier protests of the Mothers of Plaza de Mayo" (Brown, 2003, page 248). Finally, Antonious C.G.M. Robben's perception of the mothers' activism is equally relevant. Robben comments on the symbolic significance of *las madres*' collective activism: "these women moved their sorrow from the intimacy of their home to the most coveted square in Argentina and thus undermined the authoritarian state's control of public space. The public protest was an exteriorization of personal pain and the first open manifestation of a social trauma suffered by thousands" (Robben, 2005, page 301). While *las madres* marched publically as to collectively seek information about the whereabouts of their disappeared – who initially believed to be alive – the Srebrenica mothers have reached out nationally and internationally through their weaving workshop regarding the fate of their family members' remains. The weavers' efforts garnered even more visibility through another international and aforementioned venue: the Advocacy Project (AP). According to

its mission, AP "helps marginalized communities to tell their story, claim their rights and produce social change" globally.[13] And just as *las madres* gained their first financial support from abroad through the officially overt support group in The Netherlands (i.e. Solidarity with the Mothers of Plaza de Mayo or SAAM), the Srebrenica weavers have stayed linked with AP for financial and advocacy assistance regarding their aesthetic representations of the genocide aftermath through personal and group memory. Unlike most Argentine *madres* in the 1970s, whose children's corpses were rarely recovered due to the death flights, numerous Srebrenica women weavers continue to commemorate yearly at the Potočari Memorial Cemetery by burying those whose remains continue exhumed.[14] As such, 540 newly identified victims were buried on the seventeenth anniversary of the genocide on July 11, 2012.

Yet some Srebrenica victims' fate might forever remain unsettled. Such an unsettlement links the Srebrenica weavers' search for their missing ones – perhaps in an empathetic way – closer to another site in Latin America: the Atacama Desert. The Atacama Desert, abundant in salt and felsic lava, served as a damp site for the assassinated bodies of numerous political prisoners from Chile during the Augusto Pinochet dictatorship (1973–90).[15]

[13] AP furthermore explains its involvement as follows: "We have also worked together to produce and exhibit Bosfam's memorial quilts, which were woven by Bosfam members to commemorate relatives lost in the genocide. These carpet and quilt exhibitions have raised over $80,000 for Bosfam. The quilts have been used to make the case for justice and were shown at the trial of Radovan Karadžić in The Hague. Bosfam's weavers have also inspired women and children in nine other countries to produce advocacy quilts, as described elsewhere on these pages. Beba has visited the US twice to show the quilts to the Bosnian diaspora" (http://advocacynet.org, accessed October 2013).

[14] Death flights were part of the military junta's systematic campaign aiming at kidnapping, torturing, and murdering political dissidents during the Dirty War in Argentina and ultimately disposing of their bodies into the ocean. In terms of the Mothers' international support, SAAM is just one salient example. Different international involvements in the human rights efforts across Argentina is also discussed by Crenzel (2012). Taylor points out different strategies *las madres* undertook in efforts to learn what happened during the Dirty War. As such, "a large number of the Madres of the Plaza de Mayo continue the practice of keeping the disappeared 'alive,' refusing to participate in the exhumation and identification of their children's corpses, in an effort to bring the perpetrators to justice" (Taylor, 1997, page 140).

[15] See Collier and Sater (1996). Guzmán's (2011) tackles certain traces of the surviving women's search for their family members' remains across the Atacama Desert.

Several women survivors across Chile continue to visit the desert in search of their family members' remains. Just as the dry deepness of the Atacama Desert holds the grisly secret from the recent Chilean past, the mud-saturated bottom of Lake Perućac has proven to hold the remains of victims from Višegrad as well as Srebrenica. The *International Justice Tribune* has referred to Lake Perućac as a "watery grave" in 2010, which underwent hydroelectric maintenance in July of 2010 and revealed "the largest mass grave in Europe: (54 km long and 1,100 m wide)" (International Justice Tribune, 2010, page 1). Lake Perućac rests on the border between Bosnia and Serbia and is unlikely to be drained for another 50 years. The Bosnian Missing Persons Institute confirmed that "between 700 and 1,000 bones were found" and "[s]ome could also be victims of the massacre at Srebrenica in July 1995, when the Serbian army killed over 8,000 people, mostly men and boys." The inability to locate the remains of the missing defies one interpretation regarding the affected ones' ability to reconcile. Yet these hindrances to continue the search certainly delay the reconciliatory efforts regardless of the cultural setting. One could view such a hindrance as an assault at humanity and memory; the ultimate form of tragedy. Todorov's perception of tragic occurrences is particularly apt here, for tragedy is "the impossibility of good: a place whence every path leads to tears and to death" (Todorov, 2003, page 147). The failure to locate the remains of the missing turns the act of having perished into an agonistic daily presence for the survivors.[16] Establishing meaningful ties between aesthetic representations and the field of human rights helps to mitigate against the possibility that the unresolved victims' fates will slip into historical oblivion at home and abroad.

III. Transmitting Memories, Restoring Dignity: Survivors-in-waiting

The Srebrenica Quilt weavers' work sheds light on their own collective identity in the context of the genocide's aftermath. These women's threading of the personal losses also keeps them locked in a double-witness mode, whereby their quilts confirm the brutal demise of their family members, their own survival as well as their war-imposed otherness in Hinton's terms. The violence committed against the Srebrenica survivors' family members naturally continues to shape their evolving post-war identity. Jeffrey Alexander (2012) might prove helpful here for elucidating on the war-produced identity traits for this group in particular. In his study, Alexander tackles the processes of restoring collective well-being in post-traumatic societies. According to Alexander, "individual security is anchored in structures of emotional and cultural expectations that provide a sense of security and capability. These expectations and capabilities, in turn, are rooted in the sturdiness of the collectivities of which individuals are part" (Alexander, 2012, page 15). Any threat to the "meaning" of collectivity's identity, further suggests Alexander, confirms a traumatic exposure. In brief, traumas – especially cultural traumas – materialize when the collective identity's core becomes threatened. More specifically, trauma is "the result of this acute discomfort entering into the core of the collectivity's sense of its own identity" (page 15). Writing about traumas in the Srebrenica context – for the victims as well as perpetrators – might appear rather a superfluous or an even overtly obvious effort. Yet the BosFam memorial quilts, stemming from individual memory and creativity efforts, appear to aid in piecing together portions of this group's collective memory but also reshaping of their personal

[16] One might consider the survivors' interviews in Portillo and Muñoz (1985) in conjunction with Herman (1994) regarding discussions on the challenges both traumatic experience and recovery stages entail. In the context of Srebrenica, see an interview-based article by Selimović (2011).

and collective identities. With the Srebrenica's fall (July 15, 1995), this social group was not only dehumanized through the military rhetoric and killings but also had lost most of its "sturdiness of the collectivities" that might have kept it linked to their own ethnic communities across Bosnia. This community's collective trauma might need to be viewed as that which Kai Erickson defines as "a blow to the basic tissues of social life that damages the bonds attaching people together and impairs the prevailing sense of communality" (Erikson, 1972, page 154). In other words, while Bosnia and Herzegovina as a whole was still at war in July 1995 Srebrenica was – in Maurice Halbwachs' terms – collectively and acutely "othered" through mass murder.

Halbwachs (1992) states that individual memory nearly always remains dependent on collective or group memory. For Halbwachs, individual memory is "nevertheless a part or an aspect of group memory, since each impression and each fact, even if it apparently concerns a particular person exclusively, leaves a lasting memory only to the extent that one has thought it over – to the extent that it is connected with the thoughts that comes to us from the social milieu. One cannot in fact think about the events of one's past without discoursing upon them" (Halbwachs, 1992, page 53). The Srebrenica Memorial Quilts have emerged meaningfully from among mostly the genocide survivors – one particular group – but with the individually remembered pasts of the fallen victims. The weavers' work – and discourse – therefore underscores the importance of both their collectivity as well as their individual agency. These weavers' memorial collectivity exists *vis-à-vis* the genocidal acts most of their group members had lived during and subsequent to their family members' demise. The weavers' memory therefore is kept alive through their collective experience as well as individual contributions. As such, one must not overlook the importance of the individual agency by Wulf Kansteiner (2002). Kansteiner underscores the importance of "an aggregate of individual memories which behaves and develops just like its individual composites," which is termed as "collected memories" (page 186). Quilting at the BosFam centers, though, instills a meaningful consensus regarding their shared post-war identity trait of rudimentary carriers of human rights advocacy. As this identity trait continues to harden on their shattered selves, one might also sense these women's search for the pre-war normalcy of every day life: social gathering, conversing, coffee meetings, or in Michel de Certeau's terms "the practice of everyday life" (de Certeau, 1984, page xx). Their weaving practices may have served as a reestablishment of social order and routine, even if displaced and in perpetual mourning.

Remembering the massacre in the context of Srebrenica might be one of the most effective ways for reaching out into the pre-war life narratives of these women weavers and their families. The act of remembering prevents that these survivors become utter social shells of their former selves without any ability to reconstitute the universe of history and heritage from where there were expulsed. Upon reading the AP's identification profiles on each panel of the decimated victims, we realize that most surviving women lost more than one member of their immediate family, as is the case with the Hodžićs, the Mehmedovićs, among many other families. In some cases, though, entire immediate families were annihilated. The families Nuhanović (except for their son Hasan Nuhanović) and Dudić were eradicated in their entirety; the former including both parents and their son; the latter pregnant wife and her husband. Alexander seems to suggest that "trauma will be resolved not only by setting things right in the world, but also by setting things right in the self" (Alexander, 2012, page 10). For families such as Nuhanović and Dudić, the latter remains unattainable. In such situations resolving trauma posthumously appears unarguably superfluous, but maintaining their life narratives away from oblivion morally indispensable. The act of forgetting – the historical affliction of July 1995 – risks disconnecting the survivors from the ethnically heterogeneous

life narrative before the war. The act of meaningful remembering, then, reconfirms these weavers' current collective identity of survivors-in-waiting, even if several of these women weavers have completed their wait by identifying and burying the remains of their missing family members. At a basic level, their collective evolving identity stems mainly from the mobilization of the filaments of their personal memory.

Such filaments spell the need for justice for these individuals. Yet justice is a multifaceted, elusive, and culture-specific manifestation in post-conflict societies. According to Daly and Sarkin (2007), justice "is an aspiration continually to be striven for, a process to be committed to, but not a status that has been achieved" (page 169). Justice is inevitably at the complex mercy of those who do remembrance or practice forgetting as lived and represented in both Chile and Argentina. In the context of the Srebrenica weavers, though, seeking justice might be echoing Professor Jasna Bakšić Muftić's words: [a]fter all kinds of crimes and genocide, the people need some sort of satisfaction … that someone guilty be punished" (quoted in Orentlicher, 2010, page 13). These women's act of waiting stretches beyond the physical possession or confirmation of the victim's remains. This group also weaves into their panels their wait for seeing justice at work. In 2010, the former Serbian President Boris Tadić attended the fifteenth anniversary of the Srebrenica genocide at Potočari Memorial Cemetery and pledged to apprehend alleged war criminals believed to be hiding in Serbia. Such promises and their fulfillments assist the war-torn societal fabric to avoid falling deeper into perilous dualities of justice that "pits victims against perpetrators, right against wrong, the deserving against the undeserving" (Daly and Sarkin, 2007, page 171). This approach also disallows imposing the perpetrator's culpability onto the entire group he or she is associated with ethnically, religiously, or ideologically. The weavers' workshop has taken this stance toward that which Daly and Sarkin (2007) considered "individualizing guilt"

(page 175) seriously within their quilting quarters, threading in company of those whose memory filaments might differ in psychological wounds or the sense of victimhood.

The Srebrenica Memorial Quilts remain mnemonic sites of symbolic, cultural, and often contentious exchanges regarding a tragic political past. Their contentious nature might rest with exposing strictly personal remembrances. Yet personal remembrances stay essential for (re)construction of collective and historical memory as Paul Celan eloquently reminds us: "No one / bears witness for / the witness" (quoted in Kaminsky, 2013). And restoring collective societal vigor in Srebrenica – and by extension across the nation – depends largely on coming to terms with veracities of that past. In Alexander's terms, collective restoration depends on "lifting societal repression and restoring memory" (Alexander, 2012, page 12). The Srebrenica weavers and genocide survivors' efforts can be considered as an indispensible part of such social "lifting" processes while preserving that which Thomas Cushman had called "a vivid memory of a form of barbarism unmatched in Europe since World War II" (Cushman, 1996, page 2). These artifacts indeed persist vividly in restoring personal – and inevitably contributing to collective – memory even if the latter's transmission across different ethnic groups in Bosnia and Herzegovina remains sluggish or still at odds. Despite the inevitable incongruities among individual, collective, and historical memory, the Srebrenica Memorial Quilts in their entirety ultimately unfold as material and symbolic relics from an interethnic social space of threads, conversations, and rudimentary women's human rights efforts.

Bibliography

Agosín, Marjorie (1992) *Circles of Madness*. New York: White Pine Press.

Agosín, Marjorie (1996) *Tapestries of Hope, Threads of Love*. Albuquerque, NM: University of New Mexico Press.

Alexander, Jeffrey (2012) *Trauma: A social theory.* Cambridge: Polity Press.

Brown, Jonathan (2003) *A Brief History of Argentina.* New York: Facts on File.

Chaney, David (1993) *Fictions of Collective Life: Public drama in late modern culture.* London: Routledge.

Collier, Simon and Sater, William (1996) *A History of Chile, 1808–1994.* Cambridge: Cambridge University Press.

Crenzel, Emilio (2012) *Memory of the Argentina Disappearance: The political history of Nunca Más.* London: Routledge.

Cubilié, Anne (2005) *Women Witnessing Terror: Testimony and the cultural production of human rights.* New York: Fordham University Press.

Cushman, Thomas (1996) Introduction, page 2, in Cushman, Thomas and Meštrović, Stjepan, eds. *This Time We Knew: Western responses to genocide in Bosnia.* New York: New York University Press.

Daly, Erin and Sarkin, Jeremy (2007) *Reconciliation in Divided Societies.* Philadelphia, PA: Pennsylvania University Press.

de Certeau, Michel (1984) *The Practice of Everyday Life.* Berkeley, CA: University of California Press.

Eltringham, Nigel (2004) *Accounting for Horror: Post-genocide debates in Rwanda.* London: Pluto Press.

Erikson, Kai (1972) *Everything in Its Path.* New York: Simon & Schuster.

Faulkner, William (1950) *Requiem for a Nun.* New York: Random House.

Feitlowitz, Marguerite (1998) *A Lexicon of Terror: Argentina and the legacies of torture.* Oxford: Oxford University Press.

Fisher, Jo (1989) *Mothers of the Disappeared.* London: South End Press.

Guzmán, Patricio (2011) *Nostalgia for the Light.* (*Nostalgia de la luz.*) Directed Patricio Guzmán. Icarus.

Hadžić, Beba (2012) Interview. "BOSFAM Srebrenica Memorial Quilt Project." 28 June 2012. Web (accessed February 2013).

Halbwachs, Maurice (1992) *On Collective Memory.* Chicago, IL: University of Chicago Press.

Herman, Judith (1994) *Trauma and Recovery: The aftermath of violence – from domestic abuse to political terror.* New York: Basic Books.

Hinton, Alexander (2002) The dark side of modernity: Toward an anthropology of genocide, pages 1–40 in Hinton, Alexander, ed. *Annihilating Difference: The anthropology of genocide.* Berkeley, CA: University of California Press.

International Justice Tribune (2010) Lake Perućac's watery grave. 6 October 2010. Web (accessed February 2013).

Kaminsky, Ilya (2013) Of strangeness that wakes us. *Poetry* January, pages 469–78.

Kansteiner, Wulf (2002) Finding meaning in memory: A methodological critique of memory studies. *History and Theory* Volume 41, pages 179–97.

Leydesdorff, Selma (2011) *Surviving the Bosnian Genocide: The women of Srebrenica speak.* Bloomington, IN: Indiana University Press.

Mann, Michael (2005) *The Dark Side of Democracy: Explaining ethnic cleansing.* Cambridge: Cambridge University Press.

Mousavizadeh, Nader (1996) *The Black Book of Bosnia: The consequences of appeasement.* New York: Basic Books.

Oliner, Samuel and Oliner, Pearl (1988) *The Altruistic Personality: Rescuers of Jews in Nazi Europe.* New York: Free Press.

Orentlicher, Diane (2010) *That Someone Guilty Be Punished: The impact of the ICTY in Bosnia.* New York: Open Society Justice Initiative.

Partnoy, Alicia (2010) Textual strategies to resist disappearance and the Mothers of Plaza de Mayo, pages 221–31, in McClennen, Sophia and Morello, Henry James, eds. *Representing Humanity in an Age of Terror.* West Lafayette, IN: Purdue University Press.

Portillo, Loudres and Muñoz, Susana B. (1985) *Las Madres de Plaza de Mayo.* Directed by Susana B. Muñoz and Lourdes Portillo.

Ricoeur, Paul (2004) *Memory, History, Forgetting.* Chicago, IL: Chicago University Press.

Robben, Antonius C.G.M. (2005) *Political Violence and Trauma in Argentina.* Philadelphia, PA: University of Pennsylvania Press.

Robertson, Geoffrey (1999) *Crimes Against Humanity: The struggle for global justice.* London: Penguin Books.

Roniger, Luis and Sznajder, Mario (2012) Human rights and human rights violations in the Southern Cone, pages 702–18, in Cushman, Thomas, ed. *Handbook of Human Rights.* London: Routledge.

Schaffer, Kay and Smith, Sidonie (2004). *Human Rights and Narrated Lives: The ethnics of recognition.* New York: Palgrave.

Selimović, Inela (2011) A note from Bosnia and Herzegovina: Leading a displaced life. *Human Rights Quarterly* Volume 33, Number 2, pages 397–407.

Smith, Sidonie (2012) Cultures of rescue and the global transit in human rights narratives, pages 625–36, in Cushman, Thomas, ed. *Handbook of Human Rights.* London: Routledge.

Stover, Eric (2005) *The Witness: War crimes and the promise of justice in The Hague.* Philadelphia, PA: University of Pennsylvania Press.

Taylor, Diana (1994) *Negotiating Performance: Gender, sexuality and theatricality in Latin/o America.* Durham, NC: Duke University Press.

Taylor, Diana (1997) *Disappearing Acts: Spectacles of gender and nationalism in Argentina's "Dirty War."* Durham, NC: Duke University Press.

Todorov, Tzvetan (2003) *Hope and Memory.* London: Princeton University Press.

"Stitch a Square of Colour on the Darkness": Reflections on Quilting in Ireland

E.M. O'CONNOR

THE STORYTELLING TRADITION IS strong in Ireland. From the Gaelic oral histories guarded by the *seanchaithe*,[1] to the legendary *Cattle Raid of Cooley*[2] to James Joyce's transplanting of Homerian epic on Irish soil in *Ulysses*, the Irish have long held the art of the narrative in the highest regard. To tell a story is the ultimate form of creative expression and at the core of national identity. Yet there is another Irish tradition, also a time-honored skill, a different way of storytelling. But unlike the giants of the established literary canon, this tale's teller is more than likely a woman. This woman performs not the proverbial weaving of threads but the cutting-out of stories from the fabrics of everyday life, making something new from the worn materials that layer our life with meaning, and keep our lifeblood with their warmth. This is a quieter, less-lauded, often communal endeavor that preserves memories and reveals hidden histories. It is an expression of resourcefulness and the will to survive, as well as aesthetic sensibility. This storytelling art began as a craft that was common to Irish women of all classes and creeds. It began as a housewifely skill called quilting. For as this chapter attempts to reveal, Irish quilts indeed tell Irish stories, narratives as creative and distinctive as the women who cut the cloths, arrange the pieces in a pattern and thread the needles.

As a first-generation Irish-American, I approach the history of quilts in Ireland with the care and reverence of one who opens an album of photographs in sepia. Quilts are time capsules, historic documents which mirror the moment in which they were created, as well as the religion, class, and economic statuses of the women who stitched their stories together, whether seated in grand parlors, at modest kitchen tables, or taking rest along the well-worn road bound for the immigrant ship in the bay. This chapter is the result of my search for the histories, both national and individual, stitched upon the quilts of the Irish. On this journey both academ-

[1] The *seanchaithe* were historians and storytellers. Until the British victory at the Battle of Kinsale in 1601, Ireland had an elite class of professional storytellers who were financially maintained by Gaelic chieftains. These storytellers were divided into different ranks, including teachers, poets, lesser-ranked poets called bards, and the *seanchaithe* historian-storytellers. Under British colonial rule, these storytellers were assimilated, alongside their chieftain patrons, into the ranks of Irish commoners. Their knowledge still was prized, however, and their tradition passed on from generation to generation. Today, the term *seanchaithe* is used more generally to denote those with knowledge of ancient lore who maintain the oral tradition. See Ó Súilleabháin (1973).

[2] An epic of early Irish literature, *The Cattle Raid of Cooley* (in Gaelic, *Táin Bó Cúailnge*) narrates the war waged by Queen Maeve of Connaught against her former husband, King Conchobar mac Nessa of Ulster. The proud Maeve is bound to steal his bulls so she can make good on her boast to her present husband, Ailill mac Máta, that she has more cattle than any king in all of Ireland. The hero of this legend is Ulster's young warrior Cú Chulainn.

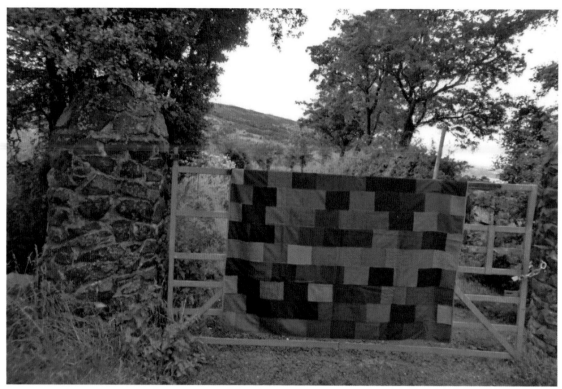

FIGURE 11.1 Quilt made from wool suiting from the Roselind Shaw collection.

ic and personal, I read Irish quilts as living texts, their every fiber alive and imbued with all the ideas, ideals, and observations of their creators. I discovered the ways Irish quilters – until only the past twenty years considered practitioners of a domestic craft that was the exclusive and in many aspects, *excluded*, realm of women – respond to their immediate environs as well as to the spirit of the times in which they live and work.

As a writer and teacher of literature, I began my study of the Irish quilting tradition by returning to a literary trope which always has appealed to me, namely patchwork as metaphor, and exploring the place quilts hold in the imaginaries of numerous Irish writers. A particular favorite of mine is the Northern Irish poet Michael Longley. His verses on the page often resemble long, rectangular quilts fashioned from words arranged in a pattern, and he employs the image of the quilt considerably in his poems.[3] Indeed, he celebrates them as an art: "Although they were intended for everyday use, sometimes these quilts turned out to be artistic masterpieces … these modest anonymous geniuses … spent long evenings with needle and thread, between household chores, and in the midst of familial hubbub. In their designs and patterns they reflected their lives as farmers, their religious festi-

3 In particular, *The Weather in Japan* (Longley, 2000) contains a number of poems about quilts, many with domestic-inspired titles such as "Broken Dishes" and "The Yellow Teapot," in which Longley offers the reader a final stanza which is also "a quilt of quilt names to keep you warm in the dark."

vals, the seasons, the countryside."[4] Longley's "The Quilt," considers the "dark" – not only the physical, that of the night in which the narrator arrives to "your little house," but also that "dark" which is a common occurrence in the human experience: the darkness of caring for "your ill father" or mourning "my daughter's broken – no" (Longley, 1995). In this poem, the quilt offers a place on which to cry, to lament familial "patterns repeating" while simultaneously finding comfort in the quilt's familiar pattern, covering "the old iron bed you brought over from Tralee." Longley breathes life into the stirring metaphor of the quilt: "we/ Stitch a square of colour on the darkness, needle- / Work, material and words." And healing, like the falling of soft snow or sleep, does indeed arrive in the end: "instead of snow the bushes/ Wear quilts left out all night to dry, like one enormous/ Patchwork spring-cleaned, well-aired, mended by/ morning." The words "stitch a square of colour on the darkness" speak to the place of quilts in the Irish imaginary as remedies for darkness of all kinds, both physical and metaphorical. It is my hope that this chapter elucidates some of the patterns, the colors, and the fabrics lifted from lives and quilted upon the background of histories, both those of individuals and that of the island of Ireland.

Sometimes the darkness a quilt covered could be that of the ultimate shadow, that of death. As a Gaelic poem composed in 1773 attests, quilts were imbued with a special significance. They warmed loved ones and thus guarded, perhaps even restored, life.

My steadfast love!
Arise, stand up
and come with myself
and I'll have cattle slaughtered
and call fine company
and hurry up the music
and make you up a bed

with bright sheets upon it
and fine speckled quilts
to bring you out in a sweat
where the cold has caught you (Ó Tuama, 1981).

Eibhlín Dubh Ní Chonaill, or, dark-haired Eileen O'Connell, wrote this famous lament when her 26-year-old husband Art O'Leary, a member of the dwindling Catholic gentry, was shot by an Englishman for refusing to sell the man his prizewinning horse for less than £5, as the Penal Laws[5] required. The keening song Eileen composed is widely considered the most important of the eighteenth century in the Irish canon, and "one of the great cries of grief and rage in any language" (Flanagan, 1988). The darkness being fought here is the "cold that has caught you," a metaphor for death. Notice the power given to the quilt – to bring the still-warm body into a life-restoring sweat.

Indeed, the significance of a warm bed to the Irish mind is not to be downplayed. Hospitality has been important in the Irish tradition since the times of the Gaelic chieftains. Even when there was no bed, "reeds and fresh rushes were commonly strewn upon floors for the comfort of guests … to sleep were provided, feather beds, quilts and pillows."[6] Eileen may have made the quilt she keens of in preparation for

[4] "The Poet Speaks: Some comments by Michael Longley on his own poetry." http://resources.teachnet.ie/ckelly/poetspeaks.htm (accessed October 2013).

[5] The Laws in Ireland for the Suppression of Popery, commonly called the Penal Laws, were enacted by the British in colonial Ireland in 1691 in order to consolidate their power as the ruling class. As religion was a distinguishing feature between colonizer and colonized, The Penal Laws denied political, economic and religious rights to Catholics, resulting in poverty and marginalization of Ireland's native sons and daughters. The Penal Laws were upheld well into the nineteenth century. See http://library.law.umn.edu/irishlaw/intro.html (accessed October 2013).

[6] Hospitality was one of the most important virtues among the medieval Irish. It was also a universal right, protected by religious and secular law. Chieftains demonstrated their greatness through the welcomes they bestowed upon guests. The ability to measure a person's honor through generosity to visitors reflects the ancient Greek values found in the *Odyssey* and *Iliad*. And, as in Homer's epic poems, inhospitality in Ireland could be harshly punished by the gods. Doors were opened, tables lavishly set, and beds strewn with warm quilts to ward off retaliation from the supernatural realm. See O'Sullivan (2004).

her marriage to Art O'Leary. Ironically, she could have learned its pattern from the wife of the man who murdered her husband.

It is generally accepted that patchwork quilts[7] came to Ireland by way of the English aristocracy. According to Roselind Shaw, a quilter, historian and collector of antique quilts for over twenty years, the patchwork quilt tradition in Ireland originated from the country estates, known commonly to this day as "the big house," where ladies taught needle skills to the women who worked for them. These women took their newfound craft home, and it "spread to surrounding cottages, villages and towns …" where it "thrived and grew rapidly out of thrift and necessity."[8]

Each piece of an Irish quilt contains a story. Often times, these are the stories of a community in addition to those of an individual. Quilting was, and continues to be, a social activity. Neighbors would gather at a house for a quilting party, a lively forum often used for matchmaking. As in many cultures, mothers made quilts as wedding presents for their daughters. Girls also made them to line their own "bottom drawer" where they collected the domestic items they would bring to their new home when they were married.[9] But most quilts, at least those made by common folk, were made for immediate use to answer an immediate need – warmth. Irish quilters often made do with the scant materials they had on hand. This is evidenced by the fact that many antique Irish patchwork quilts have only the top and bottom layers: only the mistress of the big house could afford to line a quilt with wool, while her husband's tenants would have put it to another use, such as knitting a sweater to guard against the damp cold. In the bleakness of Connemara mountain winters, a woman named Margaret Moran, my great-grandmother, perhaps would have used a worn blanket or threadbare sheet as a layer for extra warmth on a quilt. Shaw says such antique patchworks appear "rough and primitive," as they "were purely functional made from hand woven fabrics" such as tweeds and old suiting, and "usually tie quilted with carded sheep's wool or roughly quilted with linen thread" (see Shaw, n.d.). But, as my Nana also worked for the Thomas family of Leenane as a maid and a cook in the big house, she might have obtained scraps of finer fabrics, castoffs from her mistress, and used them to decorate her quilts.

[7] The classic definition of a quilt is a bottom layer of fabric, a layer of filler, and a top layer of fabric held together by stitching which pierces all layers, done in a pattern. Both these stitches and the act of rendering them are called quilting. In "A Quilt and Its Pieces," Colleen R. Callahan enumerates various styles of bedcovers typically called quilts in Ireland, although they diverge from the strict definition above. These include: two covers quilted together without filler; three layers held together by "tufting," or threads which emerging from the top in short, fluffy pieces; and unstitched bedcovers, the tops of which are made of pieces of fabric arranged in a design and attached by small stitches on a background cloth, and are thus called patchwork quilts. Unquilted covers such as these, in which patches are attached by small stitches in a design on a background cloth, are called appliqué coverlets and the technique is called appliqué or applied work. Another technique is inlaid work, when shapes are cut from a cloth and then patches of different fabric and colors are sewn underneath the cutouts. Patchwork quilts are considered the most authentic. They are made by "piecework," or cutting various geometric shapes from different fabrics and putting them together like a puzzle to form a new cloth, which serves as the top cover of the quilt. In this chapter, the terms patchwork and quilt include all the designs and techniques enumerated above.

[8] I am very grateful to Roselind Shaw for her generosity with her knowledge and time. Without our transatlantic correspondence, I never would have realized how unfolding a quilt is much like opening an ancestor's trunk that was hidden away in an attic for centuries. See Shaw (n.d.).

[9] A primary reason quilts are communal endeavors is because the word *quilting*, which Jones (2003) defines as the sewing that penetrates all layers of fabric and holds them together, is an activity that needs more than one pair of helping hands. Quilting is traditionally performed in a six-square-feet frame composed of two sides and two lathes. The top of the quilt is sewn to one side of the frame and the bottom to the other. Six or eight quilters work at once, sewing from the outside inwards to about eighteen inches in and then the quilted surface is moved around in the frame so the unquilted cloth is in sewing reach.

Women sewed patchwork to make bedcovers – quilts to warm their sleeping children at night and keep the sheets beneath them clean during the day. Patchwork served this practical purpose, but even if the "bed" was merely hay piled upon a dirt floor, quilts had an aesthetic function too. In making a quilt, women found an outlet for creativity. Even among the poorest women, whose primary concern was a warm place for their family to sleep, there also existed the awareness that their creation would be *seen* as well as used. Especially among the aristocracy, who were not concerned with basic survival, the aesthetics of their creation were as important as its function.[10] But even the farmer's wife might chose to add her favorite color or a symbol of familial significance, making use of the materials at her disposal in order to personalize her quilt. She had before her a blank page and wrote her story by selecting visual elements. Indeed, shapes and stitches, borders, and linings all serve as symbols – as alphabet, genre, and text. Even when following a pattern, as most quilters did, she added her own touches to the borders, flowers, and birds,[11] thus capturing her unique vision of a place and a point in time which otherwise would be forgotten. For each quilt is a composite of fabrics that function as memories, pieces of the past fit together to create a story as unique as the fingerprints on the hands that cut and stitched its patches.

Irish quilts tell the stories of the homes and hills in which they were made, as well as the hearts patiently hovering above the hands that swiftly sewed them. For quilts are intimate portraits of creativity and industry which to my own eyes are more revealing than a daguerreotype. And Irish quilts are history, valuable recorders of the social histories of otherwise marginalized communities. When I first returned to my family home in Connemara, I caught my breath as I watched from the window as the plane hovered above Shannon Airport. It was the almost unearthly shades of green that brought tears to my eyes, but I also remember marveling at how the hills resembled patchwork. Indeed, the island looks this way in great part due to the fragmentation history wrought upon its landscape. So too, history created the social conditions which influenced the fabrics and styles women both rich and poor chose to make their quilts. Literally and metaphorically, quilts are layered and pieced together from the fabric of daily life.

Each Irish quilt tells about the lives led by those who stitched its colors. And, as I learned from Roselind Shaw, a quilt also gives us an intimate glimpse of the quilters' characters. Admiring the thrift and ingenuity that went into the quilts made by working class and tenant farmers in Ireland, she describes how her great-grandmother "made sacks from ticking, material used to cover a mattress, which she filled with chaff, worthless husks of corn … The family slept on these covered with patchwork quilts" (Shaw, n.d.). The values and stories held within the squares and stitches are varied indeed, as women of all social classes, Catholic and Protestant, quilted. Laura Jones, former head of textiles at the Ulster Folk and Transport Museum, notes that "in a country noted for strife and division it [patchwork] was common to all women and was made equally enthusiastically in the drawing rooms of Anglo-Irish ladies, in the farm parlours of Ulster Presbyterians and in the cabins of labourers in Connemara" (Jones, 2003, page 38).

The latter was my great-grandmother, and the quilts she made to keep her daughter warm utilized, as already mentioned, a miscellany of materials: pieces of old tweed, men's wool suiting, and fabrics of different weights and textures from her employ-

[10] The craft was a pastime for ladies; quilting filled their leisure time as did painting watercolors, playing the pianoforte, or embroidering lace.

[11] Laura Jones notes that the earliest surviving patchwork quilts prominently feature both flowers and birds, often done in red and white. Red, as the dye was readily available, and white, as many quilts were made from bleached flour bags (Jones, 2003, page 41). Indeed, necessity acted as the mother of creativity.

ers' worn dresses. It is likely she quilted at least one in the "log cabin" style, cut into rectangular strips and placed around the sides of a central square on background sturdy enough to hold heavy fabrics.[12] These quilts were not the most striking in terms of intricacy of pattern or delicacy of materials, but they exemplify the ingenuity of their makers and speak to the place of quilts in the history of immigration, one of the most significant chapters in modern Irish history. One of the pieces of evidence scholars use to link the log cabin style to immigration to the USA is the large number of examples from that style beginning with *An Gorta Mor*, the catastrophic and, shamefully, preventable Great Hunger.[13] On their way to the "coffin ships," so-called because so many died of disease aboard, Irish immigrants, the majority bound for the USA, tied their scant possessions in patchwork and slung them over their backs. According to Roselind Shaw (n.d.), other hungry exiles made patchworks on route. Shaw has read letters from immigrants who washed their quilts on the beaches and laid them on the rocks to dry immediately after their journeys on the ships had ended – one of the first things they did in the "new world." She also has found letters telling of patch-

work quilts being sent to the USA for wedding presents and others to young immigrants to warm their beds in faraway lands, and notes that many of the patterns found in Irish patchwork are very similar to US patterns. "Nostalgic emigrants whose thoughts lay in the green fields of Ireland stitched their Irish patterns in the new world" and also "sent ideas back to their homeland."

In keeping with tradition, the sharing of quilts and patterns across the Atlantic was done by women. And what of those Irish women still at home, those who had survived or escaped hunger? Had anything changed for women and quilting after the tragedy of hunger and exodus had changed the course of Irish history? While many Irish textile traditions, such as weaving, spinning, dyeing, or knitting, were the work of both men and women, patchwork still was almost exclusively done by women and considered a housewife's skill (Jones, 2003). In the waning years of the nineteenth century, one privileged woman, Geraldine Ponsonby, wife of the Seventh Earl of Mayo, saw an opportunity in the fact that quilting was considered women's work at a time when the nationalist movement in Ireland was becoming increasingly tied to the arts. Lady Mayo already had witnessed the communal aspect of quilting stretch beyond the scope of women gathering at a neighbor's house to stitch: with the introduction of National Schools[14] by the British govern-

[12] There is a dispute over the origins of the "log cabin" style. Irish women could have received the pattern in letters from family members in the USA, or from women's magazines. The latter half of the nineteenth century, corresponding to both a great rise in immigration and increased literacy as well as access to, and a proliferation of, women's magazines, is the time period from which most log cabin quilts survive. Jones (2003, page 41) notes, however, that this is not definitive proof that Irish log cabin quilts were not made at an earlier time, only that we do not know of any existing now.

[13] Also erroneously called the Potato Famine. There was a potato blight, but Ireland had food that was not reaching the majority of its people. In the Great Hunger, approximately 1.5 million died of starvation or related diseases between 1845 and 1850. By 1855, over two million had immigrated.

[14] One of the most interesting perspectives on the impact of the establishment of National Schools to replace the so-called "Hedge Schools," which were established in the countryside in response to the Penal Laws forbidding teaching in Gaelic and were initially held in hedges or in rocky enclaves on hills, is the play *Translations* (1980) by Brian Friel. The playwright was a key a participant in the Field Day movement, a second Celtic revival of sorts with the added motive of fostering a dialogue space between Protestants and Catholics, unionists and republicans, through culture. For historical background on National versus Hedge schooling, see Regan (1992).

ment in 1831, education commissioners as well as what Jones calls "philanthropic landlords" had been encouraging tenant farmers and other members of the peasant class to make patchwork, believing "it fostered industry and thrift, improved the comfort of the home," and saved money (Jones, 2003, page 38). It was Lady Mayo who made quilting a counterpart to the nationalistic "Celtic Revival" in literature and arts of the late nineteenth and early twentieth centuries[15] which complicatedly, if not ironically, was sponsored by what was known as the Protestant Ascendancy, the Anglo-Irish aristocracy to whom Ireland had been home for generations.

The Celtic Revival, and the corresponding Irish Arts and Crafts Movement[16] founded by Lady Mayo's husband, looked to the most western reaches of Ireland, particularly the Connemara peninsula and Aran Islands in County Galway, as sources of authentic Irish culture. These areas and indeed all of Connaught, a province known for poor, rocky soil and remoteness from Dublin and London, had always been of little interest to the British.[17] Subsequently, life went on there much as it had for centuries. Language and traditions were preserved. It was the lives of these people, and the breathtaking landscapes in which they lived, which served as inspiration for literature, music, and the arts. And the scope of traditional Celtic arts, because of Lord Mayo's patronage, now included crafts such as lace, embroidery, weaving, and wool products. But what of quilts? Were they to stay in the home and not be carried to the exhibitions of Irish culture taking place in Dublin? What did this say of cultural atti-

tudes towards the women from all walks of life who quilted them? The lady of the big house and her chambermaid, who is also the wife of her husband's tenant farmer and mother to his future tenants – are we all to be excluded? Does Celtic culture value women's contributions at all? I can imagine the astute Geraldine Ponsonby asking such questions.

She responded by reviving the Royal Irish School of Art Needlework[18] as a compliment to her husband's work with the Arts and Crafts Society. Lady Mayo, a talented embroiderer, wanted needlework to be considered not only a craft, but an art of the highest caliber in Ireland. "Any work that can be done by the needle we undertake to do, and in the best manner," she wrote to the Arts and Crafts Society. Lady Mayo admired the delicacy of the old designs, the priests' "vestments, the quilts and the screens." She also recognized the deep emotional investment the "lady of olden times" had in her needlework, and the intimate satisfaction and sense of selfhood she would have derived from it: "Her frame was her close and intimate companion, and these elaborate art pieces filled the long hours of solitude imposed upon her by the household tyrant. Who can say whether she was a whit less happy than we in our advanced freedom?" (Coyne, 1901, page 439).

[15] A movement to develop a cohesive and distinctly Irish national identity in the late nineteenth and early twentieth centuries by promoting what was thought of as ancient Gaelic culture, the Celtic Revival is most widely known for its literary production, specifically the works of such greats as W.B. Yeats and J.M. Synge. But the visual arts also played a great role. For a comprehensive resource by an art historian, see Sheehy (1980).

[16] The dates of the Arts and Crafts Movement are generally accepted as beginning in 1886 with the founding of the Irish Arts and Crafts Society by Dermot Robert Wyndham Bourke, the Seventh Earl of Mayo, and ending in 1925, though nobody can definitively explain why it ended (Gordon Bowe, 1990/1).

[17] This is due to the malevolence of Oliver Cromwell (1599–1658), who spent nine months in Ireland violently suppressing resistance to English rule. On his return to England in 1653, Cromwell and Parliament passed the Act of Settlement of Ireland, which gave Irish landowners' holdings to the British aristocracy and pushed the disenfranchised Irish west of the River Shannon, mainly to County Galway, County Mayo, County Clare and County Roscommon, the most isolated, impoverished and barren lands in the province of Connaught. Cromwell gave the Irish the infamous choice to go "To Hell or to Connaught." See Walsh (2004).

[18] When founded in 1874 by Countess Cowper, the school seems to have lacked Lady Mayo's energy and vision. See Keenan (2006).

One of the most well-received pieces in the first exhibition of the Arts and Crafts Society in 1895 was a four-poster bed of carved walnut, with hangings and a quilt made by thirteen women from the Royal Irish School of Art Needlework.[19] I can imagine Lady Mayo's delight. Though highly unlikely that she would have considered herself a feminist,[20] Geraldine Ponsonby was a woman before her time. She worked to preserve tradition, but she also recognized that ideals of the past should not impede originality, as well as practicality. Indeed, Lady Mayo wanted what was for centuries perceived as a woman's household craft to be recognized as art, but she also displayed a thoroughly modern concern with the ability of women to independently make a living.[21] Perhaps she was influenced by witnessing the hard lives led by her husband's tenants in Mayo; this county had seen the most death due to starvation and hunger-related diseases as well as broken

families due to immigration during the Great Hunger some fifty years prior. No doubt she was sensitive to these wounds – still healing, many smarting – as well as the fact that no justice had been served, no reparations made. And she saw that it had been the women, the mothers of the sick and starving children, who perhaps suffered the most, especially if their husbands had been chained to a prison-ship bound for Australia, the fate to which the many fathers who stole food to feed their starving families were sentenced.

Although traditionally a household occupation, Lady Mayo hoped that young, lower-class women in her quilting schools would acquire not only artistic skills, but also an opportunity to make money independently of men. Her vision reflects simultaneous shifts occurring in various locales across the island in the economic value ascribed to quilts. For example, Roselind Shaw has found evidence that some linen merchants and shirt factories in Northern Ireland had a special day each week when they sold pieces of linen to their workers.[22] These pieces were made into patchwork quilts which were then sold, often by bicycle along the roadsides. Indeed, the characteristic thrift and resourcefulness of the Irish quilting tradition can be observed in the quilts that were made for the purpose of bringing in extra money: scraps of linen, pieces of handkerchiefs and table cloths, flour bags that had been washed and bleached.[23] The diary of young Levena

[19] *Journal & Proceedings of the Arts and Crafts Society of Ireland*, Volume 1, Number 1, Dublin, 1896, quoted in Symondson (1994, page 126). According to Symondson, little else is known about Lady Mayo's school, which ended in 1915 without leaving any records. He surmises that "because the greater part of its work was domestic," it was "thus perishable and easily discarded or forgotten."

[20] As the term "feminist," in the modern sense of believing in and advocating for the equal rights of women and men, made its way over to the English language in the 1890s. See Offen (1988).

[21] "Her intentions were as much altruistic and practical as aesthetic, demonstrated by her commitment to the Irish industries movement. She moved the Irish School from a small and ineffectual setting to one in which were provided opportunities of skilled training under the best available direction, thus enabling women to make an independent living. She did not limit the School's wider appeal by confining its work to Celtic interlace and runic symbolism ... but opened it to widely diverse styles and less provincial influences. Her direct response to beauty was not governed by narrow principles or relative theories of design but was free and spontaneous" (Symondson, 1994, page 133).

[22] Shaw and Jones both contend that in a series of quilts, one can study the history of the textile industry.

[23] Shaw writes that these Northern Irish quilts had names like The Derry Quilts, The Shirt Quilts, and The Belfast Patchwork, according to their city of origin and the material used to make them, instead of their patterns. She notes that flour bags labeled by the bakery of the US Army stationed in Antrim during the Second World War can be found in quilts from that place and time. Also from that era are "black-out quilts," which utilized the black material put over windows during air raids (Shaw, n.d.).

Winstanley, born in 1889 in Belfast, where her so-called "wanderer" father then worked at a spinning company, attests to this ingenuity. "We lived in a cottage owned by the mill. My mother who was clever with her hands ... had a quilting frame on which she made quilts for the beds from pieces of material from old coats, etc. ... I could have been a teacher but my mother decided that I should learn to sew, which I did, and have been doing it all my life. My first job was as an apprentice at a place in Manchester, with no wages for six months and three miles to walk each way. Anyway I am still here at 84. I never remember being unhappy or miserable; we always had enough food and clothing of a kind" (Winstanley and Land, 1988).

This trend of women earning money with their handiwork continued. By the turn of the twentieth century, quilting was not only a skill that a woman might use to make a home, but also to make a living. Roselind Shaw reflects that her own grandmother "was born in an era when young girls were encouraged to learn needlework as a form of security for the future ... Being able to create or make do and mend, having needlework skills was an asset to a young girl if she wanted to go into service in the big house." When researching Irish women who used their needlework skills professionally, I found a touching vignette which illustrates the fluidity of the boundaries between professional and domestic work, which perhaps heightened the value and emotional significance one bestowed a bedcover she was able to create – and *keep* – for herself instead of turning it in to an employer. In a recording in the archives of the Ulster Transport and Folk Museum, an embroideress from Ards speaks about a quilt decorated by her mother, also a professional embroideress, from whom she had learned her skill. After years of work, when her mother finally had the opportunity to decorate a quilt for her own use, "she just kept it. When she sewed it, she just had it done up and she kept it ... She never used it. I'll tell you the last time and the first time it ever was

used – when she died, I put it over her."[24] Initially, it was simply the sadness of this story that struck me, but then I recognized the beauty in the mother's saving of the quilt. It seems the elder embroideress had "stitched a square of colour" in the noontime of her years so that when night finally fell upon her life, her daughter was able to brighten the darkness of her mother's absence with the work of her hands.

For the meaning and feeling evoked by a quilt such as that of the Ards embroideress is just as important as skill and respect for tradition, especially when it comes to raising societal perceptions of a craft to the level of art. Quilting teacher Linda Ballard notes that quilting in Ireland, although passed from one generation to the next and thus referred to as traditional, always has been shaped by a variety of influences (Ballard, 1990/1, page 226). For the combination of the environment in which the quilter lives, and the individual world that lives inside her – her spirit, her dreams, her character – means that she and her neighbor may follow the same pattern and use the same materials, but they will never make the exact same quilt. Indeed, tradition is subject to varied influences, including the imaginations and materials available to quilters; what might seem standard today was at one time innovative. As an example, Ballard offers the case of a quilt in the Ulster Transport and Folk Museum with hearts and birds in the Ulster patchwork style. Instead of the traditional red and white, the patchwork is green and white, more natural and less stylized. Also, its border manifests pure creativity in a uniquely personal moment of inspiration. As the donor of the quilt describes, her grandmother simply "went into the orchard and thought that the chestnut leaf would make a nice pattern" (Ballard, 1990/1, page 226).

To be sure, the transition of the quilt from utilitarian craft to visual art could never be clearly

[24] Ulster Folk and Transport Museum, tape-recorded archive, R86. 258 quoted by Ballard (1990/1, page 225).

delineated, nor fully completed. Ballard refers to a "Mrs. Magill of Belfast," a dressmaker by profession who attributed her ideas for quilts to spontaneous inspiration, most likely influenced by her work with dresses. Ballard notes that although "she was not consciously aware of contemporary movements in formal art," two of Mrs. Magill's quilts in the Ulster Folk and Transport Museum "illustrate how her work closely reflects formal contemporary art of the period." One is from 1935, and the other from 1970 (Ballard, 1990/1, page 226). On viewing the photographs of the colorful geometrics rendered from dressmaking remnants, I would agree that the two pieces respectively mirror contemporary trends in modern and postmodern plastic arts. I also would suggest that the quilts were influenced in particular by the fashions and in general by the tenor of the times. Mrs. Magill's creations attest to the fact that quilts indeed fulfill one of the vital functions of art: to render the *Zeitgeist* via innovation of tradition. The ingenuousness with which Mrs. Magill attributes the creativity of her designs to an inner vision, a visit from the muse, begs the question of how an artist's motivation figures as a determinant of whether her creation is perceived as an art instead of a craft. It also points to a shift in societal conceptions beginning about thirty years ago. Quilting in Ireland was more widely accepted as an art, and for the first time was appreciated principally for its form and secondarily – if at all – for its function.

> It is now an accepted opinion that the evolution of patchwork mirrors the development of women. If quilts had been produced by men, they would have long ago earned their place in the world of art.

It seems the words above could have been written on the occasion of an exhibition by students of the Royal Irish School of Art Needlework. But they were actually written nearly a century later in a review of a touring exhibition by the Patchwork Artists Guild of Ireland in 1983 (Irish Arts Review, 1984). One might presume, then, that with the passing of the Arts and Craft movement, the mysterious disper-

sion of Royal Irish School of Art Needlework, and the twilight of the age Geraldine Ponsonby, society's perception of quilts returned them to the realm of the domestic, still inextricably linked with the realm of the feminine. The anonymous reviewer's words hold a clue to this attitude; they ring with a liberal tone that would have been amiss if Lady Mayo's vision, progressive nearly a century prior, had endured to penetrate modernist art circles. One can only imagine Lady Mayo, whose philosophy about the aesthetic value of practical household objects was inspired by the ancient Greeks,[25] had she been able to witness this postmodern trend towards "liberating" the domestic woman's craft in the art world. I imagine her trying to raise her voice, once again speaking out for women and the artistry of their handiwork, over the din of Ireland in the twentieth century. Had the work of Lady Mayo to promote quilting as a utilitarian art been buried in memories of bitter strife many would rather have forgotten?[26]

Perhaps there is no answer, but the question in itself is valuable, as it hints at the circular flux of societal conceptions of art and crafts, which in turn reflect the patterns of history, and indeed the human spirit. This is something of which many of the Irish women who displayed quilts in the exhibition seemed to be aware. An apt example is the *Roaring Water Star* quilt made by five women who reside between the Bays of Bantry and Roaring Water in West Cork. As they revealed to the reviewer, "What began as just an idea to allow each patcher to use her preferences in combination of colour, came to remind the group of the endless changes of the ocean and also the equally fluctuating facets of the human personality" (Irish Arts Review, 1984).

[25] Lady Mayo's praise of the aesthetics of the ordinary in ancient Greece can be found in Coyne (1901, page 440).

[26] Roselind Shaw notes that elderly women are often dismayed by her interest in quilts, as they are "remembrances of hard times." In fact, Shaw notes that many of them burnt old quilts in an attempt to forget.

Evolving from a craft to an acknowledged art was not without its drawbacks for quilters. Sean McCrum (1986), a rather prolific reviewer of quilting exhibitions in the 1980s, set forth strict rules for what made the craft of quilting an art, and in turn what makes a quilt "good" art. He pronounced that "patchwork has reached a level of maturity at which it is no longer validated by simply existing" and defined updated criteria for Irish patchwork. Of particular importance were "diverse and experimental … colours and shapes," particularly those "based on formal, geometric designs." McCrum held quilts to high artistic standards. This is to be desired, but it also begs the question: is there value in evaluating a craft-turned-art according to the same standards one might a watercolor, or a sculpture? A case in point is his evaluation of *Women in a Floating World*, a quilt by a woman named Mary from Drogheda. McCrum criticized how the quilt "attempted to use the surface of the patchwork to illustrate literally the idea of a family or city," contending it did not "suit the medium" and "led to visually unrelated assemblances of shapes." He also questioned the role of the human figure as a formal element in the pattern. But, could it not be possible that what the art critic perceives as the "weakest piece" could have succeeded in fulfilling the mission the quilter set out to stitch? Could this critical failure be a window into Mary's experience, and as such say something universal about the experience of navigating this world as a woman? And to do this, is she not beginning with tradition and adding personal vision? Is Mary not then an artist? Perhaps it is not for the critic to have to see in the art the fulfillment of certain criteria, especially given that so much in the history of Irish quilt is about a woman making do, recycling the old into something new, and stitching her stories onto the patches. Must the personal significance transmitted from the creator to the perceiver, who imbues the piece with another layer of personal significance – his or her own – be lost to the gaze of the critic when craft becomes art? Should we not be like the ancient Greeks, seeing the beauty in utilitarian objects, as Lady Mayo wished?[27]

Yet moving forward into the 1990s until the present day, we witness Northern Irish quilters employing a concrete function for their art: social commentary. These quilters have taken the legacy of using the materials one finds on-hand, of drawing inspiration from ones surroundings, to a new level. In Northern Ireland, particularly the cities of Derry and Belfast, quilting groups comprised of Protestants and Catholics stitch messages of peace in response to what are widely referred to as the "Troubles," or political violence between Catholics and Protestants beginning in the late 1960s. They stitch to suture a painful, gaping wound in the outer landscape and the inner – that of the Irish psyche where it still festers today, even as it slowly heals. In light of Longley's poem and its call to "stitch a square of colour," I imagine the painful history of the Troubles as another "darkness" a bright patchwork can cover – not to hide the truth of its memory, but to recognize and to soothe it, to bring it back to life as something useful as well as aesthetic.

In 2008, "The Art of Survival" exhibition of Irish and international quilts and hanging textiles took place in the Northern Irish city of Derry. From March 8 to April 19, a total of twenty-six Irish quilts were on display.[28] The city, also known as London-

[27] As Lady Mayo said: "It is well known that nothing lowers the tone of the mind more than a low tone in the surroundings; and it will be remembered that it was the rule in Greek domestic life that no object in daily use, however lowly it might be, should be fashioned after a low or sordid type. In the poorest households the child's eye grew accustomed to forms of beauty and art, fashioned out of the rudest materials" (Coyne, 1901, page 440).

[28] I am grateful to curator Roberta Bacic for speaking to me about her work with Irish quilts for the exhibition, and for her invaluable insights into the distinctions between theory and the actual practice of quilting. For more about "The Art of Survival," as well as the ensuing display of Irish quilts at the Verbal Arts Centre in Derry from 2008 to 2013, see http://cain.ulst.ac.uk/quilts/exhibit/irish_quilts.html (accessed October 2013).

derry,[29] was a significant setting, as sits on the border between the Republic and Northern Ireland and was an epicenter of violence during the Troubles.[30] In a clever choice by the exhibition organizers, the quilts were shown in nine venues located in both "Catholic" and "Protestant" neighborhoods, meaning people had to cross the divided city in order to view them. According to curator Roberta Bacic, it was the first ever exhibition from both sides of the conflict, an attempt by the Derry City Council Heritage and Museum Service "to have women sit together to quilt and have their pieces shown together."[31] Many of the quilts in "The Art of Survival" were created by victims and survivors of the conflict in Northern Ireland. Some ask for peace and promote reconciliation, while others act as windows into personal experiences of violence, discrimina-

tion and loss. As Roberta Bacic explained to me, even women who were not directly affected by the conflict have also chosen to respond to the tension between loyalists and nationalists, Protestants and Catholics, through the medium of quilt-making. Some of the titles of Irish quilts in the exhibition which I found exceptionally moving are: *Common Loss: 3000+ dead between 1969 and 1994*, a patchwork quilt by Irene MacWilliam of Belfast; *Remembering Quilt*, a large, multi-paneled quilt by *Relatives for Justice*, Belfast; and *Northern Ireland Reconciliation Quilt*, a patchwork quilt by Women Together, Belfast.

Quilting has provided these women with what Bacic calls "a language to express their experiences of the conflict." Just as one learns a language and then employs it to respond to her surroundings and communicate what is in her heart or mind, the 400-year-old quilting tradition existed inside the women – figuratively speaking, as one might think of a language living inside us – as a precursor to their choosing to express their experiences of the Northern Irish conflict through the medium of textiles. In our conversation, Bacic reminded me that although the Irish quilts in "The Art of Survival" have catalyzed dialogue in local communities, initially women came together in cross-cultural quilting groups because they had something "they needed to say, but they didn't overtly decide 'we are going to be political' ... Many quilt simply because it enhances their wellbeing."

Other Irish quilts in the exhibition addressed broader social issues such as human rights, historical legacies such as immigration, or universal human experiences such as friendship and the therapeutic power of community. "The range of expression is wide," Bacic said, "as is indicated by the quilts." Examples of such quilts are *Pathways of Life*, a quilt by the Shared City Project, Derry/Londonderry; *Women's Rights are Human Rights: Cearta ban, Cearta daonna*, an appliquéd quilt commissioned by the Committee on the Administration of Justice and the Centre for Research and Documentation,

[29] The name of the city is a point of contention between Irish nationalists (who favor Derry) and unionists (who prefer Londonderry). As part of the UK, the city and the county are legally called Londonderry.

[30] The Catholic civil rights movement, culminating in the eruption of the "Battle of Bogside" in March 1968, is considered the beginning of the Troubles. The infamous "Bloody Sunday" massacre, in which 26 unarmed civil rights protesters and onlookers were shot by the British army, also occurred in Derry in 1972. It is interesting to observe that the number 26 corresponds with the number of Irish quilts on display in *The Art of Survival*, as well as the traditional number of counties in the Republic of Ireland. For more on Derry in the Troubles, see Ó Dochartaigh (1997).

[31] Interview with Roberta Bacic, April 21, 2013. Bacic writes about the origins of the exhibition in an introduction on its website: "During 2006 and 2007 Quaker House Belfast asked me to facilitate a series of meetings with women from different backgrounds to discuss issues related to dealing with the past that had affected their lives. To open the discussions, which some participants found difficult, we decided to show a Peruvian Arpillera made by displaced women, from both sides of the conflict, who designed and made the quilt together and used as their testimony to the Truth Commission. Out of this grew the idea of contacting quilt makers in Ireland to see how they had represented the conflict in their work. At the time Helen Quigley, then Mayor of Derry, attended one of the presentations of the Peruvian quilt and asked me to bring to Derry a display of examples of quilts, arpilleras and wall-hangings in the context of International Women's Day 2008. From that initial idea the Art of Survival exhibition was developed." See http://cain.ulst.ac.uk/quilts/intro.html (accessed October 2013).

Ireland; and *Love Across the Waves*, a painted and patchwork Quilt by the Arranmore and Tir Gohaine Women's Groups, Donegal, Republic of Ireland.

And what was the impact of "The Art of Survival" exhibition? Bacic spoke of a movement currently emerging of women from both sides of the conflict in Northern Ireland coming together to quilt and – through the act of choosing themes, materials, patterns and colors – "identify the elements of the shared society they are pursuing." Just as neighbors came together for quilting parties hundreds of years ago and, bent over their patches, shared stories and intimacies, quilting together promotes the values needed to grow and strengthen a community, such as the "understanding, respect and compromise" Bacic attributes to the nascent politically-minded quilters groups in Derry. I imagine the quilt stretched before them like a bridge. Each patch is a name, a place, a birth, a loss, a memory, or a dream. Each patch represents one quilter's step toward their common goal. For their quilt is a shared path. I imagine it grow inside the circle of their hands. It is a structure that unites them today as their stitches mend their own wounds and that of their torn city. It is a bridge that leads to a future they choose. The quilt, and the story it tells, is their own shared creation.

The task of these Northern Irish quilters is not a simple one. It reminds me of the difficult question Michael Longley asks in "The Design," another of his poems about quilts:

> Sometimes the quilts were white for weddings, the
> design
> Made up of stitches and the shadows cast by stitches.
> And the quilts for funerals? How do you sew the
> night? (Longley, 1995).

As I learned in my research for this chapter, making a quilt has never been easy. Whether an aristocratic lady, a factory worker, a maid, a farmer's daughter, or a fisherman's wife, the Irish quilter has never pursued her art for the sake of ease, she has created for the sake of producing something of value, of utility, of beauty as beheld by her own eye, and of warmth

in all its connotations. And for the majority of Irish women who quilted from the late 1600s until only a few decades past, their quilt has been stitched from almost nothing, and yet it became an immeasurable *something*, a material of sustenance that would contribute to her and her family's survival. And although only recently considered an art, I believe it has always been one. For in the words of Longley, "All art is to a greater or lesser extent improvisatory, conjuring something out of nothing – a quilt out of trimmings and leftovers, a radiantly coloured rug out of a pile of old rags."[32] These luminous hues were present in "the famous ragbag of clippings" Roselind Shaw's maternal grandmother Millar, a gifted seamstress, kept "for the women of the village who gathered the scraps to make their patchwork quilts." Shaw fondly reflects upon her grandmother's undying gift to those women and their families: "Receiving the scraps gave them the opportunity to express their hidden talent, being artists in their own right and most importantly, providing a little extra luxury and colour in their homes when in some cases only a coat or a blanket would have covered the bed." For both utility and cheer have been in the minds of women – rich and poor, Protestant and Catholic – who have quilted as Ireland's history unfolded itself upon their own lives. Stories wordlessly stitched by hands smooth or rough, but always industrious, always inspired, always quilting her own story. This is the spirit of the Irish quilt. And the spirits of the women who made them – sustained, freed and immortalized in its form.

[32] "The Poet Speaks: Some comments by Michael Longley on his own poetry." http://resources.teachnet.ie/ckelly/poetspeaks.htm (accessed October 2013).

Bibliography

Ballard, Linda M. (1990/1) Is it traditional? *Irish Arts Review Yearbook.*

Coyne, William P. (1901) *Ireland: industrial and agricultural.* Dublin: Browne & Nolan.

Flanagan, Thomas (1988) Two roads through West Cork. *New York Times,* travel section. March 13.

Gordon Bowe, Nicola (1990/1) The Irish arts and crafts movement (1886–1925). *Irish Arts Review Yearbook.*

Irish Arts Review (1984) The first touring exhibition of contemporary patchwork wallhangings called *Breacadh. Irish Arts Review* Volume 1, Number 1, page 47.

Jones, Laura (2003) Patchwork, in Shaw-Smith, David, ed. *Traditional Crafts of Ireland.* New York: Thames & Hudson.

Keenan, Desmond (2006) *Post-famine Ireland: Social structure.* Bloomington, IN: Xlibris Corporation.

Longley, Michael (1995) The Quilt. *Poetry* Volume 167, Issue 1/2, pages 64–5.

Longley, Michael (2000) *The Weather in Japan.* Winston-Salem, NC: Wake Forest University Press.

McCrum, Sean (1986) Crawford patchwork exhibition. *Irish Arts Review* Spring, page 56.

Ó Dochartaigh, Niall (1997) *From Civil Rights to Armalites: Derry and the birth of the Irish Troubles.* Cork: Cork University Press.

Ó Súilleabháin, Séan (1973) *Storytelling in Irish Tradition.* Cork: Mercier.

O'Sullivan, Catherine Marie (2004) *Hospitality in Medieval Ireland.* Dublin: Four Courts.

Ó Tuama, Seán, ed. (1981) The lament for Art Ó Laoghaire, translated by Kinsella, Thomas, in *An Duanaire 1600–1900 (Poems of the Dispossessed).* Dublin: The Dolmen Press/Bord na Gaeilige.

Offen, Karen (1988) On the French origin of the words "feminism" and "feminist." *Feminist Issues* Volume 8, Number 2, pages 45–51.

Regan, Stephen (1992) Ireland's field day. *History Workshop* Number 33, Spring, pages 25–37.

Shaw, Roselind (n.d.) Early Irish patchwork quilts and traditions. Available at www.antiquequiltdating.com/Early_Irish_Patchwork_Quilts_and_Traditions.html (accessed October 2013).

Sheehy, Jeanne (1980) *The Rediscovery of Ireland's Past: The Celtic revival, 1830–1930.* London: Thames & Hudson.

Symondson, Anthony (1994) Art needlework in Ireland. *Irish Arts Review Yearbook,* Volume 10, pages 126 and 133.

Walsh, John (2004) Hedgemaster's Archives of the Irish Cultural Society of the Garden City Area. Available at www.irish-society.org/home/hedgemaster-archives-2/people/cromwell-oliver-to-hell-or-to-connaught (accessed October 2013).

Winstanley, Levena and Land, Mary (1988) Glimpses of the past in Northern Ireland and in Brindleheath Pendleton, Salford. *North Irish Roots* Volume 2, Number 1, pages 7–8.

Survival–Empowerment–Courage: Insights into the History and Developments of Peruvian *Arpilleras*

GABY FRANGER

The more we work, the more creativity we find in ourselves. In the beginning, I never thought the *arpilleras* would help me in my life. But this is an art that has no ending. We are always trying to renew our ideas. We are very proud that our pieces are appreciated and sold. The fact that they are exported is a big compensation: it animates us. We all have a little art in our minds and in our hands; we will leave something as a legacy for society. It will stay behind us, in another place, in another time (Gianturco and Tuttle, 2000, page 71).

STITCHING, KNITTING, WEAVING, AND embroidery have always been forms of the individual expression of women as well as indicators of their worry and care for loved ones, when they produce clothes or household textiles. With their artistry, they adorn themselves and others, express love and rage or denounce what has happened to them or their surroundings. With needle and thread they give testimonies and are writing a history of art.

Peruvian *arpilleras* – originating from the slums of Lima at the end of the 1970s – are present at markets and in exhibitions and are being discussed as a new form of naïve, urban folk art (Willow, 1995; Gianturco and Tuttle, 2000; Rios Acuña, 2004).

The story of this textile art is the story of intercultural exchange, it is an expression of "hybrid cultures" (Canclini 1989), globalized markets, and local development. The story of the Peruvian *arpilleras* can be told – as any story – from various points of view, which can be quite different depending on the protagonists. Similar to the Chilean *arpilleras*, they are the expression of a social and political movement. They give testimony to economic misery in the *pueblo jovenes*, the young villages of Lima, of the women's mobilization in committees such as *vaso de leche* (cup of milk) or *comedores populares* (community kitchens), through which they not only tried to ensure their families' nourishment, but also to contribute to social justice. They accuse the monstrosity of the twenty-year long civil war, which still today – thirteen years after its end – as having a traumatizing effect on individuals and a society that has difficulties coming to terms with the human rights violations.

The story of the *arpilleras* can be told as story of female individuals, artists, activists, feminists, and social workers, who initiated changes and fulfilled themselves. And yet it is the story of the many unnamed women who are trying to organize their environment, to enter markets by having new ideas and therefore wish to escape economic misery. The story of the *arpilleras* is also partly my own story – even though I've never created one. I have accompanied *arpilleristas* over a long period of time and as historian and social scientist, I have always been fascinated by the subversive power of textiles in every culture and at any time (Akkent and Franger, 1987; Bala *et al.*, 2012; Franger, 1987, 1988, 1992, 2005, 2009; *Mujeres Creativas*, 1996).

How It All Began

In January 1978, Eva Maria Delbeck, a teacher of Humboldt School in Lima, drove to Chile and saw in the Vicaría de Solidarid for the very first time *arpilleras*, which pictured the unjust Chilean regime from the perspective of the oppressed.

At this time, Delbeck had been working for two years with a women's group from the Ampliación de Virgen de Buen Paso, neighborhood in Pamplona Alta settlement, Lima, with the aim of producing goods for the domestic and the German markets. "We had made and offered caps and gloves and scarves and also egg cozies for the German breakfast table – which appeared to be really ridiculous to the women – but it was far from satisfying. So I stood now in the shaded room and believed to have found a suitable product for the group's wit and the technical and financial possibilities" (Delbeck, 2012, unpublished).

Eva Maria Delbeck returned with a few *arpilleras* and introduced them to her group in joyful anticipation. "How disappointing it was to see the reaction on the women's faces! They didn't seem to understand the potential. I left the group that day with great frustration. Yet – incredibly surprising and very uplifting – three weeks later, two women of the group visited me in my apartment in Miraflores and carried with them two self-made, essentially perfect *arpilleras*" (Delbeck 2012, unpublished).

So it was in May 1978 that the first *arpilleras* were produced in Pamplona Alta. The first exhibition in the Humboldt School in fall 1979 resulted from an encounter of students of this elite school and women from a shanty town. The encounter was meaningful to both groups. The women documented their first meeting in a middle-class house in Miraflores in one *arpillera*, whose most important feature for them were the sanitary arrangements – a quality of life worth pursuing. The participating students got to know the misery, but also the power of people, who they've believed to be dangerous troublemakers.

The *arpilleras* and the women's testimonies document the land occupation of 120 families at the crack of dawn on March 10, 1974, they show how women arrived with straw mats, few belongings, and their children on their backs and at hand, "with the good faith to create a society responsible for the future of its children, its community and its country" (1979 exhibition poster). They document the threat of a massive force of police, the activity of the community, the assembly of elected spokespersons, the waste cleanup campaign for the area, the collective construction of a school for a better future of their children. They reported on a teachers' strike, which was convulsing the society and resulted in its course in establishing the first community kitchens (*Ollas communes*) to support the strikers.

Compacto Humano and Centro Comunal Artesanal Puertas Abiertas (CCAPA) – An "Intersubjective Voice" (Smith, 2008)

This group, which chose the name Compacto Humano, can be seen as the birthplace of the *arpilleria* in Peru. After 1980, an art teacher at the Humboldt school took over the "systematic" further training: "knowledge about composition of colors, perspectives, etc. were the daily routine" (Roswitha López Rodas-Utters, 2012, unpublished). In times of greatest demand, eighty to 150 women worked in the group. Through these activities, and with the help of a supporting group, the Centro Comunal Artesanal Puertas Abiertas (CCAPA) was formed 1991. The CCAPA's very name indicates that it is available for the community (Noris Vásquez Linares, 2012, unpublished), As well as the *arpillera* group with its traditional range of products, it also houses the small family-owned enterprise *Kuurmi* (Rainbow), a center for further education of *arpilleristas*.

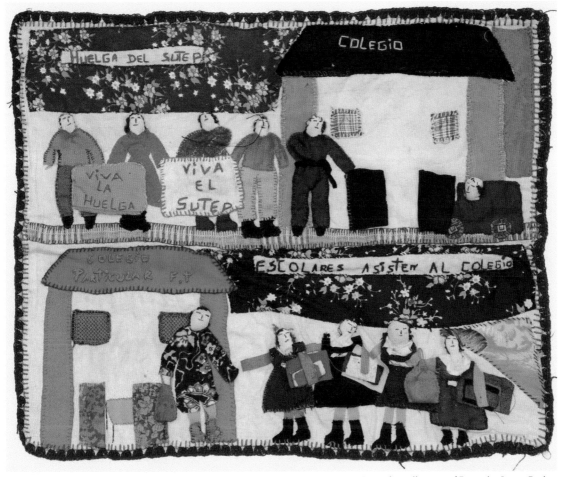

FIGURE 12.1 *Teacher's Strike*. Compacto Humano, 1978. SUTEP. 45 cm × 38 cm. From the collection of Roswitha López Rodas-Utters. Photograph by Gert Gremmelspacher.

Noris Vásquez Linares – the center's current director and outstanding *arpillera* artist – began her career within the group in 1981. She came to Lima from Cajamarca when she was one-and-a-half years old; her family participated in the first invasion in 1963 that started the settlement in Pamplona Alta. She was critically ill and couldn't leave the house for years, so she helped her mother in making little dolls. Roswitha López Rodas-Utters had suggested to the group to further develop the two-dimension-al technique to a three-dimensional, according to the tradition of the Ayacuchan *Retablos*. "My little dolls had stood out because of their gracefulness, so one year later I was able to be part of the group. I was seventeen years old and very proud. And right from the start, I wanted to teach others what I had learnt myself. We wanted to display our world and our customs with the *arpilleras*. Gradually, our works became more perfect, we were successful" (Noris Vásquez Linares, 2012, unpublished).

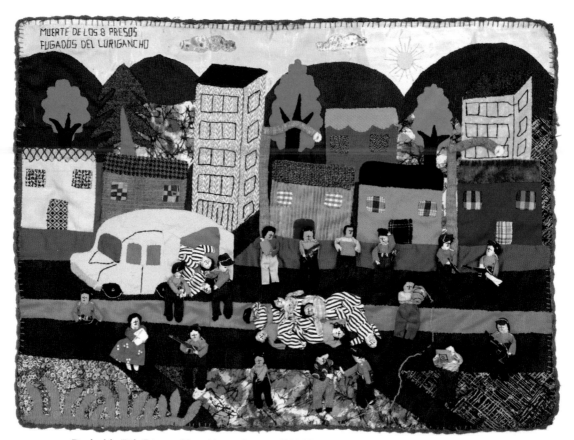

FIGURE 12.2 *Death of the Eight Prisoners*. Noris Vásques Linares, 1984. 77 cm × 56 cm. From the collection of Roswitha López Rodas-Utters. Photograph by Gert Gremmelspacher.

In this new, challenging environment, the *arpilleras* documented memories and the yearning for the supposed idyllic world of rural traditions, the celebrations and religious customs they shared, coming together from different regions, and introduced to the new community.

We developed many cultural themes, memories of the cultures – nature, agriculture, celebrations, religion of the villages of the coast, rainforest and Andes, where the families originated from and later came to Lima. These illustrations attract mainly tourists; they can take these textile images home. The *arpilleras* contributed to popularizing the devel-

opment of our community and our cultural identity. My first creation was a market; the popular markets are still appealing to me. I liked the women's stories, when they told how they had lived in their villages, how they seeded the potatoes, how they are being harvested, how they are cooked with wood billets. I imagined it as if I had been in the field myself. During the first year, when I was able to leave the house again, I collected these stories, especially with regard to acts of injustice towards the women, like when they told how their husbands treated them badly, having been told to turn off the light when she cooked, having been told to make the beds when she stitched. I had the idea to illustrate these

stories in a "spiral of life" and I was able to demonstrate the whole panorama of the living situations of these 150 people. That was in 1986. The "spiral of life" original was on display in Krefeld; a few years later, I made a replica for an exhibition in the US (Noris Vásquez Linares, 2012, unpublished).

Some of the women who started back then have now their own workshops, they are self-employed as contractors or subcontractors. They don't see themselves necessarily as ambassadors of their daily life, but executing orders when stitching images – "the llama looks to the left, the sheep to the right" (Noris Vásquez Linares, 2012, unpublished) – and the manual labor allows for their subsistence.

On the other hand, their world in the desert of Lima becomes colorful. "Babies and small children of *arpillera* women don't need picture books. Right from the start, these children have a different vision of life. Each and every scrap of cloth opens the door to a rich world of images. The next generation grows up among fabrics, stitching and knitting needles" (Roswitha López Rodas-Utters, 2012, unpublished).

Mujeres Creativas: Feminist Consciousness Raising

In 1981, Manuela Ramos – a feminist institution which was founded in Lima in 1978 – started training courses for women from the marginalized zones. Manuela Ramos pursued two goals: to generate income for women and to fight for change of the role of women in the society.

A first workshop for public relations and improvement of the visual communication for leaders of women's institutions from different *pueblos jovenes*, offered by Alicia Villanueva in 1983, was notedly successful because of the women's creativity and illustration strength. However, for them the more important question was how income opportunities could be established. They were looking for work, which preferably allowed self-determined structuring of time, possibilities to work from home,

and tied in with existing knowledge and skills. The solution for all of these challenges seemed to be to stitch, to weave, and to embroider.

Olinda Gutiérrez, one of the first women from a northern shanty town, remembers that she was integrated together with her *Club de Madres* (Mother's Club) in a program to construct the main place of the shanty town Collique. The women hauled rocks and were paid with food. "But we wanted to earn money, so we organized a stitching workshop, also courses for alphabetization were offered. The idea of the *arpilleras* was well received" (*Mujeres Creativas*, 2012, unpublished).

Rita Serapión from Pamplona Alta had already manufactured *arpilleras* in Pamplona Alta and instructed the others; Marina Haro added her experience from the market cooperative in Collique; Emma Hilario was an experienced leader, who was able to train other women. The idea for a pilot project was born (*Mujeres Creativas*, 2012, unpublished).

The manufacturing of *arpilleras* offered the opportunity to generate income, to encourage the women's artistic skills and their self-confidence, to raise awareness through the communicated feminist messages and to train future leaders, who can strengthen their institutions (Villanueva, 1995, pages 20ff.).

> We at Manuela Ramos did not then have any experience with economic activities. We were social scientists with a socialist background. A that time we would interpret all talk of income generation or individual earnings as rather conservative or right wing in its promises. Even the feminist movement was not conversant with this theme. We wanted this group of women to earn a stable income through part-time employment … It seems to me that perhaps my training as a psychologist and my interest in art lead me to found a solidarity group, in which mutual respect, self-esteem and dignified creative work could be realized (Villanueva, 1996, page 68).

Quickly, the small cooperative (the number of members settled down to between twelve and fifteen),

received wide recognition through their *arpill-eras* with messages of daily struggles and organization in the *pueblo jovenes* and their creations were sold through solidarity groups in Mexico, Canada, Denmark, the UK, and in Germany where the first exhibition took place in Nuremberg in 1988. Manuela Ramos continued to train the women – artistically and also organizationally – gave advice for the foundation of their association and helped with the commercialization. The possibility to overcome challenges as an artisan was part of a feminist methodology which tried under difficult conditions to organize the survival of the women through respect and appreciation for their skills. Being appreciated as artisan was of upmost importance.

It was not easy for the women to learn how to bring the messages that they wanted to deliver onto the fabric. In order to develop a theme, they discussed questions such as: what does violence mean to you? Which forms of violence are you faced with daily? What are the possibilities to eliminate these? The women planned the coloring together and they visited art museums. For some of the women, these activities brought them from their own homes to Lima for the very first time. The illustration of protest marches, daily acts of violence, customs in their villages, community kitchens, and other subjects were the themes of the first *arpilleras* (Franger, 1987, 1988; Villanueva, 1995).

The inquiries of feminist and solidarity groups of the "one-world-movement" led to the *Mujeres Creativas* developing large-sized, collective collages in the 1990s that showed the life and survival in the *pueblo jovenes* (Franger, 1996, pages 74ff.), honoring the memory of the settlers' achievements. These creations not only describe the daily routine and life in various colors, they also offer analysis with their view on the background of misery and crisis and the search for a way out; an excellent example is "The Foreign Debt," made for the "Living Reconciliation – Making Peace: Women's strategies against oppression, war and armament" convention by the Women in One World, 1991.

Arpillera: The Foreign Debt

Our standard of living is very low. The families that come to Lima because they can't make a living in the countryside, or who flee from the military clashes in their region, build these straw huts for themselves on the outskirts of Lima. There's no water and no electricity in these districts, no schools, no streets and no public transportation. The confrontations over the infrastructure often last for a year, that's why we march into the center of town, in order to give emphasis to our demands. The people from the middle class districts just look on, because it's not their problem, they have water and electricity. But who's waiting for us? The police, who beat us with their sticks.

There's no work. There's a lot of unemployment … The unemployed try to earn money somehow. Everyone tries to sell something: children sell candy and newspapers. Women prepare food that they sell on the street.

But even when they earn a small profit through their hard work, it's not enough, because the inflation rate is very high. The small amount of capital is constantly shrinking and it isn't enough for anything. So people begin to borrow. But what happens? The interest rises out of all proportion and ruins people. The debts end up taking all the earnings. And we women bear the greatest part of the burden. In the center stands the reason: foreign capital. Who takes all our riches for themselves, at very low prices? The poor pay for it. Men, women, children work in agriculture. But it's never enough. During the latest crisis which began in the 1980s, the women began to organize themselves. Several families came together and tried to solve their problems collectively. What do we do when we don't have enough money to nourish our children? We came up with the idea of organizing communal kitchens.

But we women organize ourselves not just to cook, to share somewhat better the little we have. We want work, paid work. We *Mujeres Creativas* joined together in order to earn an income for our families with our *arpilleras*. But we also want to show the world, especially the women, how we live and how we struggle, in order to get along (interview with Franger; Haro, 1992).

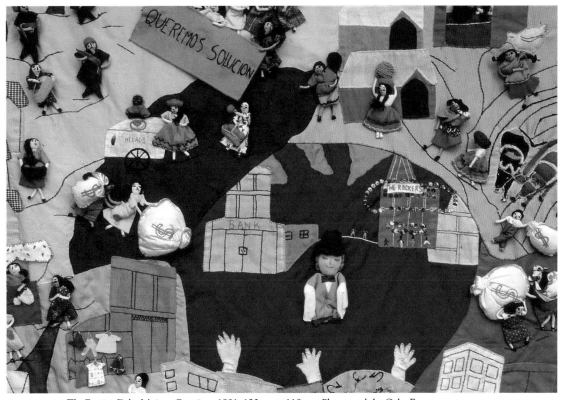

FIGURE 12.3 *The Foreign Debt. Mujeres Creativas*, 1991, 120 cm × 118 cm. Photograph by Gaby Franger.

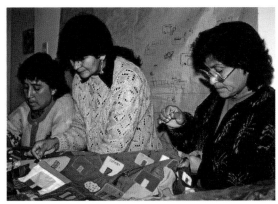

FIGURE 12.4 *The Foreign Debt* being worked on. *Mujeres Creativas*. Photograph by Gaby Franger.

At the beginning of the 1990s, the country's economic and political situation worsened dramatically, Manuela Ramos couldn't subsidize the group any longer and together they tried to find a way to exist as an autonomous cooperative. The women had to expand their productive activities if they wanted to assure their income. Therefore, for a few years they have been organizing a catering service for office employees who worked close to their workshop. They diversified their range of products by, among other things, adding fine embroidery on postcards and inner layers in the lids of wooden caskets, they made clothes and accessories of hand-printed fabrics of the *Shipibo*. Fortunately, they had continuing support of

a Bavarian scout group which allowed them to purchase a small house which they are still using as their workshop today. The donations also made health insurance possible for all women, which the women, now at retirement age, still profit from.

Arpilleras of Denunciation and Resistance: Emma Hilario

Since 1979 Emma Hilario has been a member of *Club Mujeres Cristianas de Ollantay*, a neighborly help organization, where women, having been moved to the *pueblo joven*, dedicated themselves to the development of their district, organized the contribution of milk for their children, founded two community kitchens and a dining hall where breakfast and snacks were served. In 1983 she participated in the first workshop by Manuela Ramos as promoter and consequently in the founding of the *Mujeres Creativas*.

Emma Hilario subsequently had to organize her time carefully because she was the first woman to be elected as secretary-general of the residents' association in the *pueblo joven* Ollantay in Pamplona Alta. At the same time, Emma was a delegate of the soccer club, *Los Angeles Negros*, and president of the community kitchens of the San Juan de Miraflores district. She accomplished all these tasks in addition to her responsibilities within her family in this windy and dusty neighborhood by enforcing common household chores with her husband, son, and daughter. Each weekend the family gathered, discussed the upcoming tasks and then they got started. At first, it was quite a challenge for her husband, but their common political attitude has been implemented at their home as well. Her *arpillera*, *Trabajo Compartido* (Franger, 1988, page 56) shows in many sequences what Yesenia, her eight-year-old daughter, sums up in the phrase "we don't have a patron nor a maid here, we are all equal" (Franger, 1988, page 58).

Emma Hilario had her mother as role model who was an active part in the peasant movement, while

neither being able to read nor write, also included sons and daughters in the household chores. "In her memory I take on responsibility today and achieve fulfillment as a woman, mother and wife" (Franger, 1988, page 58).

It was Emma Hilario's wish to create publicity and display injustice with her *arpilleras* – be it the violence in private life or the violence of the dirty war that had been raging in Peru since 1980. Emma was able to get her message across using the arts and crafts market. When journalists started to show an interest in her topics, which they usually wouldn't have reported on, then she felt certain that this was a great possibility to publicize the protest against the situation in the country. It was also a suitable way to raise awareness and especially media attention for political activities against social injustice and political violence itself. Not everyone in the group was politically dedicated, some had more experience, and others had just begun to develop awareness. Some focused rather on economic problems, and others reported on the development of the *pueblos jovenes* and the women's contribution or they remembered the customs of their villages. "But I wanted to denounce – the others said that I protest too much, but my *arpilleras* – *Paz, Violencia*, and *Comando Conjunto* – were sold as well" (Emma Hilario, 2012, unpublished).

Paz

Emma's son, when eleven years old, won the *Mujeres Cristianas* club's drawing competition and she embroidered his drawing on to a rough jute fabric. It shows the military's boundless power in the "anti-subversive fight" against the peasant civil society (Franger, 1987, page 98).

Violencia

The women of the *Mujeres Cristianas* club defended one member who was beaten up constantly by her husband, a well-known leader. One morning, the

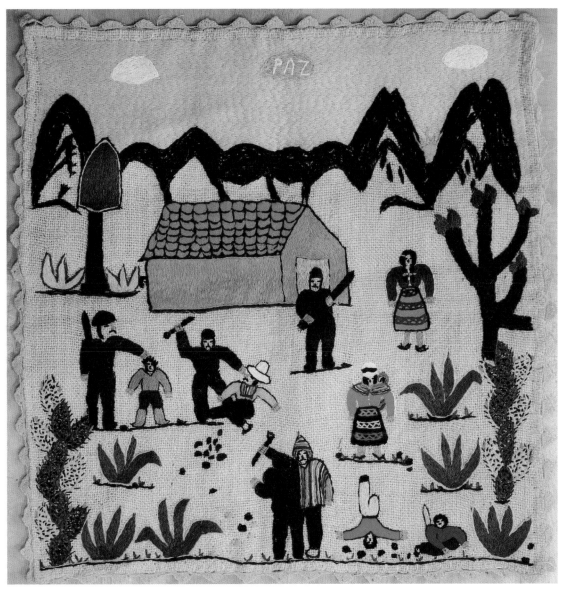

FIGURE 12.5 *Paz. Mujeres Creativas*. 44 cm × 44 cm. Photograph by Lothar Mantel.

women intervened and together they took the husband to the police station where he was only mildly reprimanded. As a result, the women tied him to a pole in the middle of a park and draped a sign around his neck, saying: "Never will I beat someone again" (Franger, 1987, page 80). Emma smiles when she thinks of this story, but this leader now detests her she emphasizes.

Comando Conjunto

This is perhaps Emma Hilario's most important work. "A massacre happened in Ayacucho in October 1985 and no one protested. We women organized a demonstration in front of the headquarters of the armed forces' general staff here in Lima. The feminist institutions, Flora Tristan, and Manuela Ramos had called for it. We wore a necklace made of flowers to protest against the death of our *compañeros*. That same night, after our demonstration, there was a massacre of political prisoners at the jail of Lurigancho" (Franger, 1987, pages 96ff.).

Emma Hilario took her unfinished *arpilleras* along to each meeting to continue working; by selling them she could cover her transportation costs and some other expenses (her political activities were voluntary).

In December 1991, Emma became a victim of the Shining Path (*Sendero Luminoso*). As a member of a left-wing social movement who clearly distanced herself from *Sendero* and its terrorist methods and as leader who won against *Sendero*'s candidates in elections over and over again, she had been threatened for nine months. Emma was attacked by three women. The beating left her with a broken hip. On

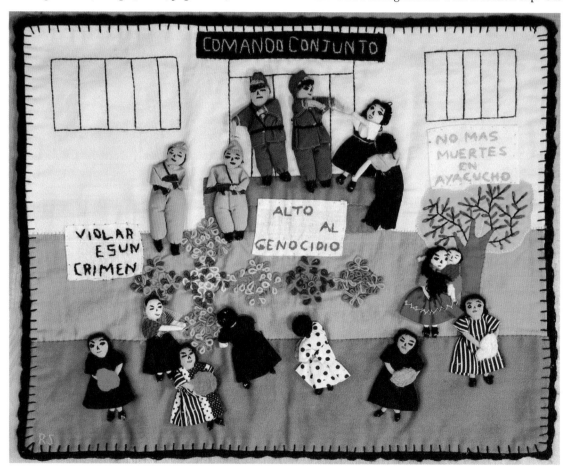

FIGURE 12.6 *Comando Conjunto. Mujeres Creativas.* 40 cm × 50 cm. Photograph by Lothar Mantel.

December 20, 1991, she, her father, and her husband barely survived an assault in her own house, being severely injured by bullets. She had to hide for a month without any medical care; finally she fled to Costa Rica with her daughter on February 2, 1992.

> I came with a tourist visa for three months, but I stayed until today. It took four months until I was finally registered as refugee. I didn't have any papers with me, nothing. We slept on the floor on cardboard boxes, we ate tuna every day and drank water, and it was very, very difficult. I've never told this to anyone in Peru, why should I have, it doesn't make sense … But everything worked out for me, I studied, primary and secondary school, university, I started from scratch after I had been waiting in vain for fifteen years that my papers would be sent from Peru. On November 15, 2012, I had my exam as a social worker (Emma Hilario, 2012, unpublished).

So far, Emma Hilario hasn't received compensation from the Peruvian government – her case appears to be in "administrative inspection." She had to undergo surgery over and over again; there are long-term consequences of a bullet wound. At the beginning of 2013 she became unemployed as many nongovernmental organizations lost their financing in Costa Rica, including her women's project. "I should write my story down, my colleagues said, but it hurts too much. Back then I just had two alternatives: victimize myself or be something else. I told myself that I couldn't make myself a victim, I want to fight for life and bear witness to that. Now that I am unemployed I'd like to create an *arpillera* for working the past" (Emma Hilario, 2012, unpublished).

Kuyanakuy – Love Each Other. The *Arpillera* Workshop of Displaced Women From the Ayacucho Region

Kuyanakuy is one of the *arpillera* groups that was founded by displaced women. The women had fled from the Ayacucho province and found refuge in Pamplona Alta.

The extent of forced displacement between 1980 and 1993, caused by the military as well as the subversive groups, can only be estimated. It is reckoned that between 430,000 and one million people were concerned; most institutions believe that there were approximately 600,000 (APRODEH, 2000, page 24). Seventy percent of the displaced persons originated from traditional village communities that were economically and ethnically marginalized and discriminated against in the cities. That applied to women in an even greater dimension, because eighty-nine percent of the displaced illiterates were women

Life for people who "only" searched for better living conditions in the cities was hard enough, which is evident in the first *arpilleras* of the women from Ampliación de Virgen del Buen Paso. There was always less work than people and the new residents competed with the better established sectors. However, against all odds and despite extreme poverty, migration involved hope for a better life for their children.

That was not the case for the forcibly displaced persons. They had to leave their villages quickly; families were torn apart. Orphans, wives, and children of missing people arrived with only the clothes they were wearing, traumatized and without urban work experience. They also had the stigma to be from Ayacucho, which was similar to being a "terrorist" for many residents in Lima.

Since 1983, displaced persons from the war regions have been seeking for refuge in Pamplona Alta, a few at first, then more and more people who experienced horrors that no one could have imagined in Lima. The Comisión Episcopal de Acción Social (CEAS; Episcopal Commission for Social Action) was one of the first institutions, starting in 1986, to offer humanitarian aid for displaced persons in collaboration with some parishes in addition to its legal services for victims of violence. As of 1991, the newly founded association Suyasun

(Hope) continues with these activities (Franger, 2005, page 166).

After the immediate humanitarian aid, methods for psychosocial assistance for the traumatized displaced persons had to be developed, especially for those who did not speak Spanish and came from a cultural environment that was unfamiliar to the psychologists and social workers.

In an economical situation that appeared hopeless, income-generating activities had to be developed for the survival of the families living under extreme poverty: training, productive workshops and micro-finance programs were designed accordingly as suitable actions. The activities basically included three programs: a psychological program, a social program, and a program to raise funds (Suyasun, 2002, pages 21ff.).

When the stream of displaced persons diminished at the beginning of the 1990s, social workers developed approaches to support the women in their base institutions (Suyasun, 2002, pages 41ff.; Franger, 2005, pages 165ff.).

The displaced persons had to learn the new rules and develop strategies for adaptation if they wanted to survive in the new, often hostile environment. Yet the women could draw from their village traditions. Resources included experience of solidarity in the village community from which they could develop strategies for survival.

The displaced persons took on responsibility and created their own functioning community kitchens that were well organized and gained respect with the residents. Social worker Raquel Reynoso points out: "There were many personal qualities, honesty, solidarity, which sometimes had gotten lost in urban areas. With them, it was a great experience; they tried to strengthen their skills in order to better adapt to Lima" (Franger, 2005, page 167).

Juliana Quijano, Kuyanakuy's coordinator, remembers the first years when the women came and she – as well as other neighbors – accommodated them. Today, Kuyanakuy's workshop is located in her house which is overgrown with bougainvillea.

Back then, her aunt had already made *arpilleras* and they began to teach the women how *arpilleras* could be fabricated. It wasn't easy, the quality was bad and no one wanted to buy the *arpilleras*. Later, they received a small fund from CEAS, they sold their *arpilleras* at local markets and established contacts with other cooperatives. "Suyasun supported us in selling the *arpilleras* to solidary groups, but we had no idea how to calculate the costs. The majority of the *señoras* were illiterate but they had to sign to receive payments. They refused to learn so I taught them to at least sign with their initials and a symbol like a chicken foot" (CIAP, 2002, pages 118ff.)

In 1995, the group got to know the organization of Peruvian craftspeople, La Central Interegional de Artesanos del Perú (CIAP), which exports members' fair trade products and improves the living conditions of the artisans and their communities. In order to become a member, the women had to give themselves a name and register as association. In 2002, they finally managed to register Kuyanakuy as legal entity (CIAP, 2002, page 119).

Organization of Production and Commercialization

The number of active members at Kuyanakuy varies – depending on the demand – but thirty to forty women are active on a regular basis. The board consists of seven women. They meet regularly to create ideas for their designs. Kuyanakuy not only offers the rectangular or square *cuadros* or *arpilleras*, but a whole range of appliquéd products: bags, backpacks, pillowcases, embroidered vests, Christmas trees, Christmas stockings, postcards, etc.

Whenever Kuyanakuy receives orders, the tasks are shared out as not all women have the same skills. The material is bought and distributed together; when there are no orders, the women fabricate little dolls or other requisites to have them in stock. The women are split in three groups according to their ability and their speed; when large orders need to be finished quickly, the best and fastest *arpill-*

eristas work on them. When an order exceeds the group's capacities, it will be given to other women in the neighborhood who from time to time assist the group. The women stitch at home and often are supported by the whole family, the husbands help as well in their free time or when they are unemployed. They are often experts for cutting the cloth; the children help after school by embroidering little details such as herbs, clouds, etc.

A committee of ten people examines the quality of the products. Payment will be received once the products are delivered. The women of the association support each other when members get sick; there is a basket of food around Christmas time and they have emergency loans. Many of the women were able to improve their living conditions through their work. Importantly, the women developed self-confidence. The association takes part in community activities, supports the parish's communal kitchen, and renders neighborly help (CIAP, 2002, pages 120ff.).

The artisan Alejandra Rojas remembers the beginnings: at the parish "they taught us how to make *arpilleras*, which is now an important contribution for our family's subsistence. I grew up in the mountains and had never learnt anything like this. I only knew how to till the field and to cook my way – now I had to learn these activities in order to survive. It was very difficult in the beginning, I had no exercise and after the quality inspections, they returned my items and said that I should unseam them and stitch them again. I stitched as well as I could but it was still not good enough, I had to unseam again and was afraid every time I handed in my items. Yet I studied further and now I know how to do it, my *arpilleras* aren't being returned anymore" (CIAP, 2003, cited by Franger and Huhle, 2003).

Testimonial *arpilleras* were created sporadically in this group also, even though the manual products that were market-oriented predominated. Juana Huaytalla, who fled from Cangallo, Ayacucho to Pamplona Alta in 1982 after her mother was "disappeared," came to terms with this traumatic ex-

perience in several *arpilleras*. In 1986, she depicted a protest march with a figure representing herself with a placard that read: "Where is my mother? They took her alive." Denouncing her mother's disappearance in an *arpillera*, she said, "I feel to continue to search for her!" (González, 2005, page 74). Later, she would make other autobiographical works with representing scenes like her mother lying on a bridge with embroidered red lines of blood running from her body. "Each *cuadro* [contains] the tears of the women who made them" (González, 2005, page 72). In 1997, Juana was chosen by her workshop to represent the association in the "Weavings of War" pilot exhibition in New York. At a public roundtable discussion, organized as part of the exhibition, Juana shared her personal testimony and spoke on behalf of peasant women displaced by the war (González, 2005, page 73).

Arpillera: Collective Commemoration of Violence and Overcoming Violence

When the truth commission held one of its official hearings in Pamplona Alta for the rehabilitation of human rights violations committed by *Sendero Luminoso* as well as military and paramilitary groups in 2002, the women from Kuyanakuy decided to bear witness in one collective *arpillera*. They submitted a brilliant work about their life, *Yesterday – Today*, to the truth commission on May 11, 2002 and later brought it along for the vigil in front of the law court's gate. Today, the *arpillera* is part of an exhibition, "When Misery Falls into Place. Political and social violence in the works of Peruvian folk artists" (Franger and Huhle, 2003; Franger, 2009, pages 42ff.).

Yesterday: "We had to leave everything behind in order to save our lives, the houses, animals, fields, family … we lost everything and began a new reality" (Suyasun, 2002, page 10).

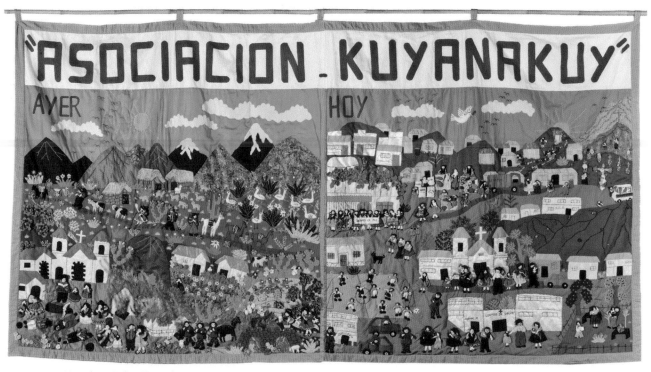

FIGURE 12.7 *Yesterday – Today*. Kuyanakuy, 2002, 282 cm × 170 cm). Photograph by Heinz Breilmann.

On the left-hand side above we show our peasant family's daily life, when it was still quiet and peaceful. We lived in rural areas, cultivated the fields, watched over our animals and had our adobe houses in this wonderful landscape. That was until *Sendero Luminoso* invaded the villages of Ayacucho from 1982 through 1984. Everything became violent, death, there were tortured, women and girls were raped. It was a nightmare. In order to save our lives, the families fled to Lima (Kuyanakuy, 2003, unpublished).

Today: "Not much time has passed – we faced our memories and organized ourselves" (Suyasun, 2002, page 50).

In Lima, our situation was very challenging, because we couldn't speak Spanish and had fled from the violence without any belongings. We only had our clothes. Some of us could stay with relatives, others with fellow countrymen and those who didn't know where to go found refuge in Catholic churches. In this neighborhood here, everything was sand, there was no water, no plant, we had to walk very far. Today, everyone has a small house, some returned through the government return program and we met up at the house of our member Juliana Quijano (Kuyanakuy, 2003, unpublished).

Arpilleras: The Subversive Power of Imaginings

Emma Hilario, Noris Vásquez Linares, Juliana Quijano, Rita Serapión, Juana Huaytalla, Alejandra Rojas, Olinda Gutiérrez, Marina Haro – they are representative for many protagonists of this testi-

monial folk art. With their art they give answers to one of the questions that Néstor García Canclini (1993) posed: Yes, their art is expression of folk culture and not merely a process of creating, marketing, and consuming a final product, but expression of their surroundings and their attempts to alter them. Their art is embedded in the collective action of their communities – it is expression of the rehabilitation of collective experience and vivid analysis of the society.

Noris Vásquez Linares talks about the skepticism towards her art, this "non-traditional" folk art: "Yet we are not approved. It is said: *but* this comes from Chile, *but* this is not original … there are many *buts* when there are talks about *arpilleras*" (Noris Vásquez Linares, 2012, unpublished). However, does not this *but* express the essence of the *arpillera* art? The boundaries between one's own and the distant disappear, various cultural influences are mixed, cultural boundaries degenerate, new traditions are being installed – a new inter-urban and international system of cultural circulations develops (Canclini, 1989, page 203; Ríos Acuña, 2004).

This young, urban form of women's art is in the tradition of Peruvian folk art which has always been a medium to deliver – often encoded – messages, be it in music, ceramics art, while carving *mate* or in the weavings of belts which was forbidden at times by the Spanish (Franger, 1992). The folk artists, *campesinos*, musicians, ceramists have spoken about life in their world of misery and oppression – and this has been told since the earliest times of the conquest.

The collective rehabilitation of trauma like in the *arpillera Yesterday – Today* by the women of Kuyanakuy in 2002, the illustrations of the art of survival, and the analysis of the crisis of the *Mujeres Creatives* in the 1990s, all these are extraordinary testimonials, but not unique creations. Over and over again, the women – the residents of the poor neighborhoods of the cities, migrants, and displaced women – took and take needle and thread and illustrate collectively their views on historical and cur-

rent happenings – very personally and at the same time related to the local situation. Full of hope, they send their messages to the world and use new media like the Internet, just like the women of the organization for displaced *quilla* in Huaycán.

In 2008, a group of women decided to document their story of forced displacement, new beginning, persecution in the new neighborhood, their success with the development of the neighborhood and the desires, for both themselves and their children, following the suggestion of the human rights organization Aprodeh. Their exhibition has been to many places in Peru and a documentary on their efforts encouraged others to speak about what they have suffered and what they claim from the government and the society as reparation and acknowledgement (Franger, 2009; Mama Quilla, 2010; Museo Itinerante Por La Memoria, 2010).

Like no other form of people's art, *arpilleras* are creations of collective communication processes, a collectively developed symbolism suitable for inspiration across borders. *Arpilleras* result from the communication of rural, local traditions with migration processes and globalized commercialization. The creations are authentic instruments of a "conscientization" (Freire, 1970), a critical consciousness and reflection of everyday life.

The instructor Noris Vásquez Linares, obtained her initial ideas from Chile and the women of her district. Today, she arranges training in rural communities in the central Peruvian rainforest, as the women there are also searching for income possibilities. And she supports women in Brazil with the foundation of an *arpillera* cooperative: Retalhios de arte.

Juliana Quijana of Kuyanakuy offered a workshop for the fabrication of *arpilleras* at the Christmas market of CIAP in Lima in December 2012, themed "skills develop between others and with others" (CIAP, 2012).

The women from the "young villages" were supported by popular educators, social workers and feminists, church-related and human rights non-

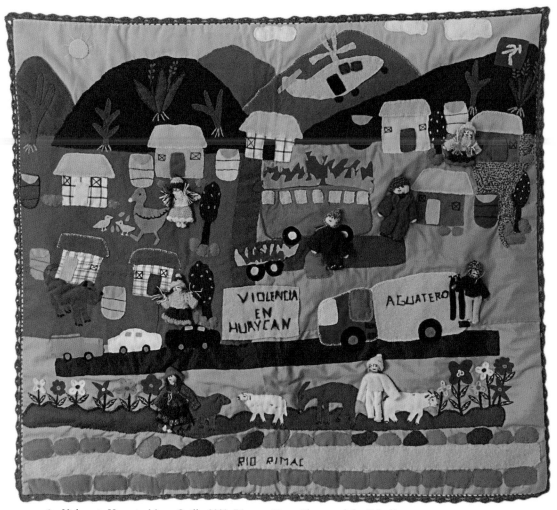

FIGURE 12.8 *Violence in Huaycán.* Mama Quilla, 2009, 76 cm × 69 cm. Photograph by Gaby Franger.

governmental organizations, and solidarity groups. It is always about gaining income. They are inventing working methods to produce their textiles with the embroidery fabric combined with their different activities. They are stitching, wherever they join to develop their neighborhood, similar to their *camp-* *esina* mothers, who never went out without the spindle in their hands. And they are moving forward. "Many women's groups that were initially created as a means of support and to share basic resources later evolved into associations that fostered consciousness-raising and empowerment" (Smith, 2008).

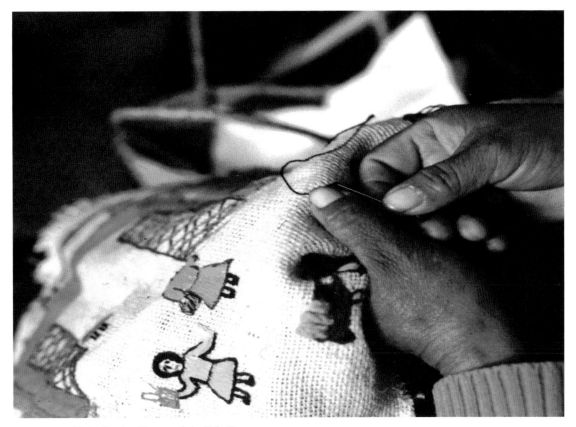

FIGURE 12.9 *Mujer Creativa*. Photograph by Gaby Franger.

Acknowledgments

The author would like to thank the following: Eva Maria Delbeck, Emma Hilario, *Mujeres Creativas*, Roswitha López Rodas-Utters, Noris Vazquez Linares, Alicia Villanueva, and the women from Kuyanakuy. The translation of this chapter from German into English was by Irina Kobrin.

The following unpublished sources (interviews, e-mail, and correspondence) are acknowledged: Eva Maria Delbeck (December 26, 2012); Emma Hilario (December 22, 2012); *Mujeres Creativas* (August 25, 2012); Noris Vásquez Linares (December 25, 2012); Roswitha López Rodas-Utters (December 8, 14, and 15, 2012); Kuyanakuy (August 11, 2003).

Bibliography

Akkent, Meral and Franger, Gaby (1987) *Das Kopftuch. Nur ein Stückchen Stoff in Geschichte und Gegenwart*. Frankfurt: Dagyeli Verlag.

APROHDEH (2000) *Los Desplazados*. Lima: Asociación Pro Derechos Humanos.

Bala, Elisabeth, Cyprian, Gudrun and Franger, Gaby, eds (2012) *Sehen und Gesehen Werden. Ansichten Aussichten Einsichten*. Nuremberg: Frauen in der einen Welt.

Canclini, Néstor García (1989) *Culturas Híbridas. Estrategias para entrar y salir de la modernidad*. México.

Canclini, Néstor García (1993) *Transforming Modernity. Popular Culture in Mexico*. Austin, TX: University of Texas Press.

CIAP (2002) *Marcando Huellas. 10 años de experiencia de CIAP por el desarollo de los artesanos.* Lima: La Central Interegional de Artesanos del Perú.

CIAP (2012) Expo Navidad. Available at http://ciap.org/blog/2012/12/05/expo-navidad-artesana-pucp-2012/ (accessed December 2013).

Franger, Gaby (1987) Arpilleras. *Bilder die sprechen.* Lima: Organisation und Alltag der Frauen in den Slums von Lima.

Franger, Gaby (1988) Arpilleras. *Cuadros que hablan.* Lima: Vida cotidiana y organización de mujeres.

Franger, Gaby (1992) Traditionelle Gürtel als Medium im politischen Kampf, pages 130–2, in Carstensen, Schroeder and Wörz, eds. *Die Welt Buchstabieren.* Ludwigsburg: Volkserziehung in Lateinamerika.

Franger, Gaby (2005) El desplazamiento forzado en el Perú. Perspectivas de apoyo y autogestión, pages 153–87, in *Red Alfa: Migración, discriminación y derechos humanos.* Bogotá: Ediciones Antropos.

Franger, Gaby (2009) Weben, Nähen und Applizieren – wie peruanische Frauen Bürgerkrieg und Verzweiflung überwinden, pages 38–47, in Franger, Gaby, ed. *Schicksalsfäden. Geschichten in Stoff von Gewalt, Hoffen und Überleben.* Nuremberg: Frauen in der einen Welt.

Franger, Gaby and Rainer, Huhle (2003) *Wenn das Leid Gestalt annimmt. Politische und soziale Gewalt in den Werken der Volkskünstler Perus.* Nuremberg.

Freire, Paolo (1970) *Pedagogy of the Oppressed.* New York: Continuum.

Gianturco, Paola and Tuttle, Toby (2000) *In Her Hands. Craftswomen Changing the World.* New York: powerHouse Books.

González, Olga (2005) Juana Huaytalla Mendez, Peruvian *arpillerista*, pages 69–74, in Zeitlin Cooke, Ariel and MacDowell, Marsha, eds. *Weavings of War. Fabrics of Memory.* Michigan State University Museum.

Haro, Marina (1992) The war of hunger, pages 127–30, in Benzing, Elisabeth, Franger, Gaby and Haun, Agatha, eds. *Living Reconciliation – Making Peace. Women's strategies against oppression, war and armament.* Special issue 5 of *Women of One World.* Nuremberg: Center for Intercultural Research of Women's Everyday Life.

Mama Quilla (2010) Blog. Available at http://mamaquillahuaycan.blogspot.de/ (accessed October 2013).

Mujeres Creativas (1996) The creative women in Lima, Peru, pages 74–5, in Franger, Gaby and Varadavajan, Geetha, eds. *The Art of Survival. Fabric Images of Women's Daily Lives.* Nuremberg: Tara Publishing.

Museo Itinerante Por La Memoria (2010) Las Otras Memorias – Mama Quilla – arpilleras de Huaycán: Available at www.museoarteporlasmemorias.pe/content/las-otras-memorias-capitulo-i-mama-quilla-arpilleras-de-huayc%C3%A1n (accessed October 2013).

Rios Acuña, Sirley (2004) Una aproximación al estudio de la arpillera peruana, pages 93–120, in *Artesanías de América*, No. 57. Ecuador: Cidap.

Smith, W. Alan (2008) Everyone but Rizzo: Using the arts to transform communities. *Forum on Public Policy,* Summer.

Suyasun (2002) *Violencia y Desplazamiento. Enfoque psicosocial y propuesta metodológica.* Lima: Suyasun.

Villanueva Chaávez, Alicia (1995) *Es necesario darnos un empujoncito. Muyer y empresa.* Lima: Movimiento M. Ramos.

Villanueva, Alicia (1996) Experiences in working with income generation programmes for women, pages 68–73, in Franger, Gaby and Varadavajan, Geetha, eds. *The Art of Survival. Fabric images of women's daily lives.* Nuremberg: Tara Publishing.

Willow, Ann Sirch (1995) Arpilleras. Pictures from the land of the sun. *Piece Work* November/December, pages 52–6.

PART III IN WOMEN'S HANDS: COMMUNITIES OF HOPE

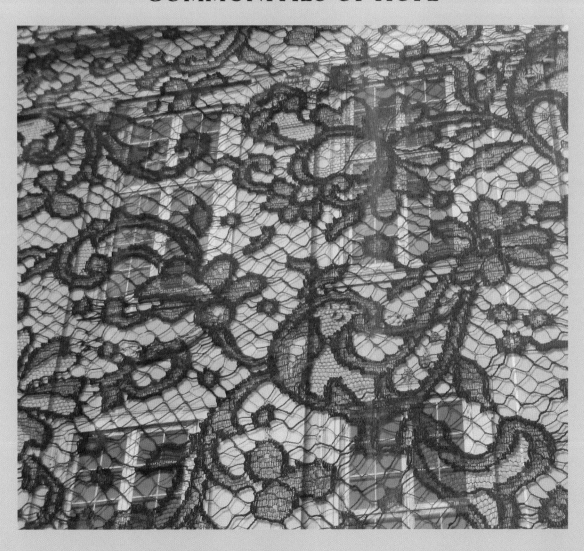

In Women's Hands: Manos del Uruguay and Stories of Empowerment

RENÉE S. SCOTT

WOMEN HAVE ALWAYS PLAYED a key role in Latin American economies. Since colonial times, women in both Brazil and Spanish America owned and operated rural and urban properties, and other economic enterprises (Burkholder and Johnson, 2004, pages 216–17). They were also street vendors, selling the handicrafts, breads, and pastries they made in their homes. In 1977, Domitila Barrios de Chungara published her much renowned autobiography, *Let Me Speak!* In this, the Bolivian activist, wife of a miner, and mother of seven children describes waking up at four o'clock to prepare the hundred *salteñas* (a Bolivian-style hot pocket) that she then sold in the streets. She explained: "I do this work to complete what is lacking from my husband's salary to pay for what we need at home" (Barrios de Chungara, 1978, page 32). Also, on the cover of the first Spanish edition of *Let Me Speak!* is a photograph of Domitila knitting; another example of the significance that hand work has played in her domestic life. During the military dictatorship of Augusto Pinochet in Chile (from 1973 until transferring power to a democratically elected president in 1990), poor women whose relatives were detained or missing met in workshops to create *arpilleras*; the patchwork tapestries depicting their daily lives and those of their incarcerated or disappeared relatives helped them cope with their difficult circumstances and also provided a source of income. In recent decades, Latin American weavers, knitters, embroiderers, and bakers have formed cooperatives – in many instances sponsored by national and inter-national organizations – to work collaboratively to produce new products, reach new markets, and generate more income for their families. This chapter explores the development of one of the oldest, most successful, and sophisticated female cooperatives in Latin America, Manos del Uruguay (Handmade in Uruguay), which since 1968 has provided work to unprivileged women artisans living in the country's most isolated rural areas.

There are presently thirteen Manos' cooperatives operating in nine of the nineteen departments of Uruguay. Manos' artisans make knitted and loom-weaved garments, blankets, tapestries, and curtains. Wool, one of Uruguay's main products since the nineteenth century, is the main fabric of all the cooperative's goods. Initially, Manos only produced woolen products, but over the years it began incorporating other natural fibers, such as linen, cotton, silk, and baby alpaca wool. The yarn is dyed in big iron pots over an open fire. The combination of the wool and other natural fibers, in addition to the multiple colors and textures created by craft dying, has made Manos' garments easily recognizable anywhere. Indeed, Manos has become a national institution sought after by world-renowned designers such as Ralph Lauren, Donna Karan, Marc Jacobs, and many others.

Each Manos co-op is independently owned by its members and dedicated to one or more artisan techniques, like hand spinning, dying, or weaving. The organization is governed by a board of directors composed of seven members; four cooperative members

and three adjunct members, who volunteer for the organization. Board members are selected every two years by the assembly of directors and secretaries that meets once a year. In addition, the assembly selects members of the education and fiscal committees. The education committee organizes summer camps, carnival floats, and other social events. The fiscal committee oversees budgetary issues affecting the co-ops, while the general accounting of all the cooperatives is done by the Center of Uruguayan Cooperatives (CCU). In Manos' headquarters, in the capital, Montevideo, about 100 employees serve the cooperatives with designs, raw materials, technical training, and merchandising.

As a young girl growing up in Uruguay in the 1970s, I vividly remember my earliest encounter with Manos when I discovered one of its first boutiques in a downtown shopping center not too far from my home. I would frequently visit the store and stare with awe and delight at the exquisite sweaters, hats, and other garments displayed in their window. Even today, many years later and living in the USA, Manos is always an obligatory stop when I am in Uruguay. I cannot control the urge to find yet another garment to add to my collection, which surely will keep me warm for many winters, and elicit admiration and questions each time I wear it.

The Uruguayan Economy

With a population of just three and a half million (eighty-eight percent of them being of European descent), Uruguay, the smallest Spanish-speaking nation in South America, is known for its temperate climate, rolling hills, large ranches or *estancias*, and sandy beaches. Rivers flow westward to the Río Uruguay, eastward to the Atlantic or tidal lagoons bordering the ocean, and south to the Río de la Plata.

Almost the entire countryside consists of cattle and sheep *estancias*. Wool is one of Uruguay's main exports. Sheep rearing is typically undertaken on medium-sized farms concentrated in the west and south. It began to boom as an export industry in the last quarter of the nineteenth century, particularly following the invention of barbed wire, which allowed the easy enclosure of properties. It was then that the gauchos went from free-spirited, horse-riding men who freely roamed the countryside, to being subservient peons in the *estancias*. This economic model left very few opportunities for women, who would often use the leftover wool from the ranches to weave blankets, ponchos, and rugs. They also worked as domestics, washers, and other low-paying occupations to contribute to the survival of the family.

For a long time, Uruguay was described with glowing accolades: the first welfare state in the hemisphere, the Switzerland of South America, and the Small Silver Cup. José Battlle y Ordoñez, president from 1903 to 1907 and again from 1911 to 1915, set the pattern for the country's modern, social, and political development. But in effect *Battlismo* – as the ideology inspired by his ideas and political agenda is known – left rural Uruguay virtually unchanged, with a deficient infrastructure and few opportunities for those who didn't own land. As historians José P. Barrán and Benjamin Nahum point out, "Dispersed in the cattle ranches as peons, or marginalized from productive employment, they choose to emigrate to Montevideo or the neighboring countries, or stay in their miserable towns … The rural upper class was comprised of approximately 1,300 families, 2% of the total cattle society and they own more than 40% of the land" (Barrán and Nahum, 1979, pages 164 and 201). Over the years, government attempts to encourage agricultural colonization by means of land reform in the interior had largely failed in economic terms, as had the promotion of wheat production; one exception is rice, most of which was produced in the eastern part of the country.

Moreover, by the late 1950s, partly because of a decrease in the world demand for agricultural products, Uruguay began a rapid economic decline, which included inflation, mass unemployment, and a steep drop in the standard of living for workers. In

1968, the same year that Manos was funded, President Jorge Pacheco declared a state of emergency. After the military seized power in 1973, all civil and political liberty ceased to exist until 1985 when democracy returned. During these years, emigration from the country rose drastically, as large numbers of Uruguayans looked for political asylum and better economic conditions throughout the world. Those who stayed faced serious economic challenges, and the farther they were from Montevideo, the fewer opportunities they had. By 1975, only thirteen percent of the country's population lived in rural areas, a number that was declining. Furthermore, there were far more men than women living in the countryside compared to the national trend, evidence of working age women migrating to the cities (Rostagnol, 1989, pages 24 and 170).

A Women's Enterprise is Born

As is the case with many nonprofit ventures, it was the vision, selflessness, and hard work of a well-to-do group of people who made Manos possible. It was in 1968, in the middle of a national political and economic national crisis that a few affluent women in the town of Fraile Muerto in the department of Cerro, Largo, conceived the idea of helping the poor women in the countryside by commercializing their crafts. For the most part, the founders were proprietors of agricultural and livestock establishments who had connections with rural schools. They noticed that some students were making various crafts as extracurricular activity, such as leather-tanning, horse blankets, and ponchos; which were difficult to sell given the low purchasing power of the local population. As Manila Ch. De Vivo, one of the founders tells it:

> It was a fall afternoon and a friend and I were waiting for our children at the school door, and exchanging ideas about what each of us was trying to do in the different rural zones in which we were settled. This meeting marked for me the beginning of Manos del Uruguay. Next day, we met at Olga's [S. de Artaga-veytia] house, with her and her mother (Manos del Uruguay website).[1]

Soon after, three other women joined the group and begun discussing ways to generate income for the hundreds of impoverished women, who for the most part were housewives. Manos' founders were particularly interested in creating an organization that the Manos' artisans would eventually own. Following a long tradition of cooperatives in the country, the founders conceived Manos as a future cooperative, a notion that would come to fruition in 1968.

The founders were related, and through economic ties, enjoyed social, political, and economic influence. Thus, they were able to provide services that were essential to get Manos off the ground, such as free facilities, vehicles, and raw materials; they also secured bank loans for which they acted as guarantors. In addition, teachers, nuns, and people from other sectors soon joined the project.

They began by identifying locations where women were already knitting and weaving. They were particularly interested in reaching the poorest women. As one of the first artisans recalls:

> I went to the Industrial School, and from there Mr. Odriozola sent me to talk to Mrs. Ema, who was the person that was assigning the jobs. But he was the pioneer, the one who organized. We had to talk to him first, and then he sent us and there we talked to Mrs. Ema, and Mrs. Ema evaluated whether she could give us a job or not, according to the situation of the person. Because it was not that jobs were assigned just like that. If the person had a good salary, her husband had a good job, she said that jobs were only for people in need. And there I enrolled, and said, look Mrs. Ema, I don't know how to spin. And she told me: no problem, come on, I will teach you. And I learned (Ema, craftswoman in Rio Branco, department of Cerro Largo).

[1] Unless otherwise specified, the artisans' testimonials are from Manos del Uruguay's website available at www.manos.com.uy/ (accessed October 2013).

The following testimony provides yet another window into the challenging economic circumstances of the women Manos wanted to help:

> I lived in a small shack. Yes, at first I lived at my mother's house, for a long time and then we built a small shack. I washed the clothes of people who worked in the fields, but washing was really a hard task. As I didn't have running water, we had to carry it from the wells, which were three blocks away … my children were small. They helped me, because I also made pies and cakes for sale, they the kids went out to sell them … I also sewed, or washed or anything else … I sewed for all the people in town. I had a lot of sewing work before. The problem was that here, in town, sometimes it took a lot of time to get paid. It is very difficult, besides I was not entitled to family allowances, or social security or anything (Marina, craftswoman in Rodó and Egaña villages, department of Soriano).

In the summer of 1968, Manos tested the market with an inventory of rugs, ponchos, and saddles, which they sold in the posh resort town Punta del Este. In winter of the same year they set up shop at the Expo Prado (where every year the Rural Association organizes cattle exhibitions, actions, and other events in the Prado neighborhood). They were very successful in their sales, despite the fact that the quality of the products was a far cry from what it is today. Elizabeth Sosa who later became the director of Manos' board, was a schoolgirl when her mother received the first order for tablecloths. She recalls, "The wool those women worked with would scare us today because it was really rudimentary, washed by hand, coarsely woven and undyed" (Durbin, 2005).

Unlike other Latin American countries, Uruguay did not have a handcraft tradition. The first Manos' artisans learned to use looms and mostly followed fashion trends to create their own products. To refine the quality of its products, the organization hired Beatriz de María, a former nun. She also connected the funders to the Cooperative Center of Uruguay (CCU) in order to create an enterprise that would gradually place the decision making in the artisans' hands. The same year, the nonprofit Sociedad Civil Manos del Uruguay was legally incorporated and its first by-laws approved. By August 1968, 281 craftswomen were organized in twelve cooperatives in various areas of the country; and by 1969, the number had increased to 750 members and forty-nine groups. Other than the assistance of CCU, the organization had few employees. Because volunteers provided administrative and training advice, Manos was able to operate at a very low cost. In addition to organizing the cooperatives, the members had to contend with the repressive military regime that ruled the country; Manos' telephones were tapped and every meeting needed to be authorized and monitored by a policeman.

While learning new knitting techniques and self-government, the craftswomen also had to assert themselves with their husbands, uncomfortable with the notion that women could sustain regular employment outside the home:

> I know of craftswomen that have attended a production meeting, for example, and their husbands have locked them out of the house, they wouldn't let them in. Sometimes you have to argue with your husband; sometimes you have a kind of quarrel. Because husbands do not want their wives to work, they don't believe it's correct, they are not used to it, their mothers did not work. It's different nowadays with young women, because when they get married they are already working (Dora, craftswoman in Rodo village, department of Soriano).

Once the men saw their wives' determination and the economic benefits their work in Manos provided for the families, they came around:

> For him it was horrible when I spun, he said it was dirty, or whatever; that wool was dirty, he didn't want me to spin. And later I told him I was going to join the knitting group, because you know … the fields were fields and were very, very poor, and we didn't have anything. And I had two kids. And then I said, OK, I will join the knitting group. And he didn't like it very much either. But when he saw that

I was doing well in the knitting group, and that I was happy, he started to help me out with the kids (Graziella, craftswoman in Solis Grande, department of Lavalleja).

At first, the artisans worked in their homes, but as the organization grew it became necessary to find locations where they could meet and the wool and garments could be stored until they were shipped to Montevideo. One group secured a classroom and would gather on Saturdays, when school was not in session. Since many artisans could not rely on public transportation, they devised creative ways to communicate with others about upcoming meetings. In one group, an artisan who lived closed to the train station would display a white flag on the church roof next door, alerting the women that the wool had arrived from Montevideo and they needed to gather. In other groups, women transported the wool from the train station to their communities by horse, wagons, handcarts, and their own shoulders. Buses were scarce and when it rained the roads would flood.

Becoming cooperative members also meant that the artisans needed to master their new responsibilities as businesswomen; to learn about deadlines and self-government. Many women only had two or three years of formal education while others had never attended school at all, because school was too far and their mothers kept them home. Although most of them learned fairly quickly to operate a spinning wheel, having done manual work all their lives, they faced challenges with the cooperative's administrative work. For starters, they had to fill in forms to register the raw material they received, and what they produced in order to get paid.

As one artisan remembers: "I went to the butcher to ask: if one kilogram of wool costs ten pesos, how much does 100 grams cost? And she taught me, the butcher's wife taught me … And I learned a lot, much more than I did in school, because today I know how to do calculations and everything" (Zulema, craftswoman in Poblado Uruguay, de-

partment of Cerro Largo). A few asked their own children for help with the multiplication tables or asked other craftswomen: "Until eleven o'clock at night with Berta, fighting against those forms, me and Rose. Then Rose began to fill in the loom form, and I filled the yarn form and the monthly controls" (Nair, craftswoman in Rio Branco, department of Cerro Largo).

As the women mastered technical and administrative tasks, what once was shyness and perceived incompetence turned to self-confident. They realized that their social awkwardness was the result of their challenging personal circumstances: "It was a question of lack of contact with people; lack of opportunity to express myself and say what I felt" (Rufina, craftswoman in Egaña village, department of Soriano).

Moreover, for the first time, the women began leaving their villages – and their husbands and children behind – to participate in training workshops at headquarters in Montevideo. For many of them, the farthest they had previously traveled from their homes was the capital of the department to vote or visit relatives. Being in the "big city" was not always easy. They counted the days until they would return home, and at night the noise of every passing car would wake them up. But progress was made. As one of these women asserts, "Now I go, I spend the days at ease, I eat, I sleep, and I have no problem" (Tona, craftswoman in Solis Grande, department of Lavalleja).

Thus, the first women who worked in Manos underwent an empowering transformation, acquiring confidence and technical skills. They went from being economically deprived and dependent on their husbands to being able to make their own decisions and economically contribute to support their families. Their positive transformation also trickled down to their children. When one of their sons was asked by his teacher to draw a cooperative, he drew a loom and all the wool colors. The youngsters also learned to appreciate their mothers' work: "because before I didn't have anything, and now I

have everything, thanks to my job ... I have ten children. And now from the youngest to the eldest, they look after the youngest and do all the housework. Now the youngest is five years old, and she has already started to go to school ... I made them understand that Mommy is working, and that if you want things and want to eat such or such foods, if you want to get dressed with such or such clothes, you have to help Mommy; because otherwise Mommy won't be able to make it" (Elba, craftswoman in Guichon village, department of Paysandú).

In 1976, Manos secured its first grant from the Inter-American Foundation (IAF) for training and technical development. A second grant in 1980 from the Inter-American Development Bank (IDF) facilitated the process of shifting artisans to management. By then Manos had 1,022 artisans and had become one of Uruguay's largest employers. In 1988, the successful transfer of artisans to management position was completed. Manos by-laws were redrafted so that the directing board would be comprised of artisans, elected by the assembly of presidents and secretaries of the various cooperatives.

A Second Generation of Artisans

Over time, Manos artisans have made the transition from working at home to working in workshops. For the most part, they now work a regular forty-hour week and enjoy regular social benefits. Each cooperative is comprised of several shops and is constituted as an independent business enterprise. The shops are equipped with electric weaving looms and other modern machinery and Manos trains its women in manufacturing and administrative tasks. The administrators are in charge of the finances, etc. Fifty percent of the profit stays inside the cooperative to pay social security, salaries, etc. The rest goes to pay Manos' employees in Montevideo and other general expenses. At the same time, the Center of Uruguayan Cooperatives (CCU) is in

charge of coordinating the bookkeeping for the whole organization. Since 1978, in order be accepted as a co-op member, an artisan must have basic education, demonstrate manual skills, and cognitive ability. An exam is administered by either a cooperative instructor or a committee and the results are sent to the board of directors in Montevideo.

As national import/export barriers were lifted in the 1980s, the number of exporters grew steadily, eventually reaching its maximum in 1992 (Snoeck et al., 2009). It was then that Manos' founders set out to accomplish their long-held objective of exporting their goods. They began requesting Uruguayans who were traveling abroad for diplomatic and political reasons to take garments and show them around. The first Manos importer happened to be a Frenchman who was in Uruguay looking for artisanal cheeses. Although the exports to France were never on a large scale, Manos was particularly pleased to have penetrated a strict European market, and when the magazine *Elle* featured a Manos cape on one of its covers, the founders decided that exporting was the way to go.

For the craftswomen, exporting meant improved new products to satisfy foreign markets, and increased production under stricter deadlines. One of them recalled:

And a few of them had the misfortune of having to travel to headquarters in Montevideo to fix sweaters. We went because the sweaters needed to be shipped and they could not do it. We had to go quickly and fix them. And it was not very agreeable there. And thankfully, we got help in Montevideo, because otherwise, they could not have been shipped, because they had to be shipped at four o'clock and we finished at three-thirty. We had to fix the sweaters and also package them and everything (Twins Knitting group, department of Rio Negro).

Between 1976 and 1985, Manos received every prize awarded by the national Banco de la República, for being the primary exporter of wood products. By 1985, the organization was responsible for eighteen percent of all wood exports in Uruguay. By then,

Manos had begun selling in its shops crafts made by independent craftsmen. They created unique pieces made from leather, wood, glass, and pottery. Manos also added more men to its rolls. Among them, Santiago Vera Puglia, who is now Manos' head dyer.

Like so many young artisans living in rural Uruguay, Santiago began selling his woodcrafts at exhibitions at his hometown of Molles (department of Durazno). A group of women were organizing in the town; they were spinning yarn but not dying it yet. One of the women saw Santiago's work and asked him to be the group's dyer. In those early years Manos had no central lab, it worked with a palette of ten to twelve colors, and each group selected their colors. Additionally, since each location had different conditions, the "same" colors varied from one location to the other.

In 1977, Santiago was invited to establish a Manos dye lab in Montevideo. After standardizing the colors for all the shops, he set his sights on creating new colors. In the late 1980s, when a co-op member returned from a trip to Milan with multicolored yarn, he duplicated it. Working with Anne Simpson (US Manos distributor from 1986 to 1999), he also came up with yarn colors specifically targeted for the US market. Today, some of Manos colors require up to six separate dyes, and Santiago estimates that in all he has created over 1,000 colors.

Over the years, the children of the first generation of artisans grew up to become Manos artisans themselves. Margot works as a spinner at a co-operative in Rio Branco, in the department of Cerro Largo. In this small town of 16,000, sources of income include the rice plantations and the nearby tourist town of Marin Lagoon. Margot's mother, a widow, was working as a maid before she joined Manos. In 1984, Margot was already a knitter and when Manos grew and was seeking more artisans, she joined. Her work there has not only given her more economic independence, but also has taught her skills far beyond handcrafts. By attending numerous workshops taught by social workers, she has learned about finance, allowing her to become a member of the co-op fiscal commission and later in charge of the co-op finances.

As Uruguay sank into a deep recession in the 1980s, Manos faced serious challenges. In 1983, it secured an Inter-American Foundation (IAF) grant which it used to structure and meet credit obligations. Since then, Manos has only received one loan from the IDF in 1997. Still, as a cooperative, Manos benefits from certain tax exceptions; however, since its properties belong to each individual cooperative, the organization cannot easily access external capital. Furthermore, following a period of growth in the 1990s, the country experienced a 17.5 percent fall in output between 1998 and 2002, which obliged Manos to take drastic measures. It reduced its membership from 1,200 to 450 in 1983 while a number of employees in Montevideo were also let go. Many of the first artisans are retiring while others find new jobs thanks to the skills they acquired in the organization. With globalization comes large orders; during peak exporting seasons, Manos employs up to 600 additional workers. At the same time, globalization means that companies can outsource work for lesser pay. Manos' largest competitor is China, which has radically increased its production of sweaters in recent years. Since its foundation, Manos has been committed to paying fair wages by calculating how long garments take to make, and rewarding fast artisans with higher pay. Presently, when the price a client is willing to pay for an order is too low, Manos gives the cooperative the option to accept or reject the order. The organization is aware that its high-end products would never be sold in large retail stores. Its success now depends on operating within smaller margins and keeping up with the unique and high quality products it is known for. At the same time, the organization is taking the advice it received from a British consultant more than twenty years ago by concentrating on one single item: Manos hand-spun and dyed cotton stria yarns. They are soft, come in ninety-five colors, and are now its top international sellers. Manos' history of helping poor Uruguayan women in rural communities is an

additional incentive for conscientious knitters from the USA and Europe to purchase Manos yarns.

Since 1989, Manos has been proud member of the World Fare Trade Organization (WFTI), which is comprised of more than 350 organizations committed to fair trade. It recognizes Manos' commitment to "environmental policy and practice, and continual reinvestment in marginalized artisans, farmers and producer communities" (Manos website). It is clear that Manos' directors, including president Elisabeth Sosa and senior designer Cecilia Lalanne are steering the organization in the right direction. Manos has stores in Montevideo and Punta del Este, sells yarns, has its own ready-to-wear and home décor lines, and produces knitwear for international brands, such as Victoria Secret, Chanel, DKNY, Marc Jacobs, Ralph Lauren, Stella McCartney, and Peruvian Connection. The organization averages $4.2 million in annual revenue and seventy percent of the revenues are generated by export (Durbin, 2005).

In order to stay ahead of the national trends, Manos' employees in Montevideo work diligently to identify new markets, find new clients, and build customer loyalty; they also coordinate the whole production process. At various times in the year Manos' designers collaborate with its clients' own designers to jointly create new models, which are then actually made. This on-going teamwork between the designers encourages Manos to constantly develop new techniques to provide their clients with one-of-a-kind garments. When the first step between Manos and its clients has been successfully accomplished, Manos selects the co-operative that will produce the order. It then begins working on the pattern for each size, supplying raw materials to the cooperative, preparing the delivery of the products, making the corresponding quality controls, and dispatching the shipment. Manos' vehicles cover approximately 100,000 km each year transporting raw materials, garments, and tools between the cooperatives and the main service center in Montevideo.

Conclusion

As we look back at Manos del Uruguay's history, we need to recognize the significant role the founders and other community leaders played in the success of the organization. They believed in the potential of poor women from the countryside, and provided the necessary tools, technical knowledge, and organization. Together they worked to inspire hope where there was despair and brought hundreds of poor rural women from the margins to the center of historical focus. Manos' artisans have been empowered in many ways: gender equality at home, economic security, new technical skills, and development of the entrepreneurial spirit. They have mitigated patriarchal norms and successfully negotiated new roles within their families: debunking the cultural norm that women stay at home dedicated solely to raising their children and other domestic labors. Furthermore, they learned self-governance and took charge of the organization. Artisan Eloina Morales sums up her own experiences: "For me, Manos was like going to the university. I learned to run my cooperative, then I integrated the board of directors, and finally I entered the production department acting as a bridge between the manager and the artisans' reality. Now I am the production manager and have made a career step by step with constant training and growth" (Waterman, 2012).

Despite Uruguay's economic ups and downs, Manos has stayed competitive in a global market by creating new designs and making administrative adjustments. It constantly improves its products, the relationship between the cooperatives, and the main office and developing national and international markets for its products.

One can also assume that Manos has been an inspiration to more recent female cooperatives in the country. One of them is Delicias Criollas, founded in 2001 by 150 women, and now operating in fifteen different rural locations. Combining traditional recipes with modern technology, the cooperative makes about sixty products, including jellies, syrups,

candy, and breaded and savory foods, such as pickled mushrooms. The products are sold in boutiques, as corporate gifts, and also in supermarkets (Pais, 2010).

Another female enterprise run by rural women is Calmañana, which has produced medical and aromatic herbs for more than two decades in the department of Canelones. The cooperative's members not only supply local supermarkets and labs, but export their products to Europe and form part of the national certification board for organic products.

Presently only eight percent of Uruguay's three and a half million residents live in rural areas. The highest rate of poverty is concentrated in rural areas with fewer than 5,000 inhabitants; in those areas, the unemployment rate is 75.9 percent for men and 46.2 percent for women. The rural poor are, for the most part, young men and women, as well as families headed by single women who have neither the economic means nor the training to obtain sustainable occupations. Therefore, it is imperative to create new sources of income in rural communities, especially for women to contribute to their economic well-being and to redress gender inequalities. The National Directorate of Artisanal, Small, and Medium Businesses (DINAPYME) has trained more than 5,000 entrepreneurs all over the country, sixty percent of whom have been women. Enterprises like Manos del Uruguay, Delicias Criollas, and Calmañana play a vital role in the life of female artisans by engaging them in small- and large-scale commercial activities. These women can then become agents of change for themselves, their families, and their communities, where they belong and want to stay.

Bibliography

Barrios de Chungara, Domitila (1978) *Let Me Speak!: Testimony of Domitila, a woman of the Bolivian mines.* New York: Monthly Review Press.

Barrán, José P. and Nahum, Benjamin (1979) *Battle, los Estancieron y el Imperio Británico.* Volume 1: *El Uruguay del Novecientos.* Montevideo: Ediciones de la Banda Oriental.

Burkholder, Mark A. and Johnson, Lyman L. (2004) *Colonial Latin America.* Oxford: Oxford University Press.

Durbin, Paula (2005) Manos del Uruguay: The bottom line. *Journal of the Inter-American Foundation* Volume 26, Number 1.

Maros del Uruguay. Available at www.manos.com.uy (accessed October 2013).

Pais, Ana (2010) Delicias Criollas: Natural food made by rural women. November 30. Available at http://infosurhoy.com/en_GB/articles/saii/features/economy/2010/11/30/feature-02 (accessed October 2013).

Rostagnol, Susana (1989) *Las Artesanas Hablan. La memoria colectiva de Manos del Uruguay,* 2nd edition. Montevideo: CIEDUR.

Snoeck, Michele, Pittaluga, Lucia, Pastori, Hector, Domingo, Rosario and Casacuberta, Carlos (2009) The emergence of successful export activities in Uruguay: Four case studies. IDB Working Paper No. 238. Available at http://ssrn.com/abstract=1815920 or http://dx.doi.org/10.2139/ssrn.1815920 (accessed October 2013).

Waterman, Annie (2012) Wooly heart and soul. *Handeye* May 17. Available at http://handeyemagazine.com/content/wooly-heart-and-soul (accessed October 2013).

Text-Tiles: Reflections of Women's Textiled World in the Judeo-Spanish (Ladino) Poetic Tradition

MICHAL HELD

Personal Prologue

A LADINO PROVERB:

"*Ken guadra para otros guadra*"

meaning "The keeper, keeps for others."

> In a square olive-oil tin
> Grandma Bulisa
> kept old buttons their price far above rubies
> And she would spread a large sheet on a cold floor
> and we would scatter the buttons that turned
> into vessels
>
> and we would sail the sea of their colors to the
> regions of garments from which they dropped
> the gowns of Victoria, Sultana and Flor
> Sephardic ladies
>
> And i was bequeathed the custom
> of buttoning the eyes of those faded dresses
> to my new attire, so that i might
> wear silks and purple (Held, 1996).

Being born into a family that belongs to the Jerusalem wing of Sephardic culture, and in which women were always holding an embroidery needle or a pair of knitting needles, the invitation to contribute to a book about the female existence among textiles encouraged me to revisit not only the Sephardic culture that had been my field of research for many years, but also my home and myself. The closeness between fabric as a material and fabrication as a cognitive activity ("to fabricate a story," "a fabricated fact") lies under the surface of the following reading, whose scholarly and creative aspects both derive from a reflexive standpoint.

I grew up experiencing women exchanging knitting instructions, and magically turning yarn into the most complicatedly designed sweaters. A few years later, I would watch them take the sweaters apart, wash the yarn, roll it and turn the yarn into new garments, no less beautiful. Around the creation of sweaters, crochet, and cross-stitch projects, stories and histories too were "fabricated," taken apart and reassembled.

According to a family legend, many years ago my aunt Victoria's comment to a friend that she had to undo a piece of knitting in order to correct a mistake in it, was met with the remark "I will burn myself and not do that!' To which Victoria replied: "Shall I get you some petrol?" The humorous nature of this incident hints at much deeper meanings that women associated with the making of textiles in the traditional society, and carried on when they stepped into modern life.

After my grandmother Bulisa died, her old nineteenth-century-style Singer sewing machine caused a big argument when more than one woman in the family wished to keep it for herself. Each had a brand-new electric sewing machine of her own by then, yet the bygone object, to use Jean Bodriard's term, has become a psychological item marking the passage of time and embodying in it a family portrait that nobody was eager to let go of.

As echoed in the poem that opens this chapter, according to the rules set by the women of my fam-

ily, buttons are never to be thrown away with an old clothing article, but must be removed and saved for future use. The hardships that the family struggled to survive in the past may have been the original reason for this custom. Yet, when I experienced it, it became a symbolic act of recreating the past in the present, and carrying its echoes on to the future. My mother still keeps my grandmother's jar of old buttons that are still full of nobility. We often use them to replace the less-pleasing ones that come with new clothes.

The context of my personal experience with the creation of fabrics and textiles serves as a vehicle for the following discussion, setting out to explore the way in which scenes from the lives of Sephardic women, evolving around the creation of handcrafted textiles, are reconstructed in traditional folk literature and echoed in contemporary poetic works.

A useful key for deciphering the complex net of meanings embedded in the process may be found in the breaking up of the word "textiles" into *Text-Tiles*, representing the link between the material (textile) and its transformation into a virtual set of signs (tiles) that enable a hermeneutic analysis of the way in which the lives of women are experienced and reflected on. This paradigm shall be further developed throughout the reading.

Definitions and Frameworks: The Sephardim[1] and their Poetic Tradition

The following close reading of folk songs and poems stitched around the characters of Sephardic women and their handcrafted artifacts should be preceded with an exposition of the sociocultural context out of which they grew.

In 1492, the Catholic monarchs decreed the expulsion of Spanish Jews, most of whom left Spain and settled in various parts of Europe, north Africa, and the then-powerful Turkish Empire. Those who had been expelled and their descendants retained the Spanish language and a culture with Hispanic roots for nearly 500 years (Díaz-Mas, 1992, page xi).

Today, the attitude of the descendants of traditional Judeo-Spanish speakers towards their Sephardic culture and language, which is ceasing to exist as a vital tool of communication, is of a movement towards a *personal ethnicity*: an individual identity nourished by the memory of a decaying collective state. Sephardic personal ethnicity in our times hardly serves a collective function, while fulfilling a strong personal psychological and emotional need.

The carriers of Sephardic tradition today are the last representatives of a rich Jewish culture. An interesting embodiment of this shift occurs in cyberspace. When Judeo-Spanish is often used more frequently online than offline, we witness the formation of what I defined as the Sephardic *digital homeland*.[2]

The current situation of Sephardic culture may be deciphered in the light of Benedict Anderson's definition of an imagined community (Anderson, 1983), as the reconstruction of an imaginary identity based on a culture that has virtually no function in today's world. Pierre Nora's description of the cultural stage in which, when *lieux de mémoire* no longer exist, *milieux de mémoire* are created provides a most relevant approach to the situation we are looking at (Nora, 1989). The following discussion shall demonstrate the way in which a fascinating Sephardic *milieux de mémoire* revolves around the "text-tiled" sphere.

A central part of the Sephardic cultural identity is formed around the group's ethnomusicological tradition. Folk songs were put to music and orally transmitted among Sephardic Jews for centuries, originating in medieval pre-expulsion Spain and constantly developing in the post-expulsion Sephardic communities. An important branch of

1 Hebrew for Spaniards, and thus "Sephardic," etc.

2 For a definition of the digital homeland and a discussion of its Sephardic version see Held (2011).

this rich musical and textual tradition includes the *romansas* – narrative songs in a definite poetic formal structure, most of which stem from the Jewish medieval Hispanic experience and reflecting the melodies and themes that characterized it.

The medieval songs continued to illustrate Sephardic life in the Ottoman Empire, accompanied with the creation of new *romansas* alongside new genres of folk songs, such as the *kantigas* – lyric songs created after the expulsion and often adopted to the music of popular songs in Turkey, Greece, Bulgaria, Yugoslavia, Israel, and other countries surrounding the Sephardic experience.[3]

The following paragraphs are concerned with the way in which the Sephardic woman's world is reflected and interpreted in traditional poetic texts portraying her and performed by her. The role of women in the process of transmitting traditional Sephardic poetry received much scholarly attention. Edwin Seroussi studied the multilayered social mechanism that allowed for the continuous practice and the survival of Judeo-Spanish folk songs among Sephardic women, enabling them to express themselves until modern times in a patriarchal traditional society that limited their expression. He goes further into exploring men's appropriation of the female repertoire, which shows that the repertoire is rooted in the female identity but is not limited to it (Seroussi, 1998).

Susana Weich-Shahak points out that the Sephardic folk songs form one of the richest and most vibrant Jewish repertoires that reached the twentieth century in full blossom. She shows how they were transmitted by Sephardic women in Morocco and the Ottoman Empire. According to her, many of the plots that comprise the rich repertoire of *romansas* and *kantigas* sung by Sephardic women include assertive female characters, although the

actions of these characters are generally triggered by their male counterparts. Sephardic women could have identified themselves with the ambiguous roles of the female characters of the ballads for they are carriers of action and at the same time are fully dedicated to their men (Weich-Shahak, 1998).

Experts from medieval and modern *romansas*, *kantigas*, and contemporary Judeo-Spanish poems looking back at the traditional folk songs are interwoven into the following discussion. The fusion of collective and individual creativity forms a transparent text-tile representing multilayered Sephardic feminine memory and identity formation mechanisms.

"Lavrando el bastidor": A Poetic Vehicle for Understanding the Sephardic Woman

This chapter sets out to trace and decipher the connection between textiles and the Sephardic women associated with them in various Judeo-Spanish poetic texts. The textiles that women wear and create in the texts are internalized as parts of the body and the self, and thus we are looking at what I suggest may be defined as "text-tiles": texts that depict and decipher the Sephardic woman by buildings layers of meaning around her interaction with textiles.

The reading process includes an attempt to understand the reflective and the reflexive nature of poetic works that are looking backwards and inwardly at the women who are portrayed in them, and at the women who created some of them.

The majority of the Judeo-Spanish texts with which we are concerned were created and orally transmitted in medieval Spain and/or in the post-expulsion Sephardic communities in the Ottoman Empire and northern Morocco. Ottoman culture, and its Jewish community, attached great importance to textiles. Apart from serving a useful

[3] For a detailed analysis of the Sephardic traditional poetry, its genres, themes, geographical distribution, and cultural importance see Díaz-Mas (1992, pages 117–32).

purpose in daily domestic use, on festive occasions and in places of prayer, textiles were also symbols of social and economic status (Juhasz, 1990, page 65).

Traditionally, the making and decorating of textiles played a central part in the life of traditional Sephardic woman, who mastered skills such as couched and gold embroidery, colored embroidery, metal appliqué decoration, and fabric patterning to create Torah Ark curtains (*parokhot*), mantels (*vestido*), and binders (*fasha, mitpahat*), ceremonial textiles such as *Huppah* (marriage canopy) covers, as well as men's and women's festive and ordinary costumes and textiles used in the domestic realm such as bridal bed covers, infants' clothing, tablecloths and cushions (Juhasz, 1990, pages 68–97).

In addition, women created homemade textiles for every stage of the Sephardic life cycle – a phenomenon that is reflected, for example, in the Judeo-Spanish proverb "*De la fasha a la mortaja*" ("From the baby's diaper to the death shroud") that uses textiles as a metonymy for a person's complete life cycle. This move from the objects of textile to their textual representation demonstrates what the following reading shall develop on a larger scale.

The Sephardic tradition that inspired the reading of texts about textiles is one that I define as the *wandering textile*. Esther Juhasz describes this tradition that was documented in various Sephardic communities:

> When domestic articles were donated to the synagogue, they underwent certain changes to adopt them to their new functions, and thus new compositions were produced. The most useful alternation was to sew several small pieces together, such as wrapping cloths and cushion covers, to make an Ark curtain or Torah mantle. Sometimes the old pieces were sewn onto a new background. Articles of clothing were usually cut up and re-stitched to make the desired ceremonial object. The composition of the new piece was thus based on the motifs that had been used on the old dress, kerchief or cushion … When the fabric background of an embroidered piece disintegrated, the embroidered parts which

were still in good condition might be preserved to make new small articles of personal use, such as a bag for the *tallit* or *tefillin* (Juhasz, 1990, pages 80–1).

The nomadic nature of the wandering textiles created by Sephardic women derived from the fact that their function was not single-aimed but evolving. Not only that their personal function was redefined when they changed form, but they have also emigrated from the private space of the home to the public one of the synagogue. The process of handmade, embroidered wedding dresses reassembled and re-composed into a Torah Ark curtain represents a fluidity of meanings associated with the textile, whose relevance to the life of the woman who created it and to her community is constantly regenerating. This notion is a pathway into the following reading of Judeo-Spanish texts about feminine textiles, which often behave in a similar way.

The Text-Tile Connection

"Text" and "textile" both originate in the Latin "woven." Judeo-Spanish traditional folk songs and contemporary poems relating to the making and decorating of textiles echo this etymological connection and offer a hermeneutic key for understanding both the texts and the textiles with which they interact. Anchored in a qualitative rather than a quantitative approach to culture, the following reading concentrates on and offers a close reading of a few representative texts as microcosms reflecting a wider phenomenon.

Women Taking Care of Textiles

Our journey opens in medieval Spain, following the road taken by the Jews who kept a rich Iberian musical tradition when they were expelled from the cradle of Sephardic culture. Many of their creations, some of which are still performed today with melodies by Sephardic Jews, portray women in text-tiled environments.

The association of the text-tiled situation with the very essence of femininity is characteristic of the Sephardic *romansas* inherited from the medieval Iberian tradition. One of them is "*El suenyo de la ija*" ("The daughter's dream"):[4]

El rey de Fransia tres ijas tenia	The king of France had three daughters
La una lavrava, la otra kuzia	One laundered, the other one sewed
La mas chika de eyas bastidor azia	The youngest of them did [worked] an embroidery hoop
I lavrando, lavrando, sfuenyo le venia.	And working, working, a dream came to her.

The princess's mother was upset with her youngest daughter dreaming away, until she found out what the symbols were that appeared in the dream. Interpreting those as signs of her daughters' good fortune, she calmed down:

M'apari al pozo, vid' un pilar de oro	Standing by the well, I saw a gold pillar
Kon tres pasharikos pikando el oro	With three little birds biting the gold
Los tres pasharikos son tus tres kunyadikos	The three little birds are your three little brothers-in-law

I el pilar de oro es el rey, tu marido	And the golden pillar is the king, your husband
M'apari a la puerta, vidi la luna entera	Standing by the door, I saw the full moon
I la luna entera es la reina, tu sfuegra.	And the full moon is the queen, your mother-in-law.[5]

What led to, and inspired, the dream in this folk song was the princess's use of the embroidery hoop, and the result is a characteristic text-tiled situation, in which the connection to textile evokes a discovery of the woman's future life. What we witness here is the emergence of a Sephardic ecotype of two international folk literary types relating to a woman's needlework leading to the anticipation of her future life (AT709 Snow-White and AT410 Sleeping Beauty). It should be noted that in AT410, Snow-White pricking her finger with a needle leads to her eternal sleep, whereas in the Judeo-Spanish song the needlework leads to the prediction of the princess's long life. In AT709 and ATU709, there is no reference to needlework, yet the association of it in relation to the Sephardic songs with which we are concerned derives from the Grimm brothers' version of *Sleeping Beauty*, in which as the princess falls asleep while spinning, her life undergoes a dramatic change.[6]

The background for the dramatic development of another medieval *romansa* portraying the loyal wife's encounter with a knight coming back from a long war is a textile-oriented setting, in which a young woman is busy doing her laundry. It opens with the following exposition:

[4] Judeo-Spanish was written in Hebrew characters until the mid-twentieth century, when attempts were made to apply different systems of Latin transcriptions to it. In this chapter, I have unified all quoted texts and re-transcribed them according to the writing system presented by the *Aki Yerushalayim* periodical that is recently being adopted by the majority of Judeo-Spanish writers worldwide. I thank Nivi Gomel for her help in transcribing the relevant texts.

[5] For the full text and information regarding the *romansa*'s origins and documentation see Weich-Shahak (2010, page 150).

[6] For full information see: Aarne and Thompson (1964), Uther (2004), and Owens (1981, page 177).

Kuando la blanka ninya	When the fair young woman
Lavava i espandia	Laundered and wringed
Kon lagrimas lo lavava	With tears she laundered
Kon suspiros l'akojia	With sighs she collected [gathered]
Por ayi paso un kavayero	A knight passed from there
Un copo d'agua le demando	A cup of water he asked her for
De lagrimas de los sus ojos	With tears of her eyes
Siete kantaros l'incho	Seven pitchers she filled for him.
De ke yores, blanka ninya?	Why do you cry, fair young woman?
Ninya blanka, de ke yores?	Fair young woman, why do you cry?
Todos tornan de la gerra	Everyone came back from the war
I el su marido no ay tornar.[7]	And [for] him her [my] husband there is no return.

In response to her begging for information concerning her husband who never returned from the battles, the soldier makes her describe his physical traits. Not only does she provide this, but she also announces that she should forever stay loyal to the missing husband. Only then does the knight reveal his identity as the husband, and the couple may be reunited.

A character of a woman reconstructing her lost identity through a textile-related interaction is the focus of another Judeo-Spanish *romansa* originating in medieval Spain. Most of the Sephardic versions of this song were documented from the descendants of the Jews expelled from Spain who settled in northern Morocco, and thus the shift of its geographical setting. The three versions presented by Weich-Shahak, for example, open with the line "*Al pasar por Kazablanka, pasi por la moreria*" ("On the way to Casablanca, I passed through the Moorish quarter") (Weich-Shakak, 1997, pages 80–4).

The narrator is a knight who encounters a beautiful young woman busy doing her laundry by a fountain. Offering water for his horses, she reveals her identity to him and confesses that she is not Moorish, but a captive girl from Spain. When he suggests that she returns to Spain with him, her reply concerns the textiles that frame her existential situation:

I la ropa el kavayero –	And the clothes knight –
donde yo la desharia	where shall I leave them
Lo ke es de seda i grana –	Those that are of silk and velvet –
en mis kavayos se iria	Shall go with my horses
I lo ke no vale nada –	And those that are good for nothing –
por el rio tornaria.[8]	Shall go to the river.[8]

All versions of this "Sepharadized" medieval Iberian *romansa* alike maintain the central function the clothes – the textiles that symbolize the woman's change from life in captivity back to her origins. The unfamiliar knight whom she meets while taking care of them is finally proved to be her Spanish brother who, instead of bringing back a bride, presents their parents with their long-lost daughter.

[7] For the full text and a commentary see Attias (1961, pages 93–4).

[8] Matilda Keon-Sarano, *Vini kantaremos: Koleksion de kantes djudeo-espanyoles*, Jerusalem, 1993, page 152.

The clothes are a key symbol of the quest for rediscovering her identity. By deposing of some of them, the worthless ones, she departs from her life in captivity, while keeping only the most important parts of her personality. The wandering textiles – those that may help her reassemble the shattered parts of her life and of herself – are the ones carried back to what shall soon be discovered as her lost family and homeland.

Women Wearing Textiles

The association of the wearing of textiles with a traumatic situation forced on a young woman reappears in another Sephardic interpretation of an Iberian medieval *romansa*. Exposing the tabooed theme of incest, it enables women to deal with it and learn how to prevent it through the unexpectedly progressive messages conveyed in a traditional folk poem. Opening with the line *"Se paseava Silvana"* ("Silvana was strolling"), the *romansa* develops into a story of a king attempting to sexually abuse his daughter. Two major turning points occur in the plot after Silvana had been seduced by her father. Her initial reaction is an attempt to postpone the king's seductive approach by asking:

Deshame ir a los banyos	Let me go to the baths
A los banyos d'agua fria	To the baths of cold water
A lavarme i entrensarme	To wash myself and comb my hair
I a mudar una kamiza	And to change a shirt
Komo azia mi madre	Like my mother did
Kuando kon el rey durmia.[9]	When with the king she slept.

The begging to change a shirt is a textile-oriented symbol that emphasizes the princess's wish to make it clear to the king that it is her mother and not herself to whom he should be directing his lust.[10] The second and even more meaningful turning point takes place towards the end of the *romansa*, when the queen encourages her daughter to exchange garments with her:

Trokadvos veustros vistidos	Change your clothes
Los mios vos meterias	Put on mine
I dezilde a vuestro padre	And tell your father
Ke no asienda kandeleria	That he should not light a candle
Al eskuro a la entrada	At dark you enter
Al eskuro a la salida.	At dark you leave.

As the plot progresses, we learn that Silvana never entered the king's chamber. Instead, the queen did so dressed in her daughter's clothes, and when the king demanded Silvana's "honor," she revealed her identity and made him repent. Family order is regained in this *romansa* by feminine wisdom and resourcefulness, and the process is based on the exchange of women's clothes forming a perfect example of what we have defined as *wandering textiles*.

The color of textiles worn by women as symbols of their life cycle and the rites of passage during which the colored garments are made use of appear in many Sephardic folk songs. A *romansa* opening with the line *"Triste esta el rey David"* ("King David

[9] Attias (1961, pages 131–2). For a detailed thematic and social analysis of this song, see Alexander-Frizer (2007, pages 350–7).

[10] During field work I conducted in relation to this *romansa*, a native Spanish-speaking Orthodox Rabbi suggested that Silvana's plea to take a bath echoes the Jewish law of *tevilah*, according to which a wedded wife is required to take a ritual immersion prior to having sexual relations with her husband. This interpretation reinforces the reading of Silvana's begging to change a shirt as a reminder to her father that he should behave lawfully.

is sad") exposes the biblical story of the death of King David's beloved son Absalom. Central to it, is the description of the king's begging his daughter-in-law to dress in black after her husband was killed (Weich-Shahak, 2010, page 91).

The Sephardic wedding song opening with the line *"Muchachika esta en el banyo"* ("The young girl is bathing") was traditionally performed by the women who accompanied the bride to her ceremonial immersion. According to the Jewish law of *tevilah*, a bride must take a ritual immersion before the wedding. In many traditional Sephardic communities this purification ceremony was supplemented with a ceremonial immersion of both bride and groom (separately, of course), which took place in the public bathhouse.

The song portrays the bride wearing red at the beginning of the ceremony, and white at the end of it. In this text-tile, the color alternation symbolizes the progress of the purification process and the transition it marks in the individual and social identity of the bride-to-be.[11]

Women Making Textiles

An interesting example of the poetic tradition that intimately connects the woman's body and the textiles she creates is found in a Greek ballad that the Sephardic Jews have adopted after the Spanish expulsion as part of their own tradition. It tells the story of a slave crying out for his wife who is kept in tall, unreachable towers. Sewing a blouse for the queen's son, the wife replaces the missing materials required for making the royal garment with parts of her own body:

Si le mankare un klavedon	If she misses a thread
De sus kaveyos le ajusta	She adds it from her hair
Si le mankare una perla	If she misses a pearl
De sus lagrimas la ajusta.[12]	She adds it from her tears.

The image of the woman sewing or working with an embroidery hoop as a *mise en abyme* of the complex story of her life emerges from the medieval Iberian poetic tradition that the Sephardic Jews inherited and developed in the centuries to come.

The main character of another song that may be regarded as a new *romansa* is a Sephardic woman from the city of Hebron. Opening with the words *"Povereta muchachika"* ("Poor little girl"), it had long been considered to be an anonymous folk creation. Only recently, was it proven to have been created by musician, songwriter, cantor and singer Asher Mizrahi, who reached enormous popularity in Jerusalem and Tunisia in the late nineteenth to early twentieth centuries.[13]

The realization that this text was written by Mizrahi is important because it enlarges our insight of the text-tiled Sephardic women, who in this case was originally portrayed by a male author and only then incorporated by generations of Sephardic women who made it part of their feminine tradition.

Asked by the narrator why she is locked up in a dark prison, the poor girl unfolds the tragedy that led her to murder the woman for whom her fiancé deserted her. News of his engagement to the other woman was brought to her when she was working

[11] For a detailed analysis of this song and its multilayered meanings see Held (2007).

[12] Weich-Shahak (2010, page 92).

[13] In a letter of September 11, 1959, Mizrahi gives an account of his poetic repertoire: "I have written more than 300 songs in Arabic but in Spanish I wrote three to four." Among the Judeo-Spanish songs he mentions as his own creations is *"La hevronica ke es povereta muchachica"* ("The girl from Hevron who is the poor little girl"). See Mizrahi (2001).

on an embroidery hoop by the window – a text-tiled situation affecting the morphology of the plot.

The image of the woman working a *bastidor* re-emerges in this song, as it did in the medieval *romansas*. The turning point in the modern Sephardic song's plot is marked by the poor girl's realization of her lover's disloyalty. The round embroidery frame she is working on when this occurs, and that is about to be replaced with a knife for killing her beloved's new bride, is turning the situation into a text-tiled one, symbolizing the approaching catastrophe in her life.

As Galit Hasan-Rokem and Hagar Salamon (1997, page 58) noted, on the symbolic level the embroidery process projects the juxtaposition between the feminine essence (the fabric and the thread) and the masculine one (the needle). Our corpus demonstrates the way in which Sephardic culture reverses this paradigm on two levels. Generally, the needle is not mentioned and instead we have the *bastidor* – a round object holding together the fabric that is an essence of femininity resembling a womb. Furthermore, in the last song we referred to the object that symbolizes femininity being replaced with a knife, emphasizing the fact that in the traditional Sephardic society a woman could cross the borders of gender, step into the male territory, and perform the extreme act of murder in order to express her resentment of her lover's disloyalty.

The *Bastidor* Chronotop

The *bastidor* is an embroidery hoop consisting of two wooden frames, in between which the cloth is stretched so that a design can be easily worked on it.

Having been commonly used in the traditional Sephardic home, the *bastidor* has made its way from the reality in which it was associated with women and with their needlework into the Sephardic poetic tradition. Having immigrated into the texts about women, while gradually losing its functionality outside of them in modern times, it became an important code in the text-tiled world that this essay aims at deciphering.

Today, when the *bastidor* rarely functions as an actual object, but merely as a textual representation of what it used to be, it gains a symbolic status reinforced by its repeated poetic use in relation to ancient and modern Sephardic women.

What shall we make of the fact that the exposition of many *romansas* and *kantigas* focus on a feminine character working a *bastidor*? A key for answering this question may be found in Michail Bakhtin's concept of the "chronotop" (literally "time space," the intrinsic connectedness of temporal and spatial relationships that are artistically expressed in literature). In the literary artistic chronotop, spatial and temporal indicators are fused into one carefully thought-out, concrete whole (Bakhtin, 1981, pages 84–5).

Bakhtin argued that the chronotop as a formally constitutive category determines to a significant degree the image of man in literature, and in the context of our reading, it represents the image of the woman in the Sephardic poetic tradition. Following him, I suggest a definition of the *bastidor* chronotop – the round microcosms of the woman's world, framing her dreams, her beliefs, and her identity.

The *bastidor* may be seen as an implication that the life of women in the traditional Sephardic society was framed by social norms restricting them to narrow down their ability to express themselves and to take control of their lives. No matter how innovative they were in their embroidery, it always was restricted to the boundaries of its frame.

A careful reading of the text-tiles in which a *bastidor* appears, leads to a more complex interpretation. As the texts develop, the women who are stereotypically presented in their expositions working the embroidery hoop, put it away and stand out to express strong, individual personalities. Even though they sometimes pay a price for it, they often step forward and attempt to take control of their lives – be it by following their dreams, by acting against instinct and saving their family, or even by

murdering the woman that their lovers preferred over them.

The poetic tradition we are looking at echoes and shapes the cultural conception of Sephardic women. The encounter with the object of textile (making it, wearing it, or caring for it) is depicted in the texts that transform the textile into a memory, while reflecting important junctions in their lives and encouraging them to follow their hearts within a traditional, patriarchal society mostly without breaking up its laws and norms.

Behind the text-tiles that this essay is dedicated to, hide actual textiles made by Sephardic women and then turned into Judeo-Spanish texts telling the story of the same or other women in medieval Spain, in the Ottoman Empire and in the communities worldwide that Sephardic Jews immigrated to in modern times. In all of these places, embroidery frames called *bastidors* formed part of traditional Sephardic life and texts, and are recently becoming what Jean Baudrillard defined as "bygone objects":

> Rare, quaint, folkloric, exotic or antique objects. They seem inconsistent with the calculus of functional demands in confirming to a different order of longing: testimony, remembrance, nostalgia, escapism. [...] For all their difference, these objects also form part of modernity, and this is the source of their double meaning. It [the bygone object] is astructural, it denies structure, and it epitomizes the disavowal of primary functions. Yet it is not afunctional, nor is it simply 'decorative'. It has a quite specific function within the framework of the system: it signifies time (Baudrillard, 1990, pages 35–6).

Conclusion

The above reading of Sephardic text-tile chronotops does not end at their categorization as bygone objects, but offers an understanding of texts relating to women and textiles as a movement from the actual object to the way in which it is conceived as a bygone object signifying time and constructing an identity through it. The reading is anchored in two frames of reference: thoughts about women and textiles inside and outside the Sephardic circle, accompanied with my personal experience within the Sephardic home and culture.[14]

Hasan-Rokem and Salamon (1997) examined a group of Jerusalem women who "embroider themselves" and express a complex feminine consciousness through cloth, colored thread and needle, ritual interactions, and verbal discourse. Their craft-based processing of femininity and feminine identity revolves around the categories of women-men, women-family, and fertility, and, most significantly, the "feminine frontier" of women. Although the members of the group they explored are not Sephardic, the study of their activity reveals various aspects that are quite relevant to the concerns of this chapter. The group members related to their craft-making as "a verbal reflexivity processed into a narrative that parallels the embroidery activity and the ritual that characterizes it." The analysis of their creative activity offers an interpretation of the material expression (embroidery) and the linguistic expression (feminine narrative concerning the embroidery) as two parts of a wider holistic system of cultural process and design (Hasan-Rokem and Salamon, 1997, page 55).

Our exploration of a similar system goes a step further: whereas Hasan-Rokem and Salamon analyze the interviews they conducted with women who spoke about their own embroidery, we are concerned with a multilayered poetic reconstruction of the relationship between women and textiles that was not realized by the original embroiderers, but by their Sephardic followers down the centuries.[15] Thus, the understanding of the actual women

[14] The relationship between Sephardic women and needle crafting that is focused on here deserves further investigation, which shall, I hope, be elaborated on in the future by the researchers of material cultures and ethnomusicology.

[15] For another study of women's interpretation of their own needlecrafts see Salamon (2013).

embroiderers who in Jerusalem of the twentieth century conceived themselves as various texts, transformed and expressed in different forms is reinforced and deepened in the exploration of the Sephardic feminine text-tiles. In both cases, the concept of women embroidering themselves is a powerful tool for deciphering the complex identity that is being stitched around and inspired by feminine needlework in traditional societies and also when stepping out of them into modernity.

The *arpilleras* – the handmade tapestries that were created by Chilean women during the dark times of dictatorship and denial of human rights, managed to articulate an unspoken tragedy and make it known to the world. According to Marjorie Agosín, the *arpilleras* reside in the collective memory they contribute to, relating personal histories to the narratives of the country (Agosín, 2008, page 17).

Sephardic culture that was born in medieval Spain and developed mainly in the Ottoman Empire has little to do with the point in the history of Chile that enabled the creation of the *arpilleras*. Yet, Agosín's understanding of the relationship between women and textiles is quite relevant to the way in which it is reflected in the Judeo-Spanish text-tiles focused on in this essay:

> The women making an *arpillera* are working among the rituals of memory, but while they are creating *arpilleras* they are also re-creating life … the *arpillera* is sent into the world, outside of the personal body of the creator, so that the recipient receives and can feel history (Agosín, 2008, page 24).

Agosín's observation resembles the process this chapter attempts to demonstrate concerning the wandering textiles associated with the female protagonists and performers of the Judeo-Spanish songs about women making, taking care of, and wearing textiles. The above reading of the reflections of women's textiled world in the Judeo-Spanish poetic tradition is among the rituals of memory and shows how, while creating their textile objects and re-creating them into songs, the Sephardic women also create life. The final stage of the process is achieved when the traditional texts are interpreted in retrospect and their recipient can feel history and weave it into a contemporary fabric that grows out of it.

Personal Epilogue

Text-tiles combining the work with fabric and the reconstruction of it by a verbal art were presented in this discussion as a mirror reflecting the process of feminine identity formation and its interpretation within the cultural frame of Sephardic existence from medieval Spain until our days. Had it not been channeled through the consciousness of a Sephardic woman from a family in which women used to relate to textiles both practically and emotionally for many generations, it could have been completed.

"Actual texts on items of dress are comparatively rare, and are not inherent to Jewish dress" observes Esther Juhasz (2012a). Taking her observation figuratively, we can say that poetic creations *about* Jewish dress replace the texts that are not appearing *on* it. Juhasz goes further into explaining that "the biographies" of clothing items can follow many routes. Sometimes they are interwoven with the biographies of their owners; at other times they take different courses and may be worn, torn and discarded, or mended and transformed into other garments (Juhasz, 2012b). Again, this reading follows her words figuratively by seeing in text-tiles, or texts about textiles, a unique form of a feminine biography.

My personal involvement with Sephardic textile chronotops makes me an inside reader of my own culture and of myself within it. This process intensified when the fabrics I experienced growing up with textile-making Sephardic women were re-fabricated into my own texts. The combination of the two formulates a feminine identity through space and time. Thus, what I previously defined as a wandering textile reflects a journey through Sephardic culture planted in the soul that faces its disappearance from today's world, inviting a self-reflexive and self-reflective contemplation.

A virtually seamless dialogue grows out of the connection between the poetic text-tiles created in my grandmother's mother tongue and my own poems, which were written at a time when both the Sephardic traditional fabrics and Judeo-Spanish traditional poetry focusing on them are hastily disappearing from the world.

Nothing is more suitable for concluding this chapter than a poem that enables me to revisit the bygone world of Sephardic text-tiles, by looking at the fabrics kept inside the closet of the women who created them.

Out of the Closet
The image of Grandmother may she
rest in peace
emerged as I gazed at an *ogadero* that in Ladino means
a necklace
or hanging
rope

The note next to it said that the heavy necklace was worn
By Jewish women in Rhodes
In Izmir and in Jerusalem

In most cases a wife received it from her husband
and its high value made it possible to purchase a plot
for burial
when it was
time

But Grandmother may she
rest in peace
received no heavy necklace
only thin Damascus chains and died
not knowing that they
had been stolen

Opposite the necklace in the display case
at the opening of the Jewish wardrobe exhibition
i thought the time had come to plant a cypress
at her head
as Grandfather may he rest in peace had wished
but never did
and to restore the crumbling letters on her tombstone
but i never did.

When this chapter was being prepared, I happened to be visiting Copenhagen, the Danish capital. A lace-like cover of a construction site caught my attention, and I carelessly took a picture of it. Only looking at it in retrospect, did I realize that the lace-covered façade was actually emblematic, tying together the thoughts about women and their text-tiled world. I read the half-transparent screen of lace wrapping the building as a symbol of the condensed relationship between the textile associated with women and the system of memory connected to the house, the home and the text-tiled lives of women inside them.

The protagonist of the above-mentioned traditional Sephardic *kantiga* about *la povereta muchachika*, the poor young girl deserted by the man she loves (see page 138), declares that:

Asentada en la ventana	Sitting by the window
Lavrando el bastidor	Working the embroidery frame
Haberiko me trusheron	A piece of news was brought to me
K'el mi amor se despozo.	That my lover got engaged [to another].

La povereta muchachika, like all other women whose life and culture I tried to grasp in this poetical journey, like myself when writing to them, is a figure covered with transparent lace, inhabiting a building in which text-tiles are being created, performed and interpreted.

Marjorie Agosín tells us, "All works with fabric imply a close relationship between a person's hand and history and the fabric itself" (Agosín, 2008, page 20), and goes further into identifying needlework traditions as a universal female artistic elaboration.[16] It seems that this building whose life is

[16] For a further analysis of the holistic relationship between women and needlework see Parker (1986).

FIGURE 14.1 Copenhagen's text-tiled building.

being renovated behind a laced fabric visually encompasses her understanding of the relationship between women and textiles, as well as the unique Sephardic embodiment of it.

Acknowledgments

Dedicated with love and appreciation to my mother and to her mother – the magic weavers of threads into dreams and of dreams into textiles. Their skills remain a wonder to me, who can only re-weave their creations into words.

My warm thanks go to Marjorie Agosín for inviting me to think about textiles and Sephardic women, and for inspiring the thinking process with her illuminating reading of the Chilean *arpilleras* in particular and women's creative forces in general. I also thank Susana Weich-Shahak for sharing with me a variety of folk songs about women and textiles collected during her journey to document and analyze the Sephardic ethnomusical tradition. Many thanks go to Tamar Alexander-Frizer, Nili Arye-Sapir, Galit Hasan-Rokem, and Esther Juhasz for their contribution to the analysis of Sephardic material culture and folk literature related to the essay. Finally, I thank my friend the gifted translator Evelyn Abel for her contribution to the English versions of the poems that are framing the chapter.

Bibliography

Aarne, Antti and Thompson, Stith (1964) *The Types of the Folktale: A classification and bibliography*. Helsinki: Finnish Academy of Science and Letters.

Agosín, Marjorie (2008) *Tapestries of Hope; Threads of Love: The arpillera movement in Chile*. Lanham, MD: Rowman & Littlefield.

Alexander-Frizer, Tamar (2007) *The Heart is a Mirror: The Sephardi folktale*. Detroit, MI: Wayne State University Press.

Anderson, Benedict (1983) *Imagined Communities: Reflections on the origin and spread of nationalism*. London: Verso.

Attias, Moshe (1961) *Romansero Sefaradi: Rromansot ve-Shire Am bi-Yehudit-Sefaradit*. Jerusalem. [Judeo-Spanish and Hebrew.]

Bakhtin, M.M. (1981) *The Dialogic Imagination*, edited by Michael Holquist and translated by Caryl Emerson and Michael Holquist. Houston, TX: University of Texas Press.

Baudrillard, Jean (1990) *Revenge of the Crystal: Selected writings on the modern object and its destiny*, translated and edited by Paul Foss and Julian Pefanis. London: Pluto Press.

Díaz-Mas, Paloma (1992) *Sephardim: The Jews from Spain*, translated by George K. Zucker. Chicago, IL: University of Chicago Press.

Hasan-Rokem, Galit and Salamon, Hagar (1997) Embroidering themselves: Embroidery and femininity in a Jerusalem group. *Theory and Criticism* Volume 10 [in Hebrew].

Held, Michal (1996) *The Color of Pomegranate*, page 26, translated by Michal Held.

Held, Michal (2007) "Between the Sea and the River": A multi-layered, cultural and literary analysis of a Sephardic wedding song from the island of Rhodes [in Hebrew]. *El Prezente* Volume 1, pages 91–122.

Held, Michal (2011) The people who almost forgot: Judeo-Spanish web-based interactions as a digital homeland. *El Prezente* Volume 4, pages 83–101.

Juhasz, Esther (1990) Textiles for the home and synagogue, page 65, in Juhasz, Esther and Russo-Katz, Miriam, eds. *Sephardi Jews in the Ottoman Empire: Aspects of their material culture*. Jerusalem: Israel Museum.

Juhasz, Esther (2012a) Fashioning Jewish dress, page 32, in Juhasz, Esther, ed. *The Jewish Wardrobe: From the collection of the Israel Museum, Jerusalem*. Jerusalem: Israel Museum.

Juhasz, Esther (2012b) Clothing and its afterlife, page 307, in Juhasz, Esther, ed. *The Jewish Wardrobe: From the collection of the Israel Museum, Jerusalem*. Jerusalem: Israel Museum.

Keon-Sarano, Matilda (1993) *Vini Kantaremos: Koleksion de kantes djudeo-espanyoles*. Jerusalem.

Mizrahi, Acher Shimom (2001) *Ma'adane Melekh: Facsimilie de son recueil de poemes*.

Nora, Pierre (1989) Between memory and history: *Les Lieux de Mémoire*, translated by Marc Roudebush. *Representations* Volume 26, pages 7–25.

Owens, Lily, ed. (1981) *The Complete Brothers Grimm Fairy Tales*. New York: Avenel.

Parker, Rozsika (1986) *The Subversive Stitch: Embroidery and the making of the feminine*. London: Tauris.

Salamon, Hagar (2013) "Gobelin" needlepoint: introducing the concept of "transitional object" to the study of material culture [in Hebrew], pages 691–714 in Salamon, Hagar and Shinan, Avigdor, eds. *Textures: Culture, literature, folklore for Galit Hasan-Rokem*, Volume 2. Jerusalem: The Hebrew University.

Seroussi, Edwin (1998) De-gendering Jewish music: The survival of the Judeo-Spanish folk song revisited. *Music & Anthropology* Volume 3.

Uther, Hans-Jörg (2004) *The Types of International Folktales: A classification and bibliography*. Helsinki: Finnish Academy of Science and Letters.

Weich-Shahak, Susana (1998) Social functions of the Judeo-Spanish romances, pages 245–56, in Braun, J. and Sharvit, U., eds. *Studies in Socio-Musical Sciences*, Ramat-Gan: Bar-Ilan University Press.

Weich-Shahak, Susana (2010) *Romancero Sefardí de Oriente: Antología de tradición ora*. Madrid: Alpuerto.

Stitches of Life in the Death of Winter: The *Bordadoras* of Isla Negra

EMMA SEPÚLVEDA PULVIRENTI

CHILE IS A COUNTRY that is comprised of magical extremes, and its territorial silhouette is outlined by the enchantment of those same boundaries. The sharp, abrupt cuts of the Andes rise defiantly to the east, striving to become one with a secret universe. This impressive mountain range is illuminated with eternal snow and volcanoes that spew smoke and fire. These eternally living volcanoes snore menacingly beneath the earth's crust, destroying everything that falls within their reach. To the west, extends the sea, which, although it was christened the Pacific, has never wanted to honor its name. Dark blue sea that unrolls and winds in savage waves that are born and die, continuously beating the beaches that wish to soothe it and the rocks that try to tame it.

Between the mystical contrasts of the deep ocean and the colossal mountains unfolds a long and narrow fringe of open countryside, of infinite green valleys, of lakes that reflect volcanoes, and of rivers of snow turned to water that pass through the thirsty corners of the country. Reaching the northern limit of this open land extends the Atacama Desert, where flowers speckle the sand in the springtime without asking the rain for permission. To the south dance the fjords, green ruffles that play between the land and the sea. And further still in the eternal distance, hidden in the precipice of the blue horizon is Antarctica. This bluish-white blanket, owner of the deepest and most profound silence, completes the geographic spell of this country of extremes.

This immense and slender country, proud owner of what so many have called "crazy geography," is inhabited by people who have survived earthquakes, tsunamis, and dictatorships. This indomitable nation has reconstructed and reinvented itself once and again throughout its storied history. Its liberty-loving people gained independence from their conquerors in the nineteenth century. A century later they were able to garner, vote by vote, enough power to abolish a brutal dictatorship and return triumphantly to democracy.

In every corner of this immeasurable landscape there are cities, towns, and villages anchored to the ocean, hidden in the skirts of the fertile plains, and nestled in the dry deserts that exist with only a faint dream of the sea. And in each of these corners, women and men live and survive by crafting and recreating artistic representations that reflect daily life in their own communities. There are artisans who sculpt clay in the villages of Pomaire and Quinchamalí. Others work with hide and shape it as though it was still on the animal's back. Yet others sheer the wool from the sheep, spin it, and dye it in Chiloé. There are women who weave upon the ancient looms in Doñihue, and others still in the village of Rari who use their hands to work horsehair into shapes. These craftswomen dye the horsehair into an immense rainbow and then transform it into colorful designs that take the shape of butterflies that will never die, flowers that never wither, and hearts that refuse to stop beating even after all

the love has left them. There are also women who let needle, thread, and thimble tell their life stories for them and these stories are the story of Isla Negra (the "black island"). These women, who make life spring to the edge of the seashore when it has been dried by winter, are the ones who are called the *bordadoras* (embroiderers) of Isla Negra. It is these women and their art whom I am drawn to tell you about.

Isla Negra, made famous by the Chilean poet Pablo Neruda, is a coastal village of about 2,000 people during most of the year, but in the summertime that number increases with the arrival of lovers of fish, sun, and sea. Isla Negra is found anchored in the relentless, rocky central coast of Chile, in the region of Valparaíso. Neruda, awarded with the Nobel Prize for Literature in 1970, lived and created a great portion of his work in this sleepy hamlet. His stone house, filled with items found at the edge of the sea and with the ghosts of poems that were never finished, is today a museum. Many of the museum visitors are searching for their destinies; be it to find inspiration, some lost verse, or simply to see Isla Negra as Pablo Neruda saw it. Others come to discover the countless memories that have been left behind in the town's corners.

Isla Negra is the birthplace, home, and inspiration of poets, painters, and a wide variety of creative souls who arrive and never leave. But it is also a town where people are born and spend the rest of their days in the same place devoted to the land, fishing, working, and raising their children. This combination is what provided the fertile soil from which women could create the famous tapestries of the *bordadoras* of Isla Negra.

In Isla Negra, which is neither an island nor black, one woman inspired others to take a piece of burlap from an empty food bag and begin to paint their imaginary scenes with colorful woolen threads that constantly revive life itself. That woman's name is Leonor Sobrino. When I met her in her house in Isla Negra[1] many years ago, she told me she never thought that from an idea as simple as uniting women to make embroideries, taking advantage of the opportunity to spend time together and earn a bit of extra money, a social art would emerge and remain at the heart of Isla Negra for decades.

Leonor Sobrino spent her summers in her house in Isla Negra, a house that spoke to her of the proximity of the sea through mysterious tales, myths, and histories. It was in her house that I first saw this embroidery done by the group of women. The house joined together with other homes and people who, like her, spent their summers enjoying the tranquility of Isla Negra. But beyond her house lived other residents of the town whom Leonor Sobrino wanted to meet. These permanent residents of Isla Negra remained there year after year, winter to spring and fall to summer, working the land, trapping shellfish in the rocks, fishing offshore, and doing the work necessary for the arrival of the summer vacationers, who would take over the town from December to March.

Among those permanent and continuous residents were the women of Isla Negra whom Leonor Sobrino inspired to turn their lives around. Women who worked shoulder to shoulder with their husbands, taking care of the summerhouses that are uninhabited during most of the year. Women who cooked and cleaned and washed. Women accustomed to waiting. They would wait for their employers to arrive and have work before Christmas. They waited for their partners who went offshore in their boats, extending their nets and catching fish, lost in the immense solitude of the deep blue sea. They waited for the storms to be over and they waited, hoping and begging, that calm once again return to the sea.

[1] I met Leonor Sobrino when I was part of a group of writers who were invited to read poetry in the *Fundación Neruda* in Isla Negra, and I met her again when I visited her house with poet and friend Marjorie Agosín.

FIGURE 15.1 *La fiesta de la trilla*. Tránsito Diaz 1978. Photographer: Luis F. Vera.

They waited for springtime with its carpet of flowers after the dark, grey winters on the coast. They waited nine months for their children to be born. And many of them simply waited for life to go by, between twilight and the dawn of a brand-new day. In the midst of their waiting arrived the possibility of telling stories of the island that was not an island, of painting daily life with eternal springtime colors, of embracing the everlasting wait through embroidery. They transformed themselves into artists, the creators of Chile's most widely recognized tapestries. Leonor Sobrino brought them the wool, gave them the idea to embroider, and then pushed them to create. These women transformed their daily lives into living histories that were told through needle and thread.

The *bordadoras* of Isla Negra began working on their creations in the 1960s. It was in 1966, according to the information provided by Leonor Sobrino and other residents of the village, when the designs began to take shape. In the beginning they were almost infantile. These women produced designs that evoked the first paintings children did in school and simple interpretations done by artists who wish to tell stories rather than create works of art. The stitches appeared to be done at random, and the colors seemed to be chosen more with the intuition of the heart than the acuity of the eye.[2] But between the naïve nature of the images, the coarseness of the needlework, and the fury of the color, a profound and clear creative message began to take shape. This creativity made it possible for the embroideries to become a cultural heritage that belongs to Isla Negra and Chile. With one simple tool, the common sewing needle, they elevated their lives into a universal art form – surprising both themselves and the world.

The theme of the tapestries began as something local and personal. They were created in the village, by its people, and for its people. In the early years, more than a form of art, it was a source of livelihood. With the funds that the women gathered from selling their needlework, they helped their families during the long winter months when work was scarce, and when the fish refused to be caught in the dangerous nets that the fishermen cast into the sea. But in the following years, these works became a representation of a social art that managed to dignify and validate not only the women who created it but also the place where these embroideries were born. The tapestries were introduced to the rest of the country and abroad and these women, who identified themselves as the wives of fishermen, became cultural ambassadors, and little by little they became the *bordadoras* of Isla Negra. Isla Negra embraced them just as it had done with Pablo Neruda, as it has done with other cultural treasures in the town. In this largest of small towns on the Chilean coast, these women came to embody all women who tell their life stories using needle, thread, and thimble.

The *bordadoras* of Isla Negra, from the moment they started their work in 1966, have displayed their art in galleries and museums of Chile and abroad. They had exhibits in the Museo Nacional de Bellas Artes in Chile in 1970, in the Institute of Contemporary Arts in London in 1971, in the Galerie du Passeur y L'Espace Cardin in Paris in 1972, in the Bienal of São Paulo in 1973, in the Metropolitan Museum of Art in Miami in 1975, in the Musée de L'Athénée in Geneva in 1978, and in many other places around the world.

Pablo Neruda contributed some words to the exhibition pamphlet that the *bordadoras* made in 1969 in Santiago. These comments, which came not only from a world-renowned poet, but also from a fellow Chilean, helped emphasize the importance and relevance of the work done by this group of artists.

In Isla Negra, everything blooms. The tiniest yellow flowers crawl through winter before turning blue, and even later in the springtime, they take an

2 Ximena Torres Cautivo, in her article published in *Terra Chile*, presents the idea that the *bordadora's* skill with the needle could have been developed by the constant work that they would do to repair fishermen's nets. Published May 6, 2013. Accessed May 30, 2013.

amaranth shade. The sea flourishes throughout the year. Its rose is white; its petals are salty stars.

This last winter, the *bordadoras* of Isla Negra began to blossom. Of those whom I have met from up to thirty years ago, each house plucked a tapestry as if a flower. These houses were dark and quiet before; suddenly, they filled with threads of colors, of celestial innocence, of violet depth, of crimson clarity. The *bordadoras* were pure reflections of the village and by this, they embroidered with the color of their hearts. They are called Mercedes, the wife of José Luis. They are called Eufemia, they are called Edulia, Pura, Adela, Adelaida. They are called as the town itself is called; just as they should be. They have names of flowers, just as the flowers pick their names. And they embroider with their names, with the pure colors of the earth, with the sun, with water, and with springtime.

There is nothing more beautiful than these tapestries, distinguished in their purity, radiant from a bliss that survived much suffering. I proudly present the *bordadoras* of Isla Negra. Their work explains why my poetry is deeply rooted here."[3]

Neruda's words named the reality of this new art for the first time, thus validating the artists and their relevance to Isla Negra. It was also Neruda's interpretation that has remained the best explanation and definition of the *bordadoras*. They are as he defined them: simple townswomen with names of flowers, the names of wives, daughters, and grandmothers. They are women who decided to transform melancholy, the gray colors of the island's seaside winter, and the blind mist that conceals the dramatic sunsets of the rocky coast. This transformation erased the grayness and covered reality with vibrant colors. They emerged from their houses on short winter days, and they gradually appeared in the town with each stitch that was crafted in wool. These were the same women who waited for their fishermen fathers, sons and husbands, and who one day began to embroider their feelings and to tell others the history of waiting. They told of the waiting lifestyle in Isla Negra, and with their stitches made words. They glorified the Isla Negra that Neruda claimed as his poetic inspiration when he said, "Their work explains why my poetry is deeply rooted here."

Pablo Neruda paid homage to the tapestries and their makers with his words, and Charo Cofré, a recognized Chilean folklore singer and composer who also lives in Isla Negra, continues to offer her support to the *bordadoras*.[4]

The *Bordadoras* have inspired not only poetry but also folk songs, such as this one by Chilean composer and singer María Angélica Ramírez:

Folk artists of wool, / intuitive landscapers of the soul / island gatherers of color / they bring life as they do their labor / Plunge the needle, pull the thread, / the *bordadoras* of Isla Negra spread / the white cloth and thrust their needles / and embroider the colors of your dreams. / Plant stitches upon the dresses / while the sun shines upon your tresses / Embroider the fabric, embroider with thread / so you can earn your daily bread.

Doña Leonor brings wool / and promise / because these brown hands / are always conscious. / Autumn afternoon, winter eve, / embroidering the future, embroidering memories.

Hurry up Doña Narcisa, Doña Inés / release a fish with the needle's finesse. / A rose blossoms, a star glitters / a butterfly flitters. / A boat sets out, its sails billowing, / and the strings of a guitar sing.[5]

The hands doing the needlework have changed in recent years, but the colors and the devotion

[3] Pablo Neruda, exhibition pamphlet for the *bordadoras* of Isla Negra in the UNCTAD building in Santiago, Chile, 1969.

[4] Charó Cofré is the owner of a restaurant and hotel in Isla Negra – La Candela. There are tapestries and examples of the work done by the *bordadoras* in the guest rooms.

[5] Lyrics of the song *Bordadoras de Isla Negra* by singer and composer María Angélica Ramírez. Cited from http://mgiuras.tripod.com/interprete/maramirez.html (accessed May 2013).

with which these woolen histories are crafted has remained very much the same. The generation that started this tradition passed it from their hands, tired from the impacts of time and life, along to other, younger hands throughout the years. Grandmothers, mothers, and aunts have taught their granddaughters, daughters, and nieces the art of storytelling through needle, burlap, and wool. The themes remain the same as those of yesteryear: daily life in Isla Negra, the village, its people, Neruda's home, the sea, fishing, the birds, and the flowers. Part of everything that is born, everything that is made, everything that lives and dies in Isla Negra remains portrayed in the needlework of these female "artisans of wool." Nowadays, the majority of the tapestries are made by two groups of women: Taller las Coincidencias (Workshop of Coincidences) and Taller de Bordadoras de Isla Negra (Workshop of the Embroiderers of Isla Negra). The works made by these women largely go abroad. They are purchased by visitors from faraway lands who come to the small, rocky village of giant waves and elusive fish, guided by the idea of experiencing and internalizing the mysteries of that legendary Isla Negra. Isla Negra, the black island that is neither black nor an island. This land adopts poets like Pablo Neruda, and attracts painters, potters, metal artisans, and woodworkers. This town not only adopts dreamers, it gave birth to the *bordadoras*, one of Chile's national treasures.

Pablo Neruda rests looking at the sea in Isla Negra and beneath the same land rest the remains of some of the early *bordadoras* of Isla Negra. But both are very much alive in the memory of the town, in the dirt roads, and in the wooden and stone houses. They live in the words that are carried by the wind and in the stitches of colorful wool that tell an eternally memorable story of one of many small coastal villages of Chile, the country of magical extremes.

Acknowledgment

Translated from the Spanish by Siobhan Mulreany.

PART IV EVERY STITCH A MEMORY

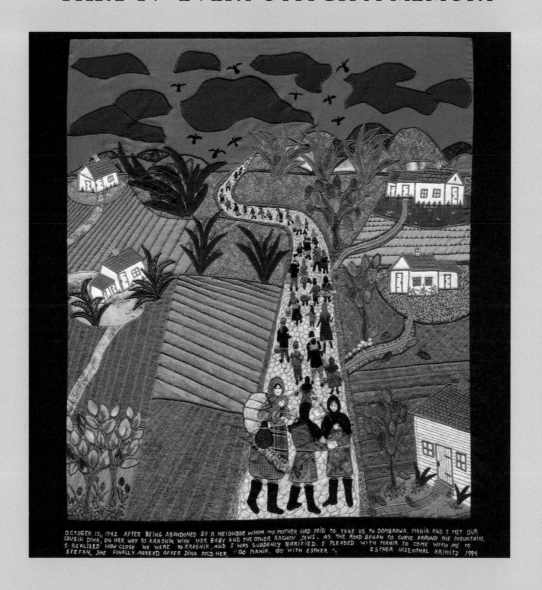

OCTOBER 15, 1942 AFTER BEING ABANDONED BY A NEIGHBOR WHOM MY MOTHER HAD PAID TO TAKE US TO DOMBROWA, MANIA AND I MET OUR COUSIN DINA, ON HER WAY TO KRASNIK WITH HER BABY AND THE OTHER RACHOV JEWS. AS THE ROAD BEGAN TO CURVE AROUND THE MOUNTAIN, I REALIZED HOW CLOSE WE WERE TO KRASNIK, AND I WAS SUDDENLY TERRIFIED. I PLEADED WITH MANIA TO COME WITH ME TO STEFAN. SHE FINALLY AGREED AFTER DINA TOLD HER, "GO MANIA, GO WITH ESTHER". ESTHER NISENTHAL KRINITZ 1994

Tapestries of Survival

BERNICE STEINHARDT

M Y MOTHER, ESTHER NISENTHAL KRINITZ, had an enormous story to tell. Growing up in a small village in the center of Poland, she was twelve years old in 1939 when the Nazis invaded Poland and occupied her village and the surrounding countryside. After three years of brutal occupation, the Jews of the region were deported, ordered by the Germans to leave their homes and report to a nearby train station. Although the Jews were not told where they were going, this transport was a part of the "Final Solution," devised by the Nazis in 1942 to annihilate the Jews of Europe.

My mother, then aged fifteen, refused to go. Instead, she created new identities for herself and her thirteen-year old sister, Mania, as Polish Catholic farm girls who had been separated from their families. Armed only with this story, they eventually found work in a village whose people were willing to take them in. Near the end of the war, in 1944, they learned that they alone in their family survived.

I grew up hearing these stories of my mother's, at the center of which was an act of resistance that kept her alive. In fact, I cannot recall a time when I did not know my mother's stories. Unlike many other Holocaust survivors, my mother could not keep from talking about her life – not only during the war, but also about her childhood before the war.

But years later, when Esther was about fifty, she decided that simply telling her stories was not enough – she wanted me and my sister to *see* what her home and her family looked like. She had never been trained in art, never thought of herself as an artist. But my mother could sew anything. As a child, she had been apprenticed to a dressmaker, and creating things from fabric was second nature to her. So she came to tell her story in a way that only she could – in a series of stunningly beautiful tapestries with stitched narrative captions that depicted her life before and during the war, along with her arrival in the USA.

Esther's story of survival was a story of resistance: her defiance of orders to report to the train station, her unwillingness to accept what seemed to be the inevitable. But her storytelling and her stitching were also acts of resistance, a refusal to let her family go and accept that their memories would fade and be lost. Instead, my mother insisted on remembering them over and over again, in every way she could, telling my sister and me about them, and finally, creating the art that would memorialize her parents, her grandparents, her sisters and brother, for all time.

After Esther created each of her pictures, she gave them to me, the daughter that lived nearby. But it was clear that although intended just for her family, her panels had to be seen by a larger audience. And so began the journey to bring my mother's art out into the world.

That journey began in the late 1990s, while Esther was still living. But after her death in 2001, my sister and I founded Art and Remembrance, a nonprofit educational organization inspired by our mother's profound legacy. Since 2003, Art and Remembrance has created a traveling exhibit of Esther's work, we've published an award-winning book, *Memories of Survival*, and we've produced an award-winning documentary film about my mother, *Through the Eye of the Needle*. We also made it

our mission to showcase the work of other people who chose to tell the stories of their life struggles against injustice through art. And we are using my mother's art and story to inspire others to create story cloths that convey their own experience of prejudice and injustice. Esther's work has shown us that art and personal narrative, in expressing a common core of humanity, can help bridge divides across communities.

It all began with stories. As a child, I was riveted by my mother's courage and heroism, how she managed to elude the forces of evil and save her sister's life as well. At the same time, though, I came to feel my mother's pain, the longing she endured every day for the family she had lost. She would tell me about her dreams, in which someone contacted her to say that her mother was still alive. These dreams filled her with hope and excitement, all of which vanished when she woke. Only in her dreams did she ever hear a word about her family's fate. So I came to feel her desperate disappointment, as well as her subconscious hope that in fact her family might still turn up.

Although their visions eluded her, my mother never lost faith in her dreams. In her dreams, she could at least see her family, touch them and hold on to them. It was no surprise, then, that among the first pictures she created were of dreams, very powerful dreams, she had had during the war, when first her mother, and then later, her grandfather, appeared to her, warning her of danger and assuring her that she would survive.

My mother told her stories, but she also wrote them down in little school composition books, trying to make sense of this astounding experience she had only recently endured. Her grief and trauma, after all, were still so fresh. Only ten years earlier, she had said goodbye to her family for the last time, just a girl of fifteen. In the three years before that, she had lived in fear every day, witness to the organized horror imposed by Nazi slave labor camps and the random terror of soldiers who amused themselves by shooting Jews. In the ensuing years, she fought

for her life every day, hoping to survive in her disguise as a Polish Catholic farm girl without being discovered.

For years, her life had been lived in a constant state of anxiety. And then suddenly, she was free. And in that freedom, her life was transformed. She married, had a child and came to the USA, the other side of the world. She no longer had to worry that someone might discover she was Jewish. She could make pretty clothes for her children, she had lots of good food to cook with, and she had a safe place to live. But she also had a terrible longing for her family, especially her mother, a longing that her new family could not quell. "My thoughts turned to … my mother, father, sisters and brother," she wrote at the time. "I knew that the chance that they were still alive was slim. But a spark of hope still remained in my heart. And this was the hope that helped keep me alive, that one day I would reunite with my family."

So to keep her love for them alive, she remembered them, sharing her memories with me and my younger sister Helene, and her notebooks. We were so young, Helene and I – I think the notebooks were my mother's way of talking to herself, or a more adult and understanding audience. And she needed to take out her memories and examine them, to reflect on them in safety, free of the fear that had impeded self-reflection earlier. Her notebooks gave her a safe haven. And telling her stories to her daughters gave her a live audience, who could see and appreciate the courage and ingenuity that had kept her alive.

At some point, my mother decided that her notebooks filled with stories could be a book. Her story was amazing even to herself – perhaps it could also be of interest to others. But while she had great confidence in her storytelling, she was not a natural-born writer. She was writing in a language that she had only just learned and never mastered. And so she turned to the person closest to her who was fluent in English: me. She said, you'll tell my story, Brascia, just write it down. My mother was looking

to me to be her storyteller, her storyteller in English, her storyteller for the future.

When I was ten years old, I actually tried to do that. I had just read Anne Frank's diary, which had given me some idea of how my mother's story might be told. I managed to get out a page before I realized that I couldn't write in her voice. It was my mother's story to tell.

My mother's life grew very busy after she opened her own business, a women's clothing store, and she spent less and less time writing in her notebooks. But she never stopped telling her stories, and now she found new audiences among my friends who, like me, were also drawn into her tales of life in a Polish village before and during the Second World War.

At the same time, she started sewing pictures. These were not of her creation, but needlepoint reproductions of paintings by the great masters. They were exquisitely done, and they served as handsome decorations for her walls. She also started embroidering lovely flowers and decorative borders on clothes and curtains, pillowcases, and even some wall hangings. My sister and I were grateful beneficiaries of many of these stitchery projects, but we saw that my mother's talents were larger, and we encouraged her to draw her own pictures rather than stitching the designs of others. She began with a stitched picture of a house, the house of friends of ours, and she created as a gift for them a pillow cover with the picture of the house they had just bought. These successful forays into her own images gave her the confidence to do more.

She decided to turn next to a depiction of her own childhood home. It occurred to her now that she could actually show Helene and me what her home and family had looked like. On a large inexpensive piece of fabric, about four feet by four feet, she tentatively sketched out her house and her neighbor's house. She was very nervous at first since she didn't know how to draw, and actually asked Helene to draw it for her. But Helene very astutely pointed out that she didn't know what my mother's house looked like. My mother was on her own.

With a ruler, Esther neatly outlined the houses. But it was when she picked up needle and thread that the picture came to life. She filled the surface with remarkably perfect crewel and embroidery stitches: a streaky sky of blue and white, fields of corn and wheat, and flowers growing everywhere. She created a fringe of yarn for the thatched roofs of the houses, and sewed lace curtains in the windows. She braided yarn for her long dark braids, and crocheted the figures of her parents and brother and sisters.

For her, it was a satisfying rendition of what had only been in her mind's eye before, bringing to life in a new way the memories that she had been able to capture before in words alone. It was true to what she saw in her mind's eye, and that gave her the confidence and the determination to continue.

In the spirit of even-handedness that marked her childrearing, she gave that picture to me, as her older daughter, and then made a companion piece for Helene, as stunning as the first. This picture was the view from the other side of the road, by the Tucin River, on a beautiful day in summer. She and her brother Ruben are swimming, and her yarn braids float on the surface of the winding ribbons of crewel stitches that depict the water. The cows graze on the river banks, the ducks and geese are nearby, and her sisters watch contentedly. Life is like a beautiful dream.

Not long after she finished these pictures, my children were born, and Esther's creative energies found a new focus. She had long waited for these grandchildren, and she literally could not get enough of them. A year after my second child, my son Simon, was born, she and my father moved their clothing store and all their other worldly possessions to Frederick, Maryland, close to where we lived, so that she could be with her beloved Rachel and Simon as they grew up.

The outpouring of love, in the form of toys, clothing, costumes, books, and other stitched things for them, seemed unending. To provide storage for some of the stuffed animals she made, she covered a

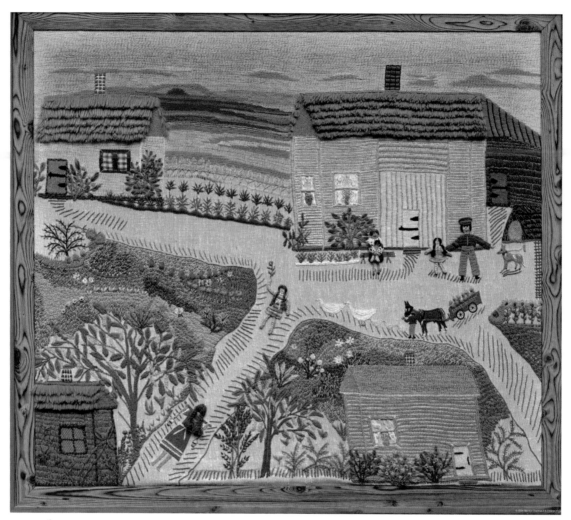

FIGURE 16.1

wooden barrel with fabric on which she had embroidered scenes of animals at play in a mythical wood. In imitation of one of her first projects as a girl, she sewed a Polish national costume, with green and red ribbons streaming from the skirt and blouse, and dressed it on a doll she fashioned to be the same height as Rachel. One summer, in fact, at the slowest time of year for business, she devoted a window display in her store to a sampling of her stitched creations.

But several years later, in the late 1980s, she began to return to her memory images. She had had two very powerful dreams during the time she was in hiding during the war, and it was these dreams that drew her back to her stitched images. This time, though, she modified her technique, and instead of filling her fabric with stitches, she used a combination of fabric collage and embroidery, along with crochet and other special kinds of stitches. In this way, she could complete a picture more quickly,

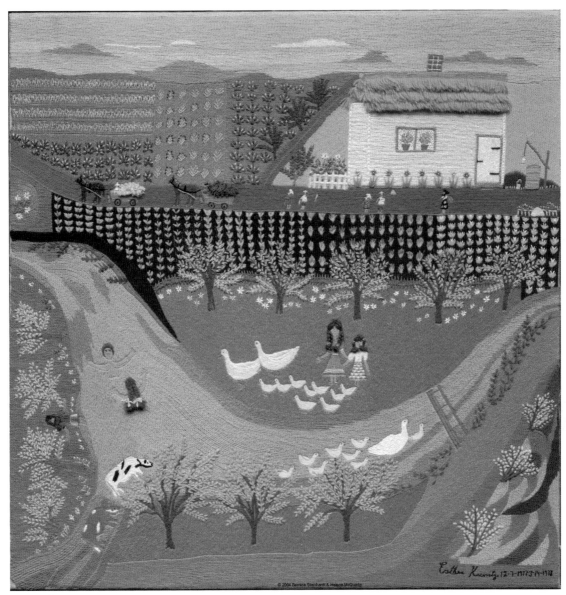

FIGURE 16.2

and since she knew she had two dreams to illustrate, she was looking for time-savers. I think, though, she was also interested in exploring the new possibilities afforded by varying her techniques.

The first picture she did was of a dream she had when she first arrived in the village of Grabowka, the village in which she and her sister Mania found refuge. In her dream, her mother came for her and

pulled her out of the house in which she was sleep-
ing and started running with her. When she asked
her mother why they were running, her mother said,
"Because the sky is falling, and when it reaches the
ground, we will die." And when my mother looked
behind her, she saw pieces of black sky, with stars

stitched into them, falling to the ground behind
them.

The next picture was of a dream in which her
grandfather appeared to her. She had been very
close to her maternal grandparents, both of whom
died during the Nazi occupation, her grandfather

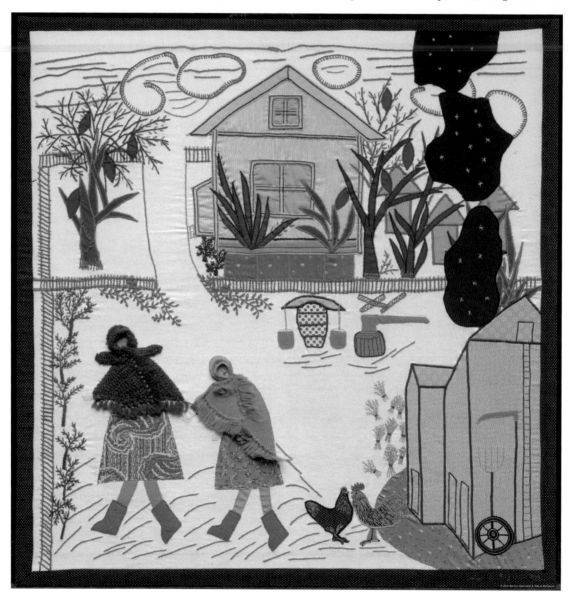

FIGURE 16.3

of a fall from a ladder. In her dream, she went to see her grandfather in his house, which she pictured with the objects she remembered so lovingly: the grandfather clock, the tapestry bedspreads, the lace curtains, and the portrait of her grandparents hanging on the wall. Knowing that her grandfather was dead, she stood at a distance from him, and holding her arms out, she begged him to help her. "You're close to God, you have to help me!" And he calmed her down and reassured her that she would be all right, that one day she would cross the river and be all right.

Now that she had started anew on these memory pictures, she kept going. The next picture – actually, what turned out to be the next few pictures – took place on October 15, 1942, the day on which the

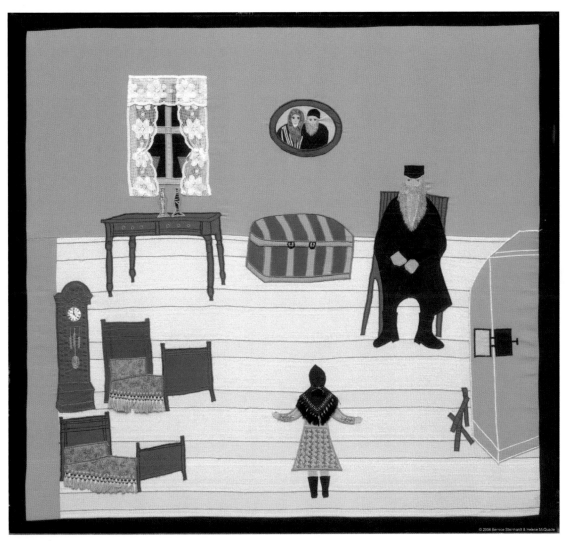

FIGURE 16.4

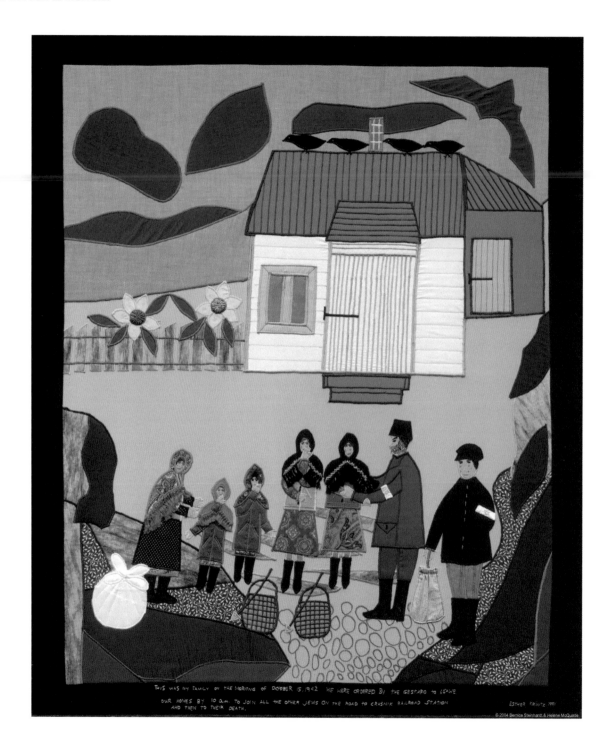

FIGURE 16.5

Jews of her village, Mniszek, and the nearby town of Rachow were ordered to leave their homes and report to the train station. It was also the last day on which she saw her family. The night before they had to leave, Esther told her parents that she refused to go with them. Instead, she begged her parents to think of someone she could work for, a Polish farmer like others she and Mania had worked for since the occupation.

And so the next morning, my mother and Mania said goodbye to their parents and their brother Ruben and younger sisters, Leah and Chana. Esther made two pictures of this leave taking. In the first one, all the members of their family are standing next to one another, and each one of them is crying. Four huge crows sit on the roof of their house, ominous symbols of death. My mother always said that this was the most difficult picture for her to make, not in a technical sense, but because it was the most emotionally painful.

And yet, five years later, she returned to the same subject, and made a second picture of this leave taking. This time, however, she and Mania are already out of the picture, small figures receding in the distance. In the foreground of the picture, her parents are coming down from their house to the road, getting ready to join their children who are already in the wagons filled with other villagers on their way to the train station in Krasnik. Now, my mother pictured the departure from the perspective of her parents, imagining what it must have been like for them to have said goodbye to two of their children while getting ready to take the rest off to a likely death. "Goodbye my children – maybe you will live." These were the last words their mother spoke to them.

Looking at these two pictures together, one can see how much my mother had learned in the years that separated their creation. In the first, done in 1993, the composition is fairly simple: the figures are depicted on a single plane, with her house on a parallel plane behind them. It is a beautiful and moving picture, relatively primitive in style. By 1998, when she completed the second picture, she had learned perspective, and her composition was much more complex, with many more elements. With each new picture, she learned something new, and the sophistication of her work grew exponentially.

These pictures also contained a new element. After the two dream pictures, the next picture my mother made depicted her and Mania standing on the side of the road, watching the procession of wagons on their way to the train station. But at the bottom of this picture, she added a stitched caption: "On Friday, October 15, 1942, it was the beginning of the end, the somber march of the Rachow Jews to their deaths."

Once she added text to her pictures, she saw that she could tell her story in this way – as a visual narrative. And once she realized this, she continued to create these memory pictures without pause. By the time she became too ill to work, in 1999, she had created a series of thirty-six pictures that together described her life before the war, her survival during the war, and her arrival in the USA after the war.

She didn't create them in chronological order, though. Their sequence had a psychological order, corresponding to the weight of their memory. As I said, the first few pictures after the dreams were of the events around October 15, 1942, the last time that she saw her home and family. After that, her memories took her back to the years of the German occupation, when Jews were taken to slave labor camps. She described as well her journey with Mania, the two of them disguised as Polish Catholics, hiding in a village that was willing to take them in without papers. She also looked back to happy times before the war, when she recalled the joyousness of celebrating the Jewish holidays. And her memories took her forward to her first vision of the USA and the Statue of Liberty.

Esther created the pictures without pause. Even though she was running a business, she still found time – in the evenings, during slow periods in the store – to work on her pictures. While they took

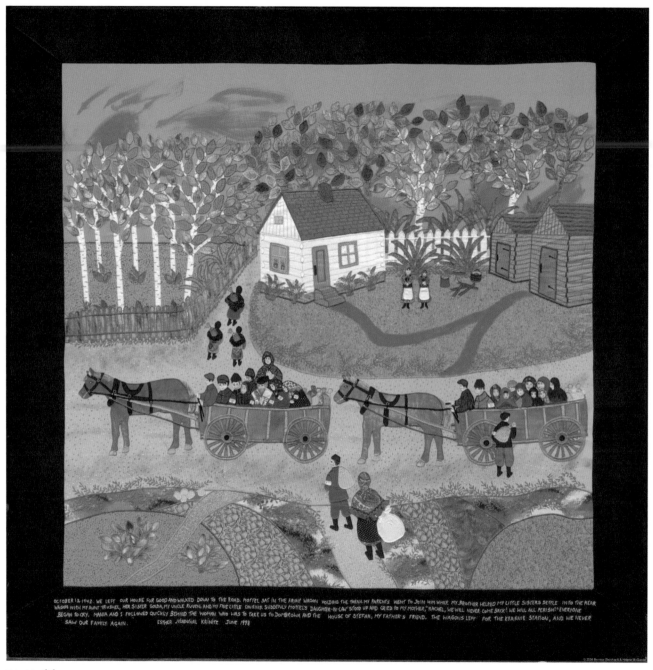

FIGURE 16.6

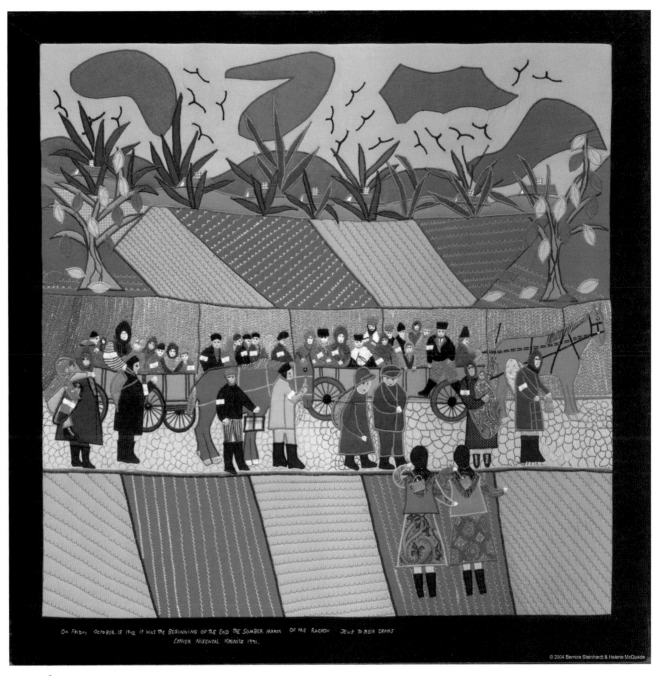

ON FRIDAY OCTOBER 15 1942 IT WAS THE BEGINNING OF THE END THE SOMBER MARCH OF THE RACHOW JEWS TO THEIR DEATHS
ESTHER NISENTAL KRINITZ 1991.

FIGURE 16.7

varying amounts of time to complete, she was remarkably quick and would finish each picture in about three months, on average. After she finished, she had them stretched and framed and gave them to me. I hung them on the walls of my house until I ran out of wall space, and had to stack them.

Esther was proud of what she was doing and was gratified by the reactions of her daughters – her intended audience. "I had no intention or ever dreamed that [my pictures] would be exhibited. I only did it for my children, my two daughters," she said. But by then, it had become clear that what my mother was creating deserved to be seen by more than the family and friends who came to my house.

And so that became my mission: to get the pictures out of my house and into the world. And in that, we've been successful. Esther's artwork has been exhibited in more than a dozen museums around the USA; *Memories of Survival* has been published not only in the USA but in Japan and Korea; and *Through the Eye of the Needle* has been screened at festivals in the USA, Canada, Poland, and Northern Ireland. The work is now truly out in the world and will continue to make its way – I'm certain of that.

I often think about how my mother would react if she could see how her work has touched such a wide number of people from very varied backgrounds. After reading *Memories of Survival*, a middle school student in Japan wrote, "I think I would have died if I had been a Jew ... I learned in society class that in Japan the Ainu people were discriminated against in the past. I thought: Why are races discriminated against? ... We must work together so that things like this won't happen anymore from now on."

For me, this feels like what I was raised to do: to help my mother tell her story so that others might know her and be inspired, as I was, by her bravery, ingenuity and resilience in the face of great terror and loss. Like many children of Holocaust survivors, I always longed for a way to alleviate my mother's pain, to somehow make up for her immense loss. I could never, of course, restore her family to her. But my mother found a way to keep alive the memories of the family she lost, and we, the family she created, are finding a way to help those memories endure and serve as inspiration for others.

The first time someone asked me how I was affected by my mother's experiences, it took me some time to sort through the multitude of life lessons Esther passed on to me. Her courage, her resourcefulness, her devotion to her family – all these aspects of my mother's character were so compelling in her stories, and even in the woman that I knew for myself. But of all her traits, the one that served most powerfully as an example was my mother's capacity for resistance in the face of inevitability. My mother showed me that to give in was to give up, that the seemingly unavoidable was not necessarily so, that there could be another way – even for a child – to sidestep a grim fate. And when she started creating her works of art, she showed me that time itself can be defied, by holding firm to the memory of love.

Acknowledgment

Photographs are reproduced by kind permission of Art and Remembrance (http://artandremembrance. org/).

Bibliography

Nisenthal Krinitz, Esther and Steinhardt, Bernice (2005) *Memories of Survival*. New York: Hyperion.

Shapiro-Perl, Nina, director (2011) *Through the Eye of the Needle – The Art of Esther Nisenthal Krinitz*. Art and Remembrance, Washington, DC.

Every Stitch a Memory

L. DUNREITH KELLY LOWENSTEIN

Netty Schwarz Vanderpol was born in Amsterdam on November 26, 1926 to loving parents, Louise Carolina Schwarz (née Pop) and Aaron "Dolf" Schwarz. She and her younger brother, Benno, spent their childhood growing up in a home in which they were treasured and nurtured. Netty's father was an affluent chemical industrialist. Her mother, while assuming the role of a society wife of that era, was first and foremost a mother. Theirs was a home where Tuesday nights were spent listening to a children's program on the radio, and visits to museums and the symphony were common family activities. An art lover, her father was an avid collector of paintings and drawings. Dinner guests were frequent, and on those evenings she and Benno would be sent to the smaller dining room. Netty's mother Louise could frequently be found in the living room creating a new needlepoint or embroidery. Netty learned the craft and often joined Louise in the activity. Prior to the war, Netty's family considered themselves first and foremost to be Dutch. They did not deny their Jewish heritage, but they were not observant. Her father considered himself a humanist; the only trace of her mother's Jewish upbringing was a yearly fast on Yom Kippur. (Netty's mother did this at the behest of her own mother, who was an observant Jew.) Netty and her brother attended a local secular private school where she excelled at her studies and had a warm circle of friends.

Netty's world changed in May 1940 when the Germans invaded the Netherlands. She still remembers seeing her father cry for the first and only time on May 14 as he heard Queen Wilhelmina address a Dutch radio audience. (The queen had fled to England.) The Netherlands surrendered to Germany the next day, and the German occupation officially began. Netty was thirteen years old.

With the Nazi occupation, Netty's Jewishness shifted from the background of her identity to becoming an aspect that defined and categorized her and her family. People with Jewish ancestry were subject to ever more draconian regulations and restrictions. Netty was forced to wear a Jewish star, compelled to leave her school and attend an all-Jewish one, and forbidden from going into public places like movie theaters that she had once frequented with her friends. Starting in 1940, Netty watched as fellow Jews were arrested, physically abused, and rounded up for deportation.

Netty's father continued to attend to his business, mindful of the importance of strategically positioning himself as indispensable to the Germans through his expertise in the chemical industry. He gained special status as a result of his ingenuity and political savvy. Her father recognized that protecting his company meant that he was sheltering his immediate family, other family members, and company employees.

Netty's father's position did not prevent her or her family from enduring the war's hardships and horrors. Nineteen years old when the war officially ended, she carried with her searing memories of the atrocities and unspeakable acts of terror she had witnessed. As the years progressed, she felt uncomfortable not being able to talk about this part of her past. But she also knew that she was not yet ready to interact with her memories in a public way. She

needed to put distance between the events and the new life she was creating in the US with Dr. Maurice "Ries" Vanderpol, her husband who also was a Dutch survivor. In her early years, she spent many nights talking through recurring nightmares with him. Fortunately, Ries had chosen to be a psychoanalyst. He was a compassionate and skilled listener. To this day, Netty credits her marriage to Ries with enabling her to live a full and enriching life after the war.

Ultimately, Netty took nearly forty years to find a way to bear witness to the ruinous consequences of Hitler's war against the Jewish people for herself, her family and the world. Netty never felt she could convey her personal stories without faltering under the weight of the memories. But she drew some comfort from the knowledge that Ries spoke often about his own experiences as a Dutch survivor, often including some aspects of her story during his presentation.

In 1984, Netty heard Elie Wiesel speak about the importance of testimony at an event for Holocaust survivors at Bergen-Belsen, the former Nazi concentration camp from which he was liberated in 1945. She understood intimately that testifying about the horrors of the Second World War was vitally important to preserve memories and to warn future generations of the dangers of intolerance and evil. She also understood that in telling her story, she was allowing others to know it and continue to bear witness for her. This was not a new concept for her, but it came at a time in her life when she was ready to receive the responsibility and take action to meet it.

Soon after hearing Wiesel speak, Netty found herself at the Textile Museum in Washington, DC. While at the museum, she saw a needlepoint on exhibit called *View from My Grandmother's Porch*. Standing in front of this piece, Netty had a moment of inspiration. Perhaps needlepoint could be a way for her to depict her memories without the fear of confronting her own demons publicly in the way that Ries and others had done. Finding a way to articulate her experience through art would allow

her to satisfy her own desire to recount her personal narrative as well as to make visible those who could no longer speak for themselves. She would not be obligated to actually speak, but would know she had shared her story and fulfilled the responsibility she had accepted.

Netty and her mother had both returned to the comfort and pleasure of doing needlepoint after the war. Netty recognized she could take this traditional domestic activity and use its inherent precision to harness the images and memories in her mind. The more she thought about the idea, the better it seemed. Thus began her multi-year journey to create images that reflected her wartime experiences. Ultimately, the very act of creating these intricate works of art became part of the healing process for Netty. The ramifications of her choice to do the needlepoint and the journey that choice took her on continue to reverberate.

Netty named her collection, "Every Stitch a Memory." The project spanned a sixteen-year period during which she spent 1,857 hours stitching nineteen works. Choosing which parts of her story to share, how to share it, and how to move from the idea to the product and the stitching itself empowered her. The needlepoint project enabled her to finally tell her story. It also helped her bring attention to the plight of the Jewish people during the Second World War and to war's destructive nature. The collection became a form of testimony whereby she voiced the stories of individuals whom the Nazis were intent on obliterating. Netty interspersed the themes of identity, memory, legacy, witness, resistance, and hope throughout the collection. This journey to revisit and record her memories has been a healing experience for her, and has served as a vehicle to share her very personal reckonings with her family and the world at large.

When Netty began her series, she consciously chose to start before the war and then make her way step by step through her wartime experiences. She didn't write anything down, but rather held her plans in her head and made her choices independ-

ent of outside counsel, especially in the early stages. She also decided at the beginning of the project to count the hours she took to complete each piece and include that with her title and description. The number reflected the actual number of hours Netty stitched. During those hours of stitching, Netty was most intensely immersed in confronting her memories of the war years and the specific experience she was capturing in each needlepoint.

Netty said about the hours: "It's very important to me because it shows the amount of hours that are involved in remembering what happened that many years ago and that you can tolerate it at this point but that is something that you truly absolutely have to do because you have to bear witness [against those] who say it never happened." People should recognize "this was how long it took for me to get out of my memory and to put this down on canvas … this is not just something you sit down and do. It was a very contemplative emotional time and you have to focus." For Netty, every stitch literally represented a memory, many of which were devastating.

Netty's record of hours conveys only a portion of the actual time she spent on each piece. She spent many additional hours choosing the subject, design, thread colors, and textures, as well as acquiring additional materials to integrate into the final products. Initially, she relied on the deep trove of her memories of that time for her "material." She also took years off after completing particularly taxing pieces – a decision that reveals the toll reentering this space and doing that creative work took on her.

As the years went on and she shared her project with others, Netty began to accumulate artifacts from the period and did research to enrich the pieces. She became a recorder of her own family history and a conveyor of other aspects of the war years. In addition, Netty went from depicting the past to expressing her hopes for the future. In this aspect, her needlepoint became a way to express her belief that creating a better world is possible if we heed the lessons of the past and choose to actively resist intolerance.

Netty began her series in 1984 with a needlepoint titled *1943*. Netty notes that she spent 112 hours to complete the twenty-eight by twenty inch piece. She brings us right into her war experience while at the same time reminding the viewer of the optimism and innocence of her youth. In the needlepoint, she stitched pastel colored threads for the background to reflect the perspective of "a young girl who sees the world in happy colors." These horizontal pastel bands of soft yellow, green, pink and lavender are interrupted by two disconnected and stark vertical black lines. The first line begins at the top and is thinner and shorter than the second vertical line. It is meant to represent her time in Westerbork. The second, wider black vertical line begins at the bottom slightly right of the Westerbork line and represents the Schwarz family's time in Theresienstadt (Terezin). Opened by the Dutch government, Westerbork was originally a collection camp for Jewish refugees from Germany. During the German occupation, it became a transit camp where many Dutch Jews were sent before being transported to extermination camps in Poland. A small number of transports went instead to Theresienstadt, a concentration camp in Czechoslovakia. Although the piece is titled *1943*, it reflects the period from 1943 through the early months of 1945.

Netty chose to title the piece *1943* because it was a perilous year for the Jews who had remained in the Netherlands. Those who stayed lived in a state of constant fear and terror as they watched neighbors, colleagues, and even relatives taken away. Netty understood the possible implications of being arrested and sent to Westerbork as early as 1940. This was when she first saw Jews being transported to the Muiderpoort Station, and then to Westerbork. By January 1943, she and her family experienced the terror first hand. The Schwarz family were arrested three times, but each time they were released, protected by her father's influence.

FIGURE 17.1 *1943.*

However, things changed when her father was arrested and taken to prison in Amsterdam in January 1944. Approximately two weeks later, Netty, her mother, brother, and maternal grandmother were arrested and taken to Westerbork. This time they stayed close to three months while her father was incarcerated. Eventually, Netty's father was released and joined the family. On April 5, 1944 all five family members were sent on a three-day journey to Theresienstadt in a cattle car filled with other prisoners. Netty felt it was important to depict the time in the two camps against the backdrop of the beauty and hope represented by the pastel colors. This conveys the optimism and hope she was able to hold onto from her earlier years. She believes her childhood foundation contributed to her resilience in the face of daily emotional and physical adversity. Netty and her mother, father, brother, and maternal grandmother left Theresienstadt in February 1945 as part of a group of 1,200 Jewish prisoners released in exchange for five million Swiss francs put up by Jewish organizations. The group consisted of 523 German Jews, 433 Dutch Jews, 153 Austrian Jews and ninety-one Protectorate Jews.

Netty's most traumatic wartime experiences occurred during the ten months she and her family were held at Theresienstadt. *The Plow*, a work she completed in 1993, represents one of them. She fell frequently during the time she worked on the piece.

Despite multiple trips to the doctor, including the emergency room, no apparent medical explanation could be found. When her husband Ries asked her what needlepoint she was working on, she told him it was the story of the incident with the plow. He said he had never heard about it; and, in fact, Netty had never told anyone the story.

The incident occurred when she was picking potatoes in the winter with eight or nine other young girls. It was very cold and they had no winter coats. In order to reach the fields, they walked past the penal section of the camp known as the "little fortress." One day as they were walking past it, they were ordered to stop by a German SS officer who was forcing two prisoners to run while pulling a plow. The plow was one big round sharp knife. One of the men fell and the officer forced the other man to continue pulling the plow, brutally killing the fallen man. The image of the event remains etched in Netty's mind to this day.

In making the piece, she chose to return to that space of absolute brutality and horror for 111 hours of stitching. Netty wanted to bear witness to this heinous act by the sadistic Nazi officer as well as to honor the unknown prisoner who was forced to cause another man's death. Netty never spoke of this with the other girls who were forced to watch it with her, nor did she tell her family what she saw when she returned to them that evening. Of her process with this piece, Netty says:

> [I thought] how am I going to do that? How can I ever portray what happened and what this man went through? ... [eventually] I came up with this [design]. It was one of the most gruesome things I had seen ... very difficult to come to any kind of decision ... I wanted something that had some depth to convey the depth of the horror ... and then the number is to remember the guy who survived it. I will never forget that face: the complete despair and hopelessness. We had to stay there and watch the whole thing. I was holding so much inside and never talked about it. The minute I was able to talk about it I could finish it.

This piece exemplifies many aspects of Netty's personal journey as she designed the collection. It took her nine years to decide to create this piece, and it was the first piece during which the pain of returning to the memory manifested itself physically. Significantly, her falling led her to reveal the previously untold and multilayered story to her own family.

The plow incident reveals many aspects of her life at Theresienstadt. The piece was partly inspired by the difficult physical conditions she and other girls her age endured in the camp. Additionally, she reflects the sadistic German officer who not only orders one prisoner to kill another against his will, but compounds the evil by forcing the young girls to stand and watch. It is a complex multidimensional piece in black and white. Netty included an identity number on a strip of black on the lower right corner. The number represents the prisoner who was left standing, thereby making him visible and an individual. Finally, the entire process of creating the piece illustrates the healing power of stitching for Netty. As she herself stated above: "The minute I was able to speak about it I could finish it." Netty still sees the desperate face of the man who was forced to kill the other prisoner in her dreams.

Two other pieces in the collection are tied to the theme of remembering the importance of individual identity. They are *Death Is ... Opa Mo, Oom Siegfried, Jeannot ... Three Out of Millions*, which she completed in 1986, and *The Nameless*, which she completed in 1994. The first consists of one vertical line to the left which is intersected near the bottom of the frame by two horizontal lines each representing a member of her family. In the title, Opa Mo is Netty's husband Ries's grandfather who died in the extermination camp Treblinka. The word "Treblinka" is stitched in the right-hand corner of the piece. The word "Bergen-Belsen," which denotes the concentration camp where her mother's brother Siegfried died, is underneath. Mauthausen, the last camp on the list, is where Netty's favorite cousin

FIGURE 17.2 *The Plow.*

FIGURE 17.3 *Death Is … Opa Mo, Oom Siegfried, Jeannot … Three Out of Millions.*

Jeannot died after being betrayed while in hiding. Originally a concentration camp for political prisoners and criminals, it was known for hard and often deadly labor. In this piece, Netty shows the fate of some of her family members who were killed and acknowledges that they were but three people of the millions who died.

Eight years later in *The Nameless*, Netty explored this concept in a new way. The piece is comprised of 35 Roman and Arabic numbers stitched in black in various sizes and styles. In addition to her own number and those of people she knew, Netty did research to find the identity numbers of people from various countries in other concentration and extermination camps. Netty spent 144 hours stitching this piece, and took care to make each of the numbers very individual in appearance to emphasize

FIGURE 17.4 *The Nameless.*

that "even [reduced to numbers], people, in spite of being nameless, were still different." This speaks to the importance of resisting being dehumanized by an oppressive system determined to extinguish one's individuality. Netty expanded her work beyond her personal experience by including the numbers of people she had never met.

Similarly, Netty at times has taken a very personal experience and used it to convey a more universal truth of war experience. Two pieces in the collection are directly inspired by her mother's wartime experience and its after effects. The first one, *And All the King's Horses and All the King's Men*, was completed in 1987. In it she uses diagonal bands in different shades of blue that start very dark and eventually merge with white to convey the deep sense of melancholy that remained with her mother from the time of the camps to the end of her life. This also provides an example of Netty's use of additional mediums to expand the range of her needlepoint. She has placed a cracked mirror on the piece to "symboliz[e] the fragmented lives that the Holocaust

FIGURE 17.5 *And All the King's Horses and All the King's Men.*

survivors experience." The title is a direct allusion to the childhood rhyme about Humpty Dumpty. In this way, she calls attention to her mother's plight as well as the more universal experience of many Holocaust survivors. Netty notes that many of the survivors she knew were not able to return to the optimism of their earlier lives or restore a semblance of normalcy. Indeed, some survivors took their own lives.

In 1995, Netty completed *Obsession*, the second piece about her mother, after 122 hours of stitching and sitting with her memories. She considers it one of the most difficult works to discuss, even with her own family. Netty's mother began to suffer from Alzheimer's when she reached her eighties. Netty visited her in the Netherlands two weeks before she

died. She found her mother sitting in a chair counting and naming the 163 members of her family who had been killed. It epitomized for Netty the deep trauma her mother had suffered. She barely recognized Netty yet obsessively kept listing each and every individual's name in an effort to remember and memorialize them.

In the piece, Netty repeated the number of murdered family members thirty-six times to create a frame for the "picture." Thirty-four of the numbers are in pale blue, while two are contrastingly stitched in red to stand for her mother's brother Siegfried and her nephew Jeannot who were also included in the earlier piece *Death Is … Opa Mo*. These two men were closest to Netty's mother, and her mother

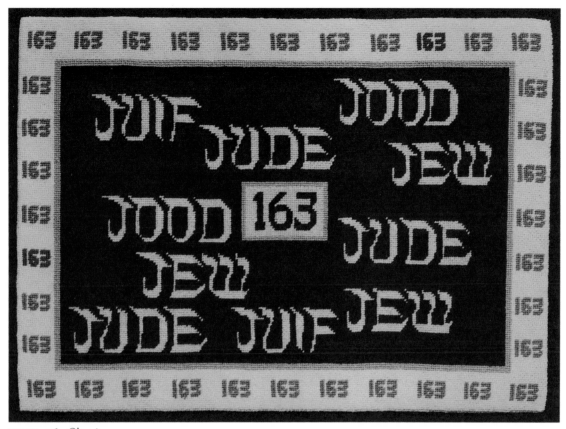

FIGURE 17.6 *Obsession.*

often expressed guilt about not having been able to save them. The "picture" is comprised of the word for Jew stitched on a dark blue background in capital letters in white two times each in four languages: JEW (English), JOOD (Dutch), JUIF (French) and JUDE (German). The repetition of the word in multiple languages highlights the range of the victims' backgrounds as well as reducing their identity to being first and foremost Jews in the Nazi extermination system. Finally, at the center of the frame in dark blue stitching on a white background is a larger number 163 that emphasizes the significant number of her family members who were, in her mother's words, "exterminated."

Netty did not speak about her feelings for her mother with anyone until many years after her mother's death. In a way these two pieces exemplify Netty's own journey of personal reckoning. She was able to represent the brokenness that haunted her mother after the war in the first piece. *Obsession* goes deeper. In speaking about this second piece, Netty reveals her intense pain at seeing her mother reduced to where she could not escape the terrible memories that incessantly played in her head. She felt compelled to return to her mother's story and elaborate how her mother's feelings of guilt about her lost relatives haunted her for the rest of her life.

At times, Netty used her needlepoint as a way of conveying other parts of Holocaust history to those who would one day view her finished collection. In 1990, she created a piece entitled *Eighteen Dead*. Named for Jan Campert's poem, "*De achttien dooden*," the work memorializes the first eighteen Dutch people, a group that included fifteen resisters and three communists, who were executed by the Nazis. The poet also honors Campert, who was arrested for aiding Jews and sent to the concentration camp Neuengamme, where he died.

The needlepoint is 15 inches by 11.5 inches and has a black background with a black braided "frame." Extending from the right corner are six rows of multidimensional squares stitched predominantly in white with the right sides in gray. The first three rows have four squares each followed by a row of three, then of two and finally one representing the eighteen prisoners, each in his own cell awaiting death by a Nazi firing squad.

Netty also wanted to call attention to resistance during the war by a group of university students who published a broadside of Campert's poem in 1943. The students sold copies of it to thousands of people to raise money to help provide resources for Jewish children in hiding (see Ness, 2010). She shared

FIGURE 17.7 *Eighteen Dead.*

stories of resistance to ensure people knew it had occurred. This piece demonstrates Netty's expanded concept of her collection's potential impact. She went from telling her own truths to using "Every Stitch a Memory" to teaching a larger lesson about the role of Dutch resistance during the German occupation.

Two of Netty's later pieces are intensely personal records of, and reflections on, her life. In 1994, she completed *My Shoes* over a period of 144 hours. This piece arose after Netty mentioned to her daughter that she had had a dream about the tattered shoes she had worn in Theresienstadt. Her daughter encouraged her to do a needlepoint about

FIGURE 17.8 *My Shoes.*

what the shoes symbolized for her. The center of the needlepoint is a square which has two brown shoes with twine across the top of one of them to show that they are barely in one piece and kept together with the twine. Netty uses the shoes to symbolize the vulnerability she felt during the war years. The border of the needlepoint is a series of sixteen different, beautiful squares of material from dresses. In her post-war years, Netty has prided herself on looking her best in contrast to the war years when her appearance was the least of her concerns. Netty's juxtaposition of the elegance and comfort of her material life after the war with the starkness of the war years reminds us that her inner vulnerability remains, even though she has an externally comfortable life.

Netty spent 138 hours in 1996 completing *Dehumanization*, the second intimate piece. As with some of her other works, Netty found inspiration in an unexpected place. After deciding to portray herself before, during and after the war, she came across a Hermès scarf with a ring pattern while at a shop in Paris. This gave her the idea to convey her experiences through a series of four rings. As she describes it: "The sequence of four rings describes me before, during, and after the Holocaust. The bright-colored

FIGURE 17.9 *Dehumanization.*

rings symbolize the happiness and optimism of a sixteen year old. As I move into the dark times, the brightness dims and shadows appear. In the deepest of despair, the rings disconnect and shadows darken ominously. The post-war 'me' rebuilds a life, but faint shadows remain." The needlepoint has a black background and the rings are varying shades of orange, gray, and white.

It is apt that an elegant silk scarf inspired Netty to depict the dehumanization she experienced and witnessed during the war. In many ways, Netty's life after the war was a return to her pre-war existence. She has lived a life rich in material and emotional comfort. Similar to her own mother, her main role for many years was as the wife of a prominent man and the mother of two children. Like her mother, she also pursued ways of creating art through stitching.

In contrast, the dark rings allowed her to abstractly reference some of her harshest memories which remain too painful to articulate in words or stitches. Although she found a way to capture the incident with the plow in Theresienstadt, she could find no images to articulate other events. Certain horrors and incidences of brutality still haunt her. These incidents involve things she was forced to do and choices she was forced to make. When Netty talked about some of the most difficult parts of the war for her, she often returned to the idea that the Nazis did their best to rob people of their humanity by forcing them to perform and witness unspeakable things.

In creating *Dehumanization*, Netty has shared her fractured self and, as in *My Shoes*, the reminder that she can never totally escape the memories of her past. Her intent in this piece is to call attention once again to the heinous acts perpetrated by the Nazi regime during the Holocaust. Although she focuses on her own experience, she also expresses her indignation with the overall dehumanization that was a hallmark of the Nazis. Additionally, her more universal message is how important it is to see all humans as human and to not allow oneself to objectify or reduce people to categories.

Netty's final piece, *In Spite of Everything*, is a return to her homeland of the Netherlands. In it, a star of David emerges from undulating waves that start light gray and become darker before the majority of the star is once again in the light. She uses the star of David to symbolize the vibrant, prewar Jewish community in the Netherlands which the Nazis nearly wiped out. Despite all that happened, there has been a renaissance of Jewish life since the end of Second World War. She reclaimed the star as a positive symbol of the Jewish people. (In some of her earlier pieces, she showed how the Nazis used the star to reduce people to their religious identity.)

Finishing this collection had a transformative effect on Netty, letting her break decades of silence and speak through her art. She communicated her story in stages. In the first decade, she created fifteen works that she shared with family and close friends. An additional ten years passed before she showed the art publicly. Between 1995 and 2002, pieces from "Every Stitch a Memory" traveled to seventeen museums, libraries, and universities across the USA as part of the Witness and Legacy exhibit, a commemorative exhibit conceived by the Minnesota Museum of American Art. Also around that time, a documentary film about Netty's work titled, *Every Stitch a Memory*, was made in 1993. It continues to be used in classrooms.

Slowly Netty began to speak more in public. She spoke briefly at some of the exhibition events, but preferred to let her art convey her message. Over the years, she has addressed a range of audiences. This includes school groups, which are her favorite. She has given interviews to media outlets, individuals and various Holocaust archives.

The work impacted her family, too. Both her son and daughter gained a more complex understanding of their family history through Netty's art and the discussions the pieces sparked. They prompted her son to write an extensive family history. Netty has spoken in each of her grandchildren's classes, and feels confident they will share the information about her wartime experiences. "Every Stitch a Memory"

FIGURE 17.10 *In Spite of Everything.*

will ultimately be donated to Het Verzetsmuseum Amsterdam (see Dutch Resistance Museum, 2013).

Close to thirty years after she first decided to heed the call of witness issued by Elie Wiesel, Netty is nearer to the end of her life. Content in the knowledge that she has fulfilled the responsibility she undertook, she still lives with the pain caused by what she endured and lost during the Second World

War. However, she has also found within herself the strength and resourcefulness to create a lasting body of artwork that carries on the tradition she learned from her mother, has helped her to gain an expanded sense of self and with each stitch, successfully resisted Nazi attempts at physical and cultural annihilation. Based on a creative rendering of her inner experience, this mix of the triumph of body, art, and memory amidst the horror of war is a powerful illustration of the possibilities and limits of resistance to authoritarian terror and genocide. Although Netty Schwarz Vanderpol is responding to her experience during the Second World War in Nazi Europe, the issues suggested by her life and work resonate with women responding to different yet similar experiences around the globe.

Bibliography

Dutch Resistance Museum (2013) Available at www.verzetsmuseum.org/museum/en/museum (accessed October 2013).

Ness, Carol (2010) Fighting Nazism with the printed word. Available at http://newscenter.berkeley.edu/2010/03/30/dutchlit/ (accessed October 2013).

Violeta Parra's *Arpilleras*: Vernacular Culture as a Pathway to Aesthetic Self-determination

GINA CANEPA

WHEN DISCUSSING VIOLETA PARRA'S[1] *arpilleras*, we should first consider some asides. The documentation of the body of Violeta Parra's work is subject to certain compromises. However, here fourteen *arpilleras* will be considered of which thirteen have been presented in rotation at the Cultural Center of the governmental palace La Moneda in Santiago, Chile from 2007 onwards.[2] According to the Violeta Parra Fundation (2007, page 16), her complete visual works consist of twenty-two *arpilleras*, also called *lanigrafias* (jute tapestries embroidered with wool), twenty-six oil paintings on canvas or pressed wood, and thirteen wire sculptures. We should also consider her works in ceramics and

[1] Violeta Parra was the daughter of Nicanor Parra, an elementary school teacher, and Clara Sandoval, a peasant and seamstress. Violeta started her elementary education in Lautaro and Chillán, and in 1934 she entered the École Normale, where she stayed less than a year. In 1938 she married Luis Cereceda, the father of her children Ángel and Isabel, who adopted the surname of their mother. From her childhood she felt a love for Chilean music and folklore; her father was a well-known folklorist in the region. After settling in Santiago, Violeta began to perform with her sister Hilda as the duo Hermanas Parra. The travels through Chile put her in touch with the social reality and economic inequalities within the country. Violeta Parra's politics turned to left-wing militancy and that led her to seek the roots of folk music. In 1952, she toured Santiago de Chile's poorest neighborhoods, the mining communities and farms, picking songs from oral tradition. She was then able give them more publicity in 1954, in a series of radio programs for Radio Chilena, which aired national folklore. Also in 1954 she received the Caupolicán award and in the same year she married Luis Arce, and Carmen Luisa and Rosa Clara were born. In 1953, Violeta met the poet Pablo Neruda. In 1955 she made a trip through Europe and then settled in France for a while. While in France she had the opportunity to record subjects of Chilean folklore for the catalogue of the *Le Chant Du Monde*. In 1956, back in Chile, she recorded the first album in the Folklore of Chile collection, a series aimed at saving folk themes, the majority of which had an anonymous authorship. Violeta was appointed director of the Museum of Popular Art at the University of Concepción and resumed performances on Radio Chilena. In 1962, she embarked on a journey with her children and granddaughter to Finland to participate in the Eighth World Festival of Youth and Students in Helsinki. After touring the Soviet Union, Germany, Italy, and France, Violeta Parra settled in Paris. She sang in La Candelaria, in L'Escale, located in the Latin Quarter, and also offered recitals at the Théâtre Des Nations of UNESCO. In addition, she acted on radio and television with her children. In 1964, she had the opportunity to organize a solo exhibition of her artistic work in the Louvre Museum in Paris, the first by a Latin American artist. After returning to Santiago, along with her children, she encouraged the *Peña of the Parras*, a legendary café-concert, to spread the folk music of Latin America. In addition to collecting and interpreting genuine folklore, she composed her own folklorist songs; her creativity also led her to cultivate ceramics, tapestries, painting, and poetry. Sadly, as a result of a deep depression, Violeta Parra ended her own life in 1967. Her sociopolitical folk songs created a precedent for the Chilean New Song movement.

[2] The *arpilleras* were granted by the Violeta Parra Foundation to the Museum of the Cultural Center in La Moneda Palace as a commodity in 2006. This agreement is for eight years and includes their restoration, conservation, and exhibition.

papier mâché. Another source, a master's thesis by Alejandro Escobar Muna (2012), mentions seventeen *arpilleras*. Violeta Parra's work was made between 1958 and 1965 in the cities of Santiago, Chile, Buenos Aires, Paris, and Geneva.

In this chapter I will attempt to discern and interpret the hybridism with which Parra combined the vernacular aesthetic with that of modern art. At first glance, her visual work evokes an essential dialogue not only between the national and global but also between folk art and so-called "high art." Certain features of her plastic production reveal a neo-indigenism and neo-ruralism, elements that she intermingled with the vanguard's styles she discovered in Santiago, Paris, and other European cities. In summary, examining the synesthesia of Violeta Parra's work more closely, it seems pertinent to explore how she developed a visual art that affirmed the vernacular tradition, and, at the same time, deconstructed it to configure a philosophy of art as a vital practice. Since this chapter will focus on the *arpilleras*, it should also be explored how Parra, from the embroidery and the wool – considered a woman's domain *par excellence* – defied their limits, transmuting them into a hermeneutical interpretation.

According to several relatives of Violeta Parra – and this has become almost legend – in 1958, she was forced to rest because of a hepatitis infection, and so, she began painting, embroidering, and sculpting with wire (Parra, 1985, page 71). Thus, Parra added a new creative facet to her artistic work as a folklorist, composer, poet, singer, and interpreter of various musical instruments. According to her daughter Isabel, Violeta Parra continued working in the field of visual arts until 1964, the year in which she exhibited her complete body of work at the Pavilion of Marsan in the Museum of Decorative Arts at the Louvre (Parra, 1985, page 101). The number of *arpilleras* on exhibit *was* twenty-two; a fact based on the original catalogue for the exhibition, however, in the palace of La Moneda, only thirteen *arpilleras* had been exhibited in rotation. We could therefore assume that some of the *arpilleras* are possessed by private individuals, although many, benefiting from Parra's artistic gifts, have returned them to the Parra family (Verdugo, 2005). After her death on February 5, 1967, in the tent of La Reina (Subercaseaux and Londoño, 1983) – a suburban canvas shelter she used as space for her presentations – there was, according to the Violeta Parra Foundation (2007, pages 21–4), a great uncertainty about the fate of her legacy. Her children were able to rescue a portion of these artistic works, and after the *coup d'état* of 1973, several of her works traveled to Cuba and France, depending on the ups and downs of the lives of her exiled children and friends. Today, we know that Parra used to give her visual works of art to her friends, thus, the total inventory of her work is still incomplete.

Some exegetists have linked Parra's visual style to a naïve and intuitive art because it deploys everyday aspects of family life, childhood memories, passages of collective history, and folk characters, among others, framed by her interest in recovering and recreating the popular culture of Latin America (Sotomayor, 1986; Rodríguez, 2007). This interpretation is quite debatable since it does not include the universalism and the multifaceted hybridism of her works. This chapter will try to demonstrate that Parra's *arpilleras*, despite the indebtedness to vernacular tradition, are a phenomenon of modernity.

At first glance, the materials used in each of the thirteen *arpilleras* at La Moneda draw attention because they seem very poor and clumsy. It is hard to overlook that the burlap – also called jute – is in itself a piece of thick, coarse textile, fabricated with various types of yarn that, in Chile, have been used for the manufacture of sacks and packaging. The burlap, or *arpillera* in Spanish, determines the lineage of these artistic productions. This fact is important because the material, together with the wools used in the embroidery, ennobled by Violeta Parra, shaped the medium and genesis of her *arpilleras*. The nature of these materials appears to link Parra's *arpilleras* to a more "vernacular" art (Bosch, 2008) or more "artisanal" creation. However, a closer analy-

sis reveals how complex the iconic signs and how intricate the processes of creating significance from images are, as well as how richly the historical and socio-anthropological elements that permeate the semiotics of the images challenge the viewer.

The fact is that Violeta Parra's *arpilleras* did not only invoke the vernacular tradition but also redefined and reverted it with complex and sophisticated strategies that exceeded folk heritage without ignoring it. They legitimized it as an expansion of the domestic space, where the convergence of needle and wool in common family use generated new universes. The hard-working hands of Violeta Parra were inexhaustible since they cooked, plucked musical instruments, wrote poems, sculpted, wove, painted, and finally, embroidered. Her hands were legitimized as diligent tools where the domestic and artistic spaces nurtured and constantly recycled into each other.

Many of the features of Parra's *arpilleras* link them with her transgressive, experimental stage during the last decade of her life, much like her instrumental compositions for guitar, the *Anticuecas* (Aravena Décar, 2004) or the suite "The Sparrow" (*El gavilán*) (Oporto Valencia, 2008) with their unpolished dissonances, and her repertoire of political songs (Canepa, 1987, chapter 3) since 1960. All of these works, including her latest compositions, reaffirmed, recreated, magnified, and transgressed the Chilean and Latin American vernacular tradition. Without a doubt, her *arpilleras* unmasked a problematic subjectivity, permanently trapped between the national culture and the overcoming of it, in a world that is transparent, and yet not, with an awareness of reality and its loss. They finally drew anguish and sometimes a hallucinating perception of a world that was rather inherent to modernity.

In trying to explain her embroidery technique with wool or thread on burlap, Violeta Parra declared that "*arpilleras* are like songs that are painted" (Brumagne, 1964). This assertion, so synesthetic, is completely modern and brings to mind the assertion of Vassily Kandinsky on the affinity of visual arts

and music (Brandstätter, 2009), a concept shared by many European intellectuals during the 1930s. Violeta Parra was a typical artist of the first half of the twentieth century. An autodidactic woman that had to migrate from the countryside to the capital in order to develop her artistic potential, as most Chilean writers, visual artists, and musicians did at the time. Without turning her back on her rural childhood and adolescence, she entered the urban bohemian world when she settled in Santiago. Her personal financial precariousness and her irregular jobs singing in taverns did not prevent her from becoming familiar with some of the visual artists of the Communist Party, with whom she had been in contact after a brief political affiliation (Canepa, 1987, chapter 1). In the same way, Parra would later absorb different visual expressions during her European travels.

The Apprenticeship: Between Tradition and Modernity

On some occasions, Parra summarized her aesthetics like this: "things are simple. I do not know how to design. I invented everything, and everyone in the world can do so. I do not know how to draw and I do not draw before I begin my tapestries, but I see, little by little, what should be. So, I am filling spaces in my tapestries ... and in my paintings: they are all in my head, like my songs" (Mena, 2011).

According to Parra's biography, she lived in Lautaro[3] from 1921 to 1927, when her father obtained a teaching position at a regiment. Here she began

3 The southern city of Lautaro is located 30 km north of Temuco and, according to the last census data, has a population of 34,590. This territory was inhabited by Mapuche indians or Araucanians until the Chilean government began a bloody colonization of the area in 1860. Between 1921 and 1960, Lautaro experienced a period of economic cultural boom as a result of industrialization that introduced some of the European immigrants taking advantage of the raw materials of the area. Today, there is a population of 3,704 Mapuches.

her elementary school education. Violeta's father, however, was removed from his post in 1927 during the time in which Chile suffered from the dictatorship of General Carlos Ibañez (Fernández Abara, 2007). The family decided to return to Chillán, close to their kin. This is important to note, if one considers that the family at this time was plunged into absolute poverty, and that the children had to supplement their school life with incidental work like singing in the streets. The only income was supplied by the mother's sewing.

Violeta Parra was barely ten years old when she left Lautaro with her family, so her habitual reference to the culture of the local Mapuche indians could have been conceived under other circumstances of which we have no knowledge. The presence of key patterns and certain geometrisms is secondary in Parra's *arpilleras* but they reveal a certain tribute to indigenous cultural tradition. The Mapuche legacy in Lautaro, as in the rest of the Araucanía region, had prevailed in spite of the Chilean and European presence. Parra was probably acquainted with the geometrism of the indigenous traditions of earthenware vessels and weaving. Years later, in 1953, to be exact, when she decided to explore the north and south of Chile with the purpose of collecting folk songs, her encounter with the geometric minimalism of the Chilean natives' arts and crafts might have made her more conscious of it.

When the Parra-Sandoval family returned to Chillán after 1927, Violeta Parra moved to the home of her relatives, the Aguileras, and settled in the nearby town of Malloa. Here she helped in the harvest and other farming tasks and had the opportunity to become familiar with a set of popular events according to the religious folkloric calendar and feasts of productivity (vintage, harvesting, threshing, etc.). From the Aguilera sisters, Parra learned a wealth of traditional dances and songs, some arts and crafts, like wire sculpture, as well as traditional culinary arts. The impact of the Malloa wire sculptures was a determining factor in the works she would produce afterwards. Not every-

thing is known about the influence that Malloa had on her visual arts in general. The rural vernacular legacy of this area was more tied to an Iberian transculturation that was more prevalent instead in Parra's folk songs and poetry.

Other sources that might have influenced the aesthetic of Parra's applied works and, in particular, her *arpilleras* could have been the graphical representations of the nineteenth-century poetry of *pliegos sueltos* (unbound sheets). These sheets were known as the *Lira Popular* (Orellana, 2005) and embodied a phenomenon of writing and re-writing the oral legacy. Rural poets who moved to the cities searching for better economic outlets sold their poems in quatrains or in ten-line *espinela* stanzas, touching on daily events in the form of popular journalism (Canepa, 1989). A new group of cultural agents had arisen in the urban scene and its margins. Their sheets included pictorial descriptions of the recounted events in black and white, somewhat naive and terse in their general features. The perspective was rather rudimentary and organized in the forefront.

FIGURE 18.1 A part of a *La Lira Popular*.

Violeta Parra arrived in Santiago when the production of the *pliegos sueltos* was already in decline. Access to this material might have occurred through her oldest brother, the "anti-poet" Nicanor

Parra[4] who kept a collection in his personal library (Brons, 1972). According to him, when he returned to Santiago from England around 1951 or 1952, Violeta visited him, and so, an irreversible collaboration between the siblings arose as well as a dialogue about *pliegos* poets. Violeta Parra would have had access to these poetry samples for the first time (Morales, 2003). There is no doubt that the impetus to denounce critically this poetic form of popular journalism that took place on the fringes of the national culture's construction in the final decades of the nineteenth century, could have had an impact on Violeta Parra or at least have strengthened her own social discontent.

The writer and singer Patricio Mann (1977) posited that the set of socio-political songs by Parra could have been influenced by the *Lira Popular* series. We could also argue that the pictorial *conciseness of the sheets* left its traces in Violeta Parra's mind. A more meticulous observation could demonstrate the ascendancy of this production in Parra but we cannot rule out that, no matter what influences determined her formative phase, her own originality and her integrative predisposition prevailed.

At the time when Violeta Parra emigrated to the capital, Santiago, in 1932, the gulf between country and city was quite profound (Barraclough, 1966; Marín, 1969). Barely set up with her relatives in Santiago and close to her older brother Nicanor Parra, Violeta encountered a new world through relatives and friends who were connected to the syndicalist movement. With cousins, her brother, and his friends, the majority being students at the emblematic boys' boarding school, Barros Arana where Nicanor was working, Violeta made contact with the future painter, Carlos Pedraza (Cruz de Amenábar, 1984),[5] and the budding writer/philosopher, Jorge Millas (Figueroa, 2002).[6] In other words,

[4] Nicanor Parra was born in San Fabian of Alice, Chillán, in 1914. Once in Santiago, he studied mathematics and physics. He had been writing poetry since his adolescence. In 1943 he traveled to the USA on a scholarship where he studied advanced mechanics at Brown University. In 1948 he was appointed acting director of the School of Engineering at the University of Chile. In 1949 he travelled to England. There he studied cosmology with E.A. Milner, staying in Britain until 1951. Later, he taught mathematics and physics at the University of Chile. He traveled to the USA, the Soviet Union, China, Cuba, Perú, Panama, Mexico, and other countries. In the beginning, his work was evocative and sentimental like *Cancionero Without a Name* (1937). He later adopted the term and iconoclastic ironic tone which he called "anti-poetry." This renewal of international impact began in *Poems and Antipoems* (1954) and lasted through a dozen more works. In 1969 he received the National Award for Literature in Chile. In 1977 he published *Sermons and Preaching of Christ of Elqui*, about a visionary mystic who preached near the mines in northern Chile. In 1991 he won the International Juan Rulfo Award. Later he won the Cervantes Award in 2011. Parra is a survivor of the oldest group of contemporary Chilean poets which included Pablo Neruda, Gabriela Mistral, Vicente Huidobro, and Gonzalo Rojas. Parra has exercised enormous influence, among others, especially on the novelist Roberto Bolaño.

[5] Carlos Pedraza Olguín, a painter, was born in Taltal in 1913 and died in 2000. He studied at the School of Fine Arts at the University of Chile and belonged to the so-called generation of forty artists who renewed the painting of landscape in Chile. He developed extensive teachings in the School of Fine Arts at the University of Chile. He was Faculty Secretary from 1954 to 1959 and was subsequently appointed Director. Finally, he was appointed Dean of the Faculty of Fine Arts in 1963 and served until 1968. In the year 1979, the Chilean Government awarded him the National Award of Art.

[6] Jorge Millas (Santiago, Chile, 1917–82) was a Chilean writer, poet and philosopher. He had great involvement at the University of Chile, where he was a professor and director of the Central Department of Philosophy and Humanities at the Faculty of Philosophy and Education from 1952 until 1967, and from then on, a professor of Philosophy of Law at the Faculty of Legal Sciences from Universidad Austral until 1975 when he resigned because of continued harassment by the military towards academic freedom. At the beginning of his career, he was more poet than philosopher. He began to study philosophy at the University of Chile in 1938, graduating in 1943. He received a Guggenheim Fellowship that allowed him to

the autodidactic Violeta Parra hobnobbed with a more academic world as well as the lower middle-class intellectuals of Santiago as part of a dynamic that Ángel Rama has characterized as the rings of the "lettered city" (Rama, 1984).

Violeta Parra, stimulated by her husband Luis Cereceda, a militant of the Chilean Communist Party, participated in a few political events in 1937. After a period of time, she ceased her direct involvement with its members, although she always stayed in touch with left-wing parties and grassroots organizations and therefore, kept close contact with intellectuals of the Chilean left wing, such as poets Pablo Neruda, Gonzalo Rojas, and Pablo de Rohka (Nomez, 1988).[7] Although little is mentioned in her biographies, her friendship with artists of the left-wing vanguard of the country could have been fundamental in furthering her choices in the field of visual arts. In 1950, Parra befriended ceramicist Teresa Vicuña from whom she learned how to work clay (Ossa, 1986).[8] Her closeness with left-wing,

bohemian Santiago intensified during the 1950s when she, along with her brother Nicanor, attended cultural social gatherings. She became acquainted with painters such as José Balmes,[9] Eduardo Martínez Bonati,[10] Alberto Pérez,[11] Gracia Barrios,[12] and others.

obtain a master's degree in sociology. In 1943 he published *Idea of Individuality* and in 1945 he obtained a master of arts in psychology from the State University of Iowa. In 1946, he was hired for five years at the University of San Juan in Puerto Rico as a visiting professor. In 1947 he was hired as a visiting professor by Columbia University in New York and published *Goethe and the spirit of Faust* in Puerto Rico in 1948. He returned to Chile in 1951. He was devoted to university teaching and continued publishing on philosophy of law and defending the freedoms of academics and universities.

[7] Violeta Parra maintained a close friendship with Pablo de Rokha (1894–68) and also with his children. Pablo de Rokha was a solid innovative poet but his apprehensive, rebellious and critical character, in addition to his controversy with Pablo Neruda, did not contribute to promote his poetic career. He was among the Chilean and Latin American avant-garde, a misunderstood poet whose uneven, pessimistic and desperate poetry created a challenge for readers and critics. He was appointed cultural ambassador in 1944 and traveled through many Latin American countries. He received the National Award of Literature in 1965. He traveled to Beijing, Moscow, and Paris in 1960. In 1964, he dedicated the prose "Violet and her guitar" to Parra in Paris. This prose was included in the prologue to the first posthumous edition of *Decime. Autobiography in Chilean Verses.* De Rokha committed suicide a year after Violeta Parra did.

[8] Teresa Vicuña Lagarrigue, a sculptor awarded several times, was born in Santiago in 1927. She studied at the School of Fine Arts of the University of Chile. Her sister Rosa Vicuña was also a renowned sculptor. She continued her education in sculpture in Paris between 1974 and 1976. During the years of the Chilean dictatorship, she also lived in Rio de Janeiro and Barcelona. Teresa Vicuña has mostly worked with soft materials. She is a professor emeritus in sculpture at the School of Fine Arts at the Catholic University in Santiago, Chile.

[9] José Balmes, a Chilean painter of Spanish origin, was born in Montesquieu, Barcelona, in 1927. He obtained Chilean nationality in 1947 and began a direct involvement with the political events in Chile. Balmes created the group *Signo* in conjunction with the painters Gracia Barrios, Alberto Pérez, and Eduardo Bonati in 1959. In the year 1973, with the advent of the military dictatorship, he had to leave the country and relocated to France. The artistic proposal of José Balmes has often been linked to a social level and a commitment of the artist with mankind and the role of art in the collective consciousness. He received the National Award of Art in 1999. See Balmes (2012).

[10] Eduardo Martínez Bonati, a Chilean painter and muralist, was born in Santiago in 1930. He studied at the School of Fine Arts of the University of Chile. At the beginning of his pictorial work, Martínez Bonati was a figurative painter with landscapes and floral themes. He was later involved with the group Segno developing sharp vigorous plastic with colorist force and suggestive ways. He was professor for gravure at the University of Chile and went into exile in Spain in 1975. He returned to Chile in 2006. He has participated in numerous exhibitions abroad and has received multiple awards. See La Tercera (2011).

[11] Alberto Pérez, a painter, creator of artistic artifacts, writer, professor and a frequent guest speaker was

It was Carmen Barrios, Gracia Barrios' sister and José Balmes' sister-in-law, who remembers Violeta Parra as a part of 1950s bohemian life in a testimonial in 2010:

> I have met many people in my life. During my second marriage, my husband and I lived in a grove in Maipú for a while. Many people, such as Nicanor and Violeta Parra visited us. In those times, Violeta had the idea of traveling to France. She was expecting a child and I was, too, my third daughter. After she gave birth to her child, she went to France and became famous. At that time, visual arts fairs were taking place in Forestal Park in Santiago, and we saw each other there: Violeta was near a *brasero*, singing and making tapestries. The group was part of bohemian Santiago, we went to the famous Bosco … (Barrios and Pablo, 2010).

born in Santiago in 1926. He began his pictorial work around the 1950s and joined the group *Signo*, together with Gracia Barrios, José Balmes, and Eduardo Bonati. Alberto Pérez, in addition to painting, has developed a wide range of teachings, and has made important contributions to the national culture, participating in seminars, meetings and cultural associations. He began to teach Ancient and Medieval Art History at the Faculty of Arts at the University of Chile in 1985, when he returned to this institution after twelve years away because of the military dictatorship in Chile. In 1986, he earned a fellowship from the Guggenheim Foundation. He died in 1999 in Santiago. See Ríos (2010).

12 Gracia Barrios was born in Santiago de Chile in 1927, the daughter of the iconic writer Eduardo Barrios, who won the National Award for Literature in 1946. Her mother was the pianist Carmen Rivadeneira. Barrios was interested in art from an early age, and she received private painting lessons. During the 1960s she belonged to Signo, which broke with post-impressionism and advocated an abandonment of "easy painting." She married her colleague José Balmes. After the coup of 1973, she and other artists were exiled to France along with partners and children. They were away from Chile for about ten years. Disillusioned by the university system, she ended her teaching career in 1997. In 2011 she received the National Award of Plastic Art de Chile. See Adams Fernández (2002).

Carmen Barrios' testimonial includes memories from 1954 to 1959. It makes references to Violeta Parra's pregnancy with Rosita Clara, the daughter who later died when she was in Paris. Parra returned to Chile in November of 1956, and after two productive sojourns in the southern city of Concepción, she exhibited her recent work of oils and *arpilleras* at the first visual arts fair at the Forestal Park, Santiago in 1959. That year, José Balmes and Gracia Barrios created the group Signo according to the principles of informal painting in collaboration with the artists Alberto Pérez and Eduardo Bonati. The mention of the mythical soda fountain El Bosco adds an important nuance to the understanding of Parra's city life (Peña Muñoz, 2001, pages 180–1). This establishment did not close its doors at night, and the most enlightened Santiago bohemians of the period met there between the 1950s and early 1960s.

FIGURE 18.2 Carmen Barrios and Violeta Parra in Cajón del Maipo in 1952.

All these antecedents would allow us to describe Violeta Parra as a visual artist who broke and reshaped the vernacular heritage and absorbed the cultural practices of the national and European vanguards in favor of very personal hybrid creations. Perhaps no one had a better understanding of her

status as a plastic artist than the painter Eduardo Martínez Bonati. The following statement was made one year after Parra's death:

> I think that Violeta Parra is definitely a modern artist. She is an artist who has been able to understand the rediscovery of fundamental realities in which we live and which do not allow us to know or to enjoy what surrounds us. Violeta Parra is, I think, one fundamental challenge to your and our capacities to rediscover the truth in the objects that surround us, in myths, in the elements of our culture ... Violeta Parra is the only person who has been able to make a new Arturo Prat, the only one who can paint a new crucifixion, the only one that gives us a world of ideas where the myths, magic, the reencounter with human beings are raised, and not, as it has been said, in a folkloric manner – and this refers exclusively to the part that I know, the plastic work, as I cannot think of her knitting as popular knitting. I think that the material that has been used is the transmutation of material in order to use the expressive form of the language that the material possesses. I do not see wool in her tapestries as I do not see oil – oil pigments – in her paintings. I see the complete world that Violeta delivers ... I cannot see her as a popular artist, I see her as an artist, as a great creator, with a language totally defined (Violeta Parra Foundation, 1968).

The *Arpilleras'* Reception

Violeta Parra presented her plastic work twice at the emblematic visual arts fair in Forestal Park, Santiago, in 1959 and in 1960, at which she played the guitar and sang. According to her daughter, Isabel Parra, her work was not understood at these two exhibitions, or the performance character that the exhibition involved. "She was selected to represent Chile in the São Paulo Biennial, but harsh criticism officially prevented her trip to Brazil," Isabel recalled. "Violeta was very discriminated against in Chile, and her work was formally ignored until 1992, when a retrospective of her work was sponsored for the first time with a sample of thirty-three paintings and *arpilleras*" (Verdugo, 2003, pages 24–7).

The rejection that Violeta's art suffered in Chile from 1950 to 1960 is partly attributed to social and political discrimination. Applying the terminology and tools of Pierre Bourdieux (1989), it could be said that existing educational and socialization models were still soaked in schemes of civilization and barbarism. They provided people with instruments for judgment (taste), which were rigid and established a cultural capital with much exclusion, reinforcing social and intellectual division. The legacy of nineteenth-century national discourse and its civilizing practices still weighed in on the official language that was proposed as being legitimate. The form that was raised by Violeta Parra was controversial. In the words of Michel Foucault (1998, pages 100–1), the discourse of power can be both an effect of the same instrument, but also an obstacle, a resistance, and a starting point for an opposite strategy of unlimited possibilities, as demonstrated by Violeta Parra.

Parra was better received in Europe. The Paris show in 1964 was followed by exhibitions in Switzerland, Cuba, and again at the Louvre. Later exhibitions in Madrid, Naples, Stockholm, The Hague, several Argentinean cities, and Washington, DC, completed a productive artistic itinerary. French acceptance could be illustrated by the changes in Europe in its aesthetic perception. European intelligence was released from the bondage of the nineteenth-century neo-classicism and opened up to extra-European cultural discourses, a phenomenon which would allow us to understand Pablo Picasso's and Constantin Brâncuşi Africanism (Leighten, 1990; Golding, 1994, pages 185–200). It is not surprising that Miguel Ángel Asturias' indigenism project flourished[13] during productive

[13] When Asturias studied at the Sorbonne in Paris, he learned more systematically about Guatemala, indigenous groups and himself, something that was reflected in his first book *Legends of Guatemala*. At the Sorbonne, he discovered the Mayan religion with Professor Georges Raynaud and began to speak as a surrealist author with the influence of the French poet and theorist Andre Breton. See Henighan (1999).

sojourns in France, and Alejo Carpentier's concept of magic realism matured as well in Paris (Monegal, 1971).

Conditions for a more fair reception of Violeta Parra's visual work in Chile arose when democracy returned in 1991. Chile's post-dictatorship era gradually entered the circuit of economic and cultural globalization. With the polarity of "capitalism versus communism" having been liquidated after the fall of the regimes of Eastern Europe, and with access to a more post-modern consciousness, some of the traditional binary oppositions were somewhat canceled in the country's collective mind (Eisner and Eisner, 1996). With a neoliberal utopia established in Chile (Vergara Estévez, 2005), economic differences during Pinochet's regime had deepened, and did not disappear during democracy. But democracy itself made it possible to confront exclusionary policies inherent in neoliberal practices, strengthen human rights awareness, and rescue the ones neglected by the previous regime (Angell, 2007).

The *Arpilleras*

At first glance, Violeta Parra's *arpilleras* propose a chromatic convergence and compositional solution, inspired by daily peasant life, personally inspired textures, and a disconcerting approach to the space and emptiness in which the protagonists float and levitate. Most of the figures are accusing, looking at the viewer with placid, sometimes helpless, eyes. The wool and interlacing yarns are complex and rich, with threads of different colors that are juxtaposed with the central motif without losing the motif's fundamental importance. The birds are busy with their own lives, playing, flapping, or observing with kind eyes. Human bodies are formed of pure lines, key patterns and symbols; all of them components that Parra had rescued from Chilean native tradition. Succinct and bald figures dominate the scene. They evoke the totemic sculptures of the Mapuche arbor rituals which Parra knew well.[14]

FIGURE 18.3 A female arbor totemic sculpture.

The influence of the European vanguard also infuses its legacy into Parra's *arpilleras*. Do her hallucinating, seemingly levitating figures not look related to their counterparts painted by Marc Chagall? According to Isabel Parra, Chagall, along with Joao Miró, was Violeta's favorite painter (Cruz Amenábar, 2007, page 31). This analogy has rarely been insinuated, but is promising nonetheless. Marc Chagall also created an artistic universe of his own, shaped by his childhood in a very rural Russian village, Yiddish folklore tales and stories of the

[14] The totemic arboreal sculptures were installed by the Mapuche people on their graves differentiating between male and female totems. In the 1950s, this custom was in decline and often, the totems were coupled with a Christian cross on the tombs denoting some syncretism. See Fernández Muñoz (2009).

Bible's Old Testament. The religious and rural dimensions marked his plastic production and when already installed in Paris, he took advantage of contemporary techniques and ideas which he always adapted to his purpose. Surrealism undoubtedly permeated much of his work, but Chagall never lost his singularity (Metzger, 2012). The parallels between Parra's and Chagall's lives are evident and might partially explain her fascination with him. She probably encountered Chagall's work during her first Parisian sojourn. *The Violinist* that Violeta Parra designed in papier mâché might have been homage to her father who played the violin. The work also recalls the many violinists painted by Chagall.

In the following, fourteen *arpilleras* will be revisited in an attempt to solidify the thesis of the aesthetic fusionism that permeates this body of work and to explore the modernity that concerns them.

FIGURE 18.4 *Thiago of Mello* (1960). Dyed jute embroidered with wool (165 cm × 130 cm). Violeta Parra Foundation.

In the forefront of Figure 18.4, to the left, the figure in red is Amadeu Thiago de Mello,[15] erupting as a guitarist and singer. De Mello is an iconic Brazilian poet who, after being detained during the Brazilian military coup of 1964, went into exile in Chile. Here he met Pablo Neruda and Violeta Parra, but he also traveled through Argentina, France, Germany, and Portugal until the end of the military regime. His function as the people's poet in the tradition of the minstrel is instituted here with the use of the red of socialism or the labor movement and the black of anarchism. The guitar, as an organic and malleable component, is an intrinsic part of the poet's body. Its "acoustic hollow" is a face that lives and sings, becoming one with the singer. The *queltehue* (southern lapwing) that flies like the voice of the singer is an extension of him and discloses his communion with the earth. The *queltehue* appears in other compositions by Parra and could suggest a few subtleties. There is no doubt that the *queltehue* has been a very common bird in Chilean rural areas, and that Violeta Parra would have grown up with it. One of the characteristics of this bird is its astounding auditory system that allows it to register any noise, danger, and caution as would be expected from the people's poet. The microcosm on the lower left, like a domestic bestiary, includes a smiling eavesdropper that enjoys listening and unites with loving animals (two ducks and a cat) in a nuclear composition that includes a zoomorphic pitcher, suggesting that life and matter are perfectly overlapped.

[15] De Mello belongs to an artistic family. He was born in Barreirinha, Brazil, in the heart of the Amazon in 1926. He has published more than twenty poetry books. His poem "The Man's Statutes" was published in more than thirty countries. He has translated the poems of César Vallejo, Pablo Neruda, Ernesto Cardenal, and Eliseo Diego into Portuguese. See Brotherston and Sá (1997).

In *Against the War* a woman appears with exceptional hair.[16] The four human figures are precariously defined, and their left arms are extended in the shape of peace doves. The first figure in blue reveals anger, and the rifle that follows is crowned by a small dove falling from the effect of violence (the altered peace). The woman who is colored in green is associated with nature and renaissance. Her smile is placid and far removed from wars. The third figure smiles, growing a menorah. The last of the four figures is Violeta Parra who was known for painting herself in her eponymous color; she has an equanimous expression, and from her head springs a Trinitarian vignette. The symbols of Jewish and Christian faith are postulated as celebrative elements of peace. Two anthropomorphic jars frame the scene split into two halves by a vertical radiance holding a balloon, like a divided world in whose interior the colors and the star of the Chilean flag are dislocated. Pennants are hung from a rope at the top, recalling celebratory practices such as coming together for Independence Day, an occasion when Chileans should be united. The minimalism of the four human figures is offset with their vibrant colors and a texture based on geometric patterns. The composition is celebratory like a feast in honor of accordance. The warm solar color of the background evokes a glimmer of hope. Violeta Parra commented "it so happens that in my country, there is always political disorder, and I don't like that ..." She added "in this *arpillera*, all the characters who love peace are present. I am the first, in violet, because it is the color of my name" (Brumagne, 1964). The problems of war were also addressed by Violeta Parra in her song "*Los pueblos americanos*" ("The Latin American peoples"). Her yearning for peace was materialized in a Bolivarian utopia.[17]

Nicanor Parra, with his humorous spirit, devised the name *The Bald Female Singer*, alluding to the baldness of the singer, although all the figures are bald.[18] The title is taken from the homonymous work by Eugène Ionesco.[19] The introduction of a drama by Ionesco that raised absurdity to its maximum dimensions is merely playful and has nothing to do with this *arpillera*'s content. This *arpillera* in itself represents a fiesta at Violeta's home. She is singing, her daughter Isabel is playing the harp, and they are observed by Tita, Violeta's granddaughter, on the right. Family harmony is sustained by the love of music in which even the pets take part. At first, this *arpillera* might look like a decorative piece but meticulous examination reveals a more centrifugal composition. The geometrism of the human figure's texture, of the dog, and of the harp is tangled and asymmetric. The zoomorphic pitchers at the top are individualized, each one constituting a small autonomous universe. In certain ways, these figures render homage to the zoomorphic ceramics of Chilean folk tradition (Dannemann, 1975; Montecinos, 1985; Rebolledo, 1994), but the ones here are alive and partaking in the cheeriness. Importantly, the figure of Tita, the granddaughter, has been embroidered with anomalous geometric stripes and a combination of white and a very pale ocher, alluding to her childhood and innocence.

In *Man With Guitar*, Violeta Parra embroidered a singer and guitarist of the Chilean tradition *par excellence*.[20] He could be her father, her son, a brother, or a lover. The representation is emblematic and fantastical. The body of the singer is designed with a semi-cubist fragmentation while the voice of the

[16] See *Against the War*, jute embroidered with wool at www.fotolog.com/asintomatico/40493103/ .

[17] The last couplet of the song says: "By a handful of earth I do not want war." From the record "La Carpa de la Reina" (Santiago: LP Odeon, 1966).

[18] See *The Bald Female Singer* (1960), jute embroidered with wool (138 cm × 173 cm) at www.violetaparra.cl/sitio/arpilleras.

[19] Eugène Ionesco (1909–94) was a Romanian playwright and writer who developed his career in France. A founder of the theater of the absurd, his first innovative bizarre play "The Bald Singer" brought him a fame that never abandoned him. See Gaensbauer (1996).

[20] See *Man With Guitar* (1960), jute embroidery with wool (134 cm × 89 cm) at www.violetaparra.cl/sitio/arpilleras.

man extends to the alert, perceptive *queltehue*. The hen, as a protective symbol, shares the same body with another bird that accompanies the man by assuming the position of the guitar. The geometric design persists in the surreal figure of the man who according to Parra "is in green because green is hope; its soul is music; but it escapes incessantly like the bird." Nevertheless, for the arabesque guitar, a delicate pink tone has been used which turns violet at the guitar handle. One of the performer's arms is completely white, documenting purity and strength. It is the left arm that changes the guitar's position, generating different tonalities and chords, the musical essence overall. The birds seem to embody the sound of music.

The Circus recreates Violeta Parra singing and playing guitar at the age of eleven in a circus.[21] Here, her figure is embroidered in a light green and not in the usual violet to express, in her words, that "she was happy singing." She articulates her own contemporariness with the echoes of her personal life during those years of poverty when she and her siblings were performing in her stepsister's circus (Anon., 1973). This is perhaps one of the most modern *arpilleras* by Violeta Parra where she generated an almost supernatural unreal universe with eccentric figures like a levitating baby, a clown juggling with an anthropomorphic ball, the traditional *queltehue* that expands the music, and a snail that floats like an ancestral symbol of protection, fertility, life, and feminine energy. Like other examples of her visual work, her memoirs and fantasies overlap here in an astonishing design. On the other hand, very luminous colors are used in which the fundamental factor is the intense contrast between primary and analog tones. From the point of view of the composition, this work is a superposition of planes that enables different representations to appear simultaneously. The colored violet woman is absentminded and drinks coffee or tea, giving back to the spectacle. Her right hand erratically supports a cup that seems to float. A delicate ballerina's leg hangs from the top portion agglutinating all of the exquisiteness of the dance. The geometric design that materializes consists of thin arabesques that embody dance as movement. The woman in violet may be Violeta Parra, recalling those years of sorrow, happiness, and hope at her stepsister's circus.

Man With a Flowery Hat belongs to the genre of countrified poetics.[22] The high Andean plateau man – indicated by the figure of the llama that follows him – is doubtlessly a peasant. His face in profile is fragmented with lines originating in the center of the eye. Parra uses a dense texture for the *corralero poncho* that covers the torso; a similar parceled design as in the head is used for the pants and boots with concentric fans. On the other hand, the sleeve is fragmented by a thick green line, and the arm culminates in a delicate gesture of the hand that holds a flower. From the hat, a whole delicate garden is born, transforming the figure and telling us more about his essence: the pleasing smile of a man who lives in conformity with nature and prevails, a fact proven by the trusting llama. From a chromatic point of view, the weaving is rather moderate compared to other *arpilleras*, predominated by colors of the earth and vegetation.

With bodies decomposed into geometric facets and strong tones that contrast with soft tones, *The Cueca* pays tribute to the *cueca*, the national dance of Chile.[23] Parra devoted a great part of her life to the compilation of this dance, its interpretation and diffusion (Parra, 1958). The tapestry's design is structured by a dynamic and balanced duality in its

[21] See *The Circus* (1961), artificial fabric embroidered with wool (122 cm × 211 cm) at www.violetaparra.cl/sitio/arpilleras.

[22] See *Man with a Flowery Hat* (1962), dyed jute embroidered with wool (127 cm × 85 cm) at www.violetaparra.cl/sitio/arpilleras.

[23] See *The Cueca* (1962), linen and embroidery in wool (119.5 cm × 94.5 cm) at www.violetaparra.cl/sitio/arpilleras.

harmony of curved lines. The woman and man celebrate the unity of dance in their lives.

Tree of Life was embroidered by Parra in 1963, that is to say during her last visit in Europe.[24] She probably never contemplated the oil painting of the same name, *The Tree of Life* (1948) by Mark Chagall which has been in a private collection. Nevertheless, they both share the motif of the tree of life. In Chagall's case, the figure of a fiancée and a tree represent the desire to create life, with a muse being the roots of a vital future. Violeta Parra's *arpillera* shows multiple routes towards the truth. The branches culminate in irises, symbols of eternal life, purity, and the celestial (Amón Feliz, 1996, page 24). The little bird to the left rests on a snake to demonstrate the victory of good over evil. To the right, the body in violet – perhaps Violeta Parra – stretches across the ground as if she wanted to be the root and soil of the tree, denoting humbleness and how arduous the ascent towards the truth is. Parra has reduced the traditional cabalistic complexity in her vision of the tree of life's conception. In fact, in the Old Testament, there is a description of the tree of knowledge (the creation of Satan) and of the tree of life (the original reality of God). The latter one can be read like a map of the human psyche and as a creational duty, both in the visible spectrum and behind the secret universal façade. By contrast, Parra conceived her tree of life as an ethical invocation.

A sense of humor much like that of Nicanor Parra is probably what came up with the name for the *arpillera* called *Christ in a Bikini*.[25] To call the *perizonium* or "purity cloth" of Jesus a bikini was perhaps a way of making him more human than God. The devotion of Violeta Parra towards Jesus and even more towards the crucified Jesus was a par-

ticular way of internalizing Christ and the popular Catholicism of the rural kind. Parra was interested in the sacrificial dimension of Jesus and his entire capacity of delivering love and ideals to his people. The imbricate embroidery of Jesus' body in this *arpillera* also includes a much-emphasized heart to indicate Jesus' love towards humanity. It is not exactly a representation of the "sacred heart" of Catholic iconography, although that one and the heart of this tapestry have the common function of unbuttoning the infinity of the love of Christ. Another distinctive element is the unfastened arm in the vein of the legendary Cristo de la Vega,[26] according to a Toledo legend. In this legend, the crucified Cristo de la Vega would have unfastened his right arm to attest and to repair an injustice. Violeta Parra transformed her *Christus dolens* into one who, beyond his suffering, has his right hand free for the world. On the right arm of the cross, a dove – the holy spirit – carries the symbol of peace. The sacrificial exaltation was demonstrated by Parra in other artistic expressions, such as in "Verse for suffering" in the second part of "Wake for a dead child" included in her Decime (Parra, 1958, 1998).

Violeta Parra was always a socialist. She rejected the riches, the army, and the Church because of the social and economic inequalities in Chile. In the tapestry *The Conquerors*, the conquerors represented by Parra are not only the Spaniards arriving in Chile in the sixteenth century, but also soldier, landowner, and priest prototypes.[27] While Parra depicts the torment of the Mapuche *cacique* Galvarino by the conquerors who cut off his hands as a warn-

[24] See *Tree of Life* (1963), jute dyed and embroidered with wool (135 cm × 97.5 cm) at www.violetaparra.cl/sitio/arpilleras.

[25] See *Christ in a Bikini* (1964) Cotton dyed and embroidered with wool (161.5 cm × 125 cm) at www.violetaparra.cl/sitio/arpilleras.

[26] The "Cristo de la Vega" is a popular Toledo legend turned literary piece by José Zorrilla under the title "For a Good Judge, The Best Witness", which was included in his volume of poems in 1838. The legend refers to a Jesus figure in the ancient Basilica of Santa Leocadia. See Magán García (2008, chapter 16).

[27] See *The Conquerors* (1964), jute dyed and embroidered with wool (142 cm × 196 cm) at www.violetaparra.cl/sitio/arpilleras.

ing, this episode goes beyond historical truth. The act, recounted by the Spanish poet Alonso de Ercilla (Ercilla y Zúñiga, 1946) in his poem "La Araucana," Canto XXXIV, was perpetuated in the form of continued usurpation of indigenous property in the history of Chile. In her song "Arauco has Sorrow," Parra accused the Chileans of continuously depriving the Mapuches of their goods, much like the Spanish conquistadors did, and commemorates the former *caciques* in a representative stanza.[28] The flamboyant texture of the sky could be interpreted as the wrath of Chau, the highest deity in the Mapuche beliefs who had the ability to express his anger by sending rays of fire.

During the War of the Pacific,[29] an armed conflict that occurred between 1879 and 1883 in which the Republic of Chile faced off against the Republics of Bolivia and of Perú, commander Arturo Prat (Sater, 2005) led the small corvette *La Esmeralda*. According to Violeta Parra's friends, Arturo Prat was her most admired national hero, since he preferred to sacrifice his life before giving up. Parra produced two *arpilleras* of this unequal battle. In both scenes, the climax is the jump of Arturo Prat onto the enemy ship that took him to his death (1879). In the *arpillera Naval Combat*, Prat is already on the enemy ship's bow holding the Chilean flag with three sailors that followed him.[30] Parra likens this act of sacrifice to the blood sacrifice of Jesus and that of

Che Guevara (the latter one briefly alluded to in her song "The Albertío"[31]), firmly establishing Prat as her national hero. The sailors of the enemy ship reveal both efficiency and indifference. The faces of *La Esmeralda*'s crew are phantasmagoric; the sinking corvette is represented like a living, organic element that convulses and agonizes, with a large mask that culminates in one of Parra's typical birds.

In *Naval Combat II*, Parra shows Arturo Prat being accompanied by Sergeant Aldea[32] in his sacrificial act.[33] In the middle of all this tragedy, the sinking *La Esmeralda* is represented here using a concise and abstract approach. Its crew is depicted in an almost expressionistic manner and shows some disparity more closely related to a baroque composition. As in the first naval battle, the sea appears swirling and stormy, reflecting the ups and downs of Pratt's sacrifice.

[28] "Where did Lautaro go to / lost in the blue sky? / And the soul of Galvarino, / did the South wind take it? / Therefore the leathers of his cultrun / pass by crying / Stand up, Calful!" In *"Canciones Reencontradas en París"* ("Songs Rediscovered in Paris"), a posthumous record with original songs by Violeta Parra released in 1971 under the record label "La peña de los Parras" and distributed by DICAP. The record included previously unreleased songs recorded by Parra between 1961 and 1963.

[29] The War of the Pacific, also referred to as "the War of Guano Manure or Saltpeter," was an armed conflict between 1879 and 1883 in which the Republic of Chile fought against the Republics of Bolivia and of Perú for control of the exportation of minerals. See Donoso and Serrano (2011).

[30] See *Naval Combat* (1964), jute dyed and embroidered with wool (134.5 cm × 179 cm) at www.violetaparra.cl/sitio/arpilleras.

[31] "By stepping through the stones / have caution with the bunions / that no one has been born here / with a star on the forehead." This song is a criticism to Violeta's last lover's conceits by the Uruguayan Eduardo Zapicán, musician and activist in favor of the rights of Uruguayan natives who accompanied and helped her in her final years in the tent of La Reina as a musician, carpenter, and companion. By mentioning the song's lyric "that nobody has been born here with a star on his forehead." Parra recounts the star on Che Guevara's beret. Included in the record "Las últimas Composiciones de Violeta Parra" (RCA Victor, Chile, 1966).

[32] Juan de Dios Aldea Fonseca was born in Chillán in 1853, as a son of the teacher and principal José Manuel Aldea and Úrsula Fonseca. Early in life, he had an interest in military life and service to the homeland. When the War of the Pacific was declared in April of 1879, he was transferred to the corvette *La Esmeralda* with the rank of sergeant. His sacrifice and loyalty did not go unnoticed by historians and poets. The poet Rubén Dario in his epic poem "To the Glories of Chile" dedicated verses extolling his bravery and loyalty. See Bravo Valdivieso (2007).

[33] See *Naval Combat II* (1964), dyed jute embroidered with wool (132 cm × 220 cm) at www.violetaparra.cl/sitio/arpilleras.

Violeta Parra embroidered a poster for an exhibition of visual arts in April and May of 1964 at the Marsan Pavilion of the Museum of the Louvre.[34] This exhibition was exemplary since, for the first time, a Latin American artist was being exhibited, and even more so, a woman. Parra has chosen an eye as the central motif of the poster. Dispersed and remarkable eyes abound in her visual work, although more frequently in her oil paintings. The eye in this poster has a rather appellant and functional character.

In *Fresia and Caupolicán* Parra re-edited the legendary episode of Caupolican and his wife Fresia, immortalized in "La Araucana" by Alonso de Ercilla.[35] Caupolicán was one of the sixteen great Mapuche chieftains who heroically resisted Spanish domination but was captured and executed in 1558 through the torment of impalement. According to Ercilla, Fresia, ashamed of the fact that the chieftain had been captured, would have thrown their son to him on the eve of the execution. The composition of Parra is concentric with the three main characters of the unfortunate family, framed in the center by two Spanish soldiers and two weeping willows. Caupolicán is represented in blue, symbolizing positive energy in the beliefs of the Mapuches. Fresia's baby is not thrown to Caupolicán. It is possible that this idea was repugnant to Parra, so she decided to present Fresia advocating for her partner. On the far left, a group of Spanish soldiers enjoy the execution. On the right, a powerless cross embodies its own uselessness. Willows were not sacred trees in Mapuche beliefs but their presence here connects with the universal poetic tradition of the willow tree as a symbol of sadness, nostalgia, and crying.

The *Arpilleras* as a Legacy

There has been much debate about the impact of Violeta Parra's *arpilleras* in the latter movement of *arpilleristas* that began under Chile's dictatorship in September 1973. At first glance, the work of Violeta Parra in the field of tapestry was a genuinely individual initiative. In terms of precedents with respect to her creations, there is no doubt that, within domestic handicraft, there have always been women who gave life to textiles with pieces of colored fabrics or wool. These traditions were common in Chile and Perú and tended to reproduce the rural and the domestic environment. Apparently, Violet Parra's *arpilleras* accounted for more than a personal act. They were a decision towards an aesthetic and political horizon that changed the cultural scenery in terms of female handicraft.

There are indications that the first collective workshops of *arpilleristas* with the technique of embroidery took place under municipal auspices in Isla Negra[36] and with the support of the Sobrino family that temporarily lived there around 1934 (Jiménez, 2010; Larrea, 1994). This workshop was successful and had its first major exhibition in the Museum of Fine Arts in Santiago, Chile in 1966, displaying eighty pieces. Pablo Neruda, for his part, was also inclined to these tasks, being an ambassador to France, and promoted the work in Europe and the USA. These *arpilleras* demonstrated technical quality, originality, and expressiveness in their designs, a product of the efforts of women without formal artistic education, most of them homemakers. The designs were rather countrified and contemplative.

[34] See *Poster* (1964), dyed jute embroidered with wool (98 cm × 66.5 cm) at www.violetaparra.cl/sitio/arpilleras.

[35] See *Fresia and Caupolicán* (1964–5), dyed jute embroidered with wool (142 cm × 196 cm) at www.violetaparra.cl/sitio/arpilleras.

[36] Isla Negra is a locality situated in the central coast of Chile in the Province of San Antonio. The locality, in spite of not being properly an island, was baptized with this name by the Chilean poet Pablo Neruda, on having seen a black rock in the sea, close to his house located opposite to the ocean. This house known as House of Isla Negra, is at present a mausoleum administered by the Foundation Neruda, where the remains of the poet lie along with those of its wife Matilde. See Larrea (1994).

During the military regime, however, a new movement of *arpilleristas* erupted onto the political scene. With support from and under supervision of the Committee for Peace in Chile, and later, the Vicariate of Solidarity, the first workshops of *arpilleras* arose in Santiago in response to the breakdown of the country's human rights (Gutiérrez, 1986). The shock of these years has been the impulse for many women to approach these centers looking for shelter after the imprisonment and disappearances of their relatives. They offered a refuge where they could share their joint experiences with other women. Early experiences were embodied in the tapestries with the scraps of fabric they received. They were afforded a productive work environment which brought money for their families and a means toward emotional and economic survival. The *arpilleras* became the medium in which they could narrate the dramatic events as they perceived them. The work of Marjorie Agosín (1987) has edifyingly analyzed the emergence and development of the *arpillerista* movement during the dictatorship. These artifacts were circulated semi-clandestinely in Chile and were promoted by European churches outside the country who sold them to benefit the Chilean families of the detained and missing. Undoubtedly, it was the Cardinal Raúl Silva Henríquez (Aguilar, 2003), ideologically closer to the spirit of the Second Vatican Council, who promoted the organization of women around the *arpilleras* with protection from the country's parishes.

From a merely technical point of view, there is a difference between Violeta Parra's *arpilleras* and the work of the *arpilleristas* under the dictatorship. Parra privileged the embroidery to materialize her stories. The *arpillerista's* workshops, under the patronage of the Vicariate of Solidarity (Gutiérrez, 1986), used *appliqué* technology to reconstruct their testimonials which opened up major possibilities and the freedom to work, as well as being able to work faster, since, given the precarious situation, saving time was essential. The *arpilleristas* resorted to scraps of sewn cloth that started as rags

of old clothes and transformed them into colorful and provocative testimonials.

The testimonial and denouncing stimulus of these *arpilleras* would have been influenced by Parra's tapestries and their invoking and critical character. Let us recall Parra's *arpilleras* on historical motifs, like the two on the naval combat of Iquique, *Against the War*, and the two with motifs about conquest depicted using the torture of Galvarino and Caupolicán. In each of these cases, glorious victims and the denunciation of violence are referenced. It can be assumed that it was Violeta Parra's entire body of work that inspired the humble *arpilleristas* of the Vicariate of Solidarity to identify their hard life with Violeta's life. In summary, all of the tapestries mentioned here touched on the problems of violence and scorn in the human condition, which were a few of the essential topics in Parra's *arpilleras*.

In general, the legacy of Violeta Parra's *arpilleras* has expanded in an artistic level as well as in a political one and the study of them recently has begun. Counted among some of the inspiring works is the above-mentioned master's thesis by Alejandro Escobar Muna (2012). Also, Lorna Dillon is working on a doctoral research on the hybridism of Violeta Parra's oil paintings, embroideries and papier mâché sculptures at King's College, London (Dillon, 2009, 2011). The Violeta Parra Foundation in Santiago Chile is making a solid effort in keeping alive Violeta Parra's legacy and has sponsored the book, *Violeta Parra: Obral visual* that includes a helpful CD with interviews of Isabel Parra about her mother's visual art methods (Agüero, 2007).

On the other hand, the *arpilleristas* movement linked to the Vicariate of the Solidarity entered a period of decline as soon as the political circumstances that had once sustained it changed. It is not that these women did not have reasons to continue protesting under democracy since the judicial system still has not responded to all demands about their missing relatives. When the Vicariate of the Solidarity ceased functioning on December 31, 1992, its work was assumed by the Vicariate of Social Pastoral

that established other communal priorities. Without institutional support, the *arpilleristas* workshops decreased dramatically in Chile. On the other hand, international solidarity began to support other countries in crises at the end of the 1980s, so that the sale and distribution of Chilean *arpilleras* abroad diminished until they stopped completely.

According to Marjorie Agosín, a human rights poet and researcher on the Chilean *arpilleristas* movement, very few workshops have survived in Chile. She has distributed and exhibited her private *arpillera* collection in several museums in the USA in order to keep alive the memory of terrible and difficult times. She has distributed the funds of the exhibitions to the few *arpillera* workshops that still survive in Chile.

Acknowledgments

Translation by Mauro Canepa. Photo credits: Figure 18.1: A sample of a *La Lira Popular* according to microfilms granted to me for my personal research by the National Library, Santiago, Chile in 1991. Figure 18.2: Carmen Barrios and Violeta Parra in Maipú in 1952, provided by Juan Pablo Yañez Barrios, owner and editor of the journal *Dedal de Oro*, Cajón del Maipo, Chile. Figure 18.3: a female arbor totemic sculpture taken by Douglas A. Smith Jr. at a Mapuche grave in Santiago, Chile. Figure 18.4: *Thiago of Mello* (1960), reproduced according to Law 20435/Art. 1 No. 8/D.O. 04/05/2010 Article 71B, Intellectual Property, Chile.

Bibliography

Adams Fernández, Carmen (2002) Instalaciones y nuevas formas expresivas en el arte chileno. *De arte. Revista de Historia del Arte* Number 1.

Agosín, Marjorie (1987) *Scraps of Life: Chilean arpilleras, Chilean women and the Pinochet dictatorship.* Translated by Cola Franzen. Trenton, NJ: Red Sea Press.

Agüero, Ignacio (2007) Violeta Parra, pintora chilena. Entrevista a Violeta Parra por Ignacio Agüero (CD). In *Violeta Parra Obra Visual.* Record label: Grabaciones Casa de Violeta en Calle Segovia.

Aguilar, Mario I. (2003) Cardinal Raull Silva Henriquez, the Catholic Church, and the Pinochet Regime. 1973–1980: Public Responses to a National Security State. *The Catholic Historical Review* Volume 89, Number 4, pages 712–31.

Amón Feliz, Carmen (1996) *El Lenguaje Oculto del Jardín: Jardín y metáfora.* Madrid: Editorial Complutense.

Angell, Alan (2007) *Democracy After Pinochet. Politics, Parties and Elections in Chile.* London: University of London.

Anon. La Parra madre y los otros Parra. In *Revista de los Domingos* Number 14 (Diario *El Mercurio*). Santiago.

Aravena Décar, Jorge (2004) Música popular y discurso académico: a propósito de la legitimación culta de las "Anticuecas" de Violeta Parra. *Revista Musical Chilena* Volume 58, Number 202.

Balmes, José (2012) *El Papel de la Pintura.* Santiago: Editorial Usach, Universidad de Chile.

Barraclough, Solon (1966) *Tenencia de la Tierra y Desarrollo Socioeconómico del Sector Agrícola.* Santiago: Comité Interamericano de Desarrollo Agrícola.

Barrios, Yánez and Pablo, Juan eds (2010) Doña Pita en San José de Maipo. *Revista Dedal de Oro* Number 53, VIII, San José de Maipo.

Bosch, Sarah (2008) *Violeta Parra.* Santiago: En Crítica y Artes Visuales en Chile.

Bourdieu, Pierre (1989) *Distinction.* London: Routledge & Kegan Paul.

Brandstätter, Ursula (2009) *Bildende Kunst und Musik im Dialog. Ästhetische, Zeichentheoretische und Wahrnehmungspsychologie.* Hamburg: Wissner.

Bravo Valdivieso, German (2007) *Prat y Aldea, Unidos en la Gloria.* Santiago: Editorial Feria Chilena del Libro.

Brons, Thomas (1972) *Die Antipoesie Parras. Versuch einer Deutung aus weltanschaulicher Sicht.* Göppingen: Alfred Kümmerle.

Brotherston, Gordon and Sá, Lucia (1997) Poetry, oppression and censorship in Latin America. *Banned Poetry* (Special Issue), Volume 26, Issue 5.

Brumagne, Madeleine (1964) *Entrevista a Violeta Parra Contenido en un Documental.* Ginebra.

Canepa, Gina (1987) *El Proyecto Cultural de Violeta Parra y Sus Relaciones con la Tradición Popular Chilena.* Berlin: Freie Universität Berlin.

Canepa, Gina (1989) La poesía popular de pliegos suel-tos y folletos del siglo XIX en Chile como periodismo popular. In *Anales del Instituto Iberoamericano de la Universidad de Gotemburgo* Number 1.

Cruz Amenábar, Isabel (2007) Violeta Parra artista visual. *Violeta Parra, Artista Visual*. Santiago: Editorial Ocho Libros.

Cruz de Amenábar, Isabel (1984) *Lo Mejor en la Historia de la Pintura y Escultura en Chile*. Editorial Antártica.

Dannemann, Manuel (1975) *Artesanía Chilena*. Santiago: Editora Nacional Gabriela Mistral.

Dillon, Lorna (2009) Defiant art: the feminist dialectic of Violet Parra's *arpilleras*. In Taylor, Claire, ed. *Identity, Nation, Discourse: Latin American Women Writers and Artists*. Newcastle upon Tyne: Cambridge Scholars Publishing.

Dillon, Lorna (2011) The representation of history and politics in Violeta Parra's visual art. In Prout, Ryan, ed. *Seeing in Spanish: From Don Quixote to Daddy Yankee – 22 essays on Hispanic visual cultures*. Newcastle upon Tyne: Cambridge Scholars Publishing.

Donoso, Carlos and Serrano, Gonzalo eds (2011) *Chile y la Guerra del Pacífico*. Santiago: Centro de Estudios Bicentenario.

Eisner, Freya and Eisner, Kurt (1996) *Zwischen Kapitalis-mus und Kommunismus*. Frankfurt: Suhrkamp Verlag.

Ercilla y Zúñiga, Alonso de (1946) *La Araucana*. Madrid: Editorial Aguilar.

Escobar Muna, Alejandro (2012) *Violeta Parra. Una aproximación a la creación interdisciplinaria*. Barcelona: Universidad de Barcelona.

Fernández Abara, Joaquín (2007) *El Ibañismo (1937–1952). Un Caso de Populismo en la Política Chilena*. Santiago: Instituto de Historia, Pontificia Universidad Católica de Chile.

Fernández Muñoz, Fulvio (2009) *Vida Habitada: Escultura Mapuche* (brochure). Concepción: Universidad de Concepción.

Figueroa, Maximiliano (2002) *Jorge Millas. El valor de pensar*. Santiago: Editorial Universidad Diego Portales.

Foucault, Michel (1998) *The History of Sexuality: The will to knowledge*. London: Penguin.

Gaensbauer, Deborah B. (1996) *Eugene Ionesco Revisited*. New York: Twayne Publishers.

Golding, John (1994) *Visions of the Modern*. Berkeley, CA: University of California Press.

Gutiérrez, Juan Ignacio (1986) *Chile: La vicaría de la soli-daridad*. Madrid: Alianza Editores.

Henighan, Stephen (1999) *Assuming the Light: The Parisian literary apprenticeship of Miguel Ángel Asturias*. London: Legenda.

Jiménez, Francisca (2010) Viaje al patrimonio. Las borda-doras de Isla Negra. *La Tercera*, September 28.

Larrea, Antonio (1994) *Isla Negra. Neruda*. Santiago: Editorial Pehuen.

La Tercera (2011) Eduardo Martínez Bonati, el regreso de una leyenda de la pintura chilena. *La Tercera* March 19, pages 90–1.

Leighten, Patricia (1990) The white peril and l'art nègre: Picasso, primitivism, and anticolonialism. In *Art Bulletin*, December, Volume 72, Issue 4, page 609.

Magán García, Juan Manuel (2008) *Leyendo Leyendas: Antología selecta de leyendas toledanas*. Toledo, OH: Everest.

Mann, Patricio (1977) *La Guitare Indocile*. Paris: Les Edi-tiones du Cerf.

Marín, Carlos (1969) El asalariado rural en Chile. *Revista Latinoamericana de Sociología*.

Mena, Rosario (2011) *Color Violeta: Obra visual de Vio-leta Parra*. Santiago: Publicación del Centro Cultural Palacio La Moneda.

Metzger, Reiner (2012) *Chagall*. Paris: Taschen.

Monegal, Emir Rodríguez (1971) Alejo Carpentier: lo real y lo maravilloso en El reino de este mundo. *Revista iberoamericana* Volume 1, pages 154–81.

Montecinos, Sonia (1985) *Quinchamalí: Reino de mujeres*. Santiago, Ediciones Cem.

Morales, Leonidas (2003) *Violeta Parra: La Última Canción. Conversación con Nicanor Parra sobre Violeta*. Santiago: Editorial Cuarto Propio.

Nomez, Nain (1988) *Pablo De Rokha: Una escritura en movimiento*. Santiago: Documentas Critica.

Oporto Valencia, Lucy (2008) *El Diablo en la Música. La muerte del amor en "El gavilán" de Violeta Parra*. Viña del Mar: Ediciones Altazor.

Orellana, Marcela (2005) *Pueblo, Poesía y Ciudad en Chile (1860–1976)*. Santiago: Editorial Universidad de Santiago.

Ossa, Nena (1986) *La Mujer Chilena en el Arte*. Santiago: Editorial Lord Cochrane.

Parra, Isabel (1985) *El Libro Mayor de Violeta Parra*. Madrid: Ediciones Michay.

Parra, Violeta (1958) La cueca presentada por Violeta Parra. In *El Folclore de Chile*, Volume III. *EMI Odeón Chilena*.

Parra, Violeta (1959) Velorios de angelitos. Santiago de Chile; In *Pomaire III, 1958–59* (field research report by the author). Santiago.

Parra, Violeta (1966) La Carpa de la Reina. *LP Odeon*.

Parra, Violeta (1966) Las últimas composiciones. *RCA Víctor*.

Parra, Violeta (1971) La peña de los Parras. *DICAP*.

Parra, Violeta (1998) *Décimas. Autobiografía en Verso*. Santiago: Editorial Sudamericana.

Peña Muñoz, Manuel (2001) *Los Cafés Literarios en Chile*. Santiago: RIL Editores.

Rama, Ángel (1984) *La Ciudad Letrada*. Hanover: Ediciones del Norte.

Rebolledo, L. (1994) Mujeres y artesanía: Pomaire. De aldea campesina a pueblo alfarero. In *Revista Latinoamericana de Estudios Urbanos Regionales*. Lima: ESAN.

Ríos M., Sylvia (2010) Alberto Pérez, breve semblanza biográfica. *En Pluma y Pince, Viernes* January 22.

Rodríguez Monegal, Emir (1971) Alejo Carpentier: lo real y lo maravilloso en El reino de este mundo. In *Revista Iberoamericana1*. Pittsburgh.

Rodríguez, Marco Aurelio (2007) Violeta Arpilleras: retazos de inocencia. *Diario Siete* September 15.

Sater, William F. (2005) *La Imagen Heroica en Chile. Arturo Prat, un santo secular*. Santiago: Centros de Estudios del Bicentenario.

Sotomayor, Enrique Solanich (1986) *Pintura Ingenua en Chile. El Patrimonio Plástico Chileno*. Santiago: Ministerio de Educación. Departamento de Extensión Cultural.

Subercaseaux, Bernardo and Londoño, Jaime (1983) De Chillán a Santiago. Gracias a la vida. Violeta Parra (Testimonio). *La Bicicleta*.

Verdugo, Waldemar (2003) Pasión de Violeta Parra. *Revista Norte Sur*, November.

Verdugo, Waldemar (2005) Pasión de Violeta Parra. Proyecto Patrimonio. Available at www.letras.s5.com/vp150905.htm (accessed October 2013).

Vergara Estévez, Jorge (2005) La utopía neoliberal y sus críticos. *Utopía y Praxis Latinoamericana. Revista Internacional de Filosofía Iberoamericana y Teoría Social* Number 31.

Violeta Parra Foundation (1968) Análisis de un genio popular hacen artistas y escritores. *Revista Educación* Number 13, pages 66–76. (Text transcribed from a tape-recorded during a round table that took place in Salón de Honor at the Catholic University during Violeta Parra Week.)

Violeta Parra Foundation (2007) El viaje de las obras. *El Arte Visual de Violeta Parra*. Santiago: Editorial Ocho Libros.

Quilted Discourse: Writing and Resistance in African Atlantic Narratives

HEATHER D. RUSSELL

The stuff of my being is ever changing, ever moving,
but never lost (Zora Neale Hurston, 1942).

for we are all children of Eshu
god of chance and the unpredictable
and we wear many changes
inside of our skin (Audre Lorde, 1978).

LITERAL AND SYMBOLIC QUILTS weave their way through the history of black women writers', artists', theorists', activists,' aesthetic imaginings. First invoked in a formal sense by Alice Walker's paradigm-shifting collection *In Search of Our Mothers' Gardens* (1983), Walker's *womanist* depiction of the quilt symbolizes the creative spark of black women kept alive under heavy duress, and bequeathed through slavery to freedom and beyond. As a newly emergent black woman writer during the early 1970s, Alice Walker sought, as many artists do, to identify artistic foremothers within and from whose aesthetic production she might identify, claim, and locate her own creative energies. In 1970, when Alice Walker published her first novel *The Third Life of Grange Copeland*, and Toni Morrison published her first novel *The Bluest Eye*, and Toni Cade Bambara edited the anthology, *The Black Woman*, all in the same year, there was a dearth of black women constituting the African American literary tradition.[1] "Tradition," writes Mary Helen Washington, "now

there's a word that nags the feminist critic … we have to recognize that the creation of the fiction of tradition is a matter of power, not justice, and that power has always been in the hands of men – mostly white but some black. Women are the disinherited" (Washington, 1990, page 32). *In Search of Our Mothers' Gardens* worked to unearth those "disinherited," silenced, and invisible black women artists and definitively construct a black woman's tradition that recouped not only Phillis Wheatley (1753–84) and Zora Neale Hurston (1891–1960), but which defined itself extraliterarily. A quilt, hanging in the Smithsonian Institute in Washington, DC portraying the crucifixion, and made by "an anonymous black woman in Alabama" in the 1870s, comes to represent for Alice Walker, the very canvas on which she and other black women writers/ artists might paint their black feminist subjectivity (Walker, 1983, page 239).

Central to Walker's project of recuperation is the necessity to claim a space for the valorization of *alternative modes* of creative expression such as quilting, blues singing, and gardening. "We have constantly looked high," she writes, "when we should have looked high – and low" (Walker, 1983, page 239). Her admonition reflects her commitment to leveling hierarchical structures (like canon-construction) which seek ethnocentrically to ascribe artistic value. Thus, she makes the case for redefining artistic endeavors like quilting to be read as a variety of "high art," or at least considered alongside "high art" as legitimate artistic and aesthetic

[1] The 1970s was a period of prolific production for black women writers. See Walker (1970), Morrison (1970), Cade Bambara (1970), and Hull *et al.* (1982).

expression. In fact, Walker traces her own artistic inspiriting influence to witnessing her mother's gardening, in touch with the divine, she was "involved in work her soul must have" (Walker, 1983, page 241). Such work is both salve and salvation, deftly militating against the enervating and brutal realities of poverty, race, and gender that have historically worked to stifle black women's creativity. As Walker poignantly recalls, "because of my [mother's] creativity with her flowers, even my memories of poverty are seen through a screen of blooms" (Walker, 1983, page 241). In a similar vein, black women's quilt-making is framed by Walker as similarly transformative and vested with "powerful imagination and deep spiritual feeling" that kept alive black women's "vibrant creative spirit" for contemporary black women artists and writers to inherit. Walker reclaims the unknown nineteenth-century black woman quilt-maker whose work now hangs in one of our nation's bastions of artistic excellence, as "one of our grandmothers – an artist who left her mark in the only materials she could afford" (Walker, 1983, page 239). In both cases, gardening and quilting are imbued with subversive power. These acts of creativity symbolize black women's refusal to be circumscribed, scripted, or narrated by those who would exploit and marginalize them on the bases of race and gender.

Even more fascinating, however, is the following description Walker gives of the Smithsonian quilt: "It is considered quite rare, beyond price. *Though it follows no known pattern of quilt-making,* and though it is obviously made of bits and pieces of worthless rags …" (Walker, 1983, page 239, my emphasis). The description Walker offers of the anonymous black woman quilt-maker artist, whose work "follows no known pattern of quilt-making," is actually germane to conclusions advanced about black aesthetic forms and patterning by Jacqueline Tobin and Raymond Dobard in their provocative (if controversial) history theorizing African American quilt-making, *Hidden in Plain View* (2000). In their chapter titled, "The Fabric of Heritage: Africa and

African American Quiltmaking," Tobin and Dobard suggest that an African American quilt is a "cultural hybrid" encoding multiple meanings and thus operating as a kind of "fabric griot," or storyteller (Tobin and Dobard, 2000, page 36). In other words, the quilt itself functions as an African *griot* or storyteller might, preserving and transmitting African American history and culture and narrating stories of black resistance and resilience. According to the authors, African American quilts typically reflect stitched together "geometric patterns, abstract improvised designs, strip-piecing, bold, singing colors and distinctive stitches" (Tobin and Dobard, 2000, page 36) for specific historical, philosophical and political purposes. Much of the symbolism in these quilts, they argue, reflect deeply held and long preserved African beliefs which survived the Middle Passage and were adapted in the new American landscape, under the rigidity and repressive strictures of enslavement that necessitated innovation and deft navigation, if one was to survive. Theorization of aesthetic production aside, Tobin and Dobard's principal contention, with regards to the so-called "Quilt Code," has been the subject of great contestation.

The Quilt Code concludes that enslaved Africans in the USA hid signs and symbols in quilts they made to guide potential fugitives with safe passage to freedom. This assertion gained popularity in the 1990s, and since then, the idea of the Quilt Code has been taught routinely in schools as empirically accurate. While Tobin and Dobard do in fact, in their introduction, suggest that their interpretation of the code "is based upon informed conjecture," they absolutely offer a theory in their narrative about how the Quilt Code "may have worked for slaves escaping on the Underground Railroad" (Tobin and Dobard, 2000, page 33). Most historians have critiqued this particular assertion, rejecting Tobin and Dobard's linkage of quilt-making to the Underground Railroad on the bases of insufficient evidence, the absence of any references to such practices in slave narratives (written and oral),

the fact that there are no surviving quilts with such symbols, and that the authors base their conclusions on oral histories that are simply unsubstantiable. In *National Geographic*, Dobard addresses the lack of concrete supporting evidence, highlighting the fragility of quilts: "Consider the nature of quilts. A quilt was to be used," Dobard said. "To expect a quilt that remained within the slave community to survive more than one hundred years is asking a lot" (Ives, 2004). Despite Dobard's expostulation and insistence on plausible truth, Leigh Fellner (2010) reveals that over time, "after scholars pointed out numerous discrepancies between the Code and documented Underground Railroad history, earlier supporters of the Code began distancing themselves from its claims." Tobin herself has since complained that "people have tried to push the book in directions that it was not meant for," and when Dobard was asked in 2009 where his book should appear on library shelves, he said "somewhere between fact and fiction" (Fellner, 2010).

In response to such blurring of disciplinary boundaries, according to Stacie Stukin (2007), "historians … are trying to set the record straight every chance they get. They present papers for publication and at conferences. They fill pages and pages of websites debunking what they believe to be a myth akin to George Washington chopping down the cherry tree." Even so, there remain numerous large presentations and smaller lectures taking place at local libraries, churches, and quilt guilds all over the country which perpetuate the Quilt Code idea. Stukin reveals that "the story has also ended up in lesson plans and textbooks (*TIME For Kids* even published an article about *Hidden in Plain View* in a middle school art book published by McGraw-Hill in 2005)." For many debunkers, the major infraction has to do with the emergence of an industry (quilts, books, dolls) mostly driven by white entrepreneurs who profit from romanticized mythification of the horrors of enslavement and the violations and risks involved in what Frederick Douglass called, "praying with your feet" (i.e. running away).

Harriet Tubman biographer Kate Clifford Larson agrees: "By dressing the story up all cute and pretty with quilt patterns and kindly folks who used them to guide runaways to freedom – then we don't have to talk about the realities of slavery, and of running away, etc. It seems to me to be part and parcel of the continued erasure of African American history – by creating mythical stories the truth is eventually lost" (Fellner, 2010).

And yet, in the realm of oral history, the allure of the subversive quilting concept continues to enchant. Fact or myth, people agree that the idea of a Quilt Code is compelling. Bonnie Browning of the American Quilter's Society in Paducah, Kentucky, said: "It makes a wonderful story" (Ives, 2004). According to Stukin (2007), "the story continues to be told in places like the Plymouth Historical Museum in Plymouth, Mich., where an exhibition entitled 'Quilts of the Underground Railroad' is up for the fifth year in a row. Over 6,000 school children have seen the exhibit, which presents the thesis of a quilt code." Recently, the issue garnered national attention when New York City planned to include a quilt element in a Central Park Memorial statue of anti-slavery activist Frederick Douglass; because of the Quilt Code controversy, however, historians asked the city to reconsider using quilts in the design (Stukin, 2007). But the education coordinator at the Plymouth Historical Museum, Anna Lopez, argues that she can "see no reason why the story of quilt codes cannot be fact. What I tell kids is, who writes history? Men do. Mostly white men. Then I ask, who made quilts? Women did, and a lot of black women made quilts and passed on their oral history. No one wrote down their history, so who knows?" Here, Lopez raises a salient point regarding the historical exclusion of women from history, and the attendant tendency to devalue oral history. As quilt historian Laurel Horton relevantly remarks, "It's not a matter of one group having the truth and the other not. It's a matter of two different sets of beliefs. It's made me realize that belief doesn't have a lot to do with factual representation. People feel in

their *gut* that it's true so no one can convince them in their *head* that it's otherwise" (Stukin 2007, my emphasis). As with Horton, I am not at this juncture, concerned with the history whose domain is "the head." I would rather leave questions related to the absolute authenticity of the Quilt Code to the purview of Underground Railroad and quilt historians, believers and non-believers alike.

But, what if we dispense with history for the moment, with the disciplinary expectations that necessitate an entrenched and opposing relationship between fact, (head) and myth (gut)? What if we actually view black women's quilt production as both imbued with a history of resistance and survival as exemplified in most African American aesthetic production *and* as metaphorizing that very struggle. In other words, might the quilt and its meaning be productively framed at the interstices of history and metaphor? Might we view the practice of African American quilting as a kind of metonymy for the ways in which black women negotiate power, difference, resistance, and art? Despite the questions surrounding the Quilt Code thesis, I do think we can safely conclude that African American women's quilts quite appropriately fall within the "fabric griot" frame theorized by Tobin and Dobard (2000). It is indeed the case that the aesthetic choices of black women quilt-makers do reflect a tendency to "follow no known pattern of quilt-making," and as such, reveal a great deal about how their work engages with forms of knowledge and power.

Irrespective of whether or not the actual pathway to freedom was "hidden in plain view" in quilts made by enslaved black women and their daughters and granddaughters, what does emerge from the study of surviving Africanisms in African American quilts is that the use of "abstract arrangement," which sometimes "seemed to glorify confusion" appears to be a consistent description of black women's quilt-making in general (Tobin and Dobard, 2000, page 48). In the 1993 issue of the *American Quilt Study Group* journal *Uncoverings*, Sandra German, founder of the *Women of Color Quilters Network* dis-

cusses co-founder Carolyn Mazloomi response to a quilt exhibit organized by collector Eli Leon in the following terms:

> I was on fire [says Mazloomi] to hear about the history – the rich history – of African American quilt-making … Instead, when we went to see the show at the museum, one of the first things I noticed was that the quilts in Eli Leon's collection *were very much unlike* my own, or those of the other women of AAQLA [African American Quilters of Los Angeles] … Then we viewed the faces of a group of white [quilters] … *It was as if they were asking whether all African American quilters produced only the seemingly haphazard, irregular and impromptu-style quilts portrayed in the show* (Fellner, 2010, my emphasis).

Although the so-called "experts" German describes seemed only interested in the few African American quilts that were more traditionally in keeping with Euro-American quilting styles, Mazloomi's admission and characterization of African American quilts as "seemingly haphazard, irregular and impromptu" in style and form is consistent with the Tobin and Dobard hypothesis. Drawing heavily on the research of noted art historian Robert Farris Thompson (1983), Tobin and Dobard intriguingly propose that the use of "fragmented patterns and the use of so many different fabric textures" in the quilts they studied, is derived from West African (primarily Mande) belief that "evil travels in straight lines" (Tobin and Dobard, 2000, pages 48–9). In his examination of "Round Houses and Rhythmized Textiles," Thompson identifies "the frequent, seemingly, imperative suspension of expected patterning" in, for example, "the West Indies patchwork dress," which "keeps the *jumbie*, the spirit away from a resting place." In another instance, in Haiti, a man procures "a special shirt" from "a ritual expert … made of strips of red, white, and blue to break up the power of the evil eye" (Thompson, 1983, page 221). As a consequence, quilt-makers would ostensibly "randomize the flow of paths" through their use of color, textile, and rhythm, in order to thwart the linear

movement of evil (Thompson, 1983, page 222).[2] In this way, black women's quilting practices share with other African American aesthetic forms like jazz, for example, whose structure is based on improvisation, breaks, and unpredictability, the use of collage, mosaic, asymmetry, and juxtaposition employed by visual artists like Aaron Douglas, Jacob Lawrence, and Romare Bearden, and even hip-hop culture whose features (music, graffiti, dance) are organized around a pattern of "flow, layering, and rupture."[3]

The same kinds of formal innovations, I would argue, are invariably found in black women's literary production. The illuminating possibilities of invoking the quilt as an aesthetic form which shares deep structural similarities with the shape and contours of narratives produced by African Atlantic (African American and Caribbean) women writers, is given fuller expression and explication by Carole Boyce Davies and Elaine Savory Fido in *Out of the Kumbla* (1990). In their paradigm-shifting work, Davies and Fido extend Walker's concept of the quilt as the sign of black women's creative spirit, to a metaphor, useful for theorizing "the quilted narrative, braided or woven" of African Atlantic women writers, which "alters the language and mode" of their literary production (Davies and Fido, 1990, page 6). Davies and Fido identify Sherley Anne Williams' *Dessa Rose* (1987) as an early notable example of such formal achievement, particularly in terms of "radical revision and redefinition" of black women's aesthetic production (Davies and Fido, 1990, page 6).

In *Dessa Rose*, Williams thematically treats the complex constructions of race, history, gender, and the imagination. Drawing on two historical incidents discovered in Herbert Aptheker's *American Negro Slave Revolts* (1947), a text she examines after having read Angela Davis' (1971) ground-breaking essay on black women's armed resistance to slavery, Williams invents a meeting between a pregnant enslaved black woman who actually helped lead an uprising in Kentucky, and a white woman in North Carolina who was giving sanctuary to fugitive enslaved blacks (Williams, 1987, page ix). Through creating a fictional interracial relationship between these two historical nineteenth-century women, Williams explores the challenges, limitations, and possibilities inherent in black and white women's differing histories, and, the ways in which through nuanced, informed, dialogic engagement, cross-racial alliances might be productively engendered in feminist movement. Additionally, *Dessa Rose* invokes and signifies on William Styron's controversial novel *The Confessions of Nat Turner* (1967), loosely inspired by Thomas Gray's (1831) *Confessions of Nat Turner*, itself a highly problematic document produced by Turner's pro-slavery amanuensis.[4]

In her "Author's Note," Williams writes the following, responding as she says, to the critically acclaimed Styron novel that "travestied the as-told-to-memoir of slave revolt leader Nat Turner:"

Afro-Americans, having survived by word of mouth – and made of that process a high art – remain at the mercy of literature and writing; often, these have betrayed us ... I now know that slavery neither elimi-

[2] Thompson traces the origins of such belief system to the Mande Atlantic world. He argues that "the double play of Mande influences, *individuality and self-protection* – suggested by the rhythmized, pattern-breaking textile modes, and the *group affiliation* mediated by communal rounds of cone-on-cylinder houses – completes a history of resistance to the closures of the Western technocratic way."

[3] See Rose (1994) for further discussion of the features of hip-hop involving "flow, layering, and rupture."

[4] William Styron published *The Confessions of Nat Turner* (1967), creating a great stir particularly with regards to his representation of Nat Turner as a conflicted coward, who was being partially motivated to lead the slave revolt because of his repressed, lustful unrequited desire for his white female teenage victim, Margaret Whitehead.

nated heroism nor love; it provided occasions for their expression. The Davis article marked a turning point in my efforts to understand that other history. This novel [*Dessa Rose*] *then is fiction*; all the characters ... while based on fact, are inventions. *And what is here is as true as if I myself had lived it* (Williams, 1987, my emphasis).

Here, Williams situates her novel within an alternative epistemological frame, in which fact and fiction exist in fluid, dynamic and elemental relationship to the production of meaning. Her revelation recalls Dobard's suggestion that *Hidden in Plain View* productively stands "somewhere between fact and fiction." Narrated in three sections, multi-perspectival, interspersing the vitality of African American vernacular tradition with the hegemony of white male written discourse, and skillfully subverting the latter, according to Deborah McDowell, *Dessa Rose*, "dramatizes not what was *done* to slave women, but what they *did* with what was done to them" (McDowell, 1989, page 146). Through employing a quilted structure of discourse, "a continuous thread of quotation marks woven throughout the text, calls attention to words as words, evoking uncertainty and ambiguity" and simultaneously working to militate against attempts to misname and misrepresent black subjects and their history (McDowell, 1989, page 148). The result is a narrative whose form, like that of the quilt, is a textual hybrid of African American history, cultural resonance and resilience.

According to Davies and Fido (1990), in Caribbean women's writing, "the linear phallocentric form of the male text is often rejected by Caribbean women writers," who like their African and African American female counterparts (such as Sherley Anne Williams) pose formal interventions that "[engage] in the process of radical re-vision and redefinition of what makes a work of art aesthetically female" (Davies and Fido, 1990, page 6). Reminiscent of Williams' fluid movement between fact and fiction, in the preface to her "autobiography" *Zami*:

A new spelling of my name (1982), Audre Lorde describes her narrative as being borne from a collage or mosaic of "dreams/myths/histories that give the book shape." To the authorial signatory she assigns the following: "A Biomythography by Audre Lorde." On the one hand, the term biomythography works to challenge the conventional linear phallocentric autobiographical form. In other words, if autobiography is conventionally believed to reflect the construction of a seemingly authentic, chronological, stable, representation of a narrating subject's life, building gradually and culminating climactically, then Lorde's titular choices self-consciously subvert traditional form, fluidly signaling her declaration of limitless dynamic creative possibilities codified by her own narrative experiment. On the other hand, as with the pattern and makeup of the quilt, myth and dream and history stand on equal footing in terms of their epistemological value. Caren Kaplan, referring specifically to *Zami*, describes "biomythography" as "an out-law genre" which "requires a recognition of layers of meanings, layers of histories, layers of readings and rereadings through webs of power charged codes" (Kaplan, 1992, page 130). Biomythography then, is itself a "cultural hybrid." As out-law genre, biomythography necessarily transcends conventional dictates of form and common reading practices. Akin to the unruly "seemingly haphazard, irregular and impromptu-style quilts," biomythography suggests that the rules of creative engagement are open-ended and unpredictable, and thus, readers are tasked with apprehending differently.

Throughout Lorde's narrative, "Audre's" cultural heritage is traced through the lineage and lessons of the Carriacou women from whom she descends, and becomes the central organizing motif weaving its way through the text and providing the means by which Lorde physically and symbolically locates the construction of Audre's lesbian subjectivity: "*How Carriacou women love each other is legend in Grenada, and so is their strength and their beauty*" (Lorde, 1982,

page 14, original italics).[5] "Zami," readers are told, is "A Carriacou name for women who work together as friends and lovers" (Lorde, 1982, page 255, original italics). Thus, the narrative embraces both its historical/geographic *and* mythic sites of origination. Contrasting the linear progression of conventional autobiographical form which chronologically charts the process of self-individuation, Audre's life story has multiple beginnings and sites of origin. Much like the "randomized flow of paths" found in black women's quilting, the narrative structure is framed via Lorde's experiences with various women who powerfully impact her life, and most significantly reflects her attempts to deftly navigate the racist and heterosexist social arrangement. Lest we forget, "evil travels in straight lines." The discourses of racism, sexism, and heterosexism are quintessentially linear, fixed, and trapped in binary terms. What Edward Said has described as the discourse of "*we* are this" and "*they* are that" (Said, 1979, page 237).

Carole Boyce Davies reminds us that "the definition of 'Zami' is a bold epigraph to the work … a word still identified negatively in the Caribbean" (Davies, 1990, page 63). But as Kaplan points out, most "out-law genres are located on the borders where colonial and neo-colonial subjectivity, cultural power and survival are played out" (Kaplan, 1992, page 134). Lorde's formal subversions simultaneously work to challenge and subvert heterosexism, Eurocentrism and phallocentrism while foregrounding her commitment to reshape the contours of black female discursive production through quilting together her life's stories. In a similar vein, in the preface to her prose-poetry collection *The Land of Look Behind* (1985), a text which also employs a quilted structure, Michelle Cliff reveals that her challenge writing from a "culture of colonialism,"

is a struggle to "get wholeness from fragmentation while working within fragmentation, producing work which may find its strength in its depiction of fragmentation, through form as well as content" (Cliff, 1985, page 15). Cliff's description of the ways in which fragmentation might be usefully deployed is germane to the concept of the quilt which itself is simultaneously unified and diverse. In fact, in *Out of the Kumbla*, Davies and Fido purposely revise the term "fragmented," replacing instead their own definition of Caribbean women's "quilted" use of form (Davies and Fido, 1990, page 6). Within this quilted structure of narrative, multiple stories and speakers co-exist, women are reinscribed in and central to African Atlantic history and the oral tradition of storytelling is integral to cross-generational survival. As Davies and Fido suggest, "the textual emplottment of history bridges the quilted/fragmented text and the storytelling text" (Davies and Fido, 1990, page 6). Again, the idea of the quilt/text as a kind of "fabric griot" powerfully emerges.

Perhaps this helps to account for the ways in which Michelle Cliff structures *No Telephone to Heaven* (1987), in which the fabric of the novel is organized around what I have described elsewhere as "a recursion to materiality."[6] Set in Jamaica, in the context of a nation swept up in post-independence disillusionment in "each unfolded narrative sequence the fabric of her text quilts together the historical, poetic, mythic, political, symbolic and *material* discourses that frame the colonial project and its aftermath" (Russell, 2009, page 89, my emphasis). After briefly introducing readers in the beginning of the novel to the (then unnamed) main

[5] In the following references to *Zami*, I am using "Audre" to distinguish between the narrator of the biomythographic work and the author Audre Lorde who wields control over the text's discursive arrangement.

[6] See Russell (2009, page 19). In *Legba's Crossing*, I argue that the "recursion to materiality" fosters the re-entry of *materiality*. The re-entry of materiality (in my own terms), specifically refers to the financial and economic implications of the colonial project in its various manifestations throughout the African New World, is crucial to theorizing African Atlantic subjectivity.

protagonist who is riding in a truck called "No Telephone to Heaven" on an undisclosed mission with other "comrades" bearing arms, the narrative movement shifts to the circumstances surrounding violent acts of bloodshed committed by another major character in the novel. Like a jazz riff, the repetition of the phrase "No Telephone to Heaven," throughout this chapter which bears the same name, becomes the structuring agent for the unfolding of the events that are ultimately revealed:

> The truck struggled on up through the Cockpits. Its side was painted with the motto – in large yellow and red letters outlined in silver metallic, almost faded to nothing by now – NO TELEPHONE TO HEAVEN … NO TELEPHONE TO HEAVEN. No voice to God. A waste to try. Cut off. No way of reaching out or up … The motto suited them. Their people. The place of their people's labor … They once had the belief. Especially the old people … The ones in the balmyard. But Jesus no balm … Begging Jesus. Jah. Moses. Shàngò. Yemanjà. Oshun. God no mus' be deaf … Depression. Downpression. Oppression. Recession. Intercession. Commission. Omission. Missionaries … Yes, mi dear bredda. NO TELEPHONE TO HEAVEN … We have been royally deceived. Who God like? Not we. NO TELEPHONE TO HEAVEN … They were tired of praying for those that persecuted them (Cliff, 1987, pages 15–18).

Marked by ruptures, breaks, and unexpected twists, Cliff's text skillfully unfolds the realities of classism, sexism, heterosexism, and racism that thwart the creation of a healthy, just, ethical nation-state, creating as it were, a text of resistant history that is itself a kind of out-law genre. Readers must work to unearth "the layers of meanings, layers of histories, layers of readings and rereadings through webs of power charged codes" that are quilted throughout the novel.

As a consequence, fragmentation, improvisation, fluidity of form, and function in black women's narrative structures take on radically significant meaning when analyzed through the rubric of the quilt. As metaphoric fabric griots, responding to the cultural knowledge embedded within their very fibers and cross-stitches, these African Atlantic women's narratives work arduously, creatively to articulate the words and worlds in which women negotiate complex networks of race, gender, sexuality, discourse, power, and access. Perhaps this is nowhere as poignant and plain as in the recent Tèt Ansanm production *Poto Mitan: Haitian women, pillars of the global economy* (Bergan and Schuller, 2009). Set in contemporary Haiti, the film traces the lives of five women who powerfully reflect and analyze the gendered face of neoliberal globalization, quilting together their individual and collective stories of worker exploitation, lack of access to adequate education, health, and housing, insufficient and sometimes corrupt nongovernmental organizations' involvement in the nation's affairs, government inadequacy, institutionalized sexism, women's struggles to unionize, and the economic incumbencies of the global marketplace. Marie-Jean, Solange, Frisline, Thèrèse, and Hèlène weave together their stories of resistance and survival, refusing to succumb to the myriad exploitative bodies that seek to conscript them. The documentary charts their tireless efforts to foment grassroots collective action, to unionize, to fight for justice, and most significantly, to educate their children.

In the opening sequence of *Poto Mitan*, a scene of a mother's hands braiding her daughter's hair appears and then recurs throughout the film bridging together the five women's stories. While the hair-plaiting takes place, the narrative overlay (spoken by Edwidge Danticat) invokes and simultaneously revises traditional Haitian folklore. The initial scene inferentially recalls a story first recounted in Danticat's *Breath, Eyes, Memory* (1998):

> *Haitian men, insist that their women are virgins and have their ten fingers.* According to Tanti Atie, each finger had a purpose … Mothering. Boiling. Loving. Baking. Nursing. Frying. Healing. Washing. Ironing. Scrubbing. It wasn't her fault, she said. Her ten fingers had been named for her even before she was born. Sometimes, she even wished she had six

fingers on each hand so she could have two left for herself (Danticat, 1998, page 151).

In the documentary *Poto Mitan*, however, the narrative voice is imbued with redefining power:

> You remember thinking when braiding your daughter's hair that she looks a lot like you at that age, but unlike you, your mother, and your grandmother before her, she is going to school. "Always use your ten fingers your mother told you," when your father took you out of school. "What use is school to a girl who only cooks and cleans? A kitchen scholar? But the resistance of your ancestors boiling in you kept the spirit alive. You use your ten fingers to grip the contours of a pen and write new words for women.

Here, the narration radically revises and re-visions the earlier folkloric instance. The woman's ten fingers, originally "named" by and in service of men are renamed and christened anew by mothers and daughters, invoking and appropriating their hands to craft words by and of service to women. Writing, reclaiming discourse, wielding the power of the pen, the possibilities for inscribing new forms of Haitian female subjectivity are engendered via the literal act of braiding. This filmic instance palpably recalls the synergistic relationship between quilting, resistance, and writing theorized by Alice Walker almost forty years ago.

Poto mitan, in Vodou belief, refers to the "center post," the "pillars," or what Audre Lorde, in the epilogue to *Zami* describes as "the mattering core, the forward visions of all of our lives" (Lorde, 1982, page 256). I read this concept of "the mattering core," alongside the aesthetic/ideological underpinnings of *Poto Mitan* "as a metaphor for the interstitial site where discourse, epistemology, hermeneutics, and praxis converge at the crossroads" (Russell, 2009, page 77). In other words, the center post, or mattering core, is the ethical place from which what we do, with what we know, once we know it, is actuated. Elsewhere, I have suggested that the framework of "quilted" discourse reflects key properties associated with Haitian *lwa* (god) *Papa Legba*, who is a shape-shifter, veiling and concealing while simultaneously unveiling and revealing, tasking human beings with figuring out what to do with the knowledge they receive. The equivalent principle applies to the quilt. As a "fabric griot," the quilt is always already more than it appears to be: "Although the African American quilt appears to be an everyday bedcover, it is more" (Tobin and Dobard, 2000, page 35). As god of the crossroads, or for our purposes, the *lwa* who presides over *poto mitan* or the mattering core, like the Greek god Hermes, from whom hermeneutics or the study of interpretation derives, Legba makes "readers" work to decipher both meaning and purpose. Reading, of course, extends way beyond engaging with the written word.

According to Thompson, "this means that one must cultivate the art of recognizing significant communications, knowing what is truth and what is falsehood, or else the lessons of the crossroads – the point where doors open or close … will be lost" (Thompson, 1983, page 19). Applied to the quilt, "it is precisely the fabric, the network of meanings, associations, juxtapositions and 'randomiz[ed] flow' that guarantees safe passage [even if only metaphorically] from enslavement to freedom" (Russell, 2009, page 21). The reader committed to deciphering the story is potentially engaged in a reconstitutive act: reading is a transactional experience of literacy and liberation. In the case of *Poto Mitan*, readers are asked to unpack the interrelationships between first-world consumptive practices, global worker exploitation, spurious US and UN foreign relations agendas, especially those couched in the language of "development" and/or "humanitarianism," and to the reject the simplistic and culturally biased relegation of Haitian women to perpetual victims. On the contrary, as the Haitian women workers/activist/mothers in the documentary astutely advise viewers: "hearing and seeing are two different things."

The practice of quilting, like the praxis engendered by quilting discourses, tangibly and metaphorically, has operated to unearth the complexities and possibilities of African Atlantic women's

experiences. From our anonymous quilt-making great-grandmother, to our daughters for whom we continuously revise, re-vision, and re-define – quilters of fabric, and stories, and activism have provided rich textile from which to craft acts of resistance against the linear, repressive forces of marginalization and exclusion, despite their twenty-first century guises. As Ozella, the African American quilt-maker from South Carolina counsels, "you will get the story when you are ready."[7]

Bibliography

Aptheker, Herbert (1947) *American Negro Slave Revolts.* New York: Columbia University Press.

Bergan, Renèe and Schuller, Mark, directors (2009) *Poto Mitan: Haitian women, pillars of the global economy.* Tèt Ansanm Productions. DVD.

Cade Bambara, Toni, ed. (1970) *The Black Woman: An anthology.* New York: New American Library.

Cliff, Michelle (1985) *The Land of Look Behind: Prose and poetry.* Ann Arbor, MI: Firebrand

Cliff, Michelle (1987) *No Telephone to Heaven.* New York: Plume.

Danticat, Edwidge (1988) *Breath, Eyes, Memory: A novel.* New York: Vintage.

Davies, Carole Boyce (1990) Writing home: Gender and heritage in the works of Afro-Caribbean/American women writers, pages 59–73, in Davies, Carole Boyce and Fido, Elaine Savory, eds. *Out of the Kumbla: Caribbean women and literature.* Trenton, NJ: Africa World Press.

Davies, Carole Boyce and Fido, Elaine Savory, eds (1990) *Out of the Kumbla: Caribbean women and literature.* Trenton, NJ: Africa World Press.

Davis, Angela (1971) Reflections on the black woman's role in the community of slaves. *The Black Scholar* December.

Fellner, Leigh (2010) Betsy Ross Redux: The Underground Railroad "Quilt Code." Available at www.ugrrquilt.hartcottagequilts.com/#Sources (accessed October 2013).

Gray, Thomas R. (1831) *The Confessions of Nat Turner,* edited by Kenneth Greenberg in 1996. Boston, MA: Bedford/St. Martin's.

Hull, Gloria T., Bell Scott, Patricia and Smith, Barbara (1982) *But Some of Us are Brave: All the women are white, all the blacks are men: Black women's studies.* New York: Feminist Press.

Hurston, Zora Neale (1942) *Dust Tracks on a Road.* New York: Harper Collins.

Ives, Sarah (2004) Did quilts hold codes to the Underground Railroad? Available at http://news.nationalgeographic.com/news/2004/02/0205_040205_slavequilts.html (accessed October 2013).

Kaplan, Caren (1992) Resisting autobiography: Out-law genres and transnational feminist subjects, pages 115–38, in Smith, Sidonie and Watson, Julia, eds. *De/Colonizing the Subject: The politics of gender in women's autobiography.* Minneapolis, MN: University of Minnesota Press.

Lorde, Audre (1978) Between ourselves. *The Black Unicorn.* New York: W.W. Norton.

Lorde, Audre (1982) *Zami: A new spelling of my name.* New York: Crossing Press.

McDowell, Deborah E. (1989) Negotiating between tenses: Witnessing slavery after freedom – *Dessa Rose,* pages 144–63, in McDowell, Deborah E. and Rampersad, Arnold, eds. *Slavery and the Literary Imagination.* Baltimore, MD: Johns Hopkins University Press.

Morrison, Toni (1970) *The Bluest Eye.* New York: Washington Square Press.

Rose, Tricia (1994) *Black Noise: Rap music and black culture in contemporary America, Music/Culture.* Hanover, NH: University Press of New England.

Russell, Heather (2009) *Legba's Crossing: Narratology in the African Atlantic.* Athens, GA: University of Georgia Press.

Said, Edward (1979) *Orientalism.* New York: Vintage.

Stukin, Stacie (2007) Unraveling the myth of quilts and the Underground Railroad. Available at www.time.com/time/arts/article/0,8599,1606271,00.html#ixzz2TnUGoPds (accessed October 2013).

Styron, William (1967) *The Confessions of Nat Turner.* New York: Random House.

[7] Despite the controversy surrounding Ozella Williams and her claims regarding the Quilt Code, there is so much that is useful in Tobin and Dobard's (2000, page 179) discussions of her work and her own analyses including this quote!

Thompson, Robert Farris (1983) *Flash of the Spirit: African & Afro-American art & philosophy*. New York: Vintage.

Tobin, Jacqueline L. and Dobard, Raymond G. (2000) *Hidden in Plain View: A secret story of quilts and the Underground Railroad*. New York: Anchor.

Walker, Alice (1970) *The Third Life of Grange Copeland*. New York: Washington Square Press.

Walker, Alice (1983) *In Search of Our Mothers' Gardens: Womanist prose*. San Diego, CA: Harvest Books/Harcourt Brace.

Washington, Mary Helen (1990) "The Darkened Eye Restored": Notes toward a literary history of black women, pages 30–43, in Gates, Henry Louis ed. *Reading Black, Reading Feminist*. New York: Plume.

Williams, Sherley Anne (1987) *Dessa Rose*. New York: Berkley.

Bombs and Baptismal Gowns: Sewing the Seeds of Resistance in Julia Alvarez's *In the Time of the Butterflies*

ANA LUSZCZYNSKA

ANY EXPLORATION OF WOMEN'S resistance must explicitly identify that which is to be resisted. In the context of US Latina literature, more often than not, patriarchal ideologies and institutions are easily identifiable as oppressive forces to be overcome or at the very least, recognized and negotiated.[1] In addition to identifying and examining phallocentrism we must perceive the concomitant logocentric/metaphysical forces at work. Grounded as it is in essentialist ideology, phallocentrism is necessarily a logocentrism and if we fail to recognize the connection between them, our hopes and projects for resistance cannot succeed.

One productive trope for examining phallogocentrism and imagining possibilities for subversion is that of sewing, a traditionally "feminine" endeavor highly associated with a correspondingly feminine domestic realm. In the context of US Latino literature, culture, and history, sewing has been highly significant both materially and metaphorically. As evidenced in texts such as *When I Was Puerto Rican* by Esmeralda Santiago (1993), *Empress of the Splendid Season* by Oscar Hijuelos (1999), and *The Moths* by Helena Viramontes (1995), to name just a few, female characters often find employment as low-wage workers sewing in factories. Such work is both a vehicle to independence and a context for the continuing exploitation of their labor. In all cases, it is considered a "feminine" activity to which they are uniquely or naturally inclined. Metaphorically, manifestations of sewing have been more straightforwardly hopeful as these allegedly "feminine" skills are reinterpreted to work in subversive manners. Gloria Anzaldua (1990, page xv), for example, uses "interfacing," a sewing term, to explain a powerful and liberatory space that lies "between" the oppressive "masks" we inevitably inherit from patriarchal cultures. Here, a sewing metaphor is indeed used to imagine a subversive and liberating space of existence for US Latinas. In spite of its traditional sensibilities, acts and products of sewing, as well as its metaphors, can resist rather than participate in phallogocentric concepts and structures. Continuing on Anzaldua's path, this exploration maintains that "the master's tools can dismantle the master's house" as far as sewing is concerned.[2] Our interest is

[1] A phallogocentric cultural context is almost inevitably present in US Latina literature. From groundbreaking 1980s feminist Chicana writers and critics like Gloria Anzaldúa, Cherríe Moraga, and Sandra Cisneros, to more recent and less obviously feminist Cuban thinkers like Ana Menéndez, Jennine Capó Crucet, and Achy Obejas, the issue of gender oppression and an overpowering *machista* culture is always in some way manifest.

[2] From Audre Lorde's seminal essay "Can the master's tools be used to dismantle the master's house" in *Sister Outsider* (Lorde, 1984).

in examining other ways in which the house might be unsewn, as it were, with the needle that was used to stitch it together.

In what follows we will trace the shifting perceptions of phallogocentrism and sewing in the lives of two of the famous Mirabal sisters of the Dominican Republic as they appear in Julia Alvarez's critically acclaimed historical novel *In the Time of the Butterflies*, first published in 1994, a text primarily about the transformation of three of the sisters into revolutionaries (Alvarez, 2010). Through fictional first-person narratives of each of the four sisters, Alvarez traces their lives from adolescence to adulthood. The most directly thematized portion of the novel involves their evolving understanding of and comportment toward the infamous Trujillo dictatorship (1930–61). Less obvious but equally important is a concurrent and broader demystification of phallologocentrism at large, here manifest in the power and authority of their Christian God as well as their biological father (the God of the family). The movement for each sister is generally from ignorance to knowledge concerning the atrocities committed by the regime, as well as the false omnipotence of the other Gods in their lives. They each respond to this unveiling in a different manner. Sometimes nuanced and sometimes heavy-handed, the narratives allow the reader a view into the particular evolutions of each of Las Mariposas (as they were affectionately called) from Church-trained middle-class "good" girls to revolutionary women. Our analysis will focus on the youngest and eldest sisters and their relationships to clothing, sewing, and the three Gods of their lives.[3]

We will see that demystifying phallogocentric conceptions and institutions leads to the capacity for sewing to function subversively for "Mate"

(María Teresa, the youngest Mirabal) and Patria (the eldest). Phallogocentric ideology, whether it be propelled by a metaphysical God, national "leader," or father (as in head of the household) cements and disseminates corresponding understandings and institutions while its demystification is a necessary condition for substantial theories and praxis of resistance. Furthermore, when sewing functions subversively in the novel, a central metaphysical/phallogocentric opposition, that between Individual/Subject and Other, is exploded which allows the characters to perceive and experience the opposite of phallogocentrism, a powerful and profoundly resistant community.[4]

There is ample textual evidence to indicate that the youngest Mirabal sister, Mate, is the quintessential girly girl. Every narrative, particularly those of Mate herself, in some way makes reference to or directly thematizes her proclivity for clothing, embroidery, shoes, boys, and dainty penmanship (see Alvarez, 2010, pages 30–42 particularly). Further, when telling the "fortunes" of each sister in the opening pages of the novel, Papa says simply that Mate will "be our little coquette. You'll make a lot of men's … a lot of men's mouths water" (page 8). Her role in life, it seems, is to be beautiful, romantically adored, and sexually desirable, all of which demand a particular and traditional preoccupation with

3 The narratives of all four of the Mirabal sisters in Alvarez's text are rich with interpretive possibilities. A more in depth study would at the very least need to examine the roles of storytelling and dogmatism as they concern Dedé and Minerva, respectively.

4 I draw from Jean-Luc Nancy's extensive work on community/singular plurality as it appears in *The Inoperative Community* (1991), *Being Singular Plural* (2000), and *The Creation of the World or Globalization* (2007). According to Nancy, Western metaphysical thought (what I refer to in this essay as phallogocentrism) has doomed us to think in terms of a static and oppressive Individual who has no capacity for movement toward another. Community in this view is a conglomeration of self-enclosed individual units. In contrast, true community (what he later calls singular plurality) is necessarily resistant to any and all metaphysical impositions, including and perhaps especially those of the Individual. For an extensive discussion of these issues see "The Inoperative Community" in Nancy (1991).

adornment and a corresponding view of sewing. While two of her older sisters, Patria and Minerva, are consistently concerned with God and social justice, respectively, Mate is primarily concerned with matters of self-adornment and romantic love, conceived in the most traditional terms.

From the first chapters of the novel it is clear that Mate is invested in the oppressive gender norms handed down to her without a proclivity for interrogating them. God, Trujillo, and Papa are explicitly connected and ultimately the sources of the cultural dictates she so readily digests. Supremely phallogocentric figures, they are honored and revered and further, all knowing and powerful. Although she is eventually able to acknowledge that Trujillo and Papa are capable of "wrongdoing" she can barely conceive of herself as not "loving" them (page 40). After she finds out that Trujillo is not in fact the grand benefactor of the country as he demands his "subjects" revere him, she directly compares Trujillo to God and her dad to Trujillo. "Before, I always thought our president was like God, watching over everything I did. I am not saying I don't love our president, because I do. It's like if I were to find out Papa did something wrong. I would still love him wouldn't I?" (pages 39–40).

Her life concerns and goals unfold in accordance with this "love" for her triad of Gods. At thirteen she "resolves" to be the best Catholic she can be, which largely means being attentive to her prayers and virginal. "I resolve to be diligent with my tasks and not fall asleep when I say my prayers. I resolve not to think of clothes when I am in church. I resolve to be chaste as that is the noble thing to do (Sor Asuncion said we should all resolve this as young ladies in the holy Catholic and Apostillic Church)" (Alvarez, 2010, page 35). The only thing that might keep her from the attentiveness for which she strives is boredom (sleep) and a preoccupation with clothes (many of which we later learn that Patria sews for her). Further, Trujillo and Papa *and* Mate's proclivity to think in terms of her clothing, are all directly aligned early in the novel: "Papa

is going to say the speech for the Trujillo Tillers! This time I'm inaugurating my patent leather shoes and a baby blue poplin dress with a little jacket to match. Patria made them for me with fabric I picked out" (page 37). Her penchant for and understanding of clothing (and her virginity) is directly thought alongside Papa and Trujillo. Lastly, when school gets out for the summer Mate reveals her genuine desires: "I'm going to spend the summer learning things I *really* want to learn like 1.) doing embroidery from Patria, 2.) keeping books from Dedé, 3.) cooking cakes from my Tia Flor (I'll get to see more of my cute cousin Berto, and Raul too!!!, 4.) spells from Fela (I better not tell Mama), 5.) how to argue so I'm right and anything else Minerva wants to teach me" (Alvarez, 2010, page 42). In all of these ways sewing is remarkably complicitous with patriarchal institutions and understandings.

The interlocking nature of God, Trujillo, and Papa as absolute authorities with rule-making and enforcing powers, should be thought alongside Mate's preoccupations and identification of what she "really" wants to be doing, which is first and foremost, "embroidery from Patria." The primacy of clothing (as self-adornment) in her life are part and parcel of the phallogocentric ideology in which she is immersed. Indeed, her presentation of these proclivities is contextualized by her unquestioned love for her three Gods. According to the unimpeachable authority of the male triad, she is to be "pure," passive, and pretty, while minding the household and caring for children, things to which she clearly aspires. Early in the novel Mate happily plays along. Within an ideology of a metaphysical God and his attendants (here, Trujillo and Papa) Mate thinks within their terms and has corresponding concerns and aspirations. Sewing is both a means to an end (the domestic or "feminine" product it creates), and an indicator of her ability to run a household, a central duty of a "girl" in a patriarchal context.

Mate's sensibilities shift as she is exposed to greater information about the specific "wrong-

doings" of both Trujillo and Papa. The phallogocentric mythologies of both patriarchs gradually unravel until Mate can see them as the (often severely) flawed human beings that they are. She is at last aware that Trujillo commits unspeakable crimes, mass murder and rape among them, and Papa has had an "other family" located just a short distance from the house of her childhood. When Mate marches by Trujillo's daughter "Queen Angelita" in a ceremony for the World's Fair she makes yet another comparison between the two men in which it is plain that they have been stripped of their godly status: "Looking at her, I almost felt sorry. I wonder if she knew how bad her father is or if she still thought, like I once did about Papa, that her father is God" (Alvarez, 2010, page 135). At this precise point she is also able to see the product of sewing, the clothing she had once so adored, as oppressive. As she considers her own discomfort in the Dominican heat she imagines that of Angelita: "Imagine, in this heat wearing a gown sprinkled with rubies, diamonds, and pearls, and bordered with 150 feet of Russian ermine. It took 600 skins to make that border! All this was published in the paper like we should be impressed" (page 134). Not only is the excessive ornamentation viewed as uncomfortable but additionally as unimpressive.

Eventually, Mate seems to achieve a fully revolutionary stance toward the dominant phallogocentric ideology when she abruptly decides to join the underground anti-Trujillo resistance. However, the depth of Mate's critical view of a broader phallogocentrism is dubious. She becomes a revolutionary not because she is invested in justice or freedom, but because of romantic desire for a man, a desire that she has long understood as "naturally" leading to matrimony.

> He studied me, trying to decide something. "You aren't one of us are you?" I didn't know what us he was talking about but I knew right then and there, I wanted to be a part of whatever he was. After he left I couldn't sleep for thinking about him. I went over everything I could remember about him and scolded myself for not having noticed if there was a ring on his hand (Alvarez, 2010, page 142).

At the end of the chapter Mate predictably marries this man to whom she is immediately attracted, Palomino/Leandro. She acknowledges that for her love is far more important than the struggle which actually does not seem to factor into her decision to be a part of the resistance in any way. Her revolutionary activity is thus an extension of her prioritizing of romantic love, marriage, and the patriarchal institution it suggests, rather than a genuine subversion.

However, Mate's decision to join the resistance *does* initiate an observable change in her relationship to sewing. Once she is an active and committed revolutionary her preoccupation with sewing and embroidery as a means of self-adornment in the context of domesticity dissipates. Indeed the only time we see her associated with sewing is in Patria's narrative and it is clearly subversive: "It was the shock of my life to see María Teresa, so handy with her needlepoint, using tweezers and little scissors to twist the fine wires together" (Alvarez, 2010, page 167). Mate uses the sewing skills that she learned in a traditional context for traditional purposes to literally make bombs for the underground anti-Trujillo movement. In this case both sewing as a skill and the product it can create are resistant to a dominant and oppressive phallogocentric regime, that of Trujillo. A bomb explodes and destroys. Mate is actively participating in an attempt to eliminate Trujillo's tyranny, which is plainly a manifestation of a phallogocentric order.[5]

[5] Trujillo's dictatorship epitomized phallogocentric sensibilities. Not only did he rename cities, streets, and municipal buildings after himself but he directly compared himself to God. Further, his violent and seemingly insatiable sexual appetite was a known and at this point mythologized part of his regime (see Díaz, 2007). And lastly, his will to essence in the form of racial purity is clearly manifest in the Haitian genocide that occurred under his rule. For a compelling fictional rendering of these events see Danticat (1999).

BOMBS AND BAPTISMAL GOWNS: SEWING THE SEEDS OF RESISTANCE IN JULIA ALVAREZ'S *IN THE TIME OF THE BUTTERFLIES* 217

The more radical resistance to a broadly conceived phallogocentrism occurs for Mate when she is imprisoned for her anti-government activities. While incarcerated, she is surrounded by women from various classes, does prison mending, and ultimately understands stitching in profound and *metaphorical* terms.

Mate learns about the working classes and under classes and comes to respect them in a way that was previously unimaginable. Referencing the generosity of her prison mates in sacrificing their time by the precious prison window for her, she says "the touchingest thing happened" and it "raised my spirits so much, the generosity of these girls I once thought were below me … I have to admit the more time I spend with them, the less I care what they've done or where they come from. What matters is the quality of a person. What someone is inside themselves" (Alvarez, 2010, page 230). Interestingly, Mate is not able to think beyond class hierarchies while she is bomb stitching but is capable of such a reconceptualization while among women she would previously have considered "beneath" her. "What they've done or where they come from" is finally no longer a way to assess a person. For the first time she conceives of a person's "quality" in a classless manner, an undeniably revolutionary understanding. Further, Mate describes this new way of appreciating "these girls" as moving to her. She is "touched" and her spirit "raised." A being who moves cannot be at one with itself (static) in the absolute and fixed manner that phallogocentrism necessarily implies. The opposite of a phallogocentric (absolute) identity, Mate's "moved" being is evidence of a conceptual resistance that she experiences in the material world.

In prison, both the event and product of Mate's sewing is profoundly distinct from its previous manifestations in the novel. Mate learns to "keep a schedule to ward off the panic that sometimes comes over me" and notably, one of the items on her agenda is "Doing some handiwork. The guards are always bringing us the prison mending" (Alvarez, 2010, page 235). While early in the novel she had been learning "embroidery from Patria" and so preoccupied with her clothing and presentation that she could concentrate on little else, now she sews with and for the prisoners, implicitly herself among them. This sense of being "for" and among others is arguably the most radical and intense form of resistance imaginable. As the precise opposite of absolute and unmovable grounds, and the unimpeachable and naturalizing decrees that inevitably follow, Mate's new understanding of community disallows an oppressive and dictatorial phallogocentrism.

Indeed prison is where Mate has her only earnest feeling for the struggle, justice, and freedom, those things which her country and its people had for so long been denied. "Magdalena and I had a long talk about the real connection between people. Is it our religion, the color of our skin, the money in our pocket? … There is something deeper. Sometimes I really feel it in here, especially late at night, *a current going among us, like an invisible needle stitching us together into the glorious, free nation we are becoming*" (Alvarez, 2010, page 239, my emphasis). The fact that religion, skin color, and finances are recognized as irrelevant to a "real connection" between people is not nearly as radical as the sewing simile from (and with) which she makes her observation. What she "really feels" is likened to "a current" that is itself similar to "an invisible needle stitching us together" and into a state of emancipation. Mate arguably has a material experience of the "among" that moves ("a current") between people and she understands it as a "real connection" that is associated with freedom. Notably, her understanding does not stress isolated and individual "identities" and in fact, brings to the fore the opposite, the *movement between*. Such movement is an undeniable aspect of sewing, and one that Mate is only able to recognize in the context of the prison. The very notion of the Individual (itself an offshoot of phallogocentrism) is here implicitly resisted and its opposite, a powerful and vital community, is underscored.

Patria Mirabal, the eldest and arguably most traditional of all the sisters, is actually the one

who undergoes the most radical transformation.[6] When we are first introduced to her in the opening chapters of the novel, she is profoundly preoccupied with her spiritual calling and stresses the importance of God in her life: "From the beginning, I felt it, snug inside my heart, the pearl of great price. No one had to tell me to believe in God or to love everything that lives. I did it automatically like a shoot inching its way toward the light" (Alvarez, 2010, page 45). Indeed while other girls were playfully flirting with the notion of marrying boys and changing their names accordingly, Patria was romanticizing a life as a nun: "I'd write out my name in all kinds of religious script – Sor Mercedes – the way other girls were trying out their given names with the surnames of cute boys" (page 46). Indeed, at Catholic boarding school (aptly called Inmaculada Concepción) she seriously considers joining the Church and the Sisters at the school recognize and in some way encourage her spiritual devotion. Sor Asunción inquires regarding Patria's plans for the future during her first year at Inmaculada Concepción: "We have noticed from the first how seriously you take your religious obligations. Now you must listen deeply in case he is calling. We would welcome you as one of us if that is his will" (page 46).

But Patria's "calling" in fact was to a mortal man. Her attraction and desire to be wedded to this man is presented in the most traditional terms possible. While washing the feet of the church practitioners before a service Patria recognizes the man to whom she is to be married: "A young man was staring down at me, his face alluring in the same animal ways as his feet ... Later he would say that I gave him a beatific smile. Why not? I had seen the next best

thing to Jesus, my earthly groom ... For Easter mass I dressed in glorious yellow with a flamboyant blossom in my hair ... I arrived early and there he was waiting for me by the choir stairs" (Alvarez, 2010, pages 48–9). In keeping with a traditional phallogocentric framework, she objectifies and exoticizes the *campesino* "other" literally comparing him to an animal. Rather than returning to Inmaculada Concepción to continue her education, Patria quits school and goes home to wait for him. While waiting she sews frocks for Mate: "I did not go back to Inmaculada in the fall with Dedé and Minerva. I stayed and helped Papa with minding the store and sewed frocks for María Teresa, all the while waiting for him to come around" (page 49). A more traditional scenario is difficult to imagine. She doesn't resist limiting and oppressive gender roles but unknowingly embraces them, leaving behind her opportunity to be educated at school, waiting for her man to come to her, and sewing for her sister, all indicative of a perfectly submissive subject of patriarchy. Clearly Patria fails to perceive that there is anything at all to resist. All of her activities and choices betray an intense complicity with the phallogocentric power structures of her time and place. That the absolute authority of God, Trujillo, and Papa are a part of her understanding of herself as a "feminine" subject is undeniable and indeed throughout this chapter the textile metaphors are entirely traditional and complicitous with various injustices of the Dominican Republic at that time.

At sixteen Patria marries the "man of the land" Pedrito Gonzalez and settles down to become a "good wife" in the house that her husband's great grandfather had built over a century before (Alvarez, 2010, page 148). But following the death of her son at birth, she begins to doubt the ultimate metaphysical God, that according to which all others are merely offshoots. She hides her doubts from everyone: "And so it was that Patria Mercedes Mirabal de Gonzalez was known all around San José de Conuco as well as Ojo de Agua as a model Catholic wife and mother. I fooled them all! Yes, for a long time after

6 At issue here is the extent to which the Mirabal sisters shifted perspectives. Although Minerva Mirabal was in some ways the most radical of the sisters, she did not transform significantly as the novel progressed. A more lengthy analysis could argue that Minerva was portrayed as dogmatically loyal to particular positions.

losing my faith, I went on making believe" (Alvarez, 2010, page 55).

It is in this context of lost faith that the Mirabal women decide to go on a pilgrimage to Higuey where "there had been sightings of the Virgencita" (page 55). Although all of the sisters had reasons to embark on the pilgrimage it was actually their mother who had initiated the trip, given her difficulties with her philandering husband, the girls' father. While on the journey their mother reveals to them that there was trouble with the father and when Patria inquires directly if there was another woman, Mama replies with "Ay, Virgencita, why have you forsaken me?" to which Patria thinks "I felt her question join mine. Yes, why? I thought" (page 58). So as her faith in God the father is more than troubled, Mama reveals that the patriarch of the family is also questionable. Patria is doubting two Gods at once.

An absolute (and thus necessarily tyrannical) metaphysical God is marked by its unimpeachable nature. It is that which cannot be questioned as it is not at all relative to history, culture, geography, indeed to any context at all. As such, it is necessarily outside of language and history. The fact that these Gods are understood as "above" us is indicative of their profoundly external and allegedly superior quality. They must be unimpeachably meaningful outside of (and *more* than) all contexts in order to be so absolutely true. In this case, the power and authority with which God the father, Trujillo the father (of the country), and Papa the father (of the family), are imbued, in the world and in this text, are central and crucial elements of their existences. Interestingly, as Patria engages on this pilgrimage she finds her "faith stirred" not by a God above her, but rather by the relations *around* her:

> I turned around and saw the packed pews, hundreds of weary and upturned faces, and it was as if I'd been facing the wrong way all my life. My faith stirred. It kicked and somersaulted in my belly, coming alive. I turned back and touched my hand to the dirty glass. "Holy Mary, mother of God," I joined in. I stared at

her pale pretty face and challenged her. Here I am, Virgencita. Where are you? And I heard her answer me with the coughs and cries and whispers of the crowd: Here, Patria Mercedes, I am here, all around you. I've already more than appeared (Alvarez, 2010, pages 58–9).

Rather than a hierarchical and logocentric understanding of God, Patria experiences a faith in "the coughs and cries and whispers of the crowd" that are "all around her" and the Virgencita "appears" as such. The manifestation of the divine is not above and outside at all, but rather *between* and *among* the "hundreds of weary and upturned faces" (page 59). It is clear that Patria recognizes the distinction between these approaches insofar as she plainly states that "it was as if I'd been facing the wrong way all my life" (page 58). Contemporary French philosopher Jean-Luc Nancy has discussed this fundamental relation between beings as a "sacred stripped of the sacred" community, or singular plurality (Nancy, 1991, page 35). Insofar as there is precisely no absolute or metaphysical sense to this "sacred" it is considered stripped of the transcendent (and metaphysical) character. Its power, however, is on par with the manner in which the sacred is traditionally conceived.[7] Patria Mercedes perceives this power and in another metaphor of movement, her "faith stirred" accordingly. Although sewing is not mentioned here directly, arguably her perception of the relations among and between beings is akin to that of Mate's recognition of an "invisible needle stitching us together."

These observations are significant to our study in that they indicate an important shift in perspective for Patria, one that ultimately allows her to emerge as a woman resistant to the oppressive forces around her. While the first chapters of the text presented

7 In "Poetics and politics of witnessing" from *Sovereignties in Question*, Derrida (2005, page 91) suggests that there is an intense power in non-metaphysical understandings (indicated by the figure of ash) that at the very least rivals that of metaphysics.

an entirely traditional and phallogocentrically complicit Patria, we witness her gradually change her understanding of and relationship to the oppressive forces of her world.

We next hear from Patria in chapter 8 wherein she fully transforms into a revolutionary and her perceptions of sewing and textiles change accordingly. Interestingly, the shift for her is directly thematized and comes once again from her understanding of her relationship to and this time responsibility for, the other which supersedes that of God.

Keeping company with Minerva and Mate, Patria was aware of the atrocities of the regime as well as her sisters' roles in the resistance movement. Initially and for some time Patria's primary concern regarding the revolution had been to keep her eldest son Nelson from participating and putting his life at risk. Knowing that he was a teenager with a leaning toward subversive activities she took active steps to distance him from Mate, his revolutionary aunt who lived in the capital as he did. Eventually, however, surrounded as she was by the revolutionaries in the family, she comes to question her role *vis-à-vis* the Trujillo regime as a believer in God.

Gradually, Patria's understandings of both God and textiles shift. After eighteen years of marriage and having built her "house upon a rock" as God commanded, Patria's literal and conceptual foundation shook. But this shaking (and eventual collapse) coincide with the emergence of Patria as an agent and singularity. She acknowledges that the house built "on solid rock" was the context in which she, "like every woman of her house … disappeared into what I loved, coming up now and then for air. I mean an overnight trip by myself to a girlfriend's a special set to my hair, and maybe a yellow dress" (Alvarez, 2010, page 148). Indeed Patria understands her being in a traditional religiously sanctioned context, as one in which she didn't exist (she "disappeared"). Not until after eighteen years of marriage when "the ground of my foundation began to give a little" did she emerge as an actively appearing subject, perceiving God and textiles in a newly informed

manner. Given that "foundation" is a quintessential metaphysical formulation, this "give" is indicative of a shift from phallogocentrism to something other, a radically resistant community.

Questioning what her role should be as a devoted Christian in a violently oppressive regime, Patria goes to the Father of the church for guidance. She is touched not by his "vague pronouncements " and "pat on the head" but rather by his admission of uncertainty and need for help. "This priest's frankness had touched me more than a *decree*" (page 154). The precise opposite of a metaphysical conceptual ground, this "frankness" of uncertainty is what "moved" her. Unlike the explicit privileging of clarity and truth in the text, here we see Patria "moved" by uncertainty and the vulnerability it implies. Patria changes her stance toward the resistance movement slowly, getting "braver like a crab going sideways. I inched toward courage the best way I could helping out with the little things" (page 154). Arguably, her bravery emerges from a new understanding of foundations or grounds.

In this context of uncertainty, Patria decides to go on a retreat with Padre de Jesús and the Salcedo group, a trip that "was important in renewing my faith" (Alvarez, 2010, page 157). On the last day of the journey, the military attacked some rebels in the area and the Salcedo group could easily have been killed. Patria reveals that "His Kingdom was coming down upon the very roof of the retreat house. Explosion after explosion ripped the air. The house shook to its very foundation. Windows shattered, smoke poured in with a horrible smell" (page 161). Soon after, with the windowed wall of the house blown open, Patria and the others are witnesses to a government attack on rebel soldiers. There are only four or five alive, and they are headed toward the cover of the retreat house when armed *guardias* and *campesinos* closed in on them. All but one rebel managed to "get down" in time to avoid an onslaught of shots. The one rebel who did not was shot in the back and as he died his eyes locked with Patria's. "I looked in his face. He was a boy no older than Noris. Maybe

that's why I cried out, 'Get down son! Get down!' His eyes found mine just as the shot him square in the back. I saw the wonder on his young face as the life drained out of him, and I thought, Oh my God, he's one of mine!" (page 162). Patria's witnessing of this event changed her in an abrupt and intense fashion. She comes to understand her connection to others in a far more profound way than she previously had.

> Coming down that mountain I was a changed woman. I may have worn the same sweet face, but now I was carrying not just my child but that dead boy as well. My stillborn of thirteen years ago. My murdered son of a few hours ago. I cried all the way down that mountain. I looked out the spider-webbed window of that bullet-riddled car at brothers, sisters, sons, daughters, one and all, my human family. Then I tried looking up at our Father, but I couldn't see his face for the dark smoke hiding the tops of those mountains. I made myself pray so I wouldn't cry. But my prayers sounded more like I was trying to pick a fight. I'm not going to sit back and watch my babies die, Lord, even if that's what You in Your great wisdom decide (Alvarez, 2010, page 162).

Patria is clearly responding to an imperative that is beyond that of a metaphysical or logocentric God. Her call to and responsibility for the other compels her more than God's "great wisdom." If not from any of the father's (God, Trujillo, or Papa) and their commandments and "decrees," from where did this imperative that Patria hears so powerfully, emerge? Arguably, it comes from a newly conceived sense of community, one that erupts as an "invisible needle" stitching them together. Indeed Patria perceives all others as her "human family one and all" and even if "God in his great wisdom" commands her passivity, she refuses to heed the command. Clearly, she is responding to a call or responsibility that supersedes that of a metaphysical and dictating God.

Interestingly, her textile metaphors shift accordingly. Before going on the retreat she wishes that her daughter Noris would "use her wings to soar up

closer to the divine hem of our Blessed Virgin instead of to flutter towards things not worthy of her attention" (page 157). In contrast, after rebelling against God she saw that hem as a tool for evading responsibility: "To the Salcedo gathering they invited only a few of us old members whom – I saw later – they had picked out as ready for the Church Militant, tired of the Mother Church in whose skirts they had once hid" (page 163). The hierarchical and metaphysical God *above* (the hem of our Blessed Virgin is that to which one "soars up") that Patria understood before her "human family" epiphany stands in direct contrast to the "skirts" of the Mother Church behind which clergy and practitioners had hidden. After her new understanding of her profound relationship to and accountability for her "human family," Patria perceives both God and textiles in a rejuvenated and vibrant way. She is able to revise both and as subject to revision, this God is no longer absolute and logocentric. It does not have the one and only answer being above and beyond mortals. Rather, as her earlier epiphany was located in "the coughs and cries and whispers of the crowd," this calling that supersedes the metaphysical God is also located in the between of beings.

A changed woman indeed. In addition to her own life and those of her husband and children, she places her foundation, her rock, her home at risk by making it a central hub of the resistance. Patria thus necessarily reconceives of the very notion and value of "foundation," able to perceive something far more crucial. No longer dogmatically wedded to oppressive commandments and paternalistic "decrees" Patria becomes the driving force of the household. Rather than waiting for her man "to come around" and "sewing frocks for Mate," Patria is now convincing him to join the revolution with her and eventually watching Mate make bombs that now remind her of Mate's sewing skills. Her new references to textiles include the church hiding behind a skirt, Mate sewing bombs, and guns stored among her daughters crocheted items. In a compelling palimpsest of domesticity and resistance, Patria rehearses

her role in the revolution as it is contextualized by her life as a "woman of the house:"

> So it was between these walls hung with portraits, including El Jefe's, that the Fourteenth of June Movement was founded. Our mission was to effect an internal revolution rather than wait for an outside rescue.
>
> It was on this very Formica table where you could still see the egg stains from my family's breakfast that the bombs were made. Nipples, they were called. *It was the shock of my life to see María Teresa, so handy with her needlepoint, using tweezers and little scissors to twist the fine wires together.*
>
> It was on this very bamboo couch where my Nelson had, as a tiny boy, played with the wooden gun his grandfather had made him that he sat now with Padre de Jesús, counting the ammunition for the .32 automatics we would receive in a few weeks at a prearranged spot …
>
> It was on that very rocker where I had nursed every one of my babies that I saw my sister Minerva looking through the viewfinder of an M-1 carbine – a month ago I would not have known from a shotgun …
>
> I had sent Noris away to her grandmother's in Conuco. I told her we were making repairs to her room. And in a way we were, for it was in her bedroom that we assembled the boxes. It was among her crocheted pink poodles and little perfume bottles and snapshots of her *quincenera* party that we stashed our arsenal of assorted pistols and revolvers, three .38 caliber Smith and Wesson pistols, six .30 caliber M-1 carbines, four M-3 machine guns, and a .45 Thompson stolen from a *guardia*. I know. Mate and I drew up the list ourselves in the pretty script we'd been taught by the nuns for writing out Bible passages (Alvarez, 2010, page 168).

Family breakfasts and bomb making, toy guns and real .32 automatics, nursed babies and M-1 carbines, and "crocheted pink poodles" and arsenals all coexist without contradiction for Patria. She has been able to radically reconceive of the domestic realm as a space of resistance, and understand sewing as a means to that end. In other words, that which had functioned as strictly complicitous with a phallogo-

centric ideology of God, Trujillo, and her father, and the foundational thinking it implies, has been radically reconceived by Patria such that it can be resistant. The master's tools do indeed seem capable of dismantling the master's house here. That she understood Mate's adept wielding of the tweezers used in bomb making in terms of her ability with needlework, is not to be missed. Additionally, the storing of guns among "crocheted pink poodles" points to the fact that traditional "girl" embroidery and handiwork is recontextualized as potentially resistant.

One of the last direct instances of sewing in the text is pertinent to both Mate and Patria and occurs after everyone but Dedé, Patria, and the kids are imprisoned, Patria and her husband's family's land is burned to the ground, and all of their assets confiscated. Mate, Minerva, and Nelson have been released but the three spouses have not. The women sew baptismal gowns to "keep their minds from roaming when they couldn't sleep" and earn some income to help compensate for all of the financial losses that the family has incurred. Sometimes Patria would lead them off in a prayer. In this case sewing and prayer work together to soothe the women. They sew together as self-sufficient women and in the absence of a male presence (or "head of household"). Although they may have learned both sewing and prayer as extensions of tyrannical gender norms they ultimately end up using them for subversive purposes. The sewing that is supposed to be a part of being "tied down" to a limiting domestic realm is in fact used as a means of independence in a rigidly patriarchal context. The prayer that is an extension of a phallogocentric figure par excellence (metaphysical God) is recontextualized to function in tandem with (and arguably as) a liberatory act. Yet again, the master's tools can be reimagined to take down the very house he built. Arguably, both the sewing that occurs and the prayers that are recited, together, work as a kind of "invisible needle" stitching the women together.

Sewing is here a metaphor for a way of being together that runs counter to the foundationalism

that both Mate and Patria thought was desirable and could be achieved *vis-à-vis* their relationships to their husbands. Their changed purposes for and metaphorical understandings of sewing illustrate that its subversive possibilities happen precisely in the context of a prioritizing of "withness" or community. Here the independent entity to be stitched or the product to be made are not necessarily primary. It is the act of stitching itself, the active binding between subject and other (rendering them mutually dependent) that is underscored and ultimately resistant. In these final scenes in which Las Mariposas sew together we witness precisely that.

Bibliography

Alvarez, Julia (2010) *In the Time of the Butterflies*. Chapel Hill, NC: Algonquin Books.

Anzaldua, Gloria (1990) *Making Face, Making Soul/Haciendo Caras: Creative and critical perspectives by feminists of color*. San Francisco, CA: Aunt Lute Books.

Danticat, Edwidge (1999) *The Farming of Bones*. New York: Penguin Books.

Derrida, Jacques (2005) *Sovereignties in Question*. New York: Fordham University Press.

Díaz, Junot (2007) *The Brief Wondrous Life of Oscar Wao*. New York: Riverhead Books.

Hijuelos, Oscar (1999) *Empress of the Splendid Season*. New York: HarperCollins.

Lorde, Audre (1984) *Sister Outsider*. New York: Random House.

Nancy, Jean-Luc (1991) *The Inoperative Community*. Minneapolis, MN: University of Minnesota Press

Nancy, Jean-Luc (2000) *Being Singular Plural*. Stanford, CA: Stanford University Press.

Nancy, Jean-Luc (2007) *The Creation of the World or Globalization*. Albany, NY: SUNY Press.

Santiago, Esmeralda (1993) *When I Was Puerto Rican*. Cambridge: Perseus Book Group.

Viramontes, Helena Maria (1995) *The Moths and Other Stories*. Houston, TX: Arte Publico Press.

Of Letters and Baskets: Wicker and Poetry

MARCELA ORELLANA MUERMANN

As a Starting Point: A Childhood Memory

As a girl, my summer holidays were always spent in the country, in the south of Chile. Sometimes I walked to the neighboring village to hear the names of people who had received letters, solemnly read out by the very thin and not so young postmistress. For a moment she was surrounded by hopeful villagers and she played the leading role in a brief but much acclaimed daily performance. This happened after five o'clock in the evening, when the bus from Chillán came by, delivering passengers and letters to the rural villages, spreading dust as it went on its noisy way, over the green foliage and habitual silence. In the ensuing bustle there was a moment, particularly precious for me, when I came across Don Héctor, the village cobbler. His working day over, he sat on a plank thrown across a ditch like a very low bridge. With his bare feet in the water, he held between his knees a half-finished wicker basket. The rhythm of his hands weaving the reeds and the sound of the water melted into a greater harmony that I could not explain but that I perceived as a condition of insuperable well-being. I think that was the origin of the fascination that wicker held for me and when I began to read the following verses by Joaquín Barquero, a poet from the south of Chile, the first image that came to me was that of the large, smiling man who had a few kind words for me as I went on my way.

Wicker weaver, let us sit here in the street
And let us make up with your white threads and my
 blue ones
The essential items of daily use:
Peace, the table, the poem, the cradle,
The basket for bread, the voice for love.

Today, I understand those radiant moments, not only as the awakening of interest for weaving reeds but also for the narrative. Progress in the weaving of reeds told me at the same time something local, of the south, of its people, where the voice of water is always heard.

In order to come closer to this association between reeds and water, between the weaving and the text, I build in these pages a dialogue, imaginary and arbitrary, among three poets of the south as a way of taking another look at my childish astonishment. They are Efraín Barquero, through his poem "Mimbre y Poesía" ("Wicker and Poetry"), written in the 1950s, and two Mapuche poetesses of today: Graciela Huinao, who published her novel *Desde el Fogón de Una Casa de Putas Williche* (*From the Fireside of a Huilliche Brothel*) in 2010, and Faumeliza Mauquepillán, poet and sculptress in stone, and also weaver of ñocha, a wild plant growing close to her home in the Mapuche area where she lives, whom I interviewed in February 2013.

Efraín Barquero was born in 1931; the verses selected are taken from his first book of poems *La Piedra del Pueblo*, of 1954, published at the age of twenty-three. Pablo Neruda, who writes the pro-

logue, describes him then as a "poet with class, popular, countrified, a peasant." A poet of peasant origin, his poetry would be defined by the poet himself as follows: "there is a poetry with sandals, not issuing from books, but rising from the land itself."

Where Barquero is the voice of the peasant working in harmony with his natural environment, Graciela Huinao and Faumeliza Manquepillán are part of the contemporary Mapuche voice resulting from the combination of ancestral orality and poetic writing. This originates a new voice in Chilean literature, most often published in Spanish as well as Mapudungún. Words of cultural resistance facing discrimination and imposition of an alien culture; on the other hand, it is a speech that rises from its cultural roots to a life in harmony with nature, so dear to its ancestors. This survival of nature is what enables us here to match the poetry of Barquero, from southern central Chile, and that of Graciela and Faumeliza, from the south: three poets from the southern world.

Material Conditions. The Rods and the Stroke

The association between wicker and poetry that Barquero makes in the verses above is established in the first place in the common material condition of the two artistic manifestations: the strands. The willow rods, debarked and ready for weaving are the white threads, while the ink stroke of the pen becomes the blue thread with which the poet writes his poems. Through these verses, Barquero reminds us that the Spanish words *texto* and *tejido* come from the same Latin root, *textus*. The text as a web of elements where the blue threads sew up their meaning as the white threads of wicker cross one another to shape an object.

Graciela Huinao, Mapuche poetess, also traces an analogy between the process of writing her novel and the ancestral lore of weaving on a loom. The threads are the basis of her novel; the foundation of her tale: "at first, concealed behind each of my characters, I began to set up the warp. On my knees, as my grandmother did before her loom, weaving a *manta* for my grandfather. I could sew up my own injuries, disguise my anger with a verse when someone offends me and stand fast when fear pursues me. That was the warp on which I first drew the females of the brothel: women entangled in the same skein. They surrendered to me the end of the thread of their lives and I began to untangle it: thread boiled in salt water to keep it from fading, and roots of trees bearing sweet fruit to soften the texture of their lives."

For Faumeliza Manquepillán, weaving the vegetable threads and telling a story cannot be understood separately: "In my basket-weaving, which is also poetry, *nochas* and grasses dance in my hands. My hands possess the power to create storms holding the four winds that carry the history of my people, my land, my blood."

Plaiting Rods and Words for Others

The link between writing and weaving is not exhausted in the various strands with which wicker objects or poems are woven. There is also another element of which Barquero tells: the use that those who have no power, that is, the people, may make of the words and objects that both wicker worker and poet create for them. For him, the people are those who walk along the streets where both wicker worker and poet sit at work; in the center of public and daily life; they are "anyone passing by," who may take away with them the fruit of that work, those "essential artifacts employed each day." The wicker-worker will make, among so many things, "the basket that the washerwoman requires to seed the whitest shirt," while the poet will compose a "song scented with soap and purity to sweeten her work by the river"; that is, both forms of work converge to make life easier for the people:

so that anyone passing by will understand us and
 take us away,
Will love us and make use of us. Will need us
and we will cheer him with no conditions.

Faumeliza also stresses the value that an object may
have in the life of each person, stressing the rela-
tionship with the object that grows over time in the
company of the object, "whoever has no basket in
which to keep his history, perhaps a ring that holds a
history, [the basket] becomes a part of him."

Huinao, in turn, also refers to her writing as a
way to serve the Mapuche community: her novel
seeks to recover a story told by others, those who
conquered and dislodged her people from their ter-
ritory: "it is better so; to hear it from the source,
generation after generation. Because historians wel-
comed in our land have mishandled our culture."
She also seeks to be heard by Chileans: "*Desde el
fogón de una casa de putas huilliche* will not alter the
history of the Mapuche or the Chilean people, it
would be presumptuous to expect it. It is enough for
it to be a grain of sand in the eye of the society of
this one-eyed country."

Each of the voices in this discussion seeks the
benefit of others with their creations. Their activ-
ity is not defined by their sole aesthetic function
but because they associate their art with a social
role. That is why what they do is popular art. An
art where aesthetic functions are not separate from
social and utilitarian functions, which is addressed
to the individual as part of a community, an activ-
ity that gives the group cohesion by contributing to
build a shared tradition.

Nature as Origin and Teaching

Just as nature supplies wool for spinning and veg-
etables to make baskets and other utensils for daily
use, it also gives people poetry, the two Mapuche
poets tell us.

The nature they speak of is the southern terri-
tory. The popular art mentioned here in its varied

forms of wickerwork, poetry, narrative, ñocha weav-
ing, comes from this territory where nature cannot
be overlooked because it is constantly present. The
people of the south have not become alienated from
nature but rather feel a part of it. Volcanic erup-
tions, earthquakes, unceasing rain, the immense
vegetation of evergreen forests, all leave their mark
on life in its various dimensions.

Graciela Huinao is very clear: "I see [my literary
works] like sisters. We are born of the same womb
– the earth – and are designed with the same blood
and matrix. And looking at myself in the mirror of
life, I would say that *Desde el fogón de una casa de
putas williche* is my twin, with all the savor and scent
of the south …," adding: "Nature, mother, friend,
and sister, was the architect who put in my crafts-
woman's hands the wisdom to shape the earth on
which the original Huilliche brothel was raised."

Faumeliza, in turn, takes us through the process
of learning that must be undergone to discover this
surrender of nature, an arduous task leading to a
gradual discovery and forming the artist: "the *hualles*
there are, the earth there is, the water there is, they
all knew my grandparents, my great-grandparents. I
think that is preserved and we are now they, those
who left did not leave, they are running in my body.
This must be uncovered … The same word takes
shape within me and helps me discover knowledge
lodged somewhere in my body … My surroundings
tell my tale and speak to me and speak, and that is
because I am part of this."

This labor of discovery is the road to learning, to
acquiring a skill, to recognizing a personal language
sealed with the echo of its environment. This pro-
cess is what makes artists differ from other men and
women. "Not everyone knows how to make a basket
or why or with what purpose," Faumeliza explains,
stressing not only the process of creation but also
its association with tradition, and finally the func-
tion it fills for the community. Huinao adds "I thank
nature for having taught me its wisdom and I thank
time for helping me to understand its composition,"
pointing to a long process of learning. Such learning

comes with years, and practice leads Barquero to put together poetry and wickerwork as twin trades.

> Wickerworker, my brother, there is beauty in our trade,
> when you are asked for a cradle and I am asked for hope,
> when you are asked for a table, a lampstand, a basket.
> And I for a weapon to defend these simple things.

Gratitude as a Destination

After listening to these three voices, I realize that my wonder on seeing Don Héctor weaving his baskets was because he let the material speak with its own voice, and that, as he wove, the south was telling of its landscapes and its peoples. At that moment, nature and man joined in silent and constructive dialogue, passing on stories and traditions to us walking by. I believe that those privileged moments when I entered the village to pick up letters gave me something that I was not looking for, nor did I then attach any importance to it, but that, in retrospect, appears to have pointed the way to future wanderings, including my interest for popular literature and culture, focus of interest of my academic life.

Acknowledgments

I have quoted fragments of the novel *Desde el Fogón de Una Casa de Putas Williche* by Graciela Huinao, and, at the same time, words by Faumeliza Manquepillán, collected in an interview in February 2013. I have also text included in *Hilando en la Memoria*.

Bibliography

Barquero, Efraín (1954) *La Piedra del Pueblo*. Caracas: Alfa.

Huinao, Graciela (2010) *Desde el Fogón de Una Casa de Putas Williche*. Osorno: Uniad de cultura y educación CONADI Dirección Regional de Osorno.

Manquepillán, Faumeliza (2010) *Hilando en la Memoria*. Santiago: Cuarto Propio.

Index

Printed in Great Britain
by Amazon